The Natyasastra
and the
Body in Performance

The Natyasastra and the Body in Performance

Essays on Indian Theories of Dance and Drama

Edited by SREENATH NAIR

Foreword by M. KRZYSZTOF BYRSKI

McFarland & Company, Inc., Publishers

Jefferson, North Carolina

LIBRARY OF CONGRESS CATALOGUING-IN-PUBLICATION DATA

The Natyasastra and the body in performance : essays on
 Indian theories of dance and drama / edited by Sreenath
 Nair ; foreword by M. Krzysztof Byrski.
 p. cm.
 Includes bibliographical references and index.

 ISBN 978-0-7864-7178-2 (softcover : acid free paper) ∞
 ISBN 978-1-4766-1221-8 (ebook)

 1. Bharata Muni. Natyasastra. 2. Theater—India.
3. Sanskrit drama—History and criticism. 4. Aesthetics,
Indic. I. Nair, Sreenath, editor.

 PK2931.B44N3734 2015
 891'.22—dc23 2014035787

BRITISH LIBRARY CATALOGUING DATA ARE AVAILABLE

On the cover: Kelucharan Mohapatra (1926–2004),
the legendary Indian dancer of Odissi dance form of Orissa
© Avinash Pasricha

Printed in the United States of America

McFarland & Company, Inc., Publishers
 Box 611, Jefferson, North Carolina 28640
 www.mcfarlandpub.com

To Kapila Vatsyayan
for her lifetime devotion, commitment
and invaluable contribution
to the Natyasastra studies

Acknowledgments

I am indebted to the people and institutions that offered the constant support and inspiration that made this publication a reality. It started when I took the initiative at the University of Lincoln to organize the first international conference on the Natyasastra in collaboration with Indira Gandhi National Centre for the Arts (IGNCA) and Banaras Hindu University, Varanasi. With the participation of a significant number of renowned international scholars, the conference took place in Varanasi at Banaras Hindu University in 2010. This book is not the proceedings from the conference, but the conference helped me in many ways to edit this substantial volume and make it a genuine representation of current Natyasastra scholarship. Kapila Vatsyayan, a great scholar and the cultural icon of traditional Indian knowledge, persistently supports my ideas with her invaluable suggestions and enigmatic presence. This book would not be a reality without K.D. Tripathi, a distinguished scholar and proponent of the Natyasastra. I sincerely express my gratitude to Abhijith Chatterji, editor of *Sangeet Natak,* the journal of Indian performing arts, and gratitude goes as well to the Sangeet Natak Akademi, New Delhi, the institution owning the journal, for granting permission to include Ayyappa Paniker's essay in this collection. I also thank Arya Madhavan and Mary Padden for their patience and time for copy editing and proofreading.

Table of Contents

Section 3: Neuroscience

Section 4: Religion, Ritual and *Kutiyattam*

Section 5: Transcultural Theory and Performance Practice

Foreword

M. Krzysztof Byrski

The Natyasastra, the ancient Indian treatise on theatre ascribed to Bharatamuni, can hardly be matched anywhere in the world. Neither the earlier Aristotle nor the much later Zeami, nor ancient Chinese sources, so far as I can judge, equal the precision or comprehensiveness of Bharatamuni's text on the art of theatre. Apart from highly methodical and detailed descriptions of all important component arts that, taken together, make theatre, the Natyasastra defines this art as the very nature of the human world (*loka*) made perceptible with the help of actors using four means of expression, literally termed the "leads" (*abhinayas*): body gestures, speech, power of expression and costumes together with stage props. Thus theatre, by extricating human reality from the shackles of time and space and transporting it onto the stage and by the same token "departicularizing" it (*sadharanikarana*), allows each spectator to experience such "reality." Thus theatre, by means of departicularized emotions leads us unto the experience of *rasa,* tantamount to the experience of *ananda,* i.e., satisfaction, which stems equally from happiness (*sukha*) and from despair (*duhkha*). The only requirement on the part of the spectator is "to have a heart" (*sahridaya*)—that is, be capable of experiencing emotions.

Sreenath Nair has gathered in one collection essays penned by dedicated scholars of repute, thus making a lasting contribution to the debate on the value of India's fascinating contribution to the universal art of theatre. We may justifiably expect that the ideas found in these essays may reinvigorate the interest of the Western theatremakers in the classical Indian theatre. In his introduction Nair asks a series of questions, all of which basically boil down to one fundamental query: Is the content of the monumental work still relevant for us today, and also outside the strict perimeters of Indian civilization? Nair leaves no doubt in the exhaustive introduction that ancient Indian theatrical

theory and practice is a priceless gem of human imaginative thought. The essays herein cover epistemological, aesthetic, historic and practical aspects of the Natyasastra with scholarly acumen and highly commendable inquisitiveness. The contributors in whose number I have a privilege to count my humble self, are headed by Kapila Vatsyayan, the doyen of all of Bharatmuni's contemporary students. With her characteristic lucidity she delves into some of the most important aspects of classical performing arts in India.

Since the foreword should not overlap too much with Nair's introduction, let me only express my excitement at so many new ideas presented here. One such idea, which we owe to Vashishtha Jha, is that the transformational nature of aesthetic experience signifies we live in two worlds: the given and the created. To Richard Schechner we are beholden for his consequent integration of Natyasastra principles into contemporary performance studies and for showing the theory of rasa in the light of neuroscience. Nair follows in the same vein while concentrating on the contemporary brain studies and the theory of rasa. I am convinced that Schechner's dictum that the experience of theatre is "participating in a banquet—not looking at picture" especially in the context of "physicalization" of rasa aesthetics will in a significant way enrich the art of theatre discourse. The same may be said Sreenath Nair's opinion that "*rasa* offers 'loveness' and sadness," which strikes me as yet one more way of expressing the *sadharanikarana* principle.

For someone like myself, it is especially exciting to welcome a study of *Kutiyattam* by K. Ayyappa Paniker, which—thanks to Dr. V. Raghavan—I discovered in the early 1960s and had the privilege to be associated with its *tourné*, the first ever, of North India and Europe. Equally promising is Natalia Lidova's study of religious symbols and rituals, which will contribute to our better understanding of the phenomenon that the ancient Indian theatre undoubtedly is. It is impossible in a brief foreword to do justice to the content of the volume that is offered to us. Every author contributes meaningfully to our better understanding of the wonder that the ancient Indian *Natya* was— to paraphrase the title of the famous book of Sir Arthur Basham.

Ancient Indians tried to comprehend the harmony of creation and to recreate this harmony on the stage. The present volume offers valuable guidance in our effort to fathom the depths of this concept of theatre. Let us hope Bharatamuni and we—his contemporary acolytes with the timely help of the expert authors, whose writings make this volume—may bring some meaningful changes in the ways in which we think about theatre and practice it today.

M. Krzysztof Byrski is a professor at the Collegium Civitas University and a professor emeritus at Warsaw University. He is the former director of the Institute of Oriental Studies, Warsaw University, and ambassador of the Republic of Poland to India.

Introduction: The Natyasastra and the Body in the Natyasastra

Sreenath Nair

> The body believes in what it plays at: it weeps if it mimes grief. It does not represent what it performs, it does not memorize the past, it enacts the past, bringing it back to life (Bourdieu, 1990: 73).

What is Indian performance studies? How does the Natyasastra—an ancient Indian text on theatre arts—inform and explain structural principles and functional modalities of performance as a spatiotemporal event? How do we understand the performance discourse of the Natyasastra through the range of critical paradigms and theoretical concepts presented in the text and translate them into contemporary scholarship? Is the Natyasastra still a significant source of knowledge in understanding the multiple and complex mechanisms of the body in performance? Do the theoretical insights that the Natyasastra offers to understand performance practice have relevance or usefulness in enhancing and/or complementing our understanding of current developments in theatre and performance studies, and, if so, to what degree and level? Or is the text simply a doctrinal composition of the past? These are the fundamental questions that this collection addresses in various contexts and from various perspectives: from Sanskrit to performance studies and from Abhinavagupta to neuroscience.

Indian Performance Studies

The Natyasastra is the deep repository of Indian performance knowledge. It presents centuries of performance knowledge developed in South Asia on a

range of conceptual issues and practical methodologies of performance as a bodily practice. The body in performance produces perceptible knowledge. This knowledge of the body is produced through the body's constant engagement with physical objects and mental images of the world. However, the knowledge that the body in performance produces is not only the by-product of the object relationship of the body in a performance world, but rather beyond the level of a rational understanding of the body as a physical object, the whole relationship of the body in performance is situated in the *transitive* dynamics of the production and reproduction of cultural artifacts (Bourdieu 1990: 73). The body in performance operates in multiple dimensions and on multiple pathways. On the one hand, the body in performance is firmly positioned in the corporeal logic and physical objectifications of techniques and principles. On the other hand, the body in performance replaces itself through a series of transitions during the performance from actor through character to the audience transporting (Schechener 2003: 191) cultural objects and forms into performative experience. The entire discourse of the Natyasastra is about this transitive experience of the body and, the rasa theory in particular, offers a profound conceptual explanation as well as the methodological clarity into this performative experience. According to Abhinavagupta, rasa is the purpose and the product of *natya*, the performance (1924–1964: 271). Rasa is the beginning and end, the object and result, the medium and method, and the discourse and practice of performance. Indian performance studies, therefore, fundamentally is an attempt to understand, explain and practice the transitive nature of the body in performance known as rasa.

The body becomes an instrument in the hand of the performer. Knowledge is transmitted through the practical mastery of the practice of the body: the performer disengages the body, keeping the same engagement with the process, at the same time during the performance through motion trajectories and mental maneuvers. The body remembers and repeats all the limb movements and their numbers mechanically while taking the body out of its restrictive principles of practice. Academic disciplines and artistic practices in theatre and performance studies, in the recent past, have integrated, adapted, transformed and put to new uses of the concepts and practices of Indian bodily traditions in general and the Natyasastra in particular. Neuroscience and rasa theory influenced the development of performance studies. From Stanislavski to Richard Schechner and Eugenio Barba, to a large extent, Western theatre practice is intercultural and transnational. Raja Yoga of India informs the structural principles of Stanislavski's system. Richard Schechner's *Rasabox* is a recent example of the integration of the Natyasastra principles into contemporary performance studies. Eugenio Barba's *Theatre Anthropology* is deeply inspired by the Natyasastra principles and the performance knowledge of Samjukta Panigrahi, the Indian Odissi dancer.

The most distinctive aspect of the performative discourse in the Natyasastra is its clear emphasis on the "universality" of production and reception of emotions presented in the rasa theory. The body in the Natyasastra is culture specific and Bharata's examples are largely derived from arts, literature, music and performing arts of South Asia. He has documented extensively regional languages, customs and performance practices of South Asia of his time. Although it is highly debatable whether human emotions are culture specific, what is exceptionally distinctive in Bharata's methodology is his emphasis on the universal aspects of human emotional expression. In the context of rasa, Bharata isolated and reformulated eight fundamental emotions and subsequent facial prototypes that cover all possible human emotions, with astonishing range of precision and clarity in his methodology.

As a text, the composition of the Natyasastra is attributed to Sage Bharatha, and the authorship of the text is, arguably, dated to between 200 BC and AD 200. Written in Sanskrit, the text contains 6,000 verse stanzas integrated in 36 chapters discussing a wide range of issues in theatre arts including dramatic composition; construction of the playhouse; detailed analysis of the musical scales; body movements; various types of acting; directing; division of stage space; costumes; make-up; properties and musical instruments; and so on. As a discourse on performance, the Natyasastra is an extensive documentation of terminologies, concepts and methodologies. The aesthetic theory of *rasa* is central to the Natyasastra. The term is widely used in recent debates in aesthetics, philosophy, neuroscience and performance practice as a performative mode generating multiple layers of meaning and artistic experience. In the past several decades, in the theatre scholarship and practice in the West, we see the influence of the Natyasastra and rasa theory formulating several important intercultural theories and training methods. I must emphasize at this point that the book as a whole is an attempt to bring out the contemporary relevance of what the Natyasastra stands for and how this cultural specific "code of practice" is equally flexible for redefinitions and reinterpretations for the demands and sake of aesthetic theories and artistic practice in recent times. The Natyasastra is millennia old, but the application of its discourse is "universal" in many ways.

The Natyasastra: Implicit and Explicit

According to Kapila Vatsyayan, the Natyasastra "in its very nature is a residual record (*Shastra*) of a deeper richer experience and wider oral discourse [of theatre practice which] ... has an inbuilt fluidity that gives scope for multiple interpretations" (2008: 77) and understanding of a specific cultural discourse on bodily practice. The Natyasastra, like other classical textual

compositions in several other disciplines in India, has implicit and explicit layers. Some insight can be gained by penetrating through the language of "myth" and "legend" in which it is couched. The text insists a "code" of discourse, which is expected to be evident and illuminating to the initiated and conversant. On the surface, it is engaging to the general reader but always the text is not fully comprehensible on this level. The explicit level of the text includes systems of knowledge, the science and arts, all dimensions and orders of "space," "time" and bodily instruments. This explicit level of the Natyasastra deals with the structure, methodology and techniques particularly in relation to scores, skills, and physical abilities of the actor, not only limited to bodily animations, but also extended to the entire psychophysical possibility of the actor ranging from textual and verbal articulations to music, costumes, stage conventions and other illusory tools such as imagination and improvisations. In this sense, the bodily discourse presented in the Natyasastra is inclusive in nature, complex and multidisciplinary in structure.

Similarly, there are unsaid, unspoken implicit layers in the text dealing with the *transitive* nature of performance as a spatiotemporal practice, which is the "experiential world" of a work of art corresponding to the physical world of performance. This *transitive* world of performance is essentially "illusory" in nature in which the fundamental relationship between the actor and spectator is established. The Natyasastra proposes this relationship as the essential basis and "expressive order" of performance practice. The Natyasastra makes no distinction between the explicit and implicit; neither does it explain the aesthetic theory of *Rasa* as a self-explanatory term of principle. But, rather the term *rasa* refers to "illusory drive," the source of the very functioning of the specific logics of the field, that helps formulating deeper structure of thoughts and methodological framework of the discourse (Bourdieu 1990: 55–65). This bodily discourse of the Natyasastra, in this way, offers a complete performative engagement within a performance environment encouraging a very careful sifting of the implicit and explicit layers of the scholarship and practice. The essays in this volume will present multiple theoretical possibilities of the Natyasastra in addressing a range of aesthetic issues concerning theatre practice (*prayoga*) as well as critical scholarship (*Sastra*) of the text. The collection is divided into five sections exploring the explicit and implicit layers of a bodily discourse presented in the Natyasastra.

Epistemology

The two essays that comprise the first section explore the underlying epistemological framework of performance experience (*rasa*) proposed by the

Natyasastra. Kapila Vatsyayan argues that according to Bharatha, theatre is a practice of artistic expression and communication. It is a "process" of multiple spatial and temporal movements from the visible to the invisible and vice verse. The world of performance as a physical configuration is deeply interconnected with the invisible Rasa/Bhava correlation. The performance, in this sense, is created as a way of perceiving the rasa, which is implied and inaccessible without a visible and audible performative mediation. The invisible, here, is the reason for the visible and the "visible" emerges and submerges into the "invisible." Similarly, it can also be argued that that the rasa as the implied experience of a performance is non-existent until the performance takes a place. Rasa, therefore, is a derivative emotive state mutually created by the actor and the spectator. However, the concept of an inter-dependent discourse on the visible and the invisible forms the central debate in the Natyasastra.

Vashishtha Jha investigates the transformational nature of aesthetic experience. He argues that we live with two worlds: the given and the created. The world is given to us and we have not created even a particle of it. The created world, however, is our creation, in the sense that we have arranged and rearranged the already given. The very act of this arrangement and re-arrangement part alone is our creation. The entire process of a *rearrangement* requires extraordinary imagination that requires extraordinary genius. All forms of art are mere arrangements and re-arrangements of the given and they are beautiful because they are the products of extraordinary genius, imagination, skills and sensitivity. An artist, therefore, in the classical Indian aesthetic tradition, is considered as the "Creator" of the word of art. An artist creates his world of art by transforming *the given world* into a *created world* through his extraordinary abilities. The world of art, therefore, is the transformation of the given world. Flowers are given, but a bouquet is created. The stones are given, but the sculpture is created. The voice is given, but the melody is created. The language is given, but poetry is created, and so on and so forth. There is transformation at all levels of creation of an art form: the world of art is different from the actual world; daily experience is different from aesthetic experience; ordinary language is different from poetic language; and the very existence of the actor and the audience during a performance is transformed so that a subtle and meaningful communication is possible between the actor and the connoisseur.

Aesthetics

The four essays in this section extend the understanding of the aesthetic theory of rasa presented in the Natyasastra. The term *rasa* refers to a "unity"

of aesthetic experience manifested through a variety of physical and psychological tools employed in the process of theatre making. To better understand the creative process of rasa, we need to consider various complex and multiple layers of *time* and *space* operating within a performance (*natya*) structure. The singularity of rasa experience is regained by the audience in a performance through perceptual interactions between the macro and micro structures of time and space. The actor is central to the rasa experience, according to the Natyasastra, and remains as the basis of performative interaction between the spectacle and the perception and between the actor and the audience. Extending the debate on the aesthetic experience of rasa, M. Krzysztof Byrski brings the actor at the center of the art of theatre. The definition proper of performance (*natya*) holds that this art is nothing more and nothing less that the nature of humanity (*svabhavo lokasya*) with its happiness and despair, endowed with the four "leads" (*angadyabhinoyopetah*) of acting. These four leads, according to the Natyasastra, are gesture of limbs, speech, the power of expression and the external apparel of the leader and his companions. But where does he lead a spectator to? What is the role of the fourfold "lead," which he employs to achieve his art's end? And what precisely is this end? Bryski's investigation into the nature of aesthetic experience offers new ways of understanding rasa in contemporary theatre practice. Rasa is a transformative practice involving beatific pleasure and ethical learning representing two aspects of a performance: sentimental education and educative emotional arousal.

Daniele Cuneo argues that art brings forth a pleasurable experience, which *is* an education to make the right choice from among a fixed range of emotive possibilities in any situation to be copied. Interpreting some of the seminal philosophical concepts of Abhinavagupta, the 9th century commentator of the Natyasastra, on the purpose of the art, Cuneo insists upon a careful consideration of the cognitive, emotional and moral aspects of rasa arguing that any morally meaningful choices coincides with the emotional response to any given situation. Consequently, emotions are moral actions liable to moral judgment and evaluations.

Two other essays in this section extend the scope of the aesthetic debate on rasa drawing on consciousness studies. Daniel Meyer-Dinkgräfe demonstrates how, traditionally in the West, comedy has been viewed as tragedy's poor cousin, not least due to the loss of Aristotle's views on comedy. For him, comedy is considered a lightweight genre in the West and the characters in comedy are, conventionally, of less noble birth than in tragedy. Acting in comedy is considered the easy way out for less qualified or gifted actors. Taking the Natyasastra as the point of departure and using it as a reference point throughout, Meyer-Dinkgräfe redresses the balance and argues that the Natyasastra's position on comedy allows, for example, considerable and rele-

vant weight to the neglected position on comedy developed by Schiller to be added. Exploring the comic rasa (*hatsya*) in the Natyasastra and further investigating it as state of consciousness in line with Schiller's definition, Meyer-Dinkgräfe further argues that comedy leads the spectator to a state of consciousness that is calm, clear, free and cheerful that is neither active nor passive. According to Schiller, in comedy everything remains outside of ourselves and we simply observe the state of the gods, who are not concerned with anything human, who are hovering freely above everything, who are not moved by any fate and not bound by any law (see http://www.odysseetheater.com/schiller/schiller_tragoedie_komoedie.htm). Meyer-Dinkgräfe concludes that comedy is a higher state of human consciousness according to the Natyasastra. David Mason takes a similar view stating that the Natyasastra has become increasingly important in the West as various theorists have played with the term *rasa*. There are misinterpretations explaining rasa as emotion, or a physical sensation, or the product of the physical expressivity of performers. As Mason argues, none of them is accurate in a careful reading of the Natyasastra. Rasa is a neural activity and a state of consciousness. Based on the precepts of Neural Darwinism, as articulated by Edelman, V.S. Ramachandran and relying on a close reading of the sixth chapter of the Natyasastra, Mason seeks to re-articulate *rasa* as a state of consciousness that arises from the contingent interactivity of brain systems, intentionality and attention.

Neuroscience

The three essays in this section investigate the implications of neurosciences in rasa theory. Richard Schechner illustrates a contemporary application of the theory and practice of rasa in a most recent "rasaboxes" exercises. In the Natyasastra, the rasas, emotional "flavors," underlie aesthetic experiences both for the performers and the spectators. One way to use rasa theory is to assert that a primary avenue of aesthetic experience is the snout-to-belly-to-bowel; that preparing, sharing, and experiencing an accomplished performance is more like participating in a banquet than looking at a picture. The rasic route through the body is managed by the enteric nervous system (ENS)—the bundle of nerves in the gut that comprise a "brain in the belly." The ENS is located in sheaths of tissue lining the esophagus, stomach, small intestine, and colon. The ENS is linked to the brain via the vagus nerve. Considered as a single entity, the ENS is a network of neurons, neurotransmitters, and proteins that send messages between neurons, cells like those found in the brain proper, through its own complex circuitry the ENS is able to learn, remember, and produce "gut feelings." In addition to presenting this theory of perform-

ance the essay describes the "rasaboxes" exercise, which Schechner has devised as performer training to physicalize some of the ideas of "rasaesthetics."

Sreenath Nair investigates the links between rasa and neural mechanism demonstrating scientific studies as well as performance analysis showing parallels between contemporary brain studies and the aesthetic theories of rasa presented in the Natyasastra. Drawing on recent studies on neuroscience Nair proposes synesthetics as a theory explaining the neural mechanism of aesthetic experience. It explains a set of neurobiological principles forming the very nature of human perception and its multiple modes of emotional experiences relating to external stimuli that evoke a specific functional reaction. Perception and its subsequent psychophysical reactions are neural functions of sensory phenomena caused by genetically mediated persistent neural connections causing cross wiring between brain maps (Ramachandran, Hubbard and Butcher 2004; Hubbard and Ramachandran 2003). Aesthetic and emotional responses to sensory inputs depend on hyperconnectivity between the cortices and the limbic system, *fusiform gyrus* and *angular gyrus*, respectively (Ramachandran, Hubbard and Butcher 2004). The hyperconnectivity between these brain regions involves the neural mechanism of metaphor, the same principle that explains synesthetia and artistic creativity. It is also consistent with data suggesting that the right hemisphere of the brain, which processes spatial and nonlinguistic aspects of language, is more involved in the neural mechanism of metaphor than the left (Anaki, Faust and Kravetz 1998; Brownell et al., 1990). Taking an example from V.S. Ramachandran, he states that when we read Shakespeare's "It is the east, and Juliet is the sun," our brains instantly understand the meaning without taking the metaphor literally and therefore thinking that Juliet is a glowing ball of fire (Ramachandran, Hubbard and Butcher 2004). This metaphoric structuring of thoughts and emotions is a creative expression reinforced by the neural mechanism (Johnson 1987: 13). Based on these results, Nair shows a range of possibilities explaining the biological bases of aesthetic experience in performance practice consisting of mimetic expressions, perception, and meaning, which is a discourse that has long been dominated by phenomenological theories of perception. Cognitive mechanism encodes the perceptual world through metaphors. This suggestive nature of meaning making is essential to neural mechanism. Metaphors structure our understanding of the perceptual world and function as a language for our interactions with the world. Rasa is metaphor embodied in the sense that it refers to neural mechanisms underlying the visual perception and stimuli in performance practice. Rasa stands for a perceptual discovery of salient emotional evocation in a performance. Rasa is not actual representation of "real" objects, events and environments, but it is a perceptual process of rediscovering "objectness" and "emotioness" through performance. Rasa does not offer "real"

emotions of love or sad, but it offers "loveness" or "sadness," which are physical metaphors that are suggestive and stylized.

The discussion on rasa and neural mechanism continues. Erin B. Mee argues that the same part of our brain is activated when we feel disgust and when we see others express disgust. Thus, "observing someone else's facial expression of disgust automatically retrieves a neural representation of disgust" (Wicker et al., 660), and "seeing someone else's facial emotional expressions triggers the neural activity typical of our own experience of the same emotion" (661). There is an "automatic sharing, by the observer, of the displayed emotion" (661). Emotional contagion involves "the tendency to automatically mimic and synchronize facial expression, vocalizations, postures, and movements with those of another person, and, consequently, to converge emotionally" (Hatfield et al., 1994: 5), and experiments with emotional contagion show that people who are "in sync" tend to unconsciously copy each other's body movements. Clearly there are numerous similarities between theories of emotional contagion and theories of rasa. However, emotional contagion does not just spread feelings, it prepares the individual to act: when we feel something our premotor cortex is activated, which is a sign that we are preparing to act. Experiments in action observation demonstrate that "the network of motor areas involved in [the] preparation and execution of action [is] also activated by observation of actions," and that action observation involves "covert motor activity" (Calvo-Merino et al., 2005: 1248). This "suggest[s] that the human brain understands actions by motor simulation" (1243), which means that spectators are more than active decoders and interpreters of events on stage; they are, at the neural level, participants: feeling and doing along with the performers.

Religion, Ritual and *Kutiyattam*

This section is mainly about religion, ritual, Sanskrit theatre and the Natyasastra. Natalia Lidova considers the religious and ritualistic origin of the Natyasastra tradition, offering a detailed study of how religious symbols and rituals have been theatricalized in the post Vedic Indian society. *Kutiyattam* is often defined as the traditional presentation of classical Sanskrit drama performed in the temple theatres of Kerala. It is also frequently described as the only surviving form of the Sanskrit theatre tradition in the whole of India. Sometimes it is also claimed that it is the most authentic and most pristine form of ancient Indian theatre. These statements are perhaps not wholly incorrect: but they tell us either too much or too little about *Kutiyattam*. K. Ayyappa Paniker offers a detailed analysis of the aesthetics that explains the theatre

style and tradition. The Malayalam word *Kutiyattam* may be taken literally to mean "ensemble acting." *Kuti* means "together" and *attam* refers to acting or dancing: rhythmic and stylized movement. But this literal meaning also does not go very far. It gives us very little information about the complexity and sophistication of this performing art. That it uses scenes and situations from Sanskrit plays is true. Often it confines its attention to single acts or scenes— not to a whole play. And even a single act may take as many as 20 or 30 or 40 nights. Many scenes are presented as solo performances, without many actors appearing on the stage together, but with the same actor impersonating several characters without change of costume or makeup. So if someone takes *Kutiyattam* to mean *Kutiyattam*—that is, elaborate acting or extended performance—there is some justification for it. Actors are free to go beyond the verbal text of the play as written by the playwright and bring in related episodes from other texts. When the characters recite verses, whatever their source, they do so in a very specialized and stylized manner. The movements of the body and the gestures of the hands are highly codified. *Netrabhinaya*, or the movements of the eyes and eyebrows, as well as facial expressions are endowed with a lot of significance. Make-up and costume as well as stage decor are conditioned by rigid specifications. There are ritualistic enactments, which may not have any obvious or intimate connection with the text, of the play concerned. Excessive stylization may at times obscure the connection between the actor's gestures and speeches on the one hand and the body movement and vocal utterances in real life on the other. Realism on the surface is thus kept to the minimum. The emphasis is thus shifted to imagined reality.

One of the most distinctive features of *kutiyattam* is the art form's emphasis on the actor's imagination. The *kutiyattam* actor is trained with immeasurable sense of knowledge and precision of imaginative acting capable of depicting objects, landscapes, dramatic events and persons on a bare stage only depending upon bodily means. Widening the scope of the discussion about the actor's imagination, Arya Madhavan investigates the Natyasastra approach to actor training, particularly with imagination training in *kutiyattam*. She argues that the Natyasastra's approach to bodily engagement in theatre is highly complex and intrinsically multilayered: therefore, isolating one or two individual components that contribute to the development of the actor's imaginative qualities becomes highly problematic. However, individual acting techniques that help actor's imagination can be identified and isolated from the training and make use of contemporary actor training where imagination training is hugely important. Natyasastra is a colossal treatise on the theatre, which discusses theatre practice in 36 long chapters. However, there is no single line in the text that directly addresses the actor's imagination. The initial reference we get from Bharata about the actor training is in chapter 35, where

he discusses the necessary qualities of an actor. According to him, "an actor should be handsome, having plenty of experience in watching theatrical performances, possessing sharp memory, be knowledgeable in his art and an expert in acting" (NS 35: 61). Imagination, however, is not a point of explicit discussion in the Natyasastra. Yet the vigorous practice of any of the Indian theatre or dance forms makes an actor highly imaginative. Why is that so? How do various Indian performance forms help to develop actor's imagination? What is the connection between the actor's bodily practice and imagination and how and in what ways do the corporeal techniques in *kutiyattam* help the development and a contemporary adaptation for an imagination training method? Madhavan offers a careful consideration and a systematic analysis of the explicit layers of the Natyasastra's approach to acting.

Transcultural Theory and Performance Practice

The fifth and the final section on performance practice presents two essays that address the question of what the Natyasastra-based theatre practice is and how those principles can be understood in a cross-cultural context. According to the Natyasastra's view, acting includes singing, dancing, miming and enactment of dramatic situations followed by a range of performative means including costumes, make-up, stage props, musical accompaniments and chanting. An actor's participation, therefore, means a complete mental and physical involvement with the performance; foot, eyes, hands and each facial muscle will take part in the process of creating the rasa enjoyment which is the ultimate aim of a theatrical presentation according to Bharatha. Ralph Yarrow observes that the Natyasastra is full of measurements, classifications and definitions. The measurements are about stage architecture, detailing the dimensions of playhouse, stage space and green room. The classifications are of great variety, spanning types of plays, characters, emotions, stage techniques and modalities of performance. Definitions are kinds of procedural mechanics for producing *rasa,* the emotional states, which are present in a theatrical event. This suggests two investigations: (1) What "stage space" is like and how it can best serve an imaginative transaction with an audience and (2) What a performer does and how he or she can best operate imaginative transactions with an audience. The common question is What are the ground conditions for the generation, stimulation and reception of imaginative worlds, the creation of signs and meanings, the materialization of forms and relationships? By implication, these will give rise to the intelligent body of the performer and the active body of the receiver.

As Yarrow further argues, like the Natyasastra, Beckett was actually very

precise about measurements and definitions, length of pauses, ways of speaking, pace of walking, and so on, for his performers. Is this specificity necessary to propel the performer beyond specificity? Does it result in a skill which, like the world of Beckett's work, unremittingly engages with entropy and in so doing shows it to be generative in the most subtle and inventive ways? His answers are arrived at through an investigation of "zeroing," of the moves suggested by Beckett's words, structures and methods towards a "no-place" somehow before movement and vocalization. They mostly concerned performers and receivers in relation to the operative mechanism of imaginary transaction in a performance event. Both Beckett's texts and the Natyasastra are in the business of providing instructions for performance with a specific goal, which is to take performers and receivers to a condition in which they are "experiencing" the initial phases of the trajectory of "making work." The Natyasastra is the more direct version of this, although of course it probably, in practice, represents a writing-down of instructions, which were given verbally—or indeed, more probably, transmitted visually and physically.

In Beckett's performance worlds, any specific location, function or designation of "sets" is mooted only to be rapidly retracted or have any sense of specificity removed from it; a heap of sand, an empty road, a bare room, some jars. In *kutiyattam* and *kathakali,* the worlds may be more "recognizable" (as mythological terrains—rivers, mountains, forests), but they are in fact even less material. Indian performers "construct" them through gesture and expression; Beckettian performers have to fight against or work with the banality, discomfort, repetitiveness or lack of assistance, which the few objects in their domain afford. Both of these procedures are more interested in locating the "action" as a "set" of impermanent performative utterances. But in both cases this occurs as a result of specific "training," either as a long-term program as set out in the Natyasastra, or in response to specific instructions in the text (as stage directions) or given by the director (in many cases leading up to first performances, Beckett himself); and this training is focused on minimal but precise movements of hands, face, eyes, musculature, body positions. Concomitantly, the audience's attention is drawn to and held within this relatively small zone of action: what may extend to an imaginative engagement or co-creation starts with a practice of tight focusing. Thus, Beckett's demands require actors (and to the extent just indicated, spectators) to "move into a condition in which the performative flows of energy, attention and intention operate at the very threshold of action." Indian work, which takes Natyasastra as a basis, in some way, starts with this degree of precision, and may move "out" into variously configured bodywork and kinetic language.

Uttara Asha Coorlawala provides a deconstructive reading on the Natyasastra-based *abhinaya,* the acting, using methods developed in the fem-

inist film theories. The study yielded an alternative model to Kaplan's model of the inevitable male gaze and arises from a performance mechanism for generating transcendence. It also shows that de-contextualized readings of dance can yield very different meanings from the readings that consider the religio-aesthetic environment of Indian dance. Euro-American perceptions informed by Freud and Lacan recognize the importance of seeing and its relationship to knowing. So do yogic (*Samkhya* and *Advaita*) theories of perception that inform the dance theory and practice. Cross-examining inherently different performance methodologies, techniques and forms yield fascinating connections and insights, but it also has limitations. Perspectives cannot be equated. Each view has value-laden socio-cultural orientations, which must be considered.

This collection presents a wide variety of scholarly essays exploring the Natyasastra from the perspective of Indian performance studies from various angles—epistemological, aesthetic, scientific, religious, ethnological and practical. The Natyasastra provides an extraordinary range of concepts and vocabularies that help us to reinvestigate and reposition the theory and practice of Indian performance studies. This is the context in which this publication arises. The fourteen scholarly essays herein render a meaningful dialogue in this direction enabling a better understanding of the performative dynamics of the body through the knowledge of practice.

BIBLIOGRAPHY

Abhinavagupta. 1926–1964. *Natyasastra with the Abhinavabharathi*. M.R. Kavi, ed. Baroda: Central Library.
Anaki, D., M. Faust, and S. Kravetz. 1998. "Cerebral hemisphere asymmetries in processing lexical metaphors." *Neuropsychologia* 36, 4 (April): 353–62.
Bourdieu, P. 1992. *The Logic of Practice*. Cambridge: Polity Press.
Calvo-Merino, B., D.E. Glaser, J. Grezes, R.E. Passingham, and P. Haggard. 2005. "Action Observation and Acquired Motor Skills: An fMRI Study with Expert Dancers." *Cerebral Cortex* 15, 8: 1243–1249.
Hatfield, E., J.T. Cacioppo, and R.L. Rapson. 1994. *Emotional Contagion*. Cambridge: Cambridge University Press.
Hubbard, E.M., and V.S. Ramachandran. 2003. "Refining the experimental lever: A reply to Shannnon and Pribram." *Journal of Consciousness Studies* 9, 3: 77–84.
Johnson, M. 1987. *The Body in the Mind: The Bodily Basis of Meaning, Imagination and Reason*. Chicago: University of Chicago Press.
Ramachandran, V.S., E.M. Hubbard, and P.A. Butcher. 2004. "Synesthesia, cross-activation, and the foundations of neuroepistemology" in G. Calvert, C. Spence, and B.E. Stein, eds., *The Handbook of Multisensory Processes*. Cambridge: MIT Press.
Vatsyayan, K., and D.P. Chattopadhyaya, eds. 2008. *Aesthetic Theories and Forms in Indian Tradition*. New Delhi: Centre for Studies in Civilizations.
Wicker, B., C. Keysers, J. Plailly, J.-P. Royet, V. Gallese, and G. Rizzolatti. 2003. "Both of Us Disgusted In *My* Insula: The Common Neural Basis of Seeing and Feeling Disgust." *Neuron* 40: 655–664.

A Note on Orthography

The term Natyasastra has many different presentations. Even within Sanskrit scholarship, Indian writers have used it differently: Kapila Vatsyayan, for instance, uses the term Nātyaśāstra whereas V. N. Jha uses Näöyaçästra. Among Western scholars, Sheldon Pollock's and Krzysztof Byrski's use of the term is identical to Vatsyayan's. Richard Schechner, on the other hand, uses the term as two separate words, "Natya Shastra," without italics and without diacritical marks. The term has also appeared in numerous publications as a single word, "Natyashastra," and "*Natyashastra,*" in italics. In the Encyclopædia Britannica, the term is "Natyashastra," in full "Bharata Natyashastra," and also called "Natyasastra." In the context of this publication, different authors used different spellings, and at least four different ones were found in the manuscripts of 14 individual essays. The diversity of the use of the term in the current scholarship, therefore, also suggests the inherent difficulty in choosing a single variation for this publication. However, in order to bring consistency, in this publication the spelling "Natyasastra" is used throughout without diacritical marks, which is identical to the Encyclopædia Britannica. Sanskrit words are only italicized without diacritical marks throughout following the phonetic spellings. Nevertheless, the Sanskrit verses in the text and Notes are italicized with diacritical marks to maintain the accuracy and textual authenticity. The word Natyasastra appears on every single page of the book multiple times. The term is also common and used widely in the international academic scene. For these reasons, the word is also not italicized.

The Natyasastra:
Explicit and Implicit[1]

Kapila Vatsyayan

Although there have been many important studies on the Natyasastra and there is a historiography of the critical studies, there has not been an adequate appreciation of the historic-cultural context of the composition of the text. Also perhaps there is yet room to underline the fact that the date of composition of the text and the date of the first written text are not the same. The limitation of reassessing a text in circulation through oral transmission over a long period has to be noted. It has to be remembered that the written text in its very nature is a residual record of a deeper richer experience and wider oral discourse. Also the original text itself has an inbuilt fluidity, which gives scope for multiple interpretations. The Natyasastra, like other texts in several disciplines, has implicit and explicit layers. Some insight can be gained by penetrating through the language of "myth," "legend" and the anecdotes in which the text is couched. There is, as it were, a "code" of discourse, which is expected to be evident and illuminating to the initiated and conversant. On the surface, it is engaging to the general or "lay" reader, but it is not fully comprehensible without the implicit layer of the text. A very careful sifting of the implicit and explicit layers of the discourse is therefore necessary to explore both the unsaid, unspoken but equally unambiguous level and the more evident explicit level of structure, methodology and technique.

At the very outset, Bharata's text makes it clear that he shares the worldview of his predecessors, its cosmology and mythology. The inspiration of the creation is a-casual and transmundane, born from reflection and meditation (*sankalpa* and *anusmarana*). At the level of articulation, the endeavor (enterprise, in modern discourse) is comprehensive. Here all branches of knowledge

(*vidya*), the sciences and the arts, all dimensions and orders of "space" and "time" are encompassed. Its scope is all embracing. It deals with the universe (*sarvaloka*). Implicitly, it suggests a super-mundane (*adhidaivika*) level, not to be confused with "sacred," of experience at the initial stage (NS 1: 13–16).

Stated differently, Bharata not only acknowledges debt and identifies the sources of his work, but also outlines the broad parameters of his work and the parallel levels at which his text will proceed with a discourse. It is not necessary for him to state explicitly that the three levels—divine (*adhidaivika*), spirit/self (*adhyatmika*) and material (*adhibhautika*)—constitute the tacit framework. So, from a "divine," an a-casual origin of a happening in no time, a revelation, an intuitive experience, drama is born. It has a structure and form. Its tools are the two primary sense perceptions of sound and speech. It deals with the visible and audible, employs body language (gestures), speech, music, dress, costume and an understanding of psychic states, which involuntarily reflect themselves in the physical body, e.g., tears, horripilation, etc., to express and convey meaning and emotive states.

But, behind it all is the assimilation and acceptance of a worldview, a true familiarity with the discourse on life phenomena and a body of speculative thought with its refined and chiseled key concepts. Some amongst these already assume the status of technical terms; others are frequent in discussion. Alongside, is both the familiarity with the structure and the detailed methodology of the yajna[2] that Bharata draws from both in conceiving and visualizing his theatrical universe.

The Implicit: Cosmology of *Natya*

Elsewhere, a fuller elaboration has been attempted of the worldview, the speculative thought, methodology and system of the Vedic ritual (yajna), which is relevant for comprehending both the intent and the structure of the theatrical universe enunciated by Bharata. Without repeating the full argument, it would be useful to recapitulate the essentials of this worldview and emergent cosmology, as this is the implicit dimension of the text, which provides a unity and cohesiveness to the explicit manifested variegated level of the Natyasastra. Only a few key principles of the worldview and the metaphors used to comprehend the phenomena need be mentioned.

First and foremost, the world is an organism, a whole with each part inter-related and interdependent. This is basic and fundamental. The keyword and metaphor of this comprehension is *bija* (seed). The process of growth, the proliferation of each part being distinct and different, and yet developing from the same unitary source, is fundamental. The three principles, which

emerge from the single notion of *bija* are process, organic interconnections of the parts and the whole, and a continuous but well-defined course of growth, decay and renewal. The complementariness of "matter" and "energy," indeed, even the trans-substantiation of matter into energy and vice-versa, is implicit in these metaphors.

From the *Rigveda* to the later *Tantras*, the concept of *bija* is central to speculative thoughts, science and the arts. Bharata accepts and assimilates the concept as a central principle of his theory of aesthetics and also an enunciation of the process of artistic expression and communication. The inter-relatedness and interdependence of the parts and the whole of seeding and fruition is basic to his argument. The theatrical experience emerges from an emotive cause that is the seed (*bija*) of a fully developed dramatic composition that Bharatha explained through the interrelationships between rasa, *bhava* (emotional state) the structuring of plot (*itivritta*). In the case of the rasa, Bharata says, "just as a tree grows from a seed, including the flowers, fruits and the seed, the sentiments (rasas) are the source (root) of all the emotional states (*bhava*) as the emotional states exist as the source of all the sentiments" (NS 6: 38). The metaphoric use of the "term" clearly echoes Upanishadic thought. In the Natyasastra, the metaphor takes many shapes and forms as a tree, its branches, leaves, flowers and fruits. The metaphor, not to be extended literally, is an invisible but real foundation of the text. "Theatre" is an organism, just as life is an organism.

The concept of *bija* has further to be placed within the broader framework of the concept of man and universe (Vatsyayan 1983: 23–27). The world is a configuration of the five primary elements of earth, water, fire, air and space (*akasa*). The inanimate world and the animate world are manifestations of the primary elements. The geological, botanical, zoological and human worlds are interconnected. Flora, fauna, vegetative life, the animal world and the human are diverse manifestations and forms of the same principles. Man is no different and is one amongst all life-phenomena. His distinctiveness lies in his capacity of reflection and, above all, speech (*vak*), with which he is empowered, but qualitatively he is no different than any other form of life (*jiva*). Ecological balance and equilibrium has to be maintained and sustained between the inanimate (*jada*) and animate (*cetana*) worlds, and also amongst the different members of the animate world. The core principles of *atman* and *Brahman*, of *ananda* and *brahmanda,* of the micro and the macro, are almost a logical corollary of the notion that "life" in all forms of life is to be equally respected and recognized. The Vedas and the Upanishads are replete with discussions on the core concept of *atman* and *Brahman* as the micro and macro levels of the life-phenomenon.

Closely related and almost a part of the comprehension of the universe

as originating from the cosmic egg (*anda*) and floating on the eternal waters is the concept of man (*purusa*). Now, we have a concept of structure for comprehending the universe. The understanding of life in all its delivery is the background for placing the concept of "*purusa*" as a central principle. The Rigveda (*Purusa sukta*) gives a vivid account of the cosmic man and lays the foundation for comprehending the "human," the anatomical and physiological, physical, social and cosmic man. "Man," cosmic or human, has a defined structure with the parts and the whole again inter-related and interlocked. The metaphor of the world and society as *purusa* (Chakravarti 1988: 117–33) has to be comprehended as a term of the "structure" of the different parts interlocked and interdependent. The *yajna* is the ritual enactment of both cosmic and primordial man, as dismemberment and rememberment of the parts and the whole. This is the meaning of the sacrifice of *prajapati* in *yajna*.

Drawing on the details of the metaphysical thoughts presented in the *Rigveda*, the *bija* gives rise to a "tree," a pole, which signifies verticality. The concept of *purusa* is over-layed on it and so the purusa or image of man also suggests verticality. He too, like the tree, the cosmic pillar, connects the earth and heaven. Like the biological world, he too is born from the cosmic egg— the seed or *bija*. However, he is mortal and immortal, the created and creator, micro and macro, physical and paradigmatic: "the Moon is born from His mind; the Sun from His eyes, Indra and Fire from His mouth; Wind from His breath; the Sky from His navel; the Heaven from His head; the Earth from His feet; the four quarters, from His ear; thus the World was fashioned" (*Purusa sukta*, RV, X, 90). The elements—the sun and the moon—constitute this cosmic man who, in turn, symbolizes them in microform. The human form is in the micro-*purusa* with an analogous structure. He too comprises *atman* and *sarira*, soul and the body.

The Natyasastra does not refer to either purusa or to the elements explicitly. However, a close reading of the text makes it clear that the structure of drama is in itself a purusa, a structure of different parts and limbs where each pat is related to the whole. The physical, psychical, individual, social, horizontal and vertical dimensions are interconnected. It is the concept of purusa along with the other two components of *sarira*, the body and *atman*, the spirit, which accounts for a very distinctive attitude to the body, sense perceptions, emotive states and consciousness.

Other concepts and keywords can be identified which permeate the discussion on life-phenomenon. In turn, they provide the concurrent layers and metaphors of Indian art. We have elucidated on seven principal layers and metaphors of Indian art elsewhere (Vatsyayan 1975: 40–47). Here, our purpose is to draw attention to a few that Bharata adopts and employs consistently in his text. They denote both process and structure. Foremost amongst these

are the principles of centrality and verticality of organic process and of structure through the inter-related concepts of *bija* and *purusa* along with womb (*garbha*). The concept of *bindu* gives him scope to develop his notions of horizontal spread and basic design of structure with a point and constantly enlarging areas in terms of concentric circles. Bharata adopts these concepts to describe the relationship of the "incipient" invisible and the explicit form (e.g., context of *bhava* and *rasa*), or to suggest the relationship of the parts and the whole, or to identify the principal joints of his structure. The "body" (*sarira*, *tanu* and several other words are used) is a primary tool. It is also a term of reference. Physically, it is made up of bones, joints and muscles. The sense organs and sense perceptions are potent vehicles of feeling and sensibility. The body and the mind are independent, mutually effecting and affective. Intellection is important, but senses, feeling and sensibility are fundamental. Several key concepts in the Natyasastra can be comprehended only if we realize that Bharata was adopting and accepting a very different view of the body (*sarira*) than what is understood as corporeal frame or fleshy mass. Also, he had fully internalized the discourse on the sense and sense perceptions as articulated in the Upanishads. Bharata is, without doubt, indebted to the Upanishads for the special place given to the outer and inner senses, known by the generic word *indriya*.[3]

Bharata's adherence and debt to this worldview is clear when he repeatedly speaks of the "eye" and the "ear" and purification. It is not only ritual purification; it is the constant endeavor to arrive at a greater and greater degree of subtlety and refinement. The theatrical universe is the world of the "audible" and the "visible." The senses and sense-organs and perceptions play a critical role in the evolution of the theory, as also the techniques of each of the four instrumentalities of expression—sound, word (*vacika*) and body language (*angika*), décor and dress (*aharya*), internal states (*sattvika*). However, as in the case of the Upanishads, although the senses are primary and as indispensable as horses in a chariot, they must be disciplined, restrained and groomed. In the Upanishads the mind was the rein and the intellect the charioteers. Here, the initial discipline of the artist-creator is necessary for the probability and possibility of a total experience. If in discursive thought, the mind and intellect play a regulating role, here, the refinement of feeling and sensibility is crucial. Harnessing of capacity of the senses for outward and inward and inward reach is the discipline and austerity demanded. It is only then that the artist can have the ability to turn the "senses"—outward and inward. The introduction of the concept of yoga in the world of theatre assumes significance when seen within the framework of a worldview where equilibrium, balance and harmony of the physical, sensuous, emotive, intellectual and spiritual levels is considered essential. Yoga is the yoking and joining of these levels in an

ascending order—a movement from the physical to the metaphysical. The Natyasastra implies, although it does not explicitly state, a theory of aesthetics. Explicitly, Bharata speaks of artistic expression and communication. The concept of rasa cannot be understood fully without taking into account the larger background of the speculative thought of the Upanishads.

Without explicitly stating it, Bharata makes it clear that what he has set out to do is to present a universe of name and form (*nama* and *rupa*) of the physical, the mortal, of the body, senses and speech (*vak*), which will match speculation and meditation, ritual and sacrifice. In fact, he does make an explicit statement at the very end of his work:

> He who always hears the reading of that (*sastras*) which is auspicious, spot-full, originating from Brahman's mouth, very holy, pure, good, destructive of sins and who puts into practice and witness carefully the performance (drama, we may add the word "artistic") will attain the same blessed goal which masters of Vedic knowledge and performers of sacrifice (ritual *puja*)—attain [NS 36: 77–79].

This, read along with his continuous emphasis on discipline (*sadhana*, even *tapas*) in the artistic act, will make it clear that what Bharata has set out to do is to use the very language and vocabulary of name and form (*nama* and *rupa*— of identity and specificity of form) to evoke that which is beyond form or without form (*pararupa*), and all this through the vehicle of the senses and sense perceptions and feeling, not intellection.

Explicit: Purpose and Structure of *Natya*

At the level of structure, Bharata creates an analogue to the physical layout of *yajna*. Just as in a *sala,* altars (*vedis*) of different sizes and shapes are built, there is both concurrent and sequential action, and multiple media are employed—all for the purpose of replicating the "cosmos" and components are the ritual altars of this grand complex design. The dramatic spectacle, like the *yajna*, has a moral and ethical purpose. It will conduce moral duty (*dharma*), wealth, economic well-being (*artha*), refine sensibilities (*kama*) and lead to liberation (*moksa*). The arts are thus an alternate, if not a parallel, path for the avowed goals of a culture, which move concurrently on the three levels of the material (*adhibhautika*), self (*adhyatmika*) and the metaphysical divine (*adhidaivika*). The multidimensional nature is evident, even if not explicitly stated.

Chapters I and II of the Natyasastra lay down, in unambiguous though veiled terms, the foundations of the structure. Bharata internalizes the Upanishads worldview at the level of concepts and the ultimate goal of the artistic

experience and creates a structure, which is an analogue to an elaborate ritual (*yajna*). However, since Bharata does not make explicit the foundational design of his citadel of drama and all this is suggested, implied, even deliberately veiled (*guha*), as he says in the end, the text has given rise to a vast number of interpretations and commentaries. This also explains, in part, why both commentators and contemporary scholars focused attention on particular aspects or portions or even certain verses of the text, and not on its unseen, but very real and deep foundations of a distinctive worldview and its chiseled language of articulation. There is the implicit flow of "concepts" and attitudes like an *antah-salila* (unseen river, the *Saraswati*) which provides the integral vision to the text.

Explicitly, the Natyasastra, no doubt, is divided into thirty-six chapters and has a sequence. The structure of the text can be restated in terms of the concern of the author to present all levels of the artistic experience, forms of expression, nature and levels of response. He does not restrict himself either to a discussion on the nature of the artistic experience or only to the technical details of each media or genre of expression.

The thirty-six chapters of Natyasastra can be regrouped from the point of view of (i) artistic experience; (ii) the artistic content of states of being, the modes of expression through word, sound gesture, dress, decorations and methods of establishing correspondence between physical movement, speech and psychical states, as also communication and reception by the audience, readers; and (iii) structure of the dramatic form, popularly translated as "plot." The *itivritta* (plot) is, however, a more comprehensive term for both structure and phasing.

(i) The artistic experience is viewed from the point of view of the creator—poet, writer, artist, painter, architect, and interpreter—in this case, the actor, the singer, the executor of the architectural design, and also the spectator and receiver. The artistic experience is a-casual and whole, a state of beatitude and bliss in the mind of the experience, the creator. It is subsequently transferred, translated through either the media (e.g., words, paint, sound) or through indeed another person (i.e., actor and characters of drama). A reading of the Natyasastra, especially the sixth and seventh chapters, makes it very clear that although Bharata appears to be speaking only about artistic expression and methodologies for evoking response and resonance, he was indeed conscious of these distinctions. After all, who was conceiving and visualizing before form came into being? An experience of undifferentiation, of a state of *Samadhi* (concentration), an a-casual, a-intellect state, intuitive and non-cognitive, alone could be liberated from immediacy and boundaries. This could make it possible or prob-

able for creation to take place. Whether stated in words or not, it is "rasa" in the singular, the highly charged state of momentary freedom and emancipation which motivates, inspires creation. Distancing, *tatastha,* is consistently implied and is an underlying tenet of the Natyasastra. Exactly as in poetry, music, dance and the visual arts, the "unsaid" silence is almost more important than the "said" and "sung." Here also it is the most important implicit level, which is not explicated.

(ii) It is this experience, which facilitates an abstraction of life into its primary emotions and sentiments. The specificity of the individual, the emotive particularity is secondary, for each is but a carrier of art, known by their familiar terms, the eight or nine rasas and their expression as dominant states, *sthayi bhavas.* The two levels of the undifferentiated state of oneness, non-duality, and the differentiated states of diversity and multiplicity are connected. The establishment of a system of correspondences between the specific emotive states (*sthayi bhavas*) and the media (speech, body language, sound music) on the one hand, and the character types, social class, on the other, is logical. This is another fundamental level of the work.

(iii) The third level is the potential of the artistic work, through the specificity of content and form and the variations to evoke a similar, if not identical, undifferentiated state of release and emancipation (*svatantrya*) in the spectator and reader from the immediate so-muchness of life (*iyatta*).

On this conceptual foundation, the physical structure of the theatre is created. Chapter II deals with the actual construction of the theatre, the different types and the shapes and sizes of the theatre. Now, just as the conceptual level, a micro-model is created with the Upanishads as the source, the physical theatre, the stage and the audience area is also a micro-model of the cosmos. The consecration of the site, the laying of the foundation of the theatre, the construction of the stage, the division into central and peripheral areas and identification of a center (*brahmasthana*), the placement of deities of the directions are a replication. It is a micro-model of the cosmos. The physical place replicates cosmic space. Theatre and the stage in particular is an analogue of the ritual space of *yajna.* The *sala,* the *vedis,* the altars, were the components of the *yajna.* On the stage, the central and peripheral areas serve the same purpose. *Brahma* is the principle of centrality and verticality. Others take their places. Bharata asserts very early in the text that all the orders of space (*triloka*) and the seven divisions (continents) and seas will be included. The physical space of the theatre thus is a neutral performative space with the potential of being transformed into space of any order.

Some scholars have suggested that there is no unity and logical progression between Chapters I and II. Kupier even suggests that chapter II is a later addition.[4] If we read these chapters as Bharata's attempt to lay the conceptual and physical foundations of his scheme, the two are interconnected. The first alludes through the language of myth, the inspiration for his work and the origin of drama. The entire mythical world of Brahaman, Siva, Indra, Sarasvati, Vishnu, *Sesa* the great serpent, the Daityas, Bhutas, Yaksas, Pisacas and Guhyakas, are participators as "actors," protagonists or agitators or protectors. This is the world of the imagination, of the celestial and terrestrial, but not actual. If Indra is empowered as "hero," Saraswati is "heroine." She is *vak,* the embodiment of "speech" (NS 1: 96–97), and Siva assumes a special role of an energizer. After the cosmos has been replicated, Bharata conjures up the cosmic nature of the world of creativity where the *devas* (gods) and *asuras* (demons) meet in friendly combat and where poetic justice is demanded of all. The first chapter has drawn the attention of scholars—for trying to trace the historical origins of Indian drama. Perhaps it should be looked at as a most charming and delightful narration of the fulsome, joyful world of "creativity" and imagination. Commitment to only a single source or cult or affiliation or "ideology" is not required.

It is this world of creativity and imagination which has to be given a physical space. It can be "open," but has to be protected. In both cases the *jarjara,* the pole, is basic.[5] Chapter II provides the physical space. The chapters, which follow, namely, chapters III and IV, are closely linked. Bharata had begun with the conceptual, mythical and physical space in chapters I and II. Chapter III is the methodology of consecrating the physical space so created so that for the time and duration the space is now a sacralized cosmic space. It is, therefore, necessary to have *puja* (rituals). Consecration of physical space is "universal" whether it is *yajna* or temple, *stupa,* church or mosque, popular ritual, open doors or indoors. The rituals of all societies, the Yorubas, American Indians and countless groups in India, are living testimony. Bharata only lays down the broad parameters of the methodology of "replicating" the "cosmos" in defined finite space and time, so that in turn it can be the vehicle and instrumentality of suggesting the trans-physical, as also specified "space" and "time." Again, in this field scholars have attempted to track down the origins to Aryan or Dravidian sources rather than identifying Bharata's clear intent and purpose in devoting a whole chapter to *puja*. He is not creating religious drama of a particular class, caste or denomination. He is consecrating space, which would prepare actors, performers and audience to be transported to the world of the imagination and simultaneously to the divine and the heavenly. The celestial and the terrestrial are being interconnected. In the language of the Romantics, he is preparing the "actors" and the audience for "a willing suspension of belief" in the drama, which is to follow.

Just as through the puja all deities, directions and quarters were being established so as to locate the specific within the universal and cosmic, so in chapters IV and V Bharata suggests the methodologies of preparing participants and audience to link different orders of time and space.

Chapter IV begins by an engaging anecdote of Siva's pleasure at seeing the performance of the first play, the *Amrtamanthana samavakara*. It is Siva who suggests to Bharata that he could profitably use the characters of movement in the preliminaries of the play. Thereafter follows the long description of a category of movements, called *karanas* and *angaharas* and their composition in choreographic patterns, called *pindibandha*. Bharata accepts this because it would be the best vehicle of creating an atmosphere in the nature of an overture to the performance. Without content, meaning, theme, pleasing and delightful, these sequences could replicate the cosmic dance of Siva in its infinite variety. All this is non-content and narrative, and as such an appropriate preparation for being transported to another order of time and space. At the level of technique, Bharata introduces the concept of units of movement (e.g., *Karana* and *angahara*) before elaborating on micro movements of the different parts of the body. This he does in chapters VIII and XI.

Replication and remodeling is the essence of chapters III and IV, till we arrive at chapter V where Bharata now systematically lays down the multiple levels of his operation. The movement from the celestial to the terrestrial, from the divine to the human, from the austere ritual to humor and play, from the communication with the King and rule, young and old in the audience is described. It is in chapter V that Bharata unfolds his larger structure in minuscule. The *purvaranga,* the benedictory rituals, is a "code" to establish different orders of "time" and "space" of the three dimensions of dialogue through the three "actors" who enter and exit repeatedly in five phases to establish, each time, another order of space and time. The transformative character of "theatre," of the stage, and the role of the actor to perform and communicate at multiple levels to a variety of audiences, is now made explicit. A fuller analysis of the importance of the *purvaranga* has been made elsewhere.[6] Bharata may not have revealed his foundational plan at the level of concept, but the ground plan at the level of concrete form he makes evident. The *purvaranga* is the well laid-out ground plan of his schema on which the theatrical edifice will be constructed. He is, as it were, announcing that drama will move at multiple levels of space and time, concurrently.

Rasa

Having laid out the parameters, Bharara almost jump into the core of his work. So what will be presented? What is the creative process, which will make

it possible? What will it represent and how will it be represented and how will he communicate? The famous chapters VI and VII on *rasa* and *sthayi bhava* have captured the imagination of the theoretician and practitioner alike, for centuries. India presents a unique phenomenon of an unbroken continuity with this source; the concept of *rasa, sthayi bhava* and *vyabhicari bhavas* along with the dictum, now almost a cliché, of (*vibhavanubhava-vyabhichari-samyo-gad rasanispattih*) [NS 6: 31].[7]

The abstraction of "life" into primary moods, sentiments, primary emotive states, is basic and universal to human being. It is not culture specific or individual or particular. Yet, the culture specific, the individual or society are embodiments of the universal human physical states. The primary human emotions are expressed in a variety of ways; indeed, an infinite variety in time, space and locale through distinctive modes of speech, body language and gesticulation, dress and costume, but love laughter, jealousy, fear and wonder are universal. It is this universality of human emotions that constitute the core theme of the theory of rasa. They have determiners and stimulants *vibhava* and *anubhava*. Through the interpretation of particular rasas and *sthayi bhavas* and their coming together (*samyoga*) a state of rasa (*nispatti*) is evoked or created. Its final relish (*asvada*) is comparable to the taste or after-taste of a good meal with many flavors (*vyanjana*) when specificity is lost but the experience of a good meal or a sense of relish remains. This is what drama or all creativity explores, sheer joy or pleasure, pain or pathos, wonder or amazement, and their mutual interplay. Bharata explores the structural principles and functional modalities of rasa experience with the finesse and the mastery of a skilled craftsman, a physician, better with an artificial intelligence, and as a knowledge expert of psychic states and their manifestation through speech, body language and scenography of all kinds including the costumes and make-up.

Having dwelt on "origin," preparation, intent and the non-individualized, almost abstract content (*rasa bhava*), the artistic inspiration and process of impersonalization, from chapter VIII onwards, Bharata's concern is with the formal values of the art, "technique" and systems of communication and response. These chapters largely, not wholly, are the explicit dimension of his text.

Logically, he begins the analysis with the body—the motor and sensory system. Anatomy, especially the joints rather than the musculature, is his concern. It is obvious that he understands the nervous system from his enumeration of physical stimulus and psychic response, psychic states and expression through physical movement. The *angikabhinaya,* the physical acting, chapters of the Natyasastra have to be understood as body language in contemporary discourse. There is a cluster of chapters, which deal with the subject and the role of body language in theatre is integral to his intent and purpose. It is not

"auxiliary," as has been suggested by both medieval commentators and also some modern scholars. These chapters include a wide range of subjects. He begins by breaking up the anatomical structure into its principal parts—the head, trunk, pelvis and the upper and lower limbs. Bharata explores the possibility of physical motor movement of each part. He is exact and precise, anatomically and physiologically. These he terms as *anga* and *upānga,* normally translated as major and minor limbs. In fact, what he is doing is to take the head and face as a unit and then analyzing all possibilities of movement of the particular part from the eyes, eyebrows, eyelids, pupils to the whole eye (*drsta*), nose, cheeks, upper and lower chin, mouth, color of face and the neck. Everything above the first and second vertebrate, the atlas and axis, of the spine has been taken into account, except the ears (Ghosh NS 8). Next, he applies the same technique to the "hand" and "hands," as one unit comprising the wrist joint, palm and fingers. The underlying understanding of the joints, carpals, metacarpals and phalanges is exact and comprehensive. It is from the physical understanding that he devises a whole sub-system of hand positions and movements (i.e., wrist, palm and fingers) called *hastas.*

Bharata, then, explores direction, height and movements, including the arms, away from the body and towards the body. Just as in the case of the head and face, the first and second vertebrae were the cut-off points, so here, too, the ball-and-socket joint of the shoulder, the hinge joint of the elbows and wrist joint are points of articulation (NS 9). The same principle is followed in the third group, comprising parts of the trunk, pelvis and the lower limbs including the feet (NS 10). Each single part of the body and its possibility of movement are then co-related with its potential for giving expression to a particular emotion, or mental state. Bharata does not forget that the body is capable of moving gracefully, beautifully, without meaning, and thus in the case of movements of the hands and the lower limbs he also speaks of pure movement, *nrtta,* the dance. The word he uses for the dimension of applicability is important. He adopts the term *viniyoga* (methodology) from Vedic ritual and applies it uniformly in his enumeration of physical acting to express, to communicate, to reach out through the limbs of the body (*angas-sarira*).

Having explored the parts, he goes on to provide a broad spectrum of movement techniques where the whole body is employed. Basic to the system is training of the body. Without *vyayama,* the exercise, and proper health and nourishment, nothing is possible for the actors to explore the body in performance (NS 11). The connection between Bharta's system of exercise and what we today recognize as Hatha Yoga on the one hand, and martial arts, on the other, is more than obvious. Equilibrium and equi-balance and holding of the spine with equi-weight I suggested by the two seminal terms, *sama* and *sausthava.* These terms, as we shall see later, are applied to the spheres of music

and language. Units of movement emerge from this control of the body in sitting, standing and reclining positions. The *sthanas, asanas,* and manadalas are basic stylized first positions, static positions of standing, sitting and knee bends (plie) from which a variety of movement possibilities emerge. The *cari* (walking or moving) is the first of these movements. The foot-contact and relative distribution of weight on-the-ground and off-the-ground is suggested by the descriptive terms *bhaumi* and *Akashi* (air-sky) *caris* (NS 10 & 12). The *caris*, the walking movements as physical possibility of the lower limbs, are then transformed into the conventional typologies of gaits. This is the level of applicability in drama. The gaits (*gati*) are related to character-types, to moods and sentiments, and can be in different tempos. Bharata provides a staggering repertoire of sitting, postures and gaits to suit gender, character, occasion, mood and dramatic situation (NS 13). The *caris* are also the basic unit of movement for the cadences of movement called *karanas* and *angaharas.* Bharata had described these earlier in chapter IV. At the level of technique, these can only be comprehended or vaguely reconstructed through a proper and comprehensive competence in the techniques outlined in chapters VIII to XI. In an earlier work, a fuller analysis of the *angika,* the physical acting, has been attempted.[8]

At this point Bharata takes a pause, as if to state and remind the reader that the framework of his analysis is the "stage" and its transformative character. Chapter II had dwelt on the theatre-types, the areas of the stage, the principal divisions into the front and backstage, the central and peripheral areas, the backstage and the audience areas. Now, he returns to this at another level. The stage is his focus. This is the limited defined space. We learn of the placement of the drums, the musical ensemble (*kutapa*) and how this physical stage will become an analogue of cosmic space, or at least concurrently be the replication of the abode of the gods (*daivika*) and men (*manusi*), and the minuscule of India (*Bharatavarsa*) and its different cultural regions. A basic spatial grid is devised which makes it possible to transform a single physical area into the three spaces of water, earth and sky, diverse regions, different locales of "outside," "inside," "proximity" and "distance." Chapter XIV on *kaksavibhaga* and *pravrtti* is Bharata's devise and mechanism for encompassing all orders of "space." The chapter is important also because it touches upon concepts of style (*vrtti*), regional schools (*pravrtti*), as also of the two modes of delivery of movement and speech, namely, *natyadharmi* and *lokadharmi*. He had introduced these concepts in the chapter VI, verses 23–26. The cluster of the four notions of *kaksyavibhaga* (zonal divisions), styles (*vrttis*), regional characteristics (or schools) (*pravrttis*), the two modes—sophisticated or stylized and a more natural mode (*nata and lokadharmi*)—of delivery of movement and speech, along with energetic (*tandava*) and delicate (*sukumara*) modes and also *daivika* (divine) and *manusi* (human) (chapter XIII, 28) levels, provides

an invaluable cluster of principles which guide not only physical movement (*angika*), which he has described earlier, but also what is to follow later in the group of chapters which deal with the other two *abhinayas*, out of his four of *angika, vacika, aharya* and *sattvika*, namely the *vacika* and *aharya*. In each of these spheres of sound, speech and music, and also in the matter of costumes, coiffure, there are and can be special styles of presentation and an attempt at localizing or specifying speech, movement, music and dress. The nature of presentation can be soft, lyrical or strong, stylized or natural, grand elevated or earthly, divine or human. Appropriately, he places this crucial chapter at this stage of his work before elaborating on the other principal tools of creativity, sound, word, speech and prosody. Also, it is the reading of this chapter, which makes it explicit that Bharata's sense of "time" and "place" could not possibly have followed the Aristotelian unities of "time" and "place." As a principle of the structure of drama and its framework with a distinctly different paradigm all that we understand from either Greek drama or realistic theatre of the nineteenth century can be discerned here.

However, to move on to Bharata's next concern, "word" and "speech," he devotes four long chapters to the strictly *vacika* (chapter XV to XIX). For him the *vacika* (articulated word) is the body (*tanu*) of drama. The primacy of the word is asserted in unambiguous terms: "In this world the *sastras* are made up of words, rest on words: hence there is nothing beyond words, and words are at the source of everything" (Ghosh NS 15: 3).

The articulated word (*pathya*), he divides into two, Sanskrita and Prakrita. Thereafter, there is a minute analysis, as in the case of the body-system, of first, the principal units of structure, nouns, verbs, particles, prepositions, nominal suffices, compound words, euphonic combinations (*sandhi*) and case-endings. Then follows the further break-up into vowels and consonants, words, verse and prose, meter and rhythm, syllables (long and short, heavy and light), rhyme and feet in couplet. The units of language at their primary level are all taken care of. The method is the same as in the description of the parts of the human body. Chapter XV stops short at metrical patterns, to which Bharata devotes a separate chapter (chapter XVI). Chapter XV, called *Chandovidhana*, is distinguished from that on metrical pattern, called *Vrtta-laksana* (chapter XVI); The titles are explicit statements on how he is proceeding. In the chapter on metrical patterns, Bharata cites many examples, which exhibits his knowledge of and familiarity with versification. His corpus of information on the subject is impressive. Many fascinating myths are contained in the verses. The variety of metrical patterns is vast. The names cover all aspects of nature. The character of the flora and fauna inspires the shape and form of the meters. The word *laksana* itself has many layers of meaning and several connotations. The word has been variously translated as "hallmark,"

"indicator," "signifier" and so on (Tripathi 2001: 135–145). Each is now related to the context and field of usage and applicability. Meter, rhyme, diction are all related to the mood or sentiment (rasa) and should be so appropriately employed (chapter XVII, 42). This follows an analysis of figures of speech, principally simile (*upama*), metaphor (*rupaka*), condensed expressions, the *dipaa* and *yamaka*. After delineating upon the sub-categories of each, Bharata has an interesting section on the defects (*dosa*) of various types, and also the merits or *gunas* of speech and metrical patterns. The purpose of it all is no doubt to convey the moods and sentiments (rasa), and present the emotive states. Bharata is fully conscious of the power of the word and its effect on the listener. Agreeable and appropriate words in a play are like the adornment (*alamkara*) of swans on a lotus lake; inappropriate ones have the incongruity of a pair of courtesan and an ascetic Brahmin. These chapters have been the bedrock of subsequent theories of rhetoric and poetics in Sanskrit. A torrential stream, almost a river of *alamkāra sastra,* the poetics of literary adornment, flows out of these chapters. So much significance has been laid on them, that little needs to be added. For our purpose this brief enumeration was necessary to adequately identify the primary role of word and diction in Bharata's scheme of an inter-related world of the four *abhinayas* (the types of acting).

Chapter XVIII is devoted to languages, especially recitation in Prakrita and the use of different dialects. This chapter has to be seen in relation to Bharata's principles of the regional schools (*pravrttis*), styles (*vrttis*) and sophisticated and natural modes (*natyadharmi* and *lokadharmi*) enumerated in chapter XVIII. Bharata makes a valiant effort to be comprehensive in his treatment. However, he is aware that all rules of specificity can only be exemplary and not rigidly prescriptive. Appropriately, he ends the chapter by leaving the door open: "These are guidelines (*vidhana*), which may be used for employing languages and dialects in dramas. However, whatever has been omitted can be included by observing the world and humanity (*loke*) or literally that which wise gather from local usage" (NS 18: 61). Bharata is obviously all too conscious of the limitless variety and the possibility of change, and thus, in the matter of language and dress, he displays an open, flexible approach. Chapter XIX limits itself to modes of address and intonation. While the description of modes of address provides an insight into human interaction and social status, an interesting part of this chapter is the section on intonation and recitation and Bharata's relating the use of specific notes to particular moods/sentiments and his identification of the three voice registers (*sthana*): the breast (*uras*), throat (*kantha*) and head (*siras*). Three pitches emerge from the three registers and the relative ascending and descending orders are indicated. Once again a full acquaintance with techniques of voice production from different centers of the body is obvious. Bharata refers to the four accents (*svarita*) that are

grave (*udatta*), circumflex (*anudatta*), and quivering (*kampita*). Again, he relates them to specific sentiments and moods. This group then constitutes the basis of the six *alamkaras* of the recitative modes, which can be high or low, excited or grave, fast or slow. The purpose of introducing the basic components of "notes," "registers," pitches and tempo at this stage is, obviously to discuss the details in the following chapter (XXIII) for a fuller analysis relating to the specific sentiments/moods (*sangita*). Bharata situates the articulated sound-note (*svara*) and word both within the field of poetry and drama as also making a link with the chapters on music. He is conscious of both the intrinsic inter-relatedness of each medium as also its autonomy. This was obvious in the case of the category of *nrtta,* the dance and then in relation to both poetry and music.

Having dwelt on the primacy of sound and word, body language and gestures, the principles of transformation of physical space, he turns to time and movement of drama. This is the structural design and elevation plan of his discourse. Now formal aspects of types of structures and within the types, the movement of "time" as "plot" of each of these the structures is described. Appropriately, they are called *dasarupa-laksanam* and *itivrtta* (chapters XX and XXI). While the first (chapter XX) presents a typology of plays and their key characteristics, the second (chapter XXI) goes into the "core" of Bharata's conception of the theatrical structure. This moves not in an ascending line of beginning, conflict, climax and denouement, but in a circular fashion with a series of concentric circles, all over layered and connected to each other through the concept of *bija* (seed), suggesting organic growth, and *bindu* (drop of a liquid and point of gnomon of early geometry), indicating structure and dimension.

We have referred to these seminal concepts along with *purusa* as the pervasive language of pre–Bharata speculative thought, and also the paradigm of *purusa* in the vedic *yajna*. Bharata assimilates the concepts and uses the terms *bija* (seed) and *bindu* (point) systematically throughout his text and implies the knowledge of the concept of *purusa*. These are the unifying threads of his overall structure.

We will recall that Bharata had used the metaphor of the "seed," tree and branches in the discussion on moods/sentiments (rasa) and emotive states (*sthayi bhava*) (chapters VI and VII). He now returns to them even more explicitly while laying out the structural principles of drama. It is significant that Bharata places the two chapters on types of drama and the structure of plays roughly in the middle of his text. The two chapters link to the broad divisions of his text from chapters I to XIX to XXXVI. In the preceding chapters, he had taken up one set of issues, principally of space and methods of expression through body language, sound, note and word. In the succeeding

chapters, he takes up the other two *abhinayas* (viz. *sattvika* and *aharya*), music as a distinct category and those of spectator, audience and other issues of a general type relevant to theatre, which permeate all aspects and cannot be restricted only to the tangible structure of drama.

Understandably, this is the state at which Bharata undertakes to evolve typologies. In chapter XX and XXI he begins first by enumerating typologies of plays (*dasarupaka*). In the succeeding chapters (XXII, XXIII and XXIV) typologies of styles, heroes, heroines, characters, regional characteristics, types of situations and décor are discussed.

The two chapters taken together (XX and XXI) suggest the evolution of a dramatic structure comparable to the body (*sarira*) with its joints and limbs (*anga*) and (*upanga*). He makes the explicit at the very beginning of the chapter. However, more important is the modular approach. He provides units and modules and these can be interlocked in an infinite number of ways. We must also make the discussion thin, but the real distinction implied by the two different terms, *sandhi* (anatomically and grammatically) and *bandha* (binding and interlacing). Bharata uses the terms referring to compositional devises. *Bandha* refers to the possibilities of producing new shapes and forms not only in poetry and drama but also in Indian painting. The term is used in a variety of contexts: in versification, it is used as *citrabandha,* and in figurative art it is *narikunja bandha* and in dance it is *bandha nrtya*. Flexibility, challenge of innovation and improvisation through a series of combinations, is basic to the abstract design of form devised by Bharata, Indeed it is *itivrtta,* the plot.

Two statements by Bharata at the end of chapter XXI are clear indication of his approach to all that he has suggested. After describing the characteristics and components of the dramatic form, called *nataka,* he emphasizes the fact that drama presents, re-narrates (anucaritam) through *abhinaya* (expression), but its success is possible only when the actor has overcome and suspended, his personal self (*svabhavastyajyati*) (NS 21: 121–24). Finally, Bharata again stresses that through all that he has suggested, it is possible to present the infinite variety of the world in an innumerable number of forms (*rupa*). They can be ever new (*navina*) as also endless (*ananta*). No better statement of a clear vision of intent and flexible structure could be made despite the variant readings and interpretation of these verses.

It was important to underline these principles because they constitute the foundation of the practice of the Indian arts, not only literature and drama. A paradigmatic model with countless possibilities of creating new forms provided an inbuilt flexibility, most with countless possibilities for creating new forms, most visible today in classical Indian music to an extent, in dance. Ancient and medieval architecture and sculpture, drama and theatre, are structured on these principles. However, to move on to the next group of chapters,

namely, XXII, XXIII, XXIV, XXV and XXVI, we may draw attention only to a few important principles enunciated without going into the details of each of these.

It will be recalled that Bharata had introduced the subject of styles (*vrttis*), regional schools (*pravrttis*) and the two modes of presentation (*natyadharmi* and *lokadharmi*). He now elaborates upon the *vrttis* in chapter XXII, goes into the mythical origin of each and the appropriate employment of each, verbal (*bharati*), grand (*sattvati*), graceful (*kaisiki*) and energetic (*arabhati*). The chapter on costumes and make-up (chapter XXIII) provides a fund of information on color, correspondences and understanding of types of make-up for particular characters, people from different parts of India and techniques of constructing stage props and hand props, including the important banner staff *jarajara* and a vast variety of masks. "According to one's pleasure, colours can be changed" (NS 23: 97–98).

The chapter on *samanya abhinaya* is a long chapter of some fundamental importance. Here, Bharata is endeavoring to state that the "inner states" of the total personality are fundamental. "Feeling" and its involuntary expression is his concern. Understandably, he emphasizes that *samanya abhinaya* relates to all parts of body, a totality in acting, suggesting that not a single gesture which can reflect some feeling but a complete engagement of the body that creates feelings (NS 23: 1, 2, 3, 72 and 73). Basically, therefore, he is referring to feeling and temperament (*sattva*), which is unexpressed, but it can be discerned through physical signs such as tears, horripilation, etc. This seminal statement is now elaborated upon in chapter XXIV, which he chooses to entitle *samanya bhinaya* rather than *sattvika bhinaya*. The choice of the chapter heading is significant suggesting that Bharata's purpose is to draw attention to universality and pervasiveness, the source of which is *manas* (mind).

Bharata sums up in a nutshell all that he has outlined in the preceding chapters. Since they have been overlooked by and large, an excerpt of verses 115 to 129 in full would not be out of place. In the fifteen verses (NS 26: 115–129) Bharata sums up all that he has tried to enunciate at the level of goal, concept, manifestation, visualization, structure and technique:

115–116 Just as the garland-maker makes garlands from various kinds of flowers, the drama should be produced similarly by gestures and different limbs, and by sentiments and states.

116–117 Movements and gats have been prescribed by the rules for a character who has entered the stage, should be maintained by the actor without giving up the (particular) temperament till he makes an exit.

117–118 Now, I have finished speaking about the representation to be made through words and gestures. Things omitted here by me should be gathered from (the usage of) the people (*loka-vyavahara*).

The triple basis of drama:

118–119 The people (*loka*), the Vedas and the spiritual faculty (*adhy-atma*) are known as three authorities. The drama is mostly based on objects related to the last two (*Vedas* and the *adhyatma*).

119–120 The drama, which has its origin in the Vedas, and the spiritual faculty (*adhytma*) and includes proper words and meter, succeeds (*siddham*) when it is approved of by the people (*loka*). Hence the people are considered as the (ultimate) authority (*pramana*) on the drama.

121 A mimicry (*anukarana*) (literally a re-narration, a re-statement of a presentation and not a imitation) of the exploits of gods, sages, kings, as well as of householders in this world, is called the drama (literally, re-presentation of that which has been: *purvavarta carita*).

122 When human character with all its different states is represented with (suitable) gestures it is called drama.

People supplying norm to the drama:

123 Thus, the events (*varta*) relating to the people in all their different conditions may be (literally, should be) included in a play, by those well versed in the canons of drama (*natyaveda* and also *natyavid-hana*).

124 Whatever *sastras,* laws, arts and activities are connected with the human conduct (*lokadharma*) may be produced (literally called) as a drama.

125 Rules regarding the feelings and activities of the world, moveable as well as immovable, cannot be formulated (literally ascertained) exhaustively by the *sastra*.

126 The people have different dispositions, and on their dispositions the drama rests. Hence, playwrights and producers (*prayoktr*) should take the people as their authority (as regards the rules of the art).

127 Thus, they (*prayoktr*) should pay attention to the feelings, gestures and the temperament in representing the states of carious characters (that may appear in the drama).

128 The men who know in this order the art of histrionic representation and apply it on the stage receive in this world the highest honor for putting into practice the theory or essence of drama (*natyatattva*) as well as (the art of) acting (*abhinaya*).

129 These are to be known as the modes of representation dependent on words, costumes, make-up and gestures. An expert in dramatic production (*prayoga*) should adopt these for the success (in his under-taking).

Having laid out in a nutshell his concept and design, Bharata now turns his attention to the "final product"—the theatrical spectacle as a whole. The

acid test of any creativity, from inspiration to the process of transference of "idea" to "form," from the abstract to the "concrete," is the "product," complete and "autonomous," which must communicate at varying levels to different audiences—culture specific and trans-cultural contexts. While being in defined finite time and place, it must have power to communicate beyond time and place.

It is these sets of issues to which Bharata draws attention in chapter XXVII. He is clear that the efficacy of the artist's creation, *siddhi,* translated as "success," also denoting the command and empowerment from achievement lies in its ability to communicate. Bharata identifies two levels–the divine (*daivika*) and the human (*manusi*). We must understand theses terms to denote the different levels of consciousness. In our language we may even interpret them as intuitive, inspirational, a-casual and discursive, supramental and mundane, gross or subtle, but not "sacred" and "profane" (NS 27: 1–2). An artistic creation, a theatre production, can uplift, elevate the spectator to a sense of awe, wonder (*adbhuta*) and complete silence as response (NS 27: 17), and thus evoke speechless reverberation, or it can communicate to evoke response at lesser degrees of refinement and at a more explicit levels of applause through words or clapping.

The creator artist, dramatist and actor, can achieve this only through inner control and discipline. It is in this context that the word *sadhaka* is used (NS 27: 86). Bharata reminds us that the entire act of creation and presentation is a *sadhana,* the practice, where impersonalization, depersonalization and detachment are of primary concerns.

As for the audience and spectators, they too must be attuned, trained and initiated. The demand from them is no less exacting. Preparedness both of attitude and initiation into some technicalities is an essential pre-requisite. They are also potential artists: the artistic creation re-stimulates and energizes dormant states. It is these verses on the audience (*preksaka*), which stimulated an active debate for centuries on the nature of aesthetic response.

Bharata does not forget critics and judges and lays down the qualification of a jury. The list is daunting. It must comprise of an expert in ritual (*yajnavit*), a dancer (*nartaka*), a prosodist (*chandovit*), a grammarian (*sabdavit*), a king (*rajan*), an expert in archery (*isvastravit*), painter (*citravati*), courtesan (*vesya*), musician (*gandharva*) and a king's officer (*rajasevaka*). Could we wish for a more comprehensive list of discipline areas to be represented as adjudicators? Perhaps, Bharata should have added a medical person, perhaps a yoga specialist and an architect in the team.

The next few chapters deal with the broad spectrum of music. Bharata is concerned with the formal aspects of all categories of music, instrumental and vocal (chapters XVIII to XXXIII). Here, he outlines his system and lays

down the formal principles (*vidhana* and *vidhi* are two words used). We will recall that he had introduced the subject of voice production "notes" (*svaras*) in the context of prosody. Now, he picks it up for elaboration. These chapters lay the foundation of a distinctive system of music—its micro-intervals (*sruti*), notes (*svara*), scales (*grama*), modes (*murcchana*), melodic forms (*jatis*), rhythm (*tala*) and much else. He breaks up the whole to its smallest constituents and then develops an architectonic structure. There is so much of "value" in these chapters that no justice can be done even to the rich contents and vocabulary of these chapters in the present work. Bharata displays an extraordinary knowledge of material in the making of musical instruments that are of four types, and of the nature of sound, notes, consonance, assonance, dissonance and melodic forms. He establishes a system of correspondence between each category and its potential for arousing emotion; he develops it to establish patterns of configuration of "notes" in melodic forms and emotive states. He distinguishes between vocal and instrumental music. He further divides vocal music into two types—one, consisting only of notes and the other, with words (*varna* and *geya*). He provides details of different types of instruments and their respective characteristics. He returns to an elaboration of the category of *dhruva* songs, which he had mentioned in many earlier chapters. He identifies a category of music called *gandharva* and distinguishes it from *gana*. Bharata enumerates the different types of *tala* (time measures—rhythm, metrical cycles). In short, he lays down the foundation of a distinctly Indian style of music with its scales and modal structure. This was debated and discussed, even modified and changed, but the underlying principles were never rejected. Bharata, as in the case of *angika* (body language), *vacika* (verbal expression) and in respect of plot (*itivritta*), provides a basic framework with several components which can be used as "modules" in an infinite flexibility which has facilitated the twin phenomena of unbroken continuity at one level, and constant movement or change and flux, at the other. The history of Indian classical music in theory and practice is the most convincing and vibrant example.

The last three chapters (XXXIV to XXXVI) conclude this mighty text. Chapters XXXIV and XXXV are concerned with another group of issues. Chapter XXXV brings back to the beginning. While Bharata had spoken of types of characters as also heroes and heroines earlier, here he elaborates upon them in more specific terms and also relates them to the practical problem of casting of roles in a theatrical production. His guidelines in most cases would still be applicable although the number of character types, heroes and anti-heroes may have to be greatly enlarged to include the proliferation of disciplines and specialists as also new socio-economic phenomena. Had Bharata lived today he may have laid down guidelines for casting not only the roles of

kings, queens, attendants, military personnel, jesters, but would have included politicians, high-ranking professionals, businessmen, academicians, scientists, technocrats, brokers and innumerable others, in their identifiable and recognizable lifestyles and consequent vocabulary, body-language, intonation and attire. We are familiar with the widespread employment of stock-characters in Indian drama and on the screen. Bharata is a distant antecedent of these trends, not all totally aesthetically satisfying.

Bharata's command over the whole range of creativity from the source of creation, inspiration of the artist process and expression through the principal instrumentalities of expression of the verbal and corporeal to the final product, communication and response, is overwhelming. He has, indeed, created a *sastra* of *prayoga*, a framework of principles of praxis or practice.

Significantly and purposefully, he changes the level of his discourse in the concluding chapter. We return to the beginning, not to an identical moment of the origin of drama in the state of meditation and reflection of Brahma's *Samadhi*, but to the few but important queries of the assembly of sages who heard Bharata's exposition. The names include Atreya, Vasista, Angiras, Agastya, Visvamitra, Jamadagni, Markandeya, Bharadvaja, Valmiki, Kanva and many others. They are all creators of many branches of knowledge.

Their questions revolve around three issues: the significance of the elaborate preliminaries (*purvaranga*), why does the director (*sutradhara*) perform the rites of ablution (and *puja*) on stage and how did drama come down (literally, drop down) to earth and how did actors (descendants of Bharata) come to be equated with the fourth caste, the *Sudras?*

Bharata's replies are significant. They are cogent at the level of structure but move at the level of meaning. The preliminaries are like armor. Just as the body has armor to protect, the preliminaries provide the initial armor of maintaining and sustaining the world of the "imagination," *anukirtana,* a new creation of the universal, that which can happen and to be communicated, in the body (sarira) of drama. It heralds auspiciousness (*mangala*). To this day we know the significance of formal auspicious beginnings and inaugurals in all facets of Indian life. Thus, the preliminaries (*purvaranga*) have the dual role of protection and of heralding. Its significance in linking the different levels of the divine and the human, of the celestial and terrestrial, we have already drawn attention to. Through the device of a repeated spatial and temporal order is represented and interlinked.

Bharata goes further here and equates the sound of the *nandi* to the exposition of the Vedic mantras, the music to a holy bath and repetitive recitation (*japa*).

To the second question, why the director, the *sutradhara*, performs ablutions, Bharata, at the explicit level, gives a practical answer. The pouring of

water becomes necessary because by now he (i.e., the *sutradhara*) has bent so many times, he requires relief. At the implicit level, Bharata is drawing attention to the transition from one level of communication to another. The sacralization, of space and time, is over and a pausation is necessary. From this moment, the director recedes to the background and the drama proper appears.

The answer to the third question, as we have pointed out before (story of the descent of drama to the earth and cure), is a pointer towards the primary and fundamental requirement of the eschewing of personal "ego" and price of the artist.

The twin demands for "impersonality" and "intensity" and authenticity and of negative capability and sensitivity are stressed. Internal discipline and concentration (*tapas*) is of essence. This is the message of the curse on Urvasi to descend to earth when she said "Pururavas" instead of "Purusottama" in a performance at Indra's court. Bharata's sons (the creative community) also have to go through the intervention of King Nahusa.

With extraordinary finesse and skill, Bharata, brings his exposition to culmination by restating the totality of the original inspiration, the process of transference from the unified undifferentiated state to expression through concrete form and multiple forms, the dimensions and levels of communication and the demands of depersonalization, humility, training and discipline of the artist. But as said and done, the creative act is a mystery and there are many aspects, which are secret. *Guha* (secret) is the repeated word in chapter XXVI, of verses 9, 10, 11, etc.

The sequential narration of the thirty-six chapters was necessary to reveal the structure of the text at its implicit and explicit levels. There is a unified vision, a well-defined integral structure and a methodology of discourse, which moves on many levels and through different circuits, and is multidisciplinary in nature. His organizational pattern is also circular like his notion of plot (*itivritta*). There is, no doubt, possibility of interpolation (the most outstanding and difficult example is that of the section on *shantarasa*) and corrupt readings but the steel frame of his exposition has a unique integrity.

To briefly sum up, the sequential movement of the text is along the circumference of a circle with an unseen but real center and point. Chapters I, II, III, IV and V are one group, where spatial and temporal relations are outlined. Chapters VI and VII are a second group, where life is abstracted into a spectrum of rasa, bhava and their variations. Chapters VIII, IX, X, XI, XII and XIII deal with all aspects of the body language. Chapter XIII comes as a pause to concretize the methodology of transforming space to place on the state. Chapters XIV, XV, XVI, XVII, XVIII and XIX deal with all aspects of the verbal, sound speech (*vacika*). Another major pausation occurs with chapter XX and XXVI, which deal with the structure of drama, types of plays and

the multi-layered movement of the plot. Time is the concern. Chapters XXII, XXIII, XXIV and XXV and XXVI constitute another group which deals with matters which relate to other two instrumentalities of expression, costuming and decor (XXIII) and sattvika (XXIV). Matters which are of a general nature are considered in chapter XXII on *saamanyaabhinaya, citrabhinaya* (mixed or pictorial) in chapter XXVI, and gender relationships in chapter XXVII. There is another pause to consider dramatic success and achievements. Chapters XXVIII, XXIX, XXX, XXXI, XXXII and XXXIII are devoted to music. Two chapters follow these on distribution of rules and organization.

It will be observed that Bharata devotes equal attention to each of the principal tools, namely, body language (*angika*), words and language (*vacika*) and music (vocal and instrumental). The structural and formal aspects of each are analyzed. Structural matters he takes up in the pausation chapters of *kaksyavibhaga* (zonal divisions of stage), plot and pervasive general matters in another group, followed by another pause on dramatic success and response. Organizational matters constitute a separate group.

This grand design Bharata executes as a master conceiver of a great orchestra. He assigns a role to each instrument, lays down the plan of each group of instruments, their interaction with each other, the phasing and the movement, never forgetting that all this is for the evocation of a "mood," a state where once each instrument and player has played a part, they are no longer important and meaningful. Like the actors of his drama, the *angika*, the *vacika,* the *aharya* and the *sattvika* must transcend their individual identity and merge in the totality. Just as the instruments of an orchestra have their distinctive identity and special techniques of playing, each *abhinaya* (extended to art) is distinct and clearly identifiable, has a role to play in the totality, but is never absolutely autonomous.

While in the matter of organization of his work the comparison with an orchestra for playing a great symphony is pertinent, in the matter of the movement of consideration of issues and levels of discourse, the text is more like a piece of Indian music. It begins in a mood of reflection, unfolds the entire gamut of sounds, moves through permutations, combinations, and returns, as it were, to the tonic of the melodic system or the first best of the Indian *tala* system, namely *sama.*

Also, we have stressed the eclectic character of the undertaking and the synthesizing role of the Natyasastra. It is a confluence of many streams of thought, life, conduct and the arts. For a while, it becomes a big lake, almost oceanic in proportion. Naturally, from this confluence, lake or mini-ocean, many different streams were to flow out.

Bharata provided the basic framework and a pan–Indian vocabulary, which was to guide the theory and practice of the Indian arts for two millennia.

The course of the flow had twin dynamics; one of a lifeline of perennial immutability and continuity, and the other of change and flux.

NOTES

1. Originally published in *Aesthetic Theories and Forms in Indian Tradition*, edited by Kapila Vatsyayan and D.P. Chattppadhyaya, and published by Centre for Studies in Civilizations in 2008. The present essay is edited and reworked by the author for this publication.

2. *Yajna* is the ritual offerings accompanied by chanting of Vedic mantras, the practice which is derived from the Vedic times. The ritual fire, the divine *agni,* is an essential element in the ritual. The oblations are poured into the fire that is believed to reached the God.

3. The term refers to five senses in the body that are physiological senses that provide data for perception. Sight, hearing, taste, smell and touch are the five senses traditionally recognized. For more details see Kapila 1999.

4. Kuiper holds the view on account of different list of deities in chapters I, II and III. He is of the view that these along with some others, are the work of a devout Saivite. See for more details, Kuiper, Varuna and Vidusaka 1979, p. 153.

5. See the comprehensive discussion on the "jarjara," in Kuiper, Varuna and Vidusaka 1979, pp. 119–53. Kuiper brilliantly sums up the nineteenth and twentieth century discussion on the "jarjara." His footnotes are particularly illuminating.

6. For more details see Vatsyayan 1975, pp. 60–75, for analysis of different phases; Kuiper, Varuna and Vidusaka 1979, pp. 166–74; Lidova 1994, pp. 7–24.

7. This is where in the Natyasastra Bharata explains rasa as the combination (*samyogad*) of determinants (*vibhava*), consequences (*anubhava*) and transitory mental states (*vyabhichari*) that make the relish.

8. For more details see Vatsyayan 1977, pp. 38–97.

BIBLIOGRAPHY

Byrski, M.C. 1994. *Concept of Ancient Indian Theatre.* New Delhi: Munshiram Manoharlal.

Chakravarti, H.N. 1988. "Bija." In *Kalatattvakosa* vol. 1, ed. Bettina Baumer. New Delhi: Motilal Banarsidass.

Dillon, M. 1937 (1960). *Natakalaksanaratnakosa of Sagaranandin.* Philadelphia: American Philosophical Society.

Kapila, Vatsyayan. 1999. "Indriya." *Kalatattvakosa,* vol. vi in *Manifestation of Nature: Srsti Vistara,* ed. Advaitavadini Kaul and Sukumar Chattopadhyay, pp. 1–68. New Delhi: Indira Gandhi National Centre for the Arts and Motilal Banarsidass.

Kuiper, F.B.J. 1979. *Varuna and Vidusaka: On the Origin of Sanskrit Drama.* Amsterdam: North-Holland.

Lidova, N. 1994. *Drama and Ritual of Early Hinduism.* Delhi: Motilal Banarsidass.

Raghavan, V. R. 1993. *Sanskrit Drama: Its Aesthetics and Production.* New Delhi: Sanctum Books.

Shankar, B. 1972. *Natakalaksanaratnakosa.* Varanasi: Chaukhamba Samskrit.

Tripathi, K.D. 1998. "Lakshana." In *Kalatattvakosa* vol. 1, ed. Bettina Baumer. New Delhi: Motilal Banarsidass.

Vatsyayan, K. 1975 (1983). *The Square and Circle of the Indian Arts.* New Delhi: Roli Books.

_____. 1977. *Classical Indian Dance in Literature and the Arts.* New Delhi: Sangeet Natak Akademi.

_____. 1979. "Margi and Desi" and "Natya and Lokadharmi." *Sternbach Memorial Lecture* vol. I. Lucknow: Bharatiya Sanskrit Parisad.

Epistemology of Aesthetic Experience: Some Reflections on the Natyasastra

Vashishtha Jha

An art form develops in terms of the worldview of an artist. Therefore, in order to develop a theory of aesthetic experience, it is necessary to ask the following questions:

(a) What is the worldview of an artist?
 Is he or she an idealist or a realist or a materialist?
(b) What is the ontological status of his or her world of ordinary experience?
(c) What is the model of understanding of his or her world of experience?
(d) What is the status of understanding itself (jñāna, saàvit)?
(e) What is the status of language through which an artist verbalizes his or her experience?
(f) Who is an artist (*kavi*)?
(g) Who is a connoisseur (*sahridaya*)?
(h) What is an aesthetic experience (*rasanubhuti*)?

The answers to these questions will reconstruct a comprehensive theory of epistemology of an art experience (*jñapti-prakriya*).

We shall consider these and other related issues in the course of our discussion as and when the occasion arises.

An easier way to address these issues may be to develop a theory of linguistic communication, since our world is presented before us through a language; it is conceptualized through language, experienced through language and communicated through language.

In a theory of communication, there is a communicator on one end; there

44

is a world, the knowledge of which is communicated, when the world is known clearly with a name (*nama*) and a form (*rupa*) and when the communicator has a desire to share. The communicator communicates his or her knowledge or understanding of the world through language and the listener or reader receives the same. The receiver decodes that language and discovers the knowledge of the world, which was encoded by the speaker or the writer or the communicator (Jha 2010: 358–361).

Every sentence of a normal human being is an invitation to the listener or reader to visit the world of experience of the speaker or the writer. The communication is said to be successful (*saàvàda*) if and only if the listener is successful in capturing the speaker's intention (*tatparya*) and succeeds in visiting the same world of the speaker. Conversely, the failure in grasping speaker's or writer's or communicator's intention results into the failure of communication (*visaàvada*) (Jha 2004: 18–26).

This is the broad structure of the theory of communication. This structure is common to both, the linguistic and non-linguistic communication, since all human communication materializes through human language. As it theorizes an ordinary linguistic communication with an ordinary world of our ordinary experience so also it theorizes extraordinary communication or communication through art since there are extraordinary human beings such as artists gifted with extraordinary capacity of creating an extraordinary world. When an artist encodes his or her extraordinary experience of his or her extraordinary world, namely, the world of art, in an extraordinary language it takes the form of a literary art form. Drama emerges as a literary art form for the first instance. The dramatist presents that form with a specific structure of a theme or plot to be presented by a set of characters and environment with an aim to generate certain intended psychological impact on the spectators. The role of a dramatist comes to an end after the emergence of the literary form of art.

When the performing artists take that literary form over, and decide to stage the drama, they, as a matter fact, re-create that literary world of art of the dramatist in their own way through imagination. After re-creating, they try to actualize it through their performance in such a way that the spectators start believing in that created one, forgetting particularities of all types. This helps the spectators transcend all kinds of individualities of time and space and in turn they are taken to a transformed state of mind, which is nothing but joy or aesthetic pleasure called *rasa* by Bharata. This must be kept in mind to understand Bharata.

In this entire analysis, two processes are involved: (1) the process of creation of an art form and (2) the process of appreciation of an art form. The creator of the literary art form is viewed as the creator of the world of literary

art. The dramatist is, therefore, the first creator. He or she creates the world of art through his or her imagination. The director who takes it up for staging again creates it through his or her imagination and finally the artists or the characters re-create it on the stage or the screen through their extraordinary skill. The spectators get involved in it so much so that they, at some point of psychological transformation, start believing that the events presented before them through the acting skills of the performing artists are as good as real and this happens through the process of aesthetic transformation. What follows needs to be understood in terms of this brief background. It is Bharata Muni[1] who, for the first time, in the history of analyzing aesthetic experience, presented the psychological analysis of the process of aesthetic ecstasy (*rasa*).

This essay contemplates the analysis of Bharata, in terms of the interpretations of his *rasa-sutra* (NS 4: 32), offered by the commentators, with a focus on the epistemology of experience of an art form.

Creation of an Art Form

It's everybody's experience that the universe of our experience is partly given and partly created by man. A tree is given, a chair is created; flowers are given, garland is created; voice is given, music is created; language is given, poetry is created. There is something which is given to man which he has not created and there is something which he creates out of the given. Therefore, our world of experience consists of both the given and the created.

It is an accepted fact that what is experienced is a plural world: garden is not flower, flower is not thread; I am also not flower, nor the thread nor the garland; all of them are experienced as having independent existence. But philosophers have asked whether they are really different.

Different answers have come from different philosophers. Some have said the experience of plurality is an illusion. They have argued that "the source Reality" is only one and "the experienced plurality" is merely a function of the super-imposition of "many" on "one," as if the One Single Reality has appeared as many. Other philosophers have contested that position and have held that it is not true that "One" has appeared as "Many" but, as a matter of fact, the Single Reality has become "Many" like a single actor playing a number of roles. The earlier position converted "plurality" as illusion, whereas the second position accorded reality to "plurality."

Yet some other philosophers have held that all this appearance of plurality is fluid; there is nothing which can be characterized as something in terms of any feature and hence there is no "entity" as such and it is all void.

Still other philosophers have maintained that the "plurality" is a reality.

Reality is that which can be known and expressed in language. As a matter of fact, had there not been a garden, or flowers or thread, or a garland, there cannot arise the knowledge of garden or flower or thread or garland and we cannot refer to them by language. They exist independent of their knowledge and that is why they become the cause of their knowledge.

In Indian context, the first three worldviews mentioned above are the worldviews of Indian Idealists of various types like Sankarācārya, Vallabhācārya and the Buddhists, and the fourth is that of the Indian Realists like the Naiyāyikas and others.

The Given

The philosophers in the past have made thorough analysis of this given world. Take, for example, the analysis presented by the Indian logicians (*Nyaya-Vaisehikas*). For them, the world is a *padartha* or an "entity," which can be a referent of a linguistic term (*padasya arthaù*). Such an entity can be either positive (*bhava*) or negative (*abhava*). Please note that *abhava* is also an entity. Thus, as a "tree" is an entity similarly, the "absence" of that "tree" is also an entity.

A positive entity is classified in six sets of entities such as substance (*dravya*), quality (*guna*), action (*karman*), universal (*samanya*) particular (*visesa*), and inherence (*samavaya*).Each one of these sets is further classified into sub-sets. Thus, substance is of seven kinds, namely, earth (*prthvi*), water (*ap*), fire (*tejas*), air (*marut*), ether (*akasa*), time (*kala*), space (*disa*), soul (*atman*), and mind (*manas*). Qualities are twenty-four: color (*rupa*), taste (*rasa*), smell (*gandha*), touch (*sparsa*), number (*Sankhya*), measure (*parimaea*), contact (*saayoga*), divison (*vibhaga*), separateness (*pàthaktva*), moisture (*sneha*), heaviness (*gurutva*), fluidity (*dravatva*), remoteness (*paratva*), nearness (*aparatva*), knowledge (*buddhi*), happiness (*sukha*), unhappiness (*dukha*), desire (*iccha*), hatred (*dvesha*), volition (*prayatna*), merit (*dharma*), demerit (*adharma*), impression (*saaskaras*) and sound (*sabda*).

Actions are of five kinds, namely, going upward (*urdhvagamana*), going downward (*adhaupatana*), shrinking (*akuncana*), spreading (*prasarana*) and going (*gamana*).

Class property or generic property or universal (*samanya*) is only one, like pot-ness, tree-ness and so on.

Particulars (*visesa*) are endless and they are located in all permanent substances. Each of these particulars distinguishes its locus, i.e., one permanent substance from the other permanent substances.

Inherence (*samavaya*) is a single "permanent relationship," which is accepted in the following five cases:

(a) between a quality and its locus;
(b) between an action and its locus;
(c) between a universal and its locus;
(d) between a whole and its parts; and
(e) between a particular (*visesa*) and its locus.

Absence (*abhava*) is broadly of two kinds, mutual absence (*anyonyabhava*) and relational absence (*samsargabhava*). Relational absence (*samsargabhava*) is further classified into three types: pre-absence (*pragabhava*), destruction (*dhvaàsa*) and absolute absence (*atyantabhava*) (Jha 2011).

This is our given world with which we behave all our life. But behavior presupposes knowledge of that with which we behave. Naturally, we would like to know how we know this given world. The Indian logicians, therefore, took up this issue of the process of knowing the world. This is what is known as epistemology or *pramaea-sastra*. The logicians arrived at the conclusion after analysis that there are four ways of knowing the world: perception (*pratyaksa*), Inference (*anumana*), analogy (*upamana*) and language (*sabda*). Let us see briefly how these instruments of knowing work.

We are given with five external sense-organs made of five primordial elements (*panca-mahabhutas*) to have direct access to the external world and the sixth sense-organ called "mind" to have direct access to our internal world like cognition, desire, volition, happiness, unhappiness, hatred, love, kindness, merit (*pueya*), demerit (*papa*) and our impressions (*samskara*) left behind by our experiences.

It is not the case that we have access to the world, both external and internal, only when it is in direct contact with these six sense organs. We can know them even if, sometimes, the world is beyond the reach of a sense-organ. The instrument or the process of knowing, in such a situation, is called inference (*anumana*). An inference works on the basis of an invariable relationship (*vyapti*) between the ground (*hetu*) on the basis of which we want to know "what we want to know (*sadhya*), i.e., the world."

We also know the world through language. But the understanding of language depends on the knowledge of the relationship between a sign and what a sign stands for. The Indian tradition has discussed this issue in great detail and had discovered various ways of knowing this relationship between a word and its meaning. The following verse presents a list of such means of knowing that relationship:

Çaktigrahaà *vyäkaraëopamäna-koçäptaväkya-vyavahärataç ca|*
äkyasya çeñäd vivâter vadanti sännidhyataù siddha-padasya vâddhäù||[2]

"Elders who have analyzed the process of the verbal understanding say that the primary relationship between a word and its meaning is known from grammar,

analogy, dictionary, reliable speaker's statement, language in use, usages in literature, paraphrase, and from the proximity of a known word."

Sakti here means the primary relationship between a morpheme and its referent. It may be noted that *upamanapramaea* is one of the means of knowing the relation between a morpheme and its referent.

Similarly, language is one of the means to know the world.

The picture will be clearer if we analyze this a bit closely. While presenting the epistemology of the perceptual cognition Gautama, the author of the *Nyayasutra*, observes:

> *Indriyärtha-sannikarñotpannaà jïänam avyapadeçyam avyabhicäri vyavasäyätmakaà pratyakñaà* [*Nyayasutra* 1.1.4].

"A cognition which is produced out of the contact between a sense organ and an object and which is not expressible in language, which is not erroneous, and which is determinate in character, is *pratyakha.*"

While interpreting the clause "which is not expressible in language" (*avyapadesyam*) Vatsyayana, the commentator on Gautama-sutras, writes:

> When a perception occurs, it does not take the help of the knowledge of the relation between the object seen and its name. There is no difference between a perception of an object prior to the knowledge of its name and the perception of that object, after the name of that thing is known. It is only at the time of sharing one's thought with others, one requires language. Because without knowledge, one cannot express in language.[3]

This analysis amounts to saying that language comes in play only after cognition has arisen. In other words, a speaker encodes his cognition after it has arisen. Thus, cognition must arise prior to language. Obviously, this is the refutation of the view that no cognition is possible without language, which has found expression later on in the following verse of Bhartâhari (1.123), the celebrated author of the *Vakyapadiya:*

> *na so'sti pratyayo loke yaù çabdänugamäd äte|*
> *änubiddham iva jïänaà sarvaà çabdena bhäsate||*

"There is no knowledge without language. All knowledge is inter-mingled with language and so every thing in this world gets illumined only by language."

The *Nyaya* view is just opposite, as we have seen above. This implies that a speaker first acquires his knowledge or cognition of the world and then verbalizes it by encoding it in a language known to him. This can be theorized as follows:

This is how a text comes into being.

Once verbalization has taken place through speaking or through writing, it can reach a hearer or reader. Now, another process begins in the hearer or the reader and that is the process of decoding the text, sentence by sentence. This process of decoding is called the process of *sabdabodha* (understanding of a sentence-meaning) in the Indian tradition. A sentence, when decoded, results into verbal understanding or knowledge of the sentence-meaning (*sabdabodha*).

The following is the process through which the meaning of a sentence is understood:

Stage I reception of a sentence (*padajñāna*)
Stage II remembering the referent of each morpheme of that sentence
 (*padartha-smarana*)
Stage III inferring the intention of the speaker (*tatparyajñāna*)
Stage IV relating the remembered meanings (*padartha-anvaya*)
Stage V understanding the relations among the remembered referents
 (*sabdabodha*).

Suppose there is a sentence—a + b + c + d—consisting of four morphemes—a, b, c, and d. The following will be the picture, with regard to the process of verbal understanding

Step I a + b + c + d

Step II a + b + c + d

 | | | |
 a′ b′ c′ d′

Where a' b' c' and d' are the referents, remembered from a, b, c, and d, through a relation indicated by the vertical line above. Sometimes, it may so happen that any of the elements of the sentence may have more than one meaning, like this:

In such a situation, both the meanings will come to mind. But if both meanings are not intended by the speaker or writer, how to keep one and cancel the other?

This will be settled in the next step by knowing the intention of the speaker and thereby eliminating either a' or a." Thus

Step III

$$a + b + c + d$$

$$a' \quad b' \quad c' \quad d'$$

where a" has been eliminated after knowing the intention of the speaker
 Step IV

$$a + b + \quad c + d$$

$$a'- \quad b'- \quad c-' \quad d'$$

where relations among a', b', c' and d' have been identified and
 Step V

$$\boxed{a'- b'- c'-d'}$$

where the rectangular box is the resultant knowledge or verbal understanding of the sentence- meaning (*anvayabodha*).

 This knowledge of the hearer or reader is expected to be identical with the knowledge of the speaker or writer for establishing a rapport between them. Unless this happens, there can be no rapport between a speaker and a hearer and consequently no communication can take place. This model of communication can be presented as follows:

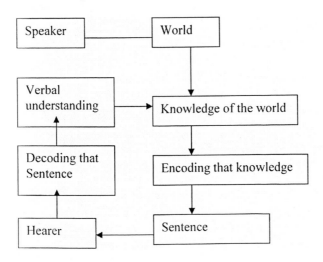

This is how we communicate with ordinary language with the ordinary "given" world of our ordinary experience. With this background, we shall turn to the analysis of the world of literary art, aesthetic experience of that world of art, language of art, appreciation of an art form and finally establishing a rapport between an artist and a connoisseur (Jha 2010, 368–372).

The Created

As against the given world of our experience, there is the created world of our experience. An art form, be it a song, a dance, a painting or a sculpture or a literary art form like a play, a poem, a short story or a novel, is created by human being unlike the ordinary world of our experience which is simply received by us.

That the world of literary art is created by a literary artist is clearly stated in the following oft-quoted verse:

äpäre kävya-saàsäre kavir ekaù prajäpatiù|
athäsmai rocate visvaà tathainaà parivartate||

"A literary artist alone is the creator of the word of literary art. He or she transforms the given world into a world of art as per his or her liking" (Panduranga 1983: 278).

Here, the word *kavya* means "literary art form," *kavya samsara* means "the world of literary art," *kavi* stands for "a literary artist" and he is conceptualized as "the creator" (*prajapati*) of the world of his literary art form. The word *visva* here stands for the "ordinary world of our experience." An artist's creation is conceived here as "transformation of the given." Thus, it is clear that an artist does not create from "nothing," rather he or she transforms the given into his world of art. He or she creates his or her world of art out of the experience of the given world. As a matter of fact, there is transformation at all levels and components. We can easily conceptualize the model of this transformation as follows.

A literary artist (*kavi*) is a transformed ordinary speaker (*vakta*); *kavya-samsara* is a transformed (*parivartana*) given world (*visva*); aesthetic experience (*rasanubhava*) is again a transformed ordinary experience (*visvanubhava*); the language of literary art is also a transformed ordinary language, and the listener or reader of literary art (*kavya*) is also not an ordinary listener (*srota*) or reader, but a transformed listener, i.e., a connoisseur (*sahridaya*).

Creation is, thus, "transformation through imagination." Classical Indian thinkers have also analyzed how such transformation takes place, but we will not go into those details here.

The artist gives an aesthetic shape to the given world through a beautiful arrangement and re-arrangement of the given and thus transforms an ordinary world into a world of art. Thus, his creation is nothing more than a beautiful arrangement and rearrangement of the given. In the words of *Jayantabhaööa,* the great logician of Kashmir of 9th century, "How are we capable of creating anything new? If at all there is anything new, it is nothing more than an arrangement of the given."[4]

Needless to say, a literary artist is both an ordinary speaker as well as a literary artist. He or she is born with the capacity of encoding his or her ordinary experience of an ordinary world, and when he or she creates a world of art, he or she extends this capacity to encode an aesthetic experience into language. When he or she finds difficulty in encoding the aesthetic experience into an ordinary language, he or she creates "a language of literary art" by transforming the ordinary language into the language of art. Here too the artist brings about the desired transformation through various arrangements and rearrangements, giving rise to various ornaments of speech (*alankara*), modes, dicta, etc., which give joy to a sensitive connoisseur (*sahridaya*).

As an ordinary language is required to encode an ordinary experience of an ordinary world, so also a literary language is required to give expression to an aesthetic experience of the world of art. This distinction is clearly known to the Sanskrit aesthetic tradition from a very early time (Jha 1998: 49–60).

This theory of creation and communication of an art form can be summarized in the following diagram:

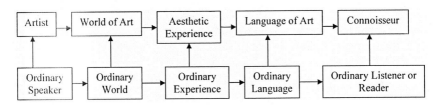

Here the vertical arrows indicate "transformation" and horizontal arrows indicate "direction of communication." While ordinary communication takes place between and ordinary speaker and an ordinary listener, the aesthetic communication takes place between an artist and a connoisseur.

Appreciation of an Art Form

Let us now turn to the issue proper, namely, the epistemology of an aesthetic experience. Appreciation of an art form can be done only by a *sahridaya.*

A *sahridaya* is one who is equal in all respects to the "creator artist." As the creator artist is endowed with a creative genius (*karayitré-pratibha*), so also the connoisseur is endowed with an appreciative genius (*bhavayitré-pratibha*). He or she is not an ordinary hearer or listener (*srota*), but a transformed connoisseur. He or she alone is capable of visiting the world, which is being shown by the creator artist. He or she alone has the access to the world of art, because he or she alone is capable of knowing the relationship between an art form and its relation with the world of art. He or she alone is capable of understanding the symbols, metaphors, and images employed by the creator artist to bring about the desired transformation.

To sum up, it is clear from whatever we have discussed so far that the classical Indian aesthetic tradition is in search of answers to the following two questions:

(1) How is an art form created?

(2) How is it appreciated?

The entire tradition of Natyasastra and *Alamkarasastra* is engaged in answering these two questions.[5] In the following section, we shall reflect on what Bharata has to say on the answer to the second question above.

Epistemology of an Aesthetic Experience

We shall now try to understand the process of deriving aesthetic pleasure from the art form such as drama as presented by Bharata and his tradition. As we stated earlier, it is Bharata who for the first time presented a theory of aesthetic experience (*rasa*) in his Natyasastra. He offered this theory in the context of performing art, called drama, but I am of the view that this statement of Bharata is applicable to any form of art.

Bharatamuni's statement (*rasa-sutra*), which provides such a theory, runs as follows:

> *Vibhävänubhäva-vyabhicäri-saàyogäd*
> *rasa-nispattià* [NS 4: 32].

> "Rasa or aesthetic joy emerges out of an association of *vibhava* such as the characters, *anubhava* such as their craft or gesture or acting modes, and *vyabhicari*—or *sancari- bhava*—such as the effects of such acting i.e., the changing moods."

Bharata thinks that a dramatist depicts the main character in a drama with an enduring or prominent state of mind or emotion (*sthayi-bhava*) in terms of which the principal aesthetic emotion (*rasa*) is required to be presented by the performing artists. That *sthayi-bhava* or enduring mental state is transformed into the aesthetic rapture at the end of the play.

This theory of audio-visual art form was extended to the literary art form too and all prominent theoreticians, including Anandavardhana, Mahimbhatta, Mammata, Vishvanatha and Jagannatha, agreed on this point that the goal of an art form has to be aesthetic pleasure (*rasa*) and nothing else and so any of theory of art must be constructed only in terms of *rasa* or aesthetic joy. Even the earlier thinkers like Bhamaha, or Daëòin, or Vamana simply tried to focus only that prominent factor which contributes to the manifestation of that state of aesthetic rapture.

As a matter of fact, the *rasa-sutra* of Bharata was interpreted differently by different literary critics. Abhinavagupta, the great theoretician, art critic and philosopher of art, has recorded three prominent earlier interpretations of this sutra in his commentary called *Abhinavabharatthi* (Nagar 2003, 271–278). These three interpreters are: (1) Bhatta Lollata, (2) Sankuka and (3) Bhatta Nayaka. According to Bhatta Lollata, the aesthetic joy (rasa) emerges from the enduring or prominent mental state or emotion (*sthayi-bhava*) when it is in association with the *vibhava* (actor), *anubhava* (acting crafts or modes) and *sancari-bhava* (effect of those acting modes, i.e., the changing moods or emotions) (Nagar 2003: 271).[6]

Lollata thinks that a sthayi-bhava is nothing but a mental state and that is created by the main actor or the hero in him and that mental state manifests itself as the aesthetic joy (271).[7]

This mental state called sthayi-bhava is the original state like the original taste of a particular vegetable, which is transformed into more palatable one in association with other ingredients. His firm opinion is

ñthäyé eva vibhävänubhävädibhiù upacitaù rasaù

"The original durable mental state itself is to be called *rasa* (aesthetic joy)
when it is enhanced by the actors and their modes of acting."

According him, the original mental state exists in the character, which is being portrayed in the drama, by the direct relationship and in the actor on the strength of his imagination.

This theory of Bhatta Lollata is not acceptable to Sankuka. He is of the opinion that the sthayi-bhava or mental state observed in the actor by the spectators is an imitation of the original, but not the original:

"The characters are materialized from the script of the play, the acting modes
are created by the actors, and the after-effects of those act crafts on the actors
are materialized by the actors out of their own experience" [272].[8]

Every element in the presentation of the play is constructed and hence not real. Some actor is playing someone's role and so he is not the actual character; the actor's actions are not the actions of the original character; the visible impacts of his make-believe activities are also not original. What to talk of the

prominent emotion or mental state (*sthayi-bhava*)? It is mere imitation and nothing else. In his words:

> "Therefore, the spectators come to know through inference that the *sthayi-bhava* is located in the actor and it is not original but the imitated one, because it is constructed by the actors, their acting, and their artificially changing mental state" [171–172].[9]

He argues that even the script of the play cannot provide the original *sthayi-bhava*, because the script simply expresses how the actor should present such a mental state, it does not present it before the spectators:

> "The durable mental state cannot be had from even the script of the play. The words like 'love,' 'depression' and the like merely express those states as their 'referents' but do not make us feel as verbal acting" [172].[10]

He continues and asks us to consider in which category we should include our experience of drama. Suppose we are watching the *Ramayana:*

(a) Can we say Rama presented before us is the original Rama?

(b) Can we say Rama presented before us is not Rama?

(c) Can we say the spectators have doubt whether the person presented before us is Rama or not?

(d) Can we also say "he is like Rama?"

Our experience does not fall into any of these categories. At the same time, we cannot also deny our experience. But it remains a fact that we are experiencing make-believe, which is neither true nor false but something like a picture of reality. Thus Sankuka concludes that the *sthayi-bhava* exists in the actor and it is a construction by the actor and hence an imitation of the real emotion. It is known by the spectators through the process of inference.

Nevertheless, even if it is unreal, it can lead to behavioral response and that is how we all enjoy an art form.

This theory of ñaìkuka has been thoroughly contested in the commentary of Abhinavagupta (Nagar 2003: 271–274). There is no way here in such a brief essay to present all the arguments against this theory. Only a few of them may be discussed here.

First of all, the critic demands that ñaìkuka must make it clear whether the theory that "*sthayi-bhava* is imitation" is from

(a) the point of view of spectators, or from

(b) the point of view of actor, or from

(c) the point of view of sensitive critics.

The first alternative is unacceptable to Bharata and it is also illogical, because unless one has a previous experience through some process of knowing, one cannot imitate.

Suppose there is scene of drinking liquor on the stage or screen and the

audience notices that the actor is drinking "water." Are we to hold that the actor is imitating "drinking liquor?" Nobody takes the actions of the actor also as the imitating actions. As a matter of fact, all this is nothing but illusory imitations.

Moreover, is it possible to have an experience of mental states of Rama on the part of any actor? This also makes it clear that one cannot even imitate a character like Rama.

If one holds that, say, the emotion of "love" of the actor himself is being imitated by the actor, one may ask in what form he does that. If the answer comes as "in the form of the mental state present in the actor which can be inferred on account of mundane experience of a situation of 'love' in which women are seen performing such acts like ogling or casting amorous glance, etc., and their after-effects," then certainly it is not at all imitating.

Ñaïkuka clarifies by saying, "the *vibhavas* etc. are real with regard to the character which is to be imitated, but false with regard to the actors." The critic, however, points out that "granting that what you say is true for the sake of argument, still, is it true that the spectators take them to be false? If you say, yes, then how can the spectators know it to be an emotion of 'love'" (272)?[11]

In the same way, when an actor plays the role of "an angry character," the actor simply looks like an angry person and it is not the case that the actor imitates any actual mental state. It is a contradiction to say that the spectators do not have the knowledge of similarity and at the same time there is merely illusory perception of imitation.

Sankuka held that when the actor plays the role of Rama, the spectators do take him to be so as they watch. So why should the knowledge of Rama not be true? And if it is argued that since such knowledge is followed by contradicting knowledge such as "he is not Rama," then why should such knowledge not be treated as false? It is also not true that such knowledge of Rama occurs only when a particular actor plays the role of Rama, but whosoever performs the role of Rama skillfully, such knowledge keeps arising. Thus, one must conclude that what the spectators are watching is the universal in Rama (274).[12]

The critic does not agree with the other view of Sankuka, which says that the characters are obtained from the script of the play through imagination. If they are obtained from the text of the drama, why not the *sthayi-bhava* too? That will justify why spectators identify a particular enduring emotion or *rasa* of the play.

In this way, on various other grounds, the critic rejects Sankuka's theory that *rasa* is imitation of the *sthayi-bhava*. Instead, he suggests that "an actor, as a matter of fact, performs the role of a character selected by him or her to actualize through his or her craft of acting (*anubhava*-s). This becomes possible

because of actor's complete involvement of heart, due to the emergence of a universal state of mind, on account of the recollection of his or her own character. But in no way the actor is imitating the *sthayi-bhava*" (274–75).[13]

Bhatta Nayaka, however, does not agree with this and offers an altogether different theory of the epistemology of aesthetic joy. He says:

> "It is not the case that *rasa* is known through inference; it is also not produced; nor it is manifested."
>
> "Had it been experienced the spectators would have undergone experience of grief after watching a tragedy; but no one is seen suffering from grief after watching such a play. The actual Sita is not the *vibhava* (the actor who is playing the role of Sita), because the actor does not remember his wife after seeing Sita on the stage.
>
> "Moreover, it is also not possible to have universal feeling with regard to a supernatural character. It is also not true that actual Rama having supernormal qualities is remembered here, because remembrance has to be preceded by experience and no one has direct experience of Rama" [275].[14]

Then what is the epistemology of an aesthetic rapture (*rasa*)? Bhatta Nayaka replies:

If the experience of rasa is "unreal" and if there is no "universal" feeling attached to rasa as explained by Bhatta Nayaka, then what is the epistemology of an aesthetic rapture (rasa) and how do we understand it? Bhatta Nayaka provides an elaborate discussion on this topic while reassessing the nature of aesthetic experience of rasa. It is to be noted that the literary art consists in the absence of defects and infusion of excellences and figure of speech and the art of drama consists in the four forms of acting. The success of both the types of artists lies in making the metal states or emotions or sentiments a universally sharable common experience of one and all of men of taste. A drama presented in this from has the capacity to remove deep levels of massive individuality and ego and allow the inner self to shine. This becomes possible because there exits a universalizing function in drama called *bhavakatva* and the spectator is prepared to relish the art through another function called *bhoga,* consumption.

After the function, called *abhidha,* has performed its job of presenting the linguistic meaning of the text, the function called *bhavakatva* strips away all individualities which block a universal feeling and makes way for the pure self to shine where the process is taken over by the function of delectation or *bhoga.* Thus, rasa is a universalized emotion, which can be shared by any sensitive connoisseur. It is materialized through the process of a deep meditative involvement and the process terminates when the spectator discovers his or her own form, which is nothing but, joy. This joy is very similar to the joy of the Vedantic Brahman, Bhatta Nayaka thinks (276).[15]

Abhinavagupta, though he does not accept the view of Bhatta Nayaka that "*rasa* cannot be known," agrees fully with his theory of *sadharanikarana* (the process of universalization of emotions or mental states). Bhatta Nayaka was a critic of the dhvani-theory of Anandavardhana and that is why he could not agree with the idea that *rasa* can be suggested. Abhinavagupta, however, was a strong champion of the *dhvani*-theory and he, therefore, disagrees with Bhatta Nayaka on this issue. Abhinava is of the opinion that delectation (*bhoga*) is nothing but a feeling, which is nothing but knowledge or suggestion. He comments: "we do not understand what else can be 'delectation' (*bhoga*), if it is not an experience" (276).[16]

In this interpretation of the *rasa-sutra* by Abhinavagupta, there is space for enjoyment for all, i.e., the dramatist, the characters, the actors and the spectators, because the limited individual self is enlarged into its pristine infinity and object of aesthetic feeling, namely, the enduring emotion (*sthayi-bhava*) is elevated to one common enjoyable unity. This happens through the process of *sadharanikarana*.

One cannot resist remembering Mahimabhatta here. He too rejects the theory of *dhvani* and establishes his own theory of the epistemology of an aesthetic rapture. His analysis of art experience is also highly penetrating. He says there is absolute difference in the emotions (*bhava*-s) of the mundane world experience and those of the constructed art form. That is why, when one infers joy or pain in the mundane world, the inferer is not seen affected by those emotions, whereas when one infers these artistic emotions and if he happens to be a connoisseur, he actually experiences joy even when the connoisseur knows that the emotions created by the actors are not real ones. Therefore, one must accept that the emotions created by *vibhava*-s *anubhava*-s and *sancaribhava*-s (and not the actual emotions) of the mundane world are relishing. Hence "art" is more beautiful than the mundane world of our experience.

That is why *rasa* is to be accepted as *prateyamana*, i.e., *anumeya* and not *pratyaksa*, holds Mahimabhatta. Of course, the relishing of *rasa* (*rasasvada*) must be a fact that gives rise to aesthetic pleasure. There is always difference between the given and the created.

Another observation of Mahimabhatta is also worth noting here. He says that all the forty-nine moods or mental states or emotions are nothing more than *sancari*- or *vyabhicari-bhava*-s only, even though they are referred to by different names such as *sthayi-bhava, vyabhicari-bhava*-s and *sattvika-bhava*-s. It implies that even a *sthayi-bhava* is, in reality, a changing mental state only; the only difference is that only these eight states called *sthayi-bhava*-s are capable of continuing from the beginning up to the end of a drama and that is why they are called *sthayin* or durable. The *sattvika-bhava*-s or the eight mental states listed by Bharata in his *Bhavadhyaya* (chapter VII) are also changing mental states.

Conclusion

From all that we have discussed so far, the following picture emerges:
(i) We live with two worlds: the *given* and the *created*. The world of art is a constructed one out of the *given*.
(ii) The worldview of an artist shapes his world of art.
(iii) The artist (*kavi*) transforms the given world into the world of art. This happens due to the inborn and cultivated "creative genius" (*karayitré-pratibha*) of the artist. Like the artist, a connoisseur (*sahridaya*) (Jha 2003: 1–7) also is gifted with the "appreciative genius" (*bhavayitri* -genius). It is because of such elevation there occurs a successful aesthetic communication.
(iv) Creativity is nothing more than an aesthetic arrangement of the given.
(v) A picture of reality is more relishing than reality in the world of art (Dwivedi 1982: 75).[17]
(vi) Indirect presentation is more beautiful than direct presentation (75).[18]
(vii) Although the constructed world of art is unreal, the aesthetic experience thereof is real (76).[19]
(viii) The aim of an art form is to generate aesthetic joy.
(ix) A comprehensive theory of art must take into account both creation (*utpatti*) and appreciation (*jñapti*) of an art form.
(x) Imagination plays a vital role in creation and appreciation of art. A dramatist creates the text of drama through his imagination; the script is prepared out of imagination; the actors re-create the characters for acting through imagination; the spectators transform the characters, moods, emotions, etc., into a universal form through imagination and make them content of aesthetic joy (Krishnamoorthy 1979: 213–226 and 206–212).
(xi) The *rasa-sutra* of Bharata (NS 4: 32) is the earliest statement of a theory of epistemology of an aesthetic experience.
(xii) Bhatta Lollata, Sankuka and Bhatta Nayaka added depth to that theory by their comments. Thanks to the *Abhinavabharathi* of Abhinavagupta through whose commentary we came to know the views of these three philosophers of art:
(xiii) The postulation of three powers, namely, *abhidha, bhavakatva,* and *bhojakatva* that Bhatta Nayaka added comprehensiveness to Indian epistemology of artistic experience.
(xiv) The concept of universalization (*sadharanikarana*) as developed by Bhatta Nayaka and as philosophized by Abhinavagupta to analyze an aesthetic rapture is a distinct contribution of India philosophy of aesthetics (Krishnamoorthy 1979: 213–226).

(xv) Both Bhatta Nayaka and Abhinavagupta seem to be highly influenced by the India philosophy of Vedanta (Krishnamoorthy 1979: 206–212 and 251–262).

NOTES

1. *Nääyaçästra.*
2. *Nyäyasiddhäntamuktävalé(çabda-khaëòa)* with the commentary of Panchanan (Bhattacharya, p. 196).
3. *yad idam anupayukte çabdärtha-sambandhe artha-jïanaà na tan nämadheya-çabdena vyapadiçyate| gåhéte api ca çabdärtha-sambandhe asya arthasya ayaà çabdo nämadheyam iti yadä tu saù arthaù gåhyate tadä tat pürvasmäd artha-jïanäd na viçiïyate tadartha-vijïänaà tädåg eva bhavati| tasya tu artha-jïänasya anyaù samäkhyä-çabdo nästi iti yena pratéyamänaà vyavahäräya kalpeta| na ca apratéyamänena vyavahäraù| tasmät jïeyasya arthasya| saijïä-çabdena iti-karaëa-yuktena nirdiçyate—rüpam iti jïänam rasa iti jïänam iti| tad evam artha-jïäna-käle sa na samäkhyä-çabdo vyäpriyate vyavahära-käle tu vyäpriyate.*
4. *Kuto vä nütanaà vastu vayam utprekñituà kñamäù|*
 Vaco-vinyäsa-vaicitrya-mätram atra vicäryatäm
 (*Nyäyamaïjaré,* 1st Ahnika, introduction).
5. Indian analytic traditions have always discussed utpatti and *jïäpti* of an art form.
6. *Vibhävädibhiù samyogaù arthät sthäyinaù tato rasa-niñpattiù* (Abhi Bhä, p. 271).
7. *Tatra vibhävaù cittavritteh sthayyätmikäyäù utpattau käraëam* (Abhi Bhä, p. 271).
8. *Vibhävä hi kävya-balänusandheyaù| änubhäväù siksataù| yabhicariëaù kåtrima-nijänubhavärjana-balät|* (Abhi Bhä, p. 272).
9. *Tasmät hetubhiù vibhäväkhyaiù käryaiù ca anubhävätmabhiù sahacäri-rüpaiù ca vyabhicäribhiù prayatnärjitatayä kåtrimaiù api tathä anabhimanyamänaiù anukartâsthatvena liïga-balataù pratéyamänaù sthäyi-bhäväù mukhya-rämädigata-sthäyi-anukaraëa-rüpaä|* (Abhi Bhä, pp. 171–72).
10. *Sthäyé tu kävya-baläd api na anusandheyaù| öatiù çokaù ityädayo hi çabdäh ratyädikam abhidheyé-kurvanti abhidhänatvena na tu väcikäbhinaya-rüpatayä avagamayanti|* (Abhi Bhä, p. 172).
11. *Te hi vibhävädayaù atat-käraëa-atatkärya-atat-sahacära-rüpä api kävya-çikñädibalopakalpitä kåtrimä santaù kim kåtrimatvena samajikaiù grhyante na vä| adi grhyante tadä taiù katham rater avagatiù|* (Abhi Bhä, p. 273).
12. *Rämatvam sämänyarüpam äyatam* (Abhi Bhä, p. 274).
13. *Naöaù çikñävaçät sva-vibhäva-smaraëät cittavåtti-sädhäraëé-bhävena hådaya-saàvädät kevalam anubhävän pradarçayan kävyam upacita-käku-prabhäti-upaskäreëa päöhän cesöate ityetävanmätre asya pratétir na tu anukäram vedayate* (Abhi Bhä, pp. 274–75).
14. *Bhaööanäyakas tu raso na pratéyate| ëa utpadyate| ëa abhivyajyate| ñva-gatatvena hi pratétau karuëe duhkhitvam syät| ëa ca sä pratétir yuktä| sétader avibhävatvät sva-käntä-smäti-avedanät| òevatädau sädhäraëékaräëyogyatvät| ñamudra-laìghanäder asädhäraëyät| ëa ca tadvatoh rämasya smätiù| Anupalabdhatvät|* (Abhi Bhä, p. 275).
15. *Kävye doñabhäva-guëälaìkäramayatva-lakñaëena nääye caturvidha-abhinayarüpena nibiòanijamohasaikäöakäriëä vibhävädi-sädhäraëékaraëätmanä abhidhäto dvitéyena aàçena bhävakatva-vyäpäreëa bhävyamäno rasaù anubhava-smätyädi-vilakñaëena rajastamonuvedha-vaicitryabaläd drutivistäravikäçalakñaëena sattvodreka-prakäça-änandamaya-nijasaàvidviçräntilakñaëena parabrahmäsväda-savidhena bhogena bhujyate* (Abhi Bhä, p. 276).
16. *Pratétyädi vyatiriktas ca saàsäre kaù bhogaù iti na vidmaù* (Abhi Bhä, p. 276).
17. *Kavi-çaktyarpitä bhäväs tanmayébhäva-yuktitaù|*
 athä sphuranty amé kävyan na tathädhyakñataù kila ||
 (*Vyaktiviveka,* p. 75).
"The factors presented by direct perception are not that enjoyable as those presented by the creative imagination of an artist."
18. *Nänumito hetvädyaiù svadate anumitaù yathä vibhävädyaiù|*
 na ca sukhayati väcyorthaù pratéyamänaù sa eva yathä || (*Vyaktiviveka,* p. 75).
"Something inferred on the basis of some ground of the reality is not that palatable as that in-

ferred on the basis of *vibhāva* etc. Something expressed through primary relationship is not that enjoyable as something suggested."

19. Bhrantir api sambandhatah prama (*Vyaktiviveka*, p. 76).

"An illusion too becomes veridical if ultimately related to the fact."

BIBLIOGRAPHY

Abhyankar, K.V. and V.P. Limaye, eds. 1965. *Vakyapadiya of Bhartrhari*. Pune: University of Pune.

Bhattacharyya, Haridas, ed. 1993. *The Cultural Heritage of India, Vol. 3*. Calcutta: The Ramakrishna Mission Institute of Culture.

De, Sushil Kumar. 1976. *History of Sanskrit Poetics*. Calcutta: Firma KLM Private.

Dwivedi, Rewaprasad. 1982. *Vyaktiviveka of Rajanaka Mahimabhatta with Hindi Translation*, 3d ed. Varanasi: Chaukhamba Sanskrit Samisthan.

Jha, V.N. 1998. "The Philosophy and Creation and Appreciation of a Literary Art-Form" (P.V. Kane Memorial Lecture). *Journal of the Asiatic Society* 73: 49–60.

_____. 2003. "Ujjwala, Concept of *sa-hādaya* in Indian Poetics." In *Indian Aesthetics and Poetics*, V.N. Jha, ed. New Delhi: Sri Sadguru Publications. 1–7.

_____. 2004. "Indian Theory of Aesthetic Communication." *Journal of Indian Intellectual Traditions* I.1–2: 18–26.

_____. 2005. *AlamBrahma*. Varanasi: Kalidasa Samsthana.

_____. 2010. "Language, Grammar and Linguistics in Indian Tradition," in *History of Science, Philosophy and Culture in Indian Civilization*, Vol. 4, V. N. Jha, ed. New Delhi: Centre for Studies in Civilizations. 358–361.

_____. 2011. *Tarkasaigraha of Annambhaööa: English Translation with Notes*. Veliyanad: Chinmaya International Foundation.

_____, ed. 2003. *Indian Aesthetics and Poetics*. New Delhi: Indian Books Centre.

_____, ed. 2006. *Journal of India Intellectual Tradition*, Vol. 1. Pune: Centre of Advanced Study in Sanskrit, University of Pune.

Kane, P.V. 1971. *History of Sanskrit Poetics*, 4th ed. Delhi: Motilal Banarsidass.

Kaundinnyayana. 1980. *Sivaraja, Kāvya Prakāça of Mammaöa with Vivåti called Hemavati*. New Delhi: Motilal Banarsidass.

Ketkar, Godavari Vasudeva, and Jashavanthi Dave. 1998. *Bharatmunikrta Natyashastram in Hindi*. New Delhi: Parimal Publications.

Krishnamoorthy, K. 1974. *Dhvanyāloka of Ānandavardhana with English Translation*. Dharwad: Karnataka University.

_____. 1979. *Studies in Indian Aesthetics and Criticism*. Mysore: D V K Murthy.

Nagar, R.S., ed. 2003. *Nātyaçāstra of Bharatamuni with the Commentary Abhinavabharati by Abhinavaguptacarya*. New Delhi: Parimal Publications.

Panduranga, P.K. 1983. *Dhvanyaloka of Anandavardhana with Locana of Abhinavagupta*. New Delhi: Munshiram Manoharlal.

Abhinaya Redefined

M. Krzysztof Byrski

It might be somewhat expected that we have to look for the proper definition of theatre (*natya*) in the last lesson of the Natyasastra which holds that this art is nothing more and nothing less than the nature of human world (*svabhavo lokasya*) with its happiness and despair, endowed with the [four] "leads" beginning with "body-lead" (*angadyabhinoyopetaḥ*) (NS 1: 119).[1] The other three leads are "speech-lead," "power of expression-lead" and "external apparel-lead." But where does the leader (*nayaka*) of each and every play lead a spectator to with the help of these four "leads?" What is the particular role of the fourfold "lead," which he employs to achieve his art's end? And what precisely is this end?

Yet before we try to answer these questions, it is necessary to explain the reason for translating the term *abhinaya* into English as "a lead." This Sanskrit term is a derivative of the verb √*nī* prefixed with *abhi*. It means "to bring near," "conduct or *lead towards*." Only subsequently it means "to act," "represent or exhibit dramatically" (Apte 1959: 501). The predilection of traditional Sanskrit scholars for etymology is well known. So it would not be uncalled for to ask why this particular verb was found suitable to denote acting on the stage of theatre. There can be no doubt whatsoever that this choice of term is carefully premeditated. The particular character of theatrical action must have been analyzed and taken into consideration while coining this term.

Now, the definition of the art of theatre quoted above gives to the nature of human world (*svabhavo lokasya*) a very prominent position. Since it appears to be a pivotal concept so far as theatre goes we shall make it our point of departure for the simple reason that theatre would be meaningless without the precincts of the nature of human world. Yet we shall also make it our final destination since the experience of the art of theatre as conceived by ancient

Indian thinkers makes the nature of human world meaningful for us—humans. According to Bharatamuni the theatrical experience is supposed to generate "beneficent instruction" (*hitopadesajanana*) (NS 1: 113) for all participants (*sarvopadesajanana*) (NS 1: 113) and for the world (NS 1: 115) (*lokopadesajanana*). Is it mere lip service or does it have a solid, logical substance not only within the discourse of the *Natyasastra* but also universally? Lesson I of the Natyasastra couched in mythological idiom is, in reality, a sort of theoretical inquiry in the nature of the art of theatre. It has to be remembered that scientific discourse was conceived as if in the womb of mythology not only in India but also in Greece. Mythology was the very first attempt to describe the reality that surrounded man. Thus mythology originally provided both imagery and language with which man tried to express his understanding of the world. The following verse of the *Natyasastra* illustrates well the passage from the mythological idiom of the discourse of god Brahma with Indra to the precise language of scientific inquiry. It bears quotation at this moment:

> *Nānābhāvopasampannam nānāvasthāntarātmakam /*
> *Lokavṛttānukaraṇam nāṭyam etan mayā kṛtam //* [NS 1: 112].

It says that "theatre has been created by god Brahma as an icon, i.e., imitation or representation (*anukarana*), of the conduct (*vrtta*) of human world endowed with various emotions and various phases and layers of actions that are built into it." Consequently the nature of human world and its conduct as interpreted in terms of classical Indian tradition, which figure so prominently in the two verses quoted above, have to be properly understood before we try to grasp precisely the logic of their presence in these definitions of theatre.

Certainly unquestioned authority of the *Bhagavadgita* permits us to refer to this text in search of a reliable opinion regarding the desirable character of the conduct of the human world referred to by Bharatamuni in the verses quoted above. We feel deeply justified while resorting to this most authoritative text, since the theoretical thinking about theatre was very deeply entrenched in the basic notions of ancient Indian thought that flourished during the Vedic period and of which the *Bhagavadgita* is an epitome.

Natyasastra and *Bhagavadgita*

Very interesting in this context is the opinion that man controls his actions but not their results (fruits), so he should not be prompted while acting by the fruit of action but neither should he cling to inactivity. We may add that the postulate of not clinging to inactivity is also valid for activity. It follows from the same verse when it says that one should not be prompted in his

actions by their fruit—and we may add—being *nistraiguṇya* and *nirdvandva* (2: 45), i.e., transcending the exigencies of time and space. The relevant key terms here are *asaṅga*, which means "free from ties," "independent" and *asakta* meaning "detached from worldly feeling or passions," "unattached," "indifferent" (Monier-Willims 1899: 118). The *Bhagavadgita* speaks of a self-possessed man who treats happiness and despair equally and who therefore is fit for immortality (*BhG* 2: 15).[2] We insist that this formula describes adequately the ideal attitude that each human being should strive to acquire for himself and above all should make it his own personal experience. It is very important to realize that it is not an emotional abnegation but it implies a special type of "satisfaction" (*ananda*) of pleasure and pain, happiness and despair, etc. The very substance of ancient Indian intellectual inquiry beginning with the *upanisads* down to the *smṛtis, puranas and itihasas* (the *Bhagavadgita* included) boils down to a question: How should conscious man treat the surrounding reality to secure for himself liberation (*moksa*)? The most rudimental answer to this query is provided by the quoted passage from the *Bhagavadgita,* which equates the state of perfect liberation with immortality.

Yet, everybody knows how difficult it is to be detached and to treat with the same gusto pleasure and pain. The tortuous path of Yoga is a challenge that very few can meet and the Natyasastra is well aware of this scenario. In this text we again find a statement which bears quotation here:

Na Vedavyavahāro'yam samśravyaḥ śudrajātiṣu /
Tasmātsṛjapram Vedam pañcamam sarvavārṇikam // [NS 1: 12].

In light of this request of Indra addressed to Brahma, "that since the members of shudra castes cannot listen to the recitation of the Vedas, he may create the fifth Veda, which will be accessible to all *varnas*, [i.e., to all humanity],"[3] I trust we are entitled to interpret the term *sudrajatayaḥ* as applying to all humanity including those Brahmins, who have no access to the Vedas.

For in this context we have to remember that the particular social system of Hindu India, commonly known as caste system, practically precluded the lowest of the four strata of society (i.e., Brahmins-intellectuals, kshatriyas-knights, vaishyas-merchants and shudras-menials) from any form of participation in religious rituals of three higher varnas. Indra apparently—very much in quite modern democratic vein—anticipates a possibility of getting by all, if not knowledge of how to attain such mental equilibrium, at least a very tangible experience of it. The god Brahma obliges and—lo and behold—creates theatre! As it has been already mentioned he fashions it into a faithful replica (*anukarana*) of the world's nature (*svabhavo lokasya*) with its pain and pleasure. At this very turn we have to understand properly the character of this truly democratic invention, which allows all and sundry to experience something

that supposedly was a privilege of those few for whom the Vedas provided guidance. The Natyasastra then hurries to assure that theatre art will become among others *dharma* (virtue) for those engaged in it, *kama* (love) for those serving its ends and *artha* (wealth) for those who survive thanks to it (NS 1: 109 & 111). Thus the three *purusarthas* (spheres of human existence) listed here mean that theatre embraces entire human existence. Those three spheres of human existence find their reflection in theatre, which therefore becomes the generator of beneficent instruction. Finally, in its last chapter this treatise says that the same fruit will accrue to him who is going to put in practice theatre, being an actor or spectator, as to the experts in the Veda, to the performers of sacrifice and to those who are generous (NS 36: 27–8).[4]

Now, all this said, there lingers a gnawing suspicion that these are all pure declaratory statements without tangible support of arguments standing the test of logic.

Abhinavagupta, Reality and Experience

In this predicament Abhinavagupta comes to our aid. This famous scholar-philosopher lived at the turn of X and XI century in Kashmir. He represented the famous Shaiva school of thought. We believe that the very positive attitude to mundane existence of this school, which holds that ultimate bliss can be attained not only through renunciation but also through joyful enjoyment of life with its happiness and despair, made him take interest in the art of theatre. In his priceless commentary on the Natyasastra he tries to grapple among others with the problem of nature of theatrical reality. As we understand his argument, he tries to answer the question: Whose reality is the one with which we deal on the stage of theatre? Is it the reality of the hero of a particular play or is it the reality of an actor who acts as a hero? Or else is it the reality of a spectator? Certainly it's none of the three and yet it is very tangible reality taking place before our eyes! Thus, following his predecessors, he says that in theatre we deal with a sort of the fourth type of reality—the "departicularized" one, which is the sole preserve of none of the individuals in some way or other participating in the event. To put it succinctly it is universalized (*sadharana*) reality, i.e., reality with which anyone can identify him or herself when confronted with it (Gnolli 1956: *passim*). The relevant term is identification, i.e., *tanmayibhava* (Byrski 1974: 153, NS [GOS] vol. I: 36, the tenth line from the top) or *tadatmya* (Pandey 1959: 170). But all the time we have to remember the fact that stage reality is created through non-particular means: the character, for instance, is non-particular for both the actor who plays and the audience who watch the performance. The stage reality, there-

fore, is non-particular and universal. Thus the spectator is made to experience emotions that are real, but since they are generated by departicularized (*sadharana*) stage reality that belongs to none of those creating it (actors) or participating in it as spectators, these emotions are similarly shorn of definite personal character and are experienced in a non-particular manner very much akin to a non-clinging way advocated by the *Bhagavadgita*. This is why fear, disgust, anger and pity are enjoyed as *bhayanaka, bibhatsa, raudra* and *karuṇa* rasas in the same way as love, mirth, heroism and wonder are enjoyed as *sringara, hasya, veera* and *adbuta* rasas.

It is time now to recollect the words of Bharatamuni already quoted at the beginning of our argument, which run as follows: *nanavasthantaratmakam*, i.e., internally built of various phases of action. Here the basic structure of drama is referred to. As we know the stage event (*itivrtta*), which is termed the body of theatre (*sarira*), is built of five phases of action, which constitute the backbone of the span-structure (*sandhi*). Elsewhere we have analyzed this concept in detail (Byrski 1974: ss. XVI 207; Byrski 1997: ss. I-XIII 1–106). Here it suffices to say that *avastha-sandhi* structure results from the in-depth analysis of human action. Each and every human action that springs from desire and aims at its fulfillment has to unfold in the rhythm of these five emotionally tinged phases: beginning (*arambha*), effort (*yatna*), achievement of hope (*praptyasa*), suppressed achievement (*niyatapti*) and arrival of fruit (*phalagama*). We also tried to prove that the archetype of such human action is the Vedic concept of sacrifice (*yajna*) both in its essence as well as in its visible form of a liturgical act. Vedic sacrifice is conceived as the first act of creation in which Man—Lord of Creatures (*Puruṣa-Prajapati*) offers himself in order that time and space may emerge and thus the paradigm of all that happens within time and space is established (Byrski 1974: 41). If we remember the Vedic exegesis formula that all that is the sacrifice (*sarvam etad yajnah*), the consequences for our argumentation will be most essential. For it means that a theatrical performance is also sacrifice and termed as such by Bharatamuni (NS 5: 108) and Kalidasa in *Malavikagnimitram* (1: 4). Thus spectators, while emotionally identifying themselves with the events on the stage, in the last span (*nirvahana sandhi*) of these events experience the very essence of existence—reintegration of desiring with desired resulting in the wonderful awareness of plenitude (*adbhuta rasa*), of the pre-creative desirelessness that characterizes "One without the second" (*ekam eva advitiyam*) and such awareness is achieved not through renunciation (*nivrtti laksana dharma*) but through fulfillment of rightful desire[5] in the spirit of active involvement in the existential process (*pravrtti laksana dharma*). General opinion is that the bliss of the ultimate reality may be attained exclusively by treading the tortuous and difficult path of renunciation. Yet, this is only one side of the coin. The

other bespeaks of possibility to obtain the same effect by engaging actively in mundane existence but in the spirit of sacrifice, i.e., without clinging to the fruits of our doings. Now, this precisely happens within the virtual space of theatre, which guarantees that we remain detached though involved. This virtual character of the theatre-space is metaphorically indicated by the fact that when the members of the audience enter the theatre-hall they have to cross over the threshold made of the rod of god Yama, the master of netherworld, and pass between Nirrti, the goddess of Death, and Kālu, the god of Time (Byrski 1974: 160). Thus they symbolically abandon their mundane existence in order to experience the same emotions but shorn of worldly material and personal character. It is precisely such experience that is called the essence or the taste (*rasa*). *Rasa* in turn is identified in the Taittiriya Upanishad with Him—the Absolute (*raso vai sah*). It is exactly the generalized (*sadharana*) form of theatrical reality that guarantees such experience comparable to that of the mystics. There is only one requirement on the part of spectators—they have "to be with heart" (*sahridaya*), i.e., they should be sensitive to emotions. Fortunately most of people meet this requirement and this is why *natya* can be termed *sarvarnika,* i.e., accessible to all strata of society.

Rasa

Before we conclude it may be proper to add few more remarks regarding the pivotal concept of ancient Indian aesthetics, which has been already mentioned but which deserves more attention. There is yet one more notion to be found in the *Bhagavadgita,* apparently totally unrelated to aesthetics, which nevertheless sheds fascinating light upon the concept of *rasa* as an aesthetic experience. It is no secret to any student of Sanskrit literature that the culinary art provided this idea and this term. The famous formula of Bharatamuni speaks of generating aesthetic taste in a similar way to a cook generating taste of food by skillfully mixing different ingredients (NS (GOS), vol. I: 287). It is therefore justified to refer to a text, which seemingly deals with fasting rather than with art perception. The *Bhagavadgita* II.59 says: "The sense objects abandon the embodied one who does not eat, with notable exception of taste (rasa). But even taste abandons that one who perceives the ultimate."[6]

Now, if we would ask the ancient Indian thinker what precisely is existence, he would most probably respond that it is the possibility to perceive, which is possible within the precincts of time and space only, i.e., in traditional Indian terminology, in the context of the three basic aspects of reality (*gunas*): luminescent being (*sattva*), space (*rajas*) and darkness (*tamas*). This most obviously applies to the art perception as well. The *Bhagavadgita* most pointedly

defines the particular place within human experience in which these sensations have to be located. We may not actually indulge in the physical act of eating and yet have the sensation of taste. This precisely is the sensation characteristic of art-perception. Although the activity of our bodies is reduced only to passive perception of images and sounds, we can enjoy the taste of activities on the stage that we are witnesses to thanks to the art of actors. Now, since according to the unfolding of dramatic plot (*itivrtta*) in five phases of action (*avastha*) that constitute the spinal column of five spans (*sandhi*) of the plot, the emotional reaction of a spectator is supposed to have a climactic character. In the last span of denouement (*nirvahana*) he is supposed to experience the taste of wonder (*adbhuta rasa*), presided over by god Brahma and constituting the apex of aesthetic rupture, in my view corresponding with the *param drstva* (having seen the ultimate) of the *Bhagavadgita*. For at this stage even the universalized object of perception recedes into subconscious state. This is why Visvanatha, the author of the *Sahityadarpana* (III. 2), can say that *rasa* is "the twin brother of tasting brahman, devoid of the touch of any other knowledge."[7]

Conclusion

It is now time to draw our final conclusion. We all know the famous upanishadic call: *tamaso ma jyotir gamaya*—"lead me from darkness to light." The expectations of ancient Indian theatrical audiences could be expressed in a similar formula addressed to an actor: *bho, bho, nayake, laukikanubhavat rasanubhavam no'bhinaya!*—"Oh, leader, lead us from the worldly experience to the experience of *rasa*"—experience of the "Taste," which will bring us to the very edge of discursive reality, where our emotions do not need any more to be fed by sensual perception of hard material world—the state that the *Bhagavadgita* pointedly formulates insisting that there is a stage of awareness when we can experience taste without actually eating food. Beyond that stage even the experience of taste ceases (2: 59).[8] But that is not any more the concern of Bharatamuni and his Natyasastra.

Instead he pays a lot of attention to the means that are left at the disposal of an *abhinetr* who assumes the role of a *nayaka*—a leader who leads a spectator towards the fulfillment of rasa experience (*rasanubhava*). These means precisely have the form of the four categories of acting (*abhinaya*) enumerated in the Natyasastra.

It will not be untoward to ask at this point out of what sort of "material" an actor fashions his work of art. A sculptor has at his disposal timber, stone or bronze, a painter canvas and colors, a musician tones and a poet words. An actor, as the etymology of this English word indicates, has at his disposal action

(*karya*). Action is precisely the "material" out of which the work of theatrical art is built. This is why what an actor does on the stage is called "acting." But in contradistinction to other artists, instead of timber or stone an actor has his body (*anga*) and colorful attire and other props that have to be taken (*aharya*) and employed on the stage. Thus he appropriates a painter's colors in order to do his makeup and to put on a colorful costume. Yet mere bodily presence on the stage is not sufficient. Besides gesture an actor communicates his action with the help of speech and thus he appropriates a poet's words (*vak*). Since his action is accompanied by music therefore he appropriates a musician's tones as well. This is why Bharatamuni says that there is no art that cannot be found in theatre (NS 1: 116). All this would not be sufficient if an actor would be deprived of power of expression stemming from his mind and spirit (*sattva*). This is precisely the decisive element of the nature of human world (*lokasvabhava*) without which any communication would be impossible including also this particular type of communication that takes place in theatre.

Now, our case is complete. A man enters the stage still keeping his measuring string (*sutradhara*) with the help of which he constructed the temple of theatre (*natyamandapa*). During the preliminaries (*prastavana*) he changes his role and assumes that of a leader (*nayaka*) who with the help of four "leads" (*angadyabhinayopeto*) leads spectators from mundane emotional entanglement into the virtual sphere (*sadharana*) of tasting pure emotions untainted by everyday mundane concerns.

NOTES

1. *Yo'yam svabhāvo lokasya sukhaduḥkhasamanvitaḥ / so'ṅgādyabhinayopeto nāṭyam ityabhidhīyate //*. In all the footnotes below, if not indicated otherwise, we refer to Bharatamuni, 1943. By the way, the reader may kindly note that I depart here from the standard mode of interpretation and do not call these as the four types of acting that are physical, verbal, scenographic and emotional.

2. *samaduḥkhsukham dhiram so'mrtatvaya kalpate.*

3. The *varṇa-jāti* social system, when it was conceived (*Puruṣasukta* RV. X. 90), meant the creation of humanity as a whole.

4. *ya idam śṛṇuyān nityam proktam cedam svaymbhuvā / kuryāt prayogam yaś caivam athavādhītavān naraḥ // yā gatir vedaviduṣām yā gatir yajñakāriṇām / yā gatir dānaśīlānām tām gatim prāpnuyad hi saḥ //*

5. *balam balavatām cāham kāmarāgavivarjitam / dharmāviruddho bhūteṣu kāmo'smi Bharatarsabha//* (Bhāgavadgīta. VII. 11).

6. *viṣaya vinivartante nirāhārasyadehinaḥ / rasovarjam raso'pyasya param dṛṣṭvā nivartate//*

7. *vedyāntarasparśaśūnyo brahmāsvādashodara.* See also Gnolli 1956, p. XXIII.

8. *Viṣayā vinivartante nirāhārasya dehinaḥ / rasavarjam raso'pyasya param dṛṣṭvā nivartate /.*

BIBLIOGRAPHY

Apte, V.S. 1959. *The Student's Sanskrit-English Dictionary*. Delhi: Motilal Banarsidass.
Bharatamuni. 1943. *The Nāṭyśāstra*. Pandit Kedarnath, ed. Kavyamala No. 42. Bombay: Nirnaya-Sagar Press.

_____.1956. *The Nāṭyśāstra*. Ramakrishna Kavi, ed. Baroda: Gaekwad's Oriental Series.
Byrski, M.C. 1974. *Concept of Ancient Indian Theatre*. Delhi: Munshiram Manoharlal.
_____. 1997. *Methodology of the Analysis of Sanskrit Drama*. Delhi: Bharatiya Vidya Prakashan.
Byrski, M.K. 2006. "A Tribute to the Text and Context of the Nāṭyaśāstra." *Tattvabodha* I, 109–123. Sudha Gopalakrishnan, ed. New Delhi: Munshiram Manoharalal.
Gnolli, R. 1956. *The Aesthetic Experience According to Abhinavagupta*. Rome: ISMEO.
Kalidasa. 1986. *Granthāvalī*. Reva Prasad Dvivedi, ed. Varanasi: Kashi Hindu Vishvavidyalaya.
Kaviraja, V. 1976. *Sahitya Darpana*. Satya Vrata Singh, ed. Varanasi: Chowkhamba.
Monier-Willims, M. 1899. *A Sanskrit-English Dictionary*. Oxford: Clarendon Press.
Pandey, K.C. 1959. *Indian Aesthetics*. Varanasi: Chokhamba Sanskrit Series.
Vishvanatha. 1956. *The Mirror of Composition*. Banaras: Reprinted from Bibliotheca Indica.

Rasa: Abhinavagupta on the Purpose(s) of Art

Daniele Cuneo

"Aut prodesse volunt aut delectare poetae."
Horace, *De arte poetica* 333

"Plaisir et instruction—saveur et savoir—sont en
effet la double fin assignée à ce théâtre."
Lyne Bansat-Boudon,
Pourquoi le théâtre? La réponse indienne

"You gave me these emotions.
You did not tell me how to use them."
The "monster" in *Frankenstein* (1994), directed by Kenneth Branagh

This essay tries to formulate an (over-) interpretation of the concept of *rasa,* as it is understood by Abhinavagupta especially, insofar as the purpose of art is concerned. In contrast with the well known binomial opposition as to the aim of art deemed as a source of knowledge and pleasure, being one of the horns of the issue primary and the other secondary and accessorial, this essay understands the *rasa* experience as a transformative practice involving both a beatific pleasure (*priti,* or better *ananda*) and an ethical *Bildung* (*vyut-patti*), which ultimately represent nothing but two aspects of the same senti-mental education or educative emotional arousal. Art brings forth a pleasurable experience that *is* an education to the right choice to be made, among a range of emotive possibilities, in front of any situational context to be coped with. In such an understanding of the concept of *rasa* as a cognitive, emotional as well as moral experience, a specific interpretation of the ethical field is implicit, i.e., any morally meaningful choice coincides with the emotional response to

any given situation. Consequently, emotions are moral acts, liable to moral judgements and evaluations.

The Dilemma

Pleasure and instruction are the dual purpose of art.[1] Such a statement is, in a way, a *topos* along the whole diachronic and diatopic network of reflections and speculations on "aesthetics," even before such a term—aesthetics— was first used in its modern and contemporary sense and even in places such a term has reached only in very recent times. However, on the different ratio and proportion of these two artistic aims, the thinkers of every latitude and time have forcefully disagreed one another, especially insofar as their respective ideas on the definitions of art and non-art diverged and also, at least by implication, insofar as their general philosophical theories diverged.

The two standard extreme opinions are obviously the two poles of the possible spectrum: the purpose of art is instruction, pleasure being at its best only a useful instrument for its achievement (cf. the *utile dulci miscere* of Horatian memory); the purpose of art is pleasure, instruction being at its best a secondary offshoot. Both appear in these extreme formulations one-sidedly unfair and partial, but even in their milder formulations they entail the germs of incongruence and unreasonableness. The purpose of the present essay is to suggest a tentatively coherent merging of the two extremes, apparently contrasting views by means of an interpretive analysis of Abhinavagupta's aesthetics.[2]

Sketching the Western Debate

Before approaching the current issue in the Classical Sanskritic cultural milieu and specifically in Abhinavagupta's aesthetic theory, it may be useful to just delineate the origin of the Western debate on the topic and a couple of contemporary, still divergent opinions.

As to the allegedly first work of the Western legacy concerned only with art, i.e., the *Poetics* of Aristotle, the problem of the effect of art—specifically of poetry and theatre—is of fundamental importance. As it is well known, Aristotle's implicit polemical response to Plato's famous devaluation of art as "copy of a copy" consists precisely in an account of the essence of art as the capacity proper to a human production to arouse pleasure along with, and in a way precisely by means of, transformative knowledge. Such edifying faculty of art depends on its imitative essence as well as on its peculiarly philosophical

nature. The ancient and traditional concept of *mimesis* is reinterpreted by Aristotle in its realistic understanding of art. Art produces knowledge since art is imitation and imitation is one of the commonest sources of knowledge. Instruction derives hence from the verisimilitude of the artistically represented events. Moreover, art, and specifically poetry, is deemed as more philosophical than history, since it deals with the universal, while history deals with the particular (*Poetics* 1451, 1b, 1–15). Thus, imitating should mean something like seizing the most essential features of any given thing. In this way, experiencing an imitated entity coincides with experiencing the given thing in its most characteristic and peculiar features. The aforementioned judgement of Plato is, on the other hand, probably also the expression of a professional rivalry, since the implication of the non-instructive nature of art is the social devaluation of artists, of poets in the specific case, which paves the way for the theoretical proposal of Plato, i.e., the philosophers as the unique moral and political leaders as well as inspirers of society. Plato's negative judgement, however, acknowledges the power of art: the capacity of art to mold mind, character and behavior. It is just a matter of choosing which kind of art will lead to which kind of epistemic import and moral transformation.

After this extremely sketchy treatment of the two seminal authors of Western Philosophy, with a leap forward in time, up to the contemporary debate on the relations among art, knowledge and morality, we can still find a battlefield of arguments wielded by powerful conflicting warriors. For instance, we have, on the one hand, the thesis as to the relation of knowledge and art to be found in a recent book by an Italian philosopher, Maurizio Ferraris (2007). Knowledge does not represent the fundamental purport of the artwork, but every artwork accidentally conveys some knowledge. The relatively straightforward path of the reasoning can be cautiously summarised here. Art is nothing but a thing that pretends to be a person, a thing that pretends to have emotions. This pretence elicits an emotional response in humans, as we are hard-wired for responding to emotions with emotions. Any involvement determined by the artworks—including first of all the hedonic component that is the most common response—is a consequence of their capacity to elicit emotions as if they were real persons. The knowledge that they may impart is just an unessential by-product, especially insofar as the source of knowledge *par excellence* is considered to be the scientific discourse and the kind of knowledge the author has in mind is the one about facts and general rules that science is aptly made to produce.[3] On the other hand, Martha Nussbaum, for instance, is a staunch upholder of the epistemic value of art, especially in her recent *Upheavals of Thought: The Intelligence of Emotions* (2001). Furthermore, her conception of the kind of knowledge that aesthetic experiences can impart and her conception of the role emotions play in human life

are extremely relevant for the interpretation I will propose of Abhinavagupta's stance on the matter. Therefore, it is better not to anticipate her main theses and close this preliminary section, whose only purpose is to sketch the complexity of the subject matter and to emphasize the open-ended nature of the problem at stake.

Bharata's Straight-forwardness

In the Classical Sanskrit cultural milieu, the issue of "the purpose of art"[4] in its dual being, hedonic and epistemic, is addressed almost at the very outset of the first extant treatise on art, the Natyasastra [NS][5] by Bharata. In the first chapter, dedicated to the creation of Theatre, Bharata, the great master of theatre, prompted by the questions of other sages, narrates how in the period of chaos and immorality determined by the transition from the Golden Age to the Silver Age, i.e., from the Kṛtayuga to the Tretayuga, the gods approached Brahmā for help. Indra, the Lord of the Gods, told him that they desired an object of diversion,[6] so to say, a pleasure-giving object and, hence, asked him to generate a fifth Veda,[7] Theatre. This two-sided request discloses the intrinsic correlation between the hedonic function of art (an object of diversion) and its epistemic/moral function (the fifth *veda,* that is, "knowledge," sought after in order to re-establish morality as well as knowledge itself). Then, this dual nature of Theatre, hedonic as well as epistemic—and, in particular, morally epistemic—becomes even clearer in Brahma's own words as soon as he accepts to create such an extraordinary entity:

> I will create this fifth Veda, called Theatre, connected with Traditional History (*itihasa*), conducive to *dharma* ("morality"), wealth (*artha*) and fame, instructive and comprehensible, a guide in all the actions of the people of the future, endowed with the significance of all the *sastra*s ("scholarly treatises") and displaying all the arts.[8]

Another crucial passage as to the hedonic as well as morally epistemic function of Theatre is NS 1.108–115 of which it is worth quoting here 1.113b: "It [Theatre] imparts instruction to reach the good and produces contentment, amusement, pleasure, etc."[9]

Therefore, from the dialogue in the first chapter and from the other quote—as well as from other related passages of the Natyasastra—it is clear that the two purposes of art, delight and instruction (called *priti* and *vyutpatti*[10] in the later terminology of Abhinavagupta) are both considered fundamental, although instruction is in a way the purpose of the purpose, the *prayojanaprayojana*. After all, according to Bharata's narration, it is for the sake of the re-establishment of *dharma* through instruction that Theatre was to be created.

The Natyasastra is therefore clear in supporting the view that knowledge—moral knowledge—is the main purpose of art.

Conversely, if one analyses the various passages on the issue in Abhinavagupta's works on art, that is, the *Locana* on Anandavardhana's *Dhvanyaloka* [DhvĀ] and the *Abhinavabharati* [ABh] on Bharata's Natyasastra itself,[11] there seem to be some apparent contradictions. As it has already been hinted at, the purpose of this essay is trying to conciliate these alleged contradictions and proposing a tentative, viable solution to the general aesthetic problem regarding the purpose of art.

Abhinavagupta's Haziness

Before focusing on Abhinavagupta's interpretation of the issue, it might be useful to quote at least some of the relevant passages from the authors who thrived between the composition of the Natyasastra and Abhinavagupta's great synthesis and systematization of the aesthetic thought of classical India. The first author to be considered is Bhamaha (7th c. CE) whose very clear statement on the matter (later taken up again by Abhinava himself, see below) reads: "The composition (or the study [according to a reading found in Abhinava's *Locana*]) of good poetry imparts skill in *dharma* ('morality'), *artha* ('power'), *kama* ('pleasure'), *moksa* ('liberation'), and the arts; it gives both fame and joy."[12] Unfortunately, Daṇḍin (7–8th c. CE) has no clear-cut statement on the subject in his *Kavyadarsa*.[13] Vamana (8–9th c. CE) is quite clear, insofar as he seems—differently to what Bhamaha maintains—to prefer delight over instruction, as it can be gleaned from *Kavyalamkarasutra* 1.1.5: "Good poetry has as aim the visible and the invisible, as it is the cause of [the visible] delight [for its appreciator] and of the [invisible] fame [for its composer]."[14] In his *Kavyalamkara*,[15] Rudraṭa (9th c. CE) clearly regards instruction in the fourfold aims of mankind as the aim of poetry, although *rasa* and its hedonic component do play the fundamental role of being the honey that allows the enjoyer of art to easily swallow the bitter medicine that is moral knowledge—to use a slightly hackneyed metaphor. Conversely, the *Agnipuraṇa,* a text whose date is very uncertain (possibly 9th–10th c. CE), has a very telling statement in the direction of the epistemic and moral significance of theatre: "Theatre is a means to attain the threefold aim of mankind [i.e., *kama, artha* and *dharma*]."[16] As far as Dhanaṃjaya (10th c. CE) is concerned, one might quote the following verse in the classical translation by Haas (1912, 3): "As for any simple man of little intelligence who says that from dramas, which distil joy, the gain is knowledge only, as in the case of history (*itihasa*) and the like—homage to him, for he has averted from what is delightful!"[17] His stance as to

the relative supremacy of pleasure over instruction is quite clear, and also confirmed by the words of his commentator Dhanika.[18] To sum up this admittedly cursory survey, the variety of opinions among the authors between Bharata and Abhinavagupta swings from one opposite of the spectrum, i.e., the prevalent purport of delight, to the other, i.e., the prevalent purport of instruction, without excluding some intermediate positions.

Let's go back to the haziness of Abhinavagupta that the title of this section promised. Since, amongst the two works treated here, the *Locana* has been composed before the *Abhinavabharati,* the first relevant statement we encounter in Abhinavagupta's works is the following:

> For the auditors it is true that both instruction [*vyutpatti*] and delight [*priti*] are goals, for it has been said, "The study of good poetry imparts skill in *dharma, artha, kama, moksa,* and the arts; it gives both fame and joy" [Bhamaha 1.2].[19] Nevertheless, of instruction and joy, joy is the chief goal. Otherwise, what basic difference would there be between one means of instruction, viz., poetry, which instructs after the fashion of a wife, and other means of instruction, such as the Vedas which instruct after the fashion of a master, or history which instructs after the fashion of a friend? That is why bliss [*ananda*][20] is said to be the chief goal. In comparison with [poetry's] instruction even in all four aims of human life, the bliss which it renders is a far more important goal.[21]

However, later in the same text, Abhinavagupta objects to Bhatta Nayaka's view that "any instruction that poetry may furnish is incidental" (Ingalls 1990: 222)[22]:

> [We further admit that] the educative effect (*vyutpadana*) [of poetry] is different from that which comes from scripture through its mandates and from history through its narrations. For in addition to the analogy it furnishes that we should behave like Rama [and not like Ravana], it produces in the final result an expansion of one's imagination which serves as the means of tasting the *rasas.*[23]

Furthermore, I argue that a more literal and slightly different translation of the second sentence will give a better idea of the "moral" enhancement—if you allow me to anticipate my conclusion—that poetry brings about: "In the end, it determines an instruction that consists in the expansion of one's imaginative power by means of the savouring of *rasa* and that is different from the analogical knowledge that I should be like Rama." In more modern terms, one might say that the *rasas,* i.e., the aesthetic emotions one experiences in appreciating art, effect cognitively valuable changes in the emotional and perceptual dispositions of the enjoyer of art. In other words, our insight into life is made keener by the very enjoyment of art.[24] But there is no need to further anticipate the conclusion of the present enterprise.

Furthermore, in a later passage, Abhinavagupta enlarges the discussion on the various sources of instruction[25] and adds, in the end, a very telling remark:

> Now since this *rasa* is brought by the union of *vibhava*s and their related factor [that is, by the whole emotional situation represented on the stage],[26] a union which is invariably connected with instruction in the four goals of man, it follows that the subjection of a man to the relishing of the *rasa*s by a literary construction of the *vibhava*s, etc., appropriate to *rasa,* serves at the same time for the instruction (*vyutpatti*) that naturally results. In this way literary delight (*priti*) is an aid to instruction. Our teacher [Bhattatauta] has put the matter thus: "*Rasa* is delight; delight is the drama; and the drama is the Veda [the goal of wisdom]." Delight and instruction are not different in nature, for they occupy a single realm.[27]

The most problematic point is exactly this identification and the meaning of the last expression, the one following the statement on the non-differentiation between delight and instruction. In this respect, Ingalls comments that "[b]oth are found where *rasa* is present." This is unproblematically true, but I suspect that there might be more at stake here.

However, before proposing my interpretation, it is better to delve further into the promised ambiguity and to analyse some passages of the *Abhinavabharati* commenting on the Natyasastra in which Abhinavagupta is much more keen to accepting the educative role of art, and to acknowledging it as its "primary" role.

As already stated before, Theatre is created as "a guide in all the actions of the people of the future,"[28] as the gods said: "We desire an object of diversion, which should be visible and audible."[29] Abhinavagupta comments on this passage: "'Visible' means pleasing, 'audible' means instructive, so the meaning is 'source of delight and instruction.'"[30] Delight and instruction seem therefore on the same plane. Then, on commenting the expression, "another Veda, the fifth, which will belong to all the classes,"[31] he understands it unambiguously as "a source of instruction."[32]

Then, on the issue of the appropriateness of representing contemporary or non-contemporary deeds, Abhinavgupta states:

> Furthermore, the reproduction of contemporary deeds is not appropriate. Since, in such cases, because of the lack of delight (*priti*) caused by the absence of identification brought about by attachment, aversion, indifference, etc., those who should be instructed cannot receive instruction (*vyutpatti*) either.[33]

Hence, it seems that, in the *Abhinavabharati*, Abhinavagupta maintains that imparting instruction is indeed the "primary" goal of theatre, as it would seem by the mere reading of the Natyasastra alone. Then, on commenting NS 1.115, it is said: "it [i.e., Theatre] improves intellect. It indeed extends such

imaginative power of one's own (*pratibha*)."[34] Furthermore, on commenting NS 1.119, Abhinavagupta clearly states: "therefore, the fruit [of theatre] is the instruction about what has to be accepted and what has to be abandoned."[35] This implicit definition of *vyutpatti* needs a further explanation. As Amaladass (1992: 261) puts it, *vyutpatti*, in general, means "learning," "knowledge," "proficiency," "training," "craftsmanship." However, in this particular context, it indicates a practical capacity, the faculty of discriminating between the right thing, to be done, and the wrong thing, not to be done.[36] To conclude this cursory list, one might quote one of the possible interpretations of the often-cited maxim by Bharata: "Verily, without *rasa*, no thing can progress."[37] Abhinavagupta glosses: "without it [i.e., the *rasa*] no thing, i.e., no purpose [of theatre], consisting of instruction and accompanied by [or, maybe, actually 'preceded by'] delight, can progress."[38]

Many more passages on the importance and centrality of *vyutpatti* might be quoted, but even more passages of the *Abhinavabharati* emphasize the crucial role of *rasa* as the *conditio sine qua non* of Theatre, and its savouring as an inherently delightful experience.[39]

Collapsing the Dilemma

What follows is my tentative and admittedly over-interpretive solution for the just depicted "alleged contradictory nature" of Abhinavagupta's statements about both the primacy of *priti* or *vyutpatti* as aims of art and their possible interrelation/identity.[40] As also Ingalls (1990: 233) put it, "Abhinava is able to make enjoyment and instruction come to much the same thing." In *Locana* ad DhvĀ 3.10–14, he says that they are non-different in nature, i.e., that they are identical, but the reason for this identification is the crux of the issue. It is said *ekavisayatvat*, Ingalls translates, "for they occupy the same realm." However, in the lines that follow the quoted passage, Abhinavagupta does say what this *visaya* is: it is *vibhavadyaucitya* "the appropriateness[41] of Determinants and so forth." This term is further qualified as *priter nidanam* 'the cause of delight.' The term *visaya* may be then translated as "object."

Therefore, the source and the object of both delight and instruction is the whole emotional situation (*vibhavadi*), insofar as it is appropriate, namely, insofar as an appropriate character (the *alambanavibhava,* in the technical terminology of Natyasastra) behaves (what is technically called the *anubhavas*) appropriately in a specific situation (the *uddipanavibhavas*). This is clearly the source and object of instruction, because such instruction consists precisely in developing the capacity to follow the "right" course of action in any particular situation. However, it is not crystal clear how the emotional situation as

such can be the source and the object of *priti*, as *priti* is nothing but another name of the very experience of *rasa*, i.e., the aesthetic sublimation of the emotion appropriate for the specific situation.

The solution might be simple: the *bhava*, the fundamental emotion, the inner life of the emotional situation, must be included in this case—at least by implication—in the *vibhavadi*, as, in any emotional situation (*vibhavadi*), the emotion one feels must also be appropriate.[42] More than that, feeling the appropriate emotion is actually the only way to have the appropriate behaviour.[43] Therefore, the real instruction (*vyutpatti*) is not only the capacity to discriminate between different courses of action, but also, and maybe especially, the capacity to choose between the various emotions one might, or better one should, feel in a specific situation. It goes without saying that this entails some kind of active mastery over the emotions, or at least the possibility to educate oneself to be "seized by" the appropriate emotion when the time comes. Hence, the source and the object of *rasa*, i.e., of both delight and instruction, is the whole *vibhavadi* including the *bhava*. To put it bluntly, the *visaya* of *priti* and *vyutpatti* is the whole emotional life of human beings.

Therefore, in my interpretation of his aesthetic theory, Abhinavagupta is arguing that the main kind of instruction offered by art is what we might call "affective knowledge," i.e., knowledge as to what it would be like to be in a particular emotional situation and as to what is the appropriate emotional response[44] to such experiential circumstance—a kind of knowledge very different from the knowledge of facts or of general rules, which concern the world as it is perceived by the senses and as it is studied today by natural sciences. Therefore, in this perspective, art comes to play an invaluable role in the very development of our moral sensibility.[45] Or, in a more pregnant fashion, the very aim of art is shaping moral sensibility through a sort of affective cultivation of the psychic dispositions of the human mind. As Pollock (1998: 141) put it, the aim of art is, "to help us develop a comprehensive moral imagination."[46] Consequently and as an aside, art as an instrument of emotional education cannot be morally neuter. It must be loaded with values and bristling with such seemingly paradoxical and implicit imperatives as "be afraid," "be astonished," "laugh," "be disgusted," and so forth, to be applied in this or that specific experiential situation.

Obviously, this interpretation of art and its hedonic-cum-ethic value is tenable only insofar as the moral field is understood as including emotions. Namely, emotions must be considered moral events, liable to ethical judgements and evaluations. Human beings must be held responsible for their emotional responses. As already hinted at, this interpretation of emotionality becomes acceptable, only insofar as modes of developing our emotional capacities, our emotional competence, actually exist, and only insofar as emotions

are not uncontrollable impulses that drive us notwithstanding our choices.[47] They must be—at least to a significant extent—choices, our choices, morally meaningful choices.[48] In order to live a moral life—practically, I am just about to paraphrase a famous passage of Aristotle's *Nicomachean Ethics*[49]—one ought to have the right emotion towards the proper object, to an appropriate degree and at the appropriate time and place. This maxim can be sensible, and even understandable, only insofar as it is possible to assess, at least theoretically, the moral significance of any specific emotion in any specific context.[50] For instance and somehow counterintuitively, anger—commonly considered a "bad emotion"—can be considered as an appropriate and therefore necessary emotional response in some specific situations (for example, the victim's anger against a rapist within the contemporary Western "average" moral framework).

To generalize the import of the present discourse, in this sort of "emotional" theory of ethics, morality cannot be understood as a set of abstract, absolute principles, prescriptions or imperatives to be grasped by sheer reason, as it is the case for Kant's "categorical imperative." On the contrary, it should be regarded as a living and practical capacity, consisting of an always self-renovating "emotional" interpretation of experiential situations. This ethically charged interpretation of emotional life has been maintained by many contemporary philosophers such as Robert Solomon and Martha Nussbaum.[51]

Along the lines of this moral theory,[52] art brings forth a pleasurable experience that *is* an education to the right choice to be made, among a range of emotive possibilities, in front of any situational context to be coped with. Reading poetry and watching drama, for instance, are therefore conducive to building a virtuous character. The different episodes represented in fictional narratives are aimed at fostering in the spectators determinate dispositions (*habitus*), or virtues, one might say, which determine the actual emotive responses one will and should have in coping with the various emotional situations one might and will encounter in real life. The consequence of reiterated aesthetic experiences is thus the development of a, "reflexive ethical capacity," as Ali (2004: 94) puts it in the closely related context of the early medieval courtly culture.

To sum up and take stock of the promised collapse of the dilemma, one might state that, in contrast with the well known binomial opposition as to the aim of art deemed as a source of "knowledge" and "pleasure," being one of the horns of the issue primary and the other secondary and accessorial, the *rasa* experience in Abhinavagupta's formulation is a morally transformative *Erlebnis* involving both a beatific pleasure (*priti*) and an ethical *Bildung* (*vyutpatti*), which ultimately represent nothing but two aspects of the same sentimental education or educative emotional arousal. I am well aware that in no place Abhinavagupta states clearly the dual nature of *rasa* as a cocktail of

beatific pleasure and laudable instruction, but I deem that this understanding is a possible and coherent interpretive solution of his many apparently contradicting statements in this regard. More than that, I believe it is highly commendable to critically engage with texts such as the Natyasastra and the *Abhinavabharati*, whose very nature of highly complex and culturally rich enterprises does not only demand for a merely philological assessment of their meaning (in the lower understanding of the term 'philological'), but also and especially for a philosophical engagement with their purport and possible relevance for the contemporary debate within the field of both aesthetics in particular and humanities at large.

This essay is, in a way, a reinforcement, a continuation and a non-mystical but emotion-centered reinterpretation of Amaladass (1992). To put it plainly, what is dissimilar in my interpretation of the current issue is, as I hope will be clear by the end of this essay, the role of emotions as such in any aesthetical experience as well as in any ethical experience. The same topic had been already treated—in a rather neutral way—also by Kulkarni (2003b). I wish to thank Elisa Ganser for her precious remarks and suggestions. Any mistakes, of course, are mine alone.

NOTES

1. For an immediate reference to the Indian case, which is the one at stake here, see the quotation by Bansat-Boudon already put *in exergo*: "Plaisir et instruction—saveur et savoir—sont en effet la double fin assignée à ce théâtre," obviously Indian theatre.

2. Abhinavagupta (ca. 950–1020 CE) is one of the most celebrated mystics, aestheticians and philosophers of ancient India. He is the greatest exponent of the so-called Kaśmīr Śaivism, i.e., a form of tantric *śaiva* monism that he himself systematized by harmonizing a number of different religious and philosophical traditions. He is the author of many fundamental works, among which his *opus magnum* is the *Tantrāloka,* a very original and extremely influential compendium of tantric Śaivism. However, his current fame in India depends mainly on the monumental contribution he gave to the field of aesthetics by commenting upon Ānandavardhana's *Dhvanyāloka* and Bharata's Natyasastra. For a general account of his life and work, see the pioneering and reasonably comprehensive study of Pandey (1966). Further information can be found in more recent and up-to-date scholarship available on the matter, such as Rastogi (1987) and Gnoli (1999).

3. The full implication of the existence of different kinds of knowledge (factual, scientific, affective and so forth—without claiming to give a complete listing) will hopefully be clear by the end of the essay.

4. The issue of the purpose of art is viewed in the present paper from the point of view of the enjoyer of art. The perspective of the artist as to the purpose of his own art is not addressed here. The crucial concept of *yaśas*—the fame that the poet accrues by means of his activity—and other related issues are therefore not dealt with in the present essay.

5. The Natyasastra (Nāṭyaśāstra, with the standard diacritics used to transliterate Sanskrit terms) is an encyclopedic treatise on dramaturgy attributed to the sage Bharata and usually dated from the second century BC to the second century AD. Besides drama *per se,* it includes the discussion of many related topics such as enactment, dance, music, meter, etc. The text as it is extant nowadays most probably represents the unification and systematization of previously existing materials. The

statements and the theories expounded in this treatise as to the theatrical art will be later considered as applicable and valid for every art form whatsoever and, hence, for art in general. For the standard translation of the text, see Ghosh (1950–1967).

　6. NS 1.11c: *krīḍanīyakam icchāmo.*

　7. NS 1.12: *vedaṃ pancamam.* The Vedas are the oldest scriptures of India, supposedly revealed to the *ṛṣis*: the ancient seers. The standard canonization of the Vedic textual corpus consists of a fourfold division: *Ṛgveda, Sāmaveda, Yajurveda* and *Atharvaveda.* Being considered as a fifth Veda implies the conferral of the highest moral and religious value. Texts for which this status has been claimed include the *Mahābhārata* and some *Purāṇas.*

　8. NS 1.14–15:

> *dharmyam arthyaṃ yaśasyaṃ ca sopadeśyaṃ sasaṅgraham |*
> *bhaviṣyataś ca lokasya sarvakarmānudarśakam ||*
> *sarvaśātrārthasampannaṃ sarvaśilpapravartakam |*
> *nāṭyākhyaṃ pañcamaṃ vedaṃ setihāsaṃ karomy aham ||*

　9. NS 1.113b: *hitopadeśajananaṃ dhṛtikrīḍāsukhādikṛt.*

　10. The issue of *vyutpatti* "education" as the prerequisite of any good poet (together with *pratibhā*, "poetic genius"), discussed in many works of *alaṃkāraśāstra* ("poetics"), is beyond the scope of the present essay, which focuses, instead, on the receptive dimension of art.

　11. Abhinavagupta composed two other texts of primarily "poetical" and "dramaturgical" content, the *Kāvyakauṭukavivaraṇa* and the *Ghaṭakarparakulakavivṛti.* The first one is a lost commentary on the lost *Kāvyakauṭuka* by Bhaṭṭa Tauta, Abhinavagupta's teacher of dramaturgy. The second one, a commentary on a short poem attributed to Kālidāsa, has no direct bearing on the issues at hand and will not be dealt with in the present essay. For a translation thereof, see Parlier (1975). For a partial study thereof, see Masson (1975).

　12. Bhāmaha's *Kāvyālaṃkāra* 1.2:

> *dharmārthakāmamokṣeṣu vaicakṣaṇyaṃ kalāsu ca |*
> *karoti kīrtiṃ prītiṃ ca sādhukāvyanibandhanam* [or *sādhukāvyaniṣevaṇam*]

Adapted translation from Ingalls (1990: 71).

　13. As to the problem of chronological priority between Daṇḍin and Bhāmaha, see Bronner (2012).

　14. *Kāvyālaṃkārasūtra* 1.1.5: *kāvyaṃ sad dṛṣṭādṛṣṭārtham, prītikīrtihetutvāt.*

　15. Rudraṭa's *Kāvyālaṃkāra* 12.1–2:

> *nanu kāvyena kriyate sarasānām avagamaś caturvarge |*
> *laghu ca mṛdu ca nīrasebhyas te hi trasyanti śāstrebhyaḥ ||*
> *tasmāt tat kartavyaṃ yatnena mahīyasā rasair yuktam |*
> *udvejanam eteṣāṃ śāstravad evānyathā hi syāt ||*

"On the other hand, poetry brings forth a quick and gentle comprehension of the fourfold aim of mankind on the part of the connoisseurs, as the flavourless scholarly treatises just frighten them. Therefore, one should greatly strive for it [i.e., poetry] to be associated with *rasa*s as, otherwise, they would be afraid of it, just as in the case of scholarly treatises."

　16. *Agnipurāṇa* 337.7c: *trivargasādhanaṃ nāṭyam.*

　17. *Daśarūpaka* 1.6:

> *ānandaniṣyandiṣu rūpakeṣu vyutpattimātraṃ phalam alpabuddhiḥ |*
> *yo'pītihāsādivad āha sādhus tasmai namaḥ svāduparāṅmukhāya ||*

　18. *Avaloka* ad *Daśarūpaka* 1.6, p. 5: "[T]he fruit of the ten kinds of drama is the savouring of *rasa* (the aesthetic emotion), which consists in supreme bliss perceivable only by one's self, not just the mere instruction regarding the three aims of mankind and the like, as it is in the case of history and the like (*svasaṃvedyaparamānandarūpo rasāsvādo daśarūpāṇāṃ phalam, na punar itihāsādivat trivargādivyutpattimātram*)."

　19. Bhāmaha's *Kāvyālaṃkāra* 1.2. See also above.

　20. It is worth noting that *ānanda* ("bliss") and *prīti* ("pleasure") are practically synonyms here and in Abhinavagupta's terminology.

　21. *Locana* ad DhvĀ 1.1, p. 40: *śrotṝṇāṃ ca vyutpattiprītī yadyapi staḥ yathoktam—dharmārthakāmamokṣeṣu vaicakṣaṇyaṃ kalāsu ca | karoti kīrtiṃ prītiṃ ca sādhukāvyaniṣevaṇam || (Bhāmaha 1.2) iti | tathāpi tatra prītir eva pradhānam | anyathā prabhusammitebhyo vedādibhyo mitrasammitebhyaś cetihāsādibhyo vyutpattihetubhyaḥ ko'sya kāvyarūpasya vyutpattihetor jāyāsam-*

mitatvalakṣaṇo viśeṣa iti prādhānyenānanda evoktaḥ | caturvargavyutpatter api cānanda eva pāryan-tikaṃ mukhyaṃ phalam | Translation by Ingalls (1990, 71).

22. *Locana* ad DhvĀ 2.4, p. 184: *vyutpattir nāmāpradhānam eva.*

23. *Locana* ad DhvĀ 2.4, p. 185: *vyutpādanaṃ ca śāsanapratipādānābhyāṃ śāstretihāsakṛtā-bbhyāṃ vilakṣaṇam | yathā rāmas tathāham ity upamānātiriktāṃ rasāsvādopāyasvapratibhāvijṛmbhā-rūpāṃ vyutpattim ante karotīti.* Translation by Ingalls (1990, 226).

24. One might also add that—as Ingalls (1990, 233) put it—"inasmuch as it [i.e., the instruction given by art] trains us to experience aesthetic bliss, it may even be said to be spiritually instructive."

25. *Locana* ad DhvĀ 3.10–14, p. 336: *iha prabhusammitebhyaḥ śrutismṛtiprabhṛtibhyaḥ kartavyam idam ity ājñāmātraparamārthebhyaḥ śāstrebhyo ye na vyutpannāḥ, na cāpy asyedaṃ vṛttam amuṣmātkarmaṇa ity evaṃ yuktiyuktakarmaphalasambandhaprakaṭanakāribhyo mitrasammitebhya itihāsaśāstrebhyo labdhavyutpattayaḥ, atha cāvaśyaṃ vyutpādyāḥ prajārthasampādanayogyatākrāntā rājaputraprāyās teṣāṃ hṛdayānupraveśamukhena caturvargopāyavyutpattir ādheyā | hṛdayānupraveśaś ca rasāsvādamaya eva.* Ingalls (1990, 437) translates: "Princes, who are not educated in scripture—those works of *śruti* and *smṛti* which consist in commands, like those of a master, to do this or that—and who have not received instruction from history, which like a friend reveals to us the connection of cause and effect with such persuasive instances as 'This result came from such an act,' and who are therefore in pressing need of instruction, for they are given the power to accomplish the wants of their subjects, can be given instruction in the four goals of man only by our entering into their hearts. And what enters into the heart is the relish of *rasa* (*rasāsvada*, the imaginative experience of emotion)." Abhinavagupta briefly repeats the same analogy in *Locana* ad DhvĀ 3.30, p. 399, translated in Ingalls (1990, 533).

26. The *vibhāvādi* are the well-known elements of any theatrical representation that have to be enacted in order to arouse the *rasa* (say, the aesthetic experience) in the spectators. It might be worth repeating here, for the sake of those unacquainted with the theatrical *termini tecnici*, what I have explained elsewhere (Cuneo 2013, 56–57): "As the renowned *rasasūtra* has established: *vibhāvānubhāvavyabhicārisaṃyogād rasaniṣpattiḥ,* namely, 'The *rasa* is produced by the union of the Determinants (*vibhāva*s), the Consequents (*anubhāva*s) and the Transitory States (*vyabhicāribhāva*s).' The *vibhāva*s ('Determinants') are those factors that make the emotion possible, that determine, or even cause it. Thus they are both the subject and the object of the emotion as well as the whole array of stimulating 'environmental' factors that determine the rise of the emotion, namely, the whole emotional situation. For instance, in a love situation, the lover and the beloved are the subject and the object of the emotion, while the stimulating factors are springtime, garlands, splendid mansions, and so forth. The *anubhāva*s ('Consequents') are the consequences, the effects or, one might say, the 'symptoms' of an emotion, namely, in the case of love, both voluntary acts, such as verbal expressions of one's feelings, sidelong glances and the like and involuntary responses, such as perspiration, horripilation and so forth. Obviously enough, these acts are the very object of representation on the part of the actors. The *vyabhicāribhāva*s ('Transitory States') are a whole set of thirty-three complementary, or secondary, emotions such as anxiety, envy, shame and indignation. Hence, the combination of all these elements on the stage determines the production of *rasa*."

27. *Locana* ad DhvĀ 3.10–14, p. 336: *sa ca rasaś caturvargopāyavyutpattināntarīyakavi-bhāvādisaṃyogaprasādopanata ity evaṃ rasocitavibhāvādyupanibandhe rasāsvādavaivaśyam eva svarasabhāvinyāṃ vyutpattau prayojakam iti prītir eva vyutpatteḥ prayojikā | prītyātmā ca rasas tad eva nāṭyaṃ nāṭyam eva veda ity asmadupādhyāyaḥ | na caite prītivyutpattī bhinnarūpe | tayor apy ekaviṣayatvāt.* Translation by Ingalls (1990, 437). Moreover, the relationship between *prīti* and *vyutpatti* is hinted at in another passage, a possibly ambiguous one. See *Locana* ad DhvĀ 3.33, p. 455: *prītimātraparyavasāyitvāt | prīter eva cālaukikacamatkārarūpāyā vyutpattyaṅgatvāt.* Although Ingalls (1990, 592) translates: "This [i.e., the non-applicability to poetry of the normal criteria of factual verifiability] is because the end of poetry is pleasure, for it [is] only by pleasure, in the form of a otherworldly delight, that it can serve to instruct us" the last phrase might also mean—in a different grammatical interpretation—that delight (*prīti*) is actually secondary (*aṅga*) with respect to instruction (*vyutpatti*). One more interesting passage correlating *prīti* and *vyutpatti*—being the first a condition for the occurrence of the second—is ABh ad NS 4.2–3, p. 85, in which, on commenting on the term *utsāhajanana* of verse 2, Abhinavagupta states: "and it is by means of that very delight [i.e., *rasa*] that there is a production of an urge to act towards [the obtainment of]

the means for the three aims of mankind [i.e., a moral instruction] (*tena ca prītiprakāreṇotsāhasya trivargopāyaviṣayasya jananam*). But we are already in the realm of the *Abhinavabhāratī* here. I wish to thank Elisa Ganser for pointing out to me this passage.

28. NS 1.14: *bhaviṣyataś ca lokasya sarvakarmānudarśakam*

29. NS 1.11: *krīḍanīyakam icchāmo dṛśyaṃ śravyaṃ ca yad bhavet.*

30. ABh ad NS 1.12, vol. 1, p. 11: *dṛśyam iti hṛdyaṃ śravyam iti vyutpattipradam iti prītivyutpattidam ity arthaḥ.*

31. NS 1.12: *vedaṃ pañcamaṃ sārvavarṇikam.*

32. ABh ad NS 1.12, vol. 1, p. 12: *vyutpattidāyī.*

33. ABh ad NS 1.58–59, vol. 1, p. 27: *na ca vartamānacaritānukāro yuktaḥ | vineyānāṃ tatra rāgadveṣamadhyasthatādinā tanmayībhāvābhāve prīter abhāvena vyutpatter apy abhāvāt.*

34. ABh ad NS 1.108–115, vol. 1, p. 41: *buddhiṃ vivardhayati | svapratibhām eva tādṛśīṃ vitarayati.*

35. ABh ad NS 1.119, vol. 1, p. 45: *tena heyopādeyavyutpattiḥ phalam.*

36. See also Namisādhu's commentary on Rudraṭa's *Kāvyālaṃkāra* 1.18: *yuktāyuktaviveka ucitānucitaparijñānaṃ [vyutpattir iyam].* Ingalls (1990, 440) translates: "Education (*vyutpatti*) is the discrimination of right and wrong, the thorough knowledge of what is appropriate and what is not." As far as the *vyutpatti* of the poet is concerned, in *Locana* ad DhvĀ 3.6, p. 317, Abhinavagupta explains that it is "the skill in the careful weighing of all that may be helpful to such [new presentations of everything one wishes to describe in poetry] (*vyutpattis tadupayogisamastavastupaurvāparyāmarśakauśalam*). Translated by Ingalls (1990, 411).

37. NS 6, prose after 31, p. 272: *na hi rasād ṛte kaścid arthaḥ pravartate.*

38. ABh ad NS 6, prose after 31, vol. 1, p. 271: *taṃ vinārthaḥ prayojanaṃ prītipurassaraṃ vyutpattimayaṃ na pravartate.* Another related passage is ABh ad NS 1.108–115, p. 40: "Furthermore, for those who, like princes, etc., are not in pain, as their conditions are utterly pleasurable, this Theatre is instructive in the world-based field of the means to reach the moral norm (*dharma*) and the other purposes of mankind (*ye punar aduḥkhitāḥ sukhabhūyiṣṭavṛttaya eva rājaputrādyās teṣāṃ lokavṛtte dharmādyupāyavarge upadeśakāry etan nāṭyam*)." On slightly different but extremely interesting notes, the brief passage preceding the one just quoted mentions a very specific kind of pleasure that Theatre can furnish, the pleasure born out of instruction: "Even in a subsequent moment, it [i.e., theatre] produces a maturation, i.e., a pleasure born out of instruction. Thus, the purpose is that those who suffer may achieve a pleasure, in a subsequent time, which surpasses the pleasure [attained during the performance] that [normally] appeases that [pain of theirs] (*kālāntare 'pi paripākaṃ sukham upadeśajam janatīty evaṃ dukhitānāṃ tatpraśamasukhavitaraṇakālāntarasukhalābhāḥ prayojanam*)."

39. Another important passage connecting the experience of *rasa* and the moral development of the enjoyer of art is the long discussion on the essence of theatre contained in ABh ad NS 1.107. For a full translation of the passage, see Gnoli (1968, 88–101 [Appendix i]) or Cuneo (2008–2009, vol. 1, 200–206). As far as the present matter is concerned, the gist of the passage—as summarized by Amaladass (1992, 266)—is the following: "[T]he effect of an aesthetic experience on the spectator is such that sometimes a kind of *camatkāra*—a sense of wonder—continues for several days. Because of *rasa* experience such an impression remains deeply fixed in the heart like an arrow in such a way that by no possible effort it can be erased, let alone extracted. Thanks to it, the desire of attaining the good and abandoning the bad are constantly present in the mind of the spectator, who accordingly does the good and avoids the bad: *śubham ācaraty aśubhaṃ samujjhati*." A survey of the theories concerning the purpose of art of the followers of Abhinavagupta lies beyond the scope of this article. However, we might just quote the famous verse by Mammaṭa on the purposes of poetry and Hemacandra's re-elaboration of the same issue. Mammaṭa's *Kāvyaprakāśa* 1.3: "Poetry leads to fame, the acquisition of wealth, the knowledge of the ways of the world [and] the instantaneous [obtainment of] supreme beatitude, associated with instruction in the manner of a beloved woman (*kāvyaṃ yaśase 'rthakṛte vyavahāravide śivetarakṣataye | sadyaḥparanirvṛtaye kāntāsammitatayopadeśayuje ||*)." Hemacandra's *Kāvyānuśāsanam* 1.3: "Poetry leads to bliss, fame and instruction in the manner of a beloved woman (*kāvyam ānandāya yaśase kāntātulyatayopadeśāya ca*)."

40. Two "easier" interpretations might come to mind, even though they are both simplistic and possibly unfair to Abhinavagupta. The first possibility is that Abhinavagupta gradually changed his mind: from an idea of art as primarily bestowing delight, as propounded in the first passages

of the *Locana*, to an idea of art as primarily bestowing instruction, as propounded in the passages from the *Abhinavabhāratī*. The second possibility is ascribing a slight contradictory or confused attitude to Abhinavagupta's characterization of the purposes of art.

41. Kṣemendra's *Aucityavicāracarcā* is an 11th-century work entirely devoted to the aesthetical-cum-sociomoral concept of *aucitya*, "appropriateness" or "propriety." For a study and a translation thereof, see Suryakanta (1952). On *aucitya* in secondary literature, see the fundamental Raghavan (1942) and Krishnamoorthy (1994).

42. The obvious counterexample is the existence of *rasābhāsa*, the 'semblance of an aesthetic emotion,' which occurs when something inappropriate is represented in art. For instance Rāvaṇa's love for Sītā is an inappropriate emotion, for the simple reason that he is a horrible and evil demon and she is a beautiful and rightful woman. On *rasābhāsa*, see Bhattacharya (1935), Krishnamoorthy (1974) and, to an extent, also Pollock (2001).

43. My abridged reasoning runs like this: one acts only on the spur of desire, and desire is the direct consequence of the emotive response to an emotional situation. For an enlarged explanation of this model of human action, see Cuneo (2007).

44. As I have diffusedly argued elsewhere (Cuneo 2013), any emotional response is nothing but a form of cognitive appraisal.

45. On art and ethics from a western perspective, see Gaut (2007).

46. Implicitly, "the criticism of poetry remains for all of them [i.e., the Indian thinkers] fundamentally a criticism of life, since in the last analysis the correct reading of Sanskrit literature requires a correct understanding of and subscription to a larger social theory" (Pollock 1998, 141). The aim of art is therefore "to create politically correct subjects and subjectivities" (Pollock 1998, 141). In Bourdieu's terms, one might say that the purpose of art is the incorporation of the social through an affective and emotive medium (cfr. Bourdieu 2003). The moral imagination that is developed by appreciating art is obviously molded by the dominant moral principles of the culture of which that very art is a harbinger. Furthermore and vice versa, it is possible to enjoy a work of art in its own terms (i.e., to experience the *rasa*) only by sharing—or at least by comprehending—the values and the moral constructs of the society that produced it. For an analysis of the social imperatives implicit in Sanskrit literary theory, see Pollock (2001).

47. In other words, in order to maintain such a view about the purposes of art, it is necessary to subscribe some form of cognitive theory of emotions, as I have argued it is the case for Abhinavagupta in particular and for Indian pre-modern culture in general (Cuneo 2007).

48. As already hinted at, the cogency of this argumentation is strengthened by the absence of a sharp distinction between emotive and cognitive phenomena in the classical culture of South Asia, see preceding note.

49. Aristotle, *Nicomachean Ethics*, Book II, Chapter 6, 1106b15–29.

50. For a comparable case, see for instance the moral justification of *manyu* ("anger") for *kṣatriya*s in Hara (2001).

51. On the close relationship between morality and emotion, often understood as a dependence of morality on fundamentally emotional judgments, see Solomon (1976), Gibbard (1990), Oakley (1992), Freeland (1997), Hjort; Leaver (1997), Blackburn (1998) and Nichols (2004). On the general importance of emotions in morality, see also Nussbaum (2001) and Solomon (2003). A very similar view has been already maintained by Sartre (2000, 23) who stated, for instance, "the existentialist does not believe in the power of passion." To elaborate, passions, desires and feelings have no power to move us without our consent and so can never be offered as an excuse for any apparently uncontrollable behavior!

52. For the main arguments—especially those advocated by Kant—against emotions as morally meaningful phenomena and for their refutation, see Oakley (1992, 86–121).

Bibliography

Primary Sources

Abhinavagupta. 1926–1964. *Nāṭyaśāstra* [NS], with the *Abhinavabhāratī* [ABh] of Abhinavagupta. M.R. Kavi, ed. Baroda: Oriental Institute.

_____. 1940. *Dhvanyālokalocana*. Pattābhirāma Śāstrī, ed. Benares: Kashi Sanskrit Series 135.
Ānandavardhana. 1940. *Dhvanyāloka*. Pattābhirāma Śāstrī, ed. Benares: Kashi Sanskrit Series 135.
Aristotle. 1915. *Nicomachean Ethics*. W.D. Ross, trans. Oxford: Oxford University Press.
Bhāmaha. 1970. *Kāvyālaṃkāra*. P.V. Naganatha Sastry, ed. and trans. Delhi: Motilal Banarsidass.
Bharata. 1926–1964. *Nāṭyaśāstra* [NS], with the *Abhinavabhāratī* [ABh] of Abhinavagupta. M.R. Kavi, ed. Baroda: Oriental Institute, 4 volumes. Vol. 1 (ch. 1–7), 2d ed., revised and critically edited by K.S. Ramaswami Śāstri, 1956; Vol. 2 (ch. 8–18), 1934; vol. 3 (ch. 19–27), 1954; vol. 4 (ch. 28–37) ed. M.R. Kavi and J.S. Pade, 1964.
Daṇḍin. 1938. *Kāvyādarśa*. Pt. Rangacharya Raddi Shastri, ed. Poona: Bhandarkar Oriental Research Institute.
Dhanañjaya. 1969. *Dāśarūpaka*, with the commentary *Avaloka* by Dhanika, and subcommentary *Laghuṭīkā*. Bhaṭṭanṛsimha, T. Venkatacharya eds. Madras: Adyar Library and Research Centre.
Hemacandra. 1964. *Kāvyānuśāsana*. R.C. Parikh and V.M. Kulkarni eds. Bombay: Śrī Mahāvīra Jaina Vidyālaya.
Kṣemendra. 1933. *Aucityavicāracarcā*. Dhundirāja Śāstrī ed. Benares: Chaukhamba Sanskrit Series.
Mammaṭa. 1921. *Kāvyaprakāśā*, with the *Saṃketa* by Māṇikyacandra. Poona: Ānandāśrama.
Mitra, R. 1870–1879. *Agnipurāṇa*. Calcutta: Asiatic Society of Bengal, Bibliotheca Indica.
Rudraṭa. 1886. *Kāvyālaṃkāra*, with the commentary of Namisādhu. Pt. Durgāprasād and Kāśīnāth Pāṇḍurang Parab, eds. Bombay: Nirnayasagar Press.
Vāmana. 1989. *Kāvyālaṃkārasūtra*, with the *Kāmadhenu* of Gopendra Tripurahara Bhūpāla. Bechana Jha, ed. Varanasi: Chaukhamba.

Secondary Sources

Ali, D. 2004. *Courtly Culture and Political Life in Early Medieval India*. Cambridge: Cambridge University Press.
Amaladass, A. 1992. "The Concept of Vyutpatti in Indian Aesthetics: Does Aesthetic Delight Bring About a Change in the Person Experiencing it?" WZKSOA 36, 261–272, Supplement.
Bhattacharya, S. 1934. "Rasābhāsa in Alaṃkāra Literature." *Calcutta Oriental Journal* 2: 237–247.
Blackburn, S. 1998. *Ruling Passions: A Theory of Practical Reason*. Oxford: Oxford University Press.
Bourdieu, P. 2003. *Méditations pascaliennes*. Paris: Éditions du Seuil, 3d ed., English translation, 2000, *Pascalian Meditations*. Stanford: Stanford University Press.
Bronner, Y. 2012. "A Question of Priority: Revisiting the Bhāmaha-Daṇḍin Debate." *Journal of Indian Philosophy* 40: 67–118.
Cuneo, D. 2007. "The Emotional Sphere in the Light of the *Abhinavabhāratī*." *Rivista di Studi Orientali* 80: 21–39 (published in 2009).
_____. 2008–2009. "Emotions Without Desire: An Interpretive Appraisal of Abhinavagupta's Rasa Theory. Annotated Translation of the First, Sixth and Seventh Chapters of Abhinavagupta's *Abhinavabhāratī*." Unpublished PhD thesis, Sapienza University of Rome, Rome.
_____. 2011. "Unfuzzying the Fuzzy: The Distinction Between *rasa*s and *bhāva*s in Abhinavagupta and Bharata." In *Puṣpikā: Tracing Ancient India Through Texts and Traditions. Contributions to Current Research in Indology*, Volume I, Nina Mirnig, Péter-Dániel Szántó, and Michael Williams eds. Oxford: Oxbow Books.
Ferraris, M. 2007. *La fidanzata automatica*, Milano: Bompiani.
Freeland, C. 1997. "Art and Moral Knowledge." *Philosophical Topics* 25: 11–36.
Gaut, B.N. 2007. *Art, Emotion and Ethics*. Oxford: Clarendon.

Ghosh, M. 1950–1967. *Nāṭyaśāstra of Bharata*. Varanasi: Chowkhamba Sanskrit Series.

Gibbard, A. 1990. *Wise Choices, Apt Feelings*. Cambridge: Harvard University Press.

Gnoli, R. 1968. *The Aesthetic Experience According to Abhinavagupta*. Varanasi: Chowkamba Sanskrit Studies 72.

_____. 1999. *Abhinavagupta. Luce dei Tantra*. Milano: Adelphi.

Haas, G.C.O. 1912. *The Daśarūpa: A Treatise in Hindu Dramaturgy by Dhanaṃjaya*. New York: Columbia University Press.

Hara, M. 2001. "Hindu Concepts of Anger: *manyu* and *krodha*." In Torella, 419–444.

Hjort, M., and S. Leaver. 1997. *Emotion and the Arts*. Oxford: Oxford University Press.

Ingalls, D.H.H. 1990. *The Dhvanyāloka of Ānandavardhana with the Locana of Abhinavagupta*. D.H.H. Ingalls, J.M. Masson and M.V. Patwardan, eds. and trans. London: Harvard Oriental Series 49.

Krishnamoorthy, K. 1974. "The Concept of Rasābhāsa in Sanskrit Literary Theory." In K. Krishnamoorthy, ed., *Essays in Sanskrit Criticism*. Dharwar: Karnatak University.

_____. 1994. "Rasaucitya as a Criterion of Literary Judgement in Indian Theory and Practice." In Narasimhaiah, 95–108.

Kulkarni, V.M. 2003a. *Abhinavabhāratī Text Restored and Other Articles*. Ahmedabad: Shreshti Kasturabi Lalbhai Smarak Nidhi.

_____. 2003b. "Abhinavagupta on the Goal of Poetry." In Kulkarni (2003a), 185–192.

Masson, J.M. 1975. "When Is a Poem Artificial? A Note on the *Ghaṭakarparavivṛti*." *Journal of the American Oriental Society* 95.2: 264–265.

Narasimhaiah, C.D. 1994. *East West Poetics at Work*. New Delhi: Sahitya Academy.

Nichols, S. 2004. *Sentimental Rules*. Oxford: Oxford University Press.

Nussbaum, M.C. 2001. *Upheavals of Thought. The Intelligence of Emotions*. Cambridge: Cambridge University Press.

Oakley, J. 1992. *Morality and the Emotions*. London: Routledge.

Pandey, K.C. 1966. *Abhinavagupta: A Historical and Philosophical Study*. Varanasi: Chowkamba.

Parlier, B. 1975. *La Ghaṭakarparavivṛti d'Abhinavagupta*. Paris: Institut de civilisation indienne.

Pollock, S. 1998. "Bhoja's *Śṛgāraprakāśa* and the Problem of *rasa*: A Historical Introduction and Annotated Translation." *Asiatische Studien/Ètudes Asiatiques* 52.1: 117–192.

_____. 2001. "The Social Aesthetic and Sanskrit Literary Theory." *Journal of Indian Philosophy* 29: 197–229.

Raghavan, V. 1942. "The History of Aucitya in Sanskrit Poetics." In V. Raghavan, ed., *Some Concepts of Alaṃkāraśāstra*. Madras: Adyar Library.

Rastogi, N. 1987. *Introduction to the Tantrāloka*. Delhi: Motilal Banarsidass.

Sartre, J.-P. 2000. *Existentialism and Human Emotions*. New York: Citadel.

Solomon, R.C. 1976. *The Passions: The Myth and Nature of Human Emotion*. Garden City, NY: Anchor/Doubleday.

_____. 2003. *Not Passion's Slave*. Oxford: Oxford University Press.

Suryakanta. 1952. "A Study of Kṣemendra's *Kavikaṇṭhabharaṇa Aucityavicāracarcā* and *Suvṛttatilaka*, with an English Translation." *Poona Orientalist* 17: 1–219.

Torella, R. 2001. *Le Parole e i Marmi. Studi* eds., *in Onore di Raniero Gnoli nel suo 70° Compleanno*. Roma: Isiao.

Comedy, Consciousness and the Natyasastra

Daniel Meyer-Dinkgräfe

In the eighteenth century, Friedrich Schiller (1759–1805) axiomatically declared that there could be no doubt about the purpose of human life, if there ever was one: bliss. The mind has to put in much effort by way of diligence to achieve bliss; we have to make many sacrifices to achieve approval for pleasure from reason, and we have to buy the pleasures of the senses through many deprivations or bear much suffering if we overdo sensory pleasure. In contrast, the arts create pleasure without prior payment through remorse and without sacrifice. This is the reason why Schiller argued further, society has mixed feelings about pleasure. The purpose of all art is to create pleasure. In everyday life we derive pleasure from many sources, accounting for individual differences. Other areas of life may bring pleasure as a side effect, but in art, pleasure is the central aim. Pleasure, enabled through art, is a way of fulfilling our highest purpose in nature. Anything that achieves our purpose in nature must be morally good. Art becomes a means towards moral behavior. Thus art itself must be morally good (1897). What precisely is it in the work of art that creates pleasure? Schiller maintains that it is the combination of form (comedy or tragedy, for example) and content (love, intrigue). Form is the ordering, structuring, enhancing or balancing of ordinary sensory impressions. The appreciation of the ordering process, and the result, give pleasure. This is pleasure of the imagination, whereas pleasure of the senses arises through direct sensual impressions. Orderliness, structure, enhancement and balance are perceived as beautiful. Art thus creates pleasure through beauty.

In the context of theater, both comedy and tragedy free the spirit, but through different means. Comedy leads to a state of indifference; if comedy

89

deals with a topic or event that would normally affect our moral feelings, then comedy has to neutralize the impact of that topic of event. For example, in Shakespeare's *King Lear* the daughters' ingratitude affects our moral feeling. In comedy, ingratitude has to come across as something natural. While tragedy makes us suffer with the person who suffers ingratitude, in comedy we must be led to find the person who expects gratitude ridiculous. Comedy leads its spectators to a state that is

> calm, clear, free, cheerful. We feel neither active nor passive, we observe, and everything remains outside of ourselves; this is the state of the gods, who are not concerned with anything human, who are hovering freely above everything, who are not moved by any fate and not bound by any law [1792].[1]

It is a state of happy balance. Schiller writes:

> Imagine, however, the pleasure to see, in a poetic rendering, everything mortal extinguished, pure light, pure freedom—no shadow, no boundaries, nothing of all that [1855].[2]

Consciousness and the Natyasastra

A view from current, twenty-first century consciousness studies supports this view, and enables us to make more sense of the experiences that Schiller relates to comedy. According to the model of the mind in the Vedanta tradition of Indian philosophy, there are three basic states of consciousness, waking, dreaming and sleeping. During the waking state of consciousness, several *functions* of consciousness can be differentiated, including decision-making, thinking, emotions, and intuition. Vedanta postulates a fourth state of consciousness which serves as the basis of the states of waking, dreaming and sleeping, and their related functions. The fourth state, referred to as *pure consciousness*, or *samadhi* in Sanskrit, is without contents, but fully awake. It has been described, albeit in different terms, across cultures. W.T. Stace, for example, writes about *pure unitary consciousness* in the context of Christian mystic experiences (1960). If pure consciousness is experienced not only briefly, and "just" on its own, but together with waking or dreaming or sleeping, according to Vedanta higher states of consciousness have been achieved.

Pure consciousness is precisely, as Schiller argued, pure balance, pure enhancement, pure order, pure structure—abstract, containing expressed balance, enhancement, order, and structure within it in seed form. Pure consciousness on its own is indifferent to any sensory impression, to any feeling or thought, just as the cinema screen is indifferent to the projections of the images onto it. Pure consciousness is pure calmness, clarity, light, freedom,

and bliss. The relevance of pure consciousness for the understanding of comedy becomes even clearer with reference to the specific further development of Vedanta philosophy by Maharishi Mahesh Yogi, whose model of consciousness, based on Vedanta philosophy, is widely discussed in the growing interdisciplinary debate about consciousness (Shear and Jevning 1999). He argues that when "odd or sharply contrasting things are closely juxtaposed, the space between them is made lively" (Orme-Johnson and Anderson 2010: 152) Conventionally, comedy is considered to create laughter by breaking expectations through the means of juxtaposition of contrasting opposites. That space between the contrasting things, Maharishi Mahesh Yogi points out, is pure consciousness, the silent field of life that underlies all manifest existence just as the unmoving, silent levels of water at the very depths of an ocean underlie the ever-changing manifestations of the waves. "Our awareness of this underlying silent field of life thrills us and makes us laugh" (Orme-Johnson and Anderson 2010: 152) Maharishi Mahesh Yogi has cognized the importance of the space, or the gaps, between the sounds. The gaps, thus, are anything but simply empty, or insignificant. Maharishi's cognition has been called *Apaurusheya Bashya,* uncreated commentary, indicating that the structure of the Veda provides its own commentary. The first word of *Rigveda* can illustrate the principles and processes involved.

The first word of the *Rigveda* is *Agnim.* The sound of *A* represents the fullness of the absolute. The next sound, *G,* represents the collapse of fullness in a point value. There is a gap between *A* and *G,* and between this first syllable and the next one, etc. Following the first syllable of *Rigveda, AG,* sound collapses into the gap, just as fullness (*A*) had collapsed into point value (*G*). The gap thus also represents a point value in the sequential development of *Rigveda:* it is characterized by non-fullness, absolute emptiness. The fullness of *A* or the previous sound/syllable is still latent, but no longer expressed (Volkamer 1983: 179). Without going into detail, the collapse from A to G can be shown to consist of eight distinct stages. The eight stages of collapse of *A* to *G* are elaborated in the eight syllables of the first phrase (*Pada*) of *Rigveda.*[3] Those eight syllables correspond, in turn, to the eight *Apara Prakriti:* AG—Ahamkara; NI—Buddhi; MI—Manas; LE—Akasha; PU—Vayu; RO—Agni; HI—Jala; TAM—Prithivi. In this structure, there are 8 gaps: the first within the first syllable, between *A* and *G,* and thereafter between the syllables, i.e., between AG and NI, between NI and MI, between MI and LE, and so on.

Three such *Padas* (phrases) of eight syllables each make up the first verse (*Richa*) of *Rigveda.* The first *Pada* expresses the eight *Prakritis* with respect to the *Rishi* aspect of the absolute (the observer or experiencer). The second *Pada* with respect to *Devata* (the observed or experienced object), the third

Pada with respect to *Chhandas* (the process of observation or experience). Together, this first verse (*Richa*), constituted of three phrases (*Pada*) of eight syllables (*Akshara*) each, shows twenty-four gaps (*Sandhis*). Out of those gaps, twenty-four further *Padas* emerge, constituting *Richas* 2–9. *Richas* 2–9 together have 192 gaps and 192 syllables. They give rise to the 192 hymns (*Suktas*) that make up the first (circle, or book, of the *Rig Veda*). In turn, the 192 gaps between the 192 *Suktas* of the first *Mandala* give rise to the 192 *Suktas* of the tenth *Mandala*. Finally, all the gaps between the nine *Richas* of the first *Sukta* are elaborated in *Mandalas* Two to Nine, thus completing the entire *Rig Veda*. Comedy, enlivening the gap, thus arises from, and leads to an experience of pure consciousness. Pure consciousness is experienced as bliss, which, according to Schiller, is the purpose of life.

Pure consciousness, finally, provides a conceptual and experiential link between comedy as a literary and dramatic genre and as an experience in the theatre, within the context of the ancient Indian treatise on drama and theatre, the Natyasastra. All aspects of human life find their representation in *natya* (drama), and that includes laughter (NS 1: 107[4]), and one of the impacts on the spectator of watching *natya* will be amusement (NS 1: 111–112). Thus, each performance has to begin with a clearly defined set of "preliminaries," actions intended to prepare actors and spectators for the performance. Central to such preliminaries is the *trigata*, the *Three Men Talk*, a conversation between the director (*sutradhara*), and two assistants. One of the assistants takes on the role of a Jester, *vidushaka* (NS 5: 28–29). In its description of the *Three Men Talk,* the Natyasastra points out that the jester "should come in and deliver a discourse consisting mostly of irrelevant words to excite the smile of the Director" (NS 5: 137–138). The comic nature of the discourse is explored further, suggesting that it is not entirely comical, and certainly not meaningless, but serves, in its comical and amusing way, the purpose of "leading to the plot of the play" in a way that does raise some controversy in relation to a topic explicitly qualified as "not unpleasant." The dispute will be between the two assistants, one of whom is the Jester. The other assistant finds fault with the Jester's words, but the Director supports the Jester (NS 5: 138–141).

Comedy as *Rasa*

Comedy is ingrained in Natyasastra not only through this introductory character, but at a much deeper level, indeed at the very core of the aesthetic conceptualization of the dramatic event in the theatre, *rasa,* defined as the aesthetic experience created within the spectator by the actor through the means of acting he employs. In specific situations in the play (determinants),

the actors employ means of histrionic representation (consequents) to achieve *rasa*. In this process, dominant states (*sthayi bhava*) combine with transitory states (*vyabhicari bhava*) and temperamental states (*sattvika bhava*).

The Natyasastra describes eight, of which the second is the comic, *hasya*. Its dominant state is mirth, its transitory state joy. It arises from the erotic *rasa:* "A mimicry of the Erotic [sentiment] is called the comic ..." (NS 6: 39–41). Abhinavagupta provides further information in his commentary on the Natyasastra to the effect that

> desire is common to all beings and the appeasement of it pleases. Therefore, *sringara* [the erotic *rasa*] has been chosen as the first *rasa*. Sringara carries a lighter vein of humour along with it. *Hasya* (humour) is conducive to *sringara*. Therefore, *Hasya* (humour) is the second *rasa* [Rai 1992: 94].

According to Tarlekar, Abhinavagupta further comments that laughter is produced from impropriety (1991: 57). When *Hasya* relates to *Sringara,* it does not weaken *sringara*. "But when *Hasya* arises out of the impropriety of sentiments like the Pathetic etc., that sentiment is at once weakened, as it becomes ridiculous" (1991: 57). Rai refers to Sharadatanaya, a further commentator on the Natyasastra:

> When Parvati entered into copulative act with the knotted-haired, the stave-wearing, the perpetually enjoying Shiva, a great laughter arose among the (women) friends of Parvati. Hence, *hasya rasa* rook roots from *sringara* [1992: 95].

According to the Natyasastra, the color associated with the comic *rasa* is white (NS 6: 42–43), and the presiding deity of the comic is *Pramathas.*

In its detailed description of the comic *rasa* (*hasya*), the Natyasastra explains that *laughter* is the dominant emotion at the basis of *hasya*. The Determinants (situations in the play when the creation of the *rasa* is appropriate) are "showing unseemly dress or ornament, impudence, greediness, quarrel, defective limb, use of irrelevant words, mentioning of different faults, and similar other things" (NS 6: 47–48). The Consequents (means of histrionic representation to present *hasya* on stage are "throbbing of the lips, the nose and the cheek, opening the eyes wide or contracting them, perspiration, colour of the face, and taking hold of the sides" (p.110). Transitory states in it are "indolence, dissimulation, drowsiness, sleep, dreaming, insomnia, envy and the like" (NS 6: 47–48). The comic *rasa* is described by the Natyasastra as being of two kinds: a person may laugh him/herself, or he/she makes others laugh. *Hasya* is therefore either self-centered or centered in others. This "sentiment is mostly to be seen in women and persons of the inferior type" (NS 6: 51).

The characteristics of the comic *rasa* are further differentiated with regard

to their intensity, and associated with the types of person for whom different intensities are associated. Thus there are the slight smile, and the smile for persons of the superior type, gentle laughter and laughter of ridicule for persons of middling type, and vulgar laughter and excessive or violent laughter for persons of the inferior type. Depending on the source, the slight smile is also referred to as gentle smile (Rai 1992: 78), the laughter of ridicule as ridiculous laughter (Rai 1992: 78) or satirical laughter (Rangacharya 1966: 54), the vulgar laughter as uproarious laughter (Rai 1992: 78) or silly laughter (Rangacharya 1966: 54), and the violent laughter as convulsive (Rai 1992: 78) or loud laughter (Rangacharya 1966: 54).

The slight smile, the Natyasastra explains further, "should be characterised by slightly blown cheeks and elegant glances, and in it the teeth should not be visible" (NS 6: 54), while the smile of superior people is portrayed by "blooming eyes, face and cheeks, and in it the teeth should be slightly visible" (NS 6: 55). Gentle laughter is expressed through "slight sound, and sweetness [...] and in it the eyes and the cheeks should be contracted and the face joyful" (NS 6: 56). During laughter of ridicule, "the nose should be expanded, the eyes should be squinting, and the shoulder and head should be bent" (NS 6: 57). Vulgar laughter is defined as laughter that comes at unsuitable moments, with tears in the eyes, or shoulders and head shaking violently (6. 58), while in excessive laughter, the "eyes are expanded and tearful sound is loud and excessive, and the sides are covered by hands" (NS 6: 59). The causes of the comic *rasa* are the same as for the terrible *rasa:* "of limbs, dress and words" (NS 6: 77).

The dominant state relating to *hasya rasa* is laughter, caused by Determinants such as "mimicry of others' actions, incoherent talk, obtrusiveness, foolishness and the like" (NS 7: 9). The transitory states related to the comic *rasa* are apprehension, envy, weariness, inconstancy, dreaming, sleeping, dissimulation (NS 7: 109). The Natyasastra provides a considerable amount of detailed description of the movements of different parts of the body in relation to achieving *rasa*. In the context of the comic *rasa,* the following stand out. With reference to the depiction of *glances,* the Natyasastra provides this guidance: "the two eyelids are by turns contracted and they open with the eyeballs moving and slightly visible" (8.46, p. 153); and "*Hrsta:* The Glance which is moving slightly bent, and in which eyeballs are not wholly visible, and there is winking, is called *Hrsta* (joyful); it is used in laughter" (NS 8: 54). There is further material with reference to the eyes, eyebrows, nose, cheeks, lower lips, chin, mouth, and color of the face.

Chapter 13 of the Natyasastra deals with the gaits that are appropriate to different characters in different situations, again with the aim of describing how the gait contribute to the creation of the appropriate *rasa*. Only middling

and inferior characters relate to the comic *rasa*. "In their astonishment and joy they are to take swift and short steps in all directions and in their laughter, too, they are to take to this and similar foot movements" (NS 13: 59–60). The Jester is described in the Natyasastra as having a gait consisting of "simple laughable steps with feet raised high [and put forward]" (NS 13: 137–140). This kind of gait is related to three kinds of laughter, in relation to the limbs, such as ugly and big teeth, a hunchback, lameness or a distorted face, in relation to words, such as talking incoherently, meaninglessly, unnaturally, or uttering obscene words, and in relation to costume, such as tattered clothes, or being covered in ink or lamp-black (NS 13: 137–146).

Suitable language is the topic at the center of Chapter 18, where the Natyasastra indicates that the appropriate language for the Jester is *pracya*, with "an abundance of pleonastic *Ka*" (NS 18: 18.50). The way the language is written needs to comply with specific rules in order to achieve the best impact on the development of *rasa*. These must be reflected in the recitation of the language, ranging from notes (the comic *rasa* is to be rendered in the *svaras* (notes) of *Madhyama* and *Pancama* (NS 19: 18–37), in the accent circumflex (*svarita*) (NS 19: 43); the intonation must be slow (NS 19: 58–59). The enunciation for the comic *rasa* "should include Presentation, Separation, Brilliance and Calming" (NS 19: 58–59). Presentation is further defined as "reciting something by filling up the auditorium with graceful modulation of voice," Separation "is due to pause," Brilliance "means the gradually augmented notes which proceed from the three voice registers, and Calming means lowering the notes of high pitch without making them discordant" (NS 19: 58–59). Finally, the tempo of the notes should be medium for the comic *rasa*.

Comedy, *Rasa* and Pure Consciousness

I have argued in detail that the experience of *rasa* combines the experience of pure consciousness and the theatre-specific contents of any given performance (2005). Pure consciousness is devoid of any contents, aware only of itself. Its coexistence, in experience, with waking or dreaming or sleeping, is characteristic of higher states of consciousness. The experience of *rasa*, then, is an experience of a higher state of consciousness. In a performance that complies fully with the multiple rules and suggestions contained in the Natyasastra, the actor experiences *rasa* and thus a higher state of consciousness. The actors' art and their experience of *rasa* have an impact on the experience of the spectator. Spectators observe the actors' movements, their costume and make up, and their language, and, on a more subtle level, spectators sense the actors' pure consciousness. This holistic reception process leads, in the spectator, to development

of consciousness in the sense that any physical, emotional, or mental obstacles to the experience of pure consciousness together with the contents of the performance, i.e., any obstacles to the experience of *rasa,* are removed. Such potential obstacles are related to the contents of plays, to the events depicted, to the characters featured—the Natyasastra depicts everyday situations, with everyday problems and issues, which mirror those of the audience, whether they are aware of it or not. All of those events and characters are presented in such a way that not only does the nature of the events and characters become very clear but all the means of histrionic representation, of acting that the actors employ to express those details of events and characters, serve to bring about the experience of pure consciousness, and with it the experience of higher states of consciousness. In the combination with pure consciousness, as *rasa* in the performance context, any events, characters, or character traits that could be considered undesirable under everyday circumstances, shed their undesirable nature and are elevated to contents of aesthetic experience. Thus elevated, they trigger the removal of obstacles to the experience of pure consciousness where they exist in actors and spectators. By further definition of a higher state of consciousness, because its experience is suffused with pure consciousness, its contents cannot be detrimental to anyone, neither the person who experiences the higher state of consciousness, nor anyone else.

Some essential characteristics of comedy as described in the Natyasastra are problematic from a contemporary perspective. In line with much comedy writing and theory of comedy in the West, there is, in the Natyasastra, an emphasis on more lowly characters, "middling" and "inferior," and women come in the same category. Much fun is made of things that would be controversial today, such as people's congenital issues, for example, lameness, facial distortion, problems with speaking, or a physical deformity like a hunchback. It is important to understand these potentially problematic implications of the Natyasastra in more depth, so as to do the text full justice.

It is possible, to start with, that the text of the Natyasastra itself is corrupt in the passages that appear problematic: there may be later additions that are based on misunderstandings or reflect a deterioration of taste and ethics characteristic of the time when the additions were composed and added. Further textual studies may provide evidence as to whether this is a viable argument.

Assuming, however, for the moment that the Sanskrit Natyasastra is not corrupt, there may be issues with the translation. The information about the comic *rasa* provided above is based on the 1950 translation of the Natyasastra by Ghosh. Cross-referencing to other translations does not reveal any differences. Assuming, further, that the translations are accurate, there is a possible clue for the problematic aspects of the Natyasastra in relation to the comic *rasa* in the Natyasastra's own claim that drama (*natya*) presents everything

there is in life, good, bad and neutral, across all human castes and all lower and higher non-human beings, including animals and gods. The Natyasastra's main purpose is to restore the Golden Age, which has just begun to deteriorate into the Silver Age. While the Golden Age was characterized by life at all levels in accordance with natural law, or divine law, and thus free from problems or difficulties of any kind, problems and illness and undesirable aspects have entered life with the onset of the Silver Age. These are being depicted in *natya,* rather than silenced or ignored; there are, in the world in the Silver Age, people who are stupid, who behave foolishly, who have speech defects on physical defects, and there are others who, in their ignorance, laugh about those characteristics of human appearance and behavior that deviate from the "norm."

Conclusion

The Indian philosophical or religious context of reincarnation might provide further perspective for this discussion. This context assumes that people are reborn after they have died; the new life is the result of actions in previous lives. In consequence, someone's birth with features or behavior that deviate from the norm, the way they cope with such deviation, and especially the amount of suffering resulting from the deviation, such as physical pain, and any suffering resulting from the way such people are treated by other people, can all be accounted for as things they received in immediate, direct, reaction to behavior in previous lives—not as a simplistic punishment, but as an expression of a natural law, which provides them with the opportunity to address the issues they were born to tackle. An awareness of these processes of reincarnation may make it easier for spectators to laugh at the outward signs of deviance from the norm, in particular in the context of a theatre performance, where there is at the same time an awareness that they are not in the presence of a person who is really mentally or physically disabled, but in the presence of an actor.

Expanding the discussion of the problematic aspects of the Natyasastra's position on the comic *rasa* even further, and beyond the strictly Indian context, it is possible to contextualize particularly the apparently misogynistic attitude inherent in the suggestion that the comic *rasa* is predominantly to be found with inferior characters and women. According to St. Germain, one of the Ascended Masters in theosophy and other esoteric traditions, the purpose for souls to be incarnated as humans on the planet earth is for them to be able to develop the feminine side of their nature, irrespective of whether they are born as man or woman (2004: 87). It stands to reason that under such conditions, a high level of opposition against and unfairness towards women will represent

the starting point that needs to be recognized and acknowledged before change can be implemented.

NOTES

1. Ruhig, klar, frei, heiter, wir fühlen uns weder tätig noch leidend, wir schauen an, und alles bleibt außer uns; dies ist der Zustand der Götter, die sich um nichts Menschliches bekümmer n, die über allem frei schweben, die kein Schicksal berührt, die kein Gesetz zwingt.

2. Denken Sie sich aber den Genuss, in einer poetischen Darstellung alles Sterbliche ausgelöscht, lauter Licht, lauter Freiheit, lauter Vermögen—keinen Schatten, keine Schranken, nichts von dem allen mehr zu sehen (1855).

3. The first verse of Rigveda is transliterated as Agnim ile purohitam/yagyasya devam ritwijam/hotram ratna dhatamam (Maharishi Mahesh Yogi 1997, 151–2). This is the conventional translation: Laud Agni, the chosen Priest, God, minister of sacrifice, the hotar, lavishest of wealth (Griffiths 1896).

4. All references are to the Ghosh translation of the Natyasastra.

BIBLIOGRAPHY

Forman, Robert K.C. 2004. *Grassroots Spirituality: What It Is, Why It Is Here, Where It Is Going.* Exeter: Imprint Academic.

Ghosh, M., ed. and trans. 1950. *The Natyasastra. A Treatise on Hindu Dramaturgy and Histrionics.* Calcutta: The Royal Asiatic Society of Bengal.

Körner, C.G. 1855. "Nachrichten von Schillers Leben." *Schillers Sämtliche Werke.* Stuttgart: J.G. Cotta'sche Buchhandlung. 1–12.

Maharishi Mahesh Yogi. 1997. *Perfection in Education.* Jabalpur: Maharishi Vedic University Press.

Orme-Johnson, Rhoda, and Susan Anderson, eds. 2010. *The Flow of Consciousness: Maharishi Mahesh Yogi on Literature and Language, 1971 to 1976.* Fairfield: Iowa: Maharishi University of Management Press.

Rai, Rama Nand. 1992. *Theory of Drama: A Comparative Study of Aristotle and Bharata.* New Delhi: Classical Publications.

Rangacharya, Adya. 1966. *Introduction to Bharata's Natya-Sastra.* Bombay: Popular Prakashan.

Saint Germain. 2004. *Das Tor zum Goldenen Zeitalter.* Seeon: ChFalk.

Schiller, Friedrich. 1879. "Ueber den Grund des Vergnügens an tragischen Gegenständen." *Schillers Sämmtliche Werke.* Stuttgart: J.G. Cotta'sche Buchhandlung, 517–526.

Shear, Jonathan, and Ron Jevning. 1999. "Pure Consciousness: Scientific Exploration of Meditation Techniques." In Francisco Varela and Jonathan Shear, eds., *The View from Within: First-Person Approaches to the Study of Consciousness,* 189–210. Thorverton: Imprint Academic.

Stace, W.T. 1960. *Mysticism and Philosophy.* London: Macmillan.

Tarlekar, G.H. 1991. *Studies in the Natyasastra: With Special Reference to the Sanskrit Drama in Performance,* 2d. ed. Delhi: Motilal Barnasidass.

Brat Tvam Asi:
Rasa as a "Conscious State"

David Mason

Among other laudable events, Madison, Wisconsin, is home each Memorial Day weekend to the world's largest bratfest. Each year the festival sets another world record for the consumption of what the dictionary describes as a type of fine German pork sausage that is typically fried or grilled, a definition that does not quite do justice to the slightly scorched packets of pulpy pig meat and melted fat, laid in hot dog buns, offering themselves up to dressings of sauerkraut, onions, pickle relish, mustard, barbecue sauce, and (in the case of the Madison Bratfest) several different colors of ketchup. Paying charity prices, the good folks of Madison and environs reportedly consumed 208,752 brats during the long holiday weekend in May 2009. Some years ago, while a graduate student with a family and no income in Madison, I looked for the annual advent of the World's Largest Bratfest at the end of each academic year not only as a marker of the conclusion of another year of study, but—coming as the Bratfest does at the end of the six months of harsh winter to which Wisconsin is annually subject—as the sign of surviving yet another hair-freezing season. You can imagine, probably, the appetite with which the hungry and penniless graduate student awakes on Memorial Day, to the sun through the window and not to an alarm clock, to a day free at the outset from classes taken and taught, from final exams, from research projects, from lectures to prepare, and from undergraduate papers to evaluate. A day in which the blue sky visible through the window does not belie a tooth-grinding frost, but frankly promises comfort. You can imagine, surely, the anticipation with which he drives with wife and children in his brown Chevy Nova, coatless, windows halfway down, toward the black smoke wafting on the horizon. You can appre-

ciate, I am sure, his delight in the fortuitous parking space and the spring breeze across the asphalt they meet outside the car that carries to their noses the smell of blackened pork grease, the smell of the goodness of the world. Perhaps you can sense the thrilling air around them, leavened with the happy laughter of their fellow men and seasoned with the upbeat tunes of Adam Isaac & The People, as they walk past the Johnsonville Brats Semi-Tractor-Trailer-Grill to the local news anchor woman who hands them, with her television smile, four brats and two hotdogs with Pepsi for a pittance. And you must know the moment, in an easy chair, in the spring breeze, with family and friends and a warm pile of pork and sauerkraut in each hand—the moment when that first bite snaps and all the world is sun and music, humanity and melted fat. The moment for which the best description is "Ahhh."

This moment may be the kind of experience to which the Sanskrit writer Bharata referred in his Natyasastra with the enigmatic term *rasa*. Apparently to articulate the operation of dramatic arts and their effects on particular audience members, Bharata employs the term *rasa* in the sixth book of his variously-dated work.[1] The term is significant to dramatic and literary theory by the time of Anandavardhana in the ninth century, CE, and in the eleventh century the term becomes a central concept in the religio-aesthetic philosophy of Abhinavagupta.[2] Following Abhinava, discussions of art and religion can hardly proceed without acknowledging *rasa*'s indispensability, until, in contemporary criticism in India, all art is measured, principally, with regard to its *rasa*. As important as *rasa* is to understanding art, we are still trying to understand what *rasa* is. While at Banaras Hindu University, G.B. Mohan Thampi acknowledged that *rasa* "has a bewildering variety of meanings" (Thampi 1965: 75). Edwin Gerow, who knows book six of the Natyasastra and its derivatives as well as anyone, declares that his own translation of part of Abhinavagupta's commentary deliberately translates all the original Sanskrit terms that other translators leave, so as to avoid "the false security of the Sanskrit, which now has become a jargon that exists entirely aside from normal communicative language" (Gerow 1994: 193). But even Gerow leaves the term *rasa*. Indeed, the word has become a kind of jargon, used frequently and loosely in reference to the experience of art, as though it has some useful meaning that we can all perceive, even if we can't articulate it.

Like medieval Christianity's *via negativa*, trying to understand what *rasa* is, more often than not, consists of determining what it is *not*. It is *not* emotion. And it is not feeling. Although emotions and feelings certainly inform our most profound experiences of dramatic art, the Natyasastra distinguishes between *rasa* and emotions and feelings, using a complex array of variations of the word *bhava* (*vibhava, sthayibhav, anubhava, vyabhicaribhava...*). In typically obscure language, the Natyasastra distinguishes between *rasa* and

bhava by suggesting that one produces the other: "As a spicy (flavour) is created from many substances (*dravya*) of different kinds, in the same way the *bhavas* along with (various kinds of) acting, create *rasas*" (Masson and Patwardhan 1970: 47). Which seems like a step in the right direction. At least, at this point, we can begin to think of about what kinds of phenomena, in our experience, emotions and feelings create. That must be *rasa*. But the text goes on almost immediately to distinguish between *rasa* and *bhava* in just the opposite way: "*bhavas* and *rasas* create each other. As a tree arises from a seed, and from the tree a flower and fruit, so all the *rasas* are the roots, and on them are founded the *bhavas*" (Masson and Patwardhan 1970: 47).

So another thing that *rasa* is not is a created thing. The emotional expression of actors does not generate whatever the *rasa* experience might be. *Rasa* seems to manifest in audiences concomitantly with the dramatic artistry they encounter, but not as a result of that artistry. In correspondence with Eliot Deutsch, Edwin Gerow stipulates the "uncreatedness" of *rasa*. "There is no cause and effect relationship," writes Gerow, "because the *rasa* is what is really there, and has been there" (Deutsch 1981: 225, n. 11). In an article of his own, Gerow reiterates, "no determinate relationship is possible, for the *rasa* is more real and more persistent than any of its so-called causes; it has been there all along, and only requires recognition" (Gerow 1981: 235). In an obscure way for the Natyasastra, and in a more confident manner for later commentators, *rasa* has a relationship with emotions, but is not dependent on them, nor brought about by them. *Rasa* is described in the classical literature very much as a self-existing thing.

Indeed, to push the matter out into even more murky waters, *rasa* is not a *thing* at all. One of the reasons *rasa* becomes important for religious discourse in the tenth and eleventh centuries is that Bharata's characterization of *rasa* as not determined by material elements of performance lends itself to understanding the phenomenon as *alaukika*, "otherworldly" or "immaterial." *Rasa*'s supernal "reality," which Gerow notes above, lies in the permanence it enjoys from not being rooted in anything material. The play, the actors, and the audience, will all disappear, but *rasa* will remain. So *rasa* is the "real" thing. You and I and the actors are unreal. For this reason, the argument that finally triumphs in Abhinavagupta's commentary is that actors don't experience *rasa*—it is a phenomenon beyond the capacity of those so deeply embedded in the material production of the performance. At least the audience can hope their experience may transcend the matter of the theatrical performance so as to reach the plane of *rasa*.

Pointing out what *rasa* is not is the easy part. Deutsch summarizes the "notness" of *rasa* nicely as "neither subjective nor objective; it neither belongs to the artwork nor to the experiencer of it" (Deutsch 1981: 215). Which might

leave us to wonder if we're not still trying to figure out not what *rasa is*, but what *rasa was*. It is possible, as Gerow implies, that what the Natyasastra speaks of is rooted in a specific temporal, cultural, and artistic circumstance that is now lost for good. Perhaps *rasa* was an experience of fourth century, CE, Sanskrit theatre audiences of the Himalayan foothills, and our attempts to know *rasa* in the context of twenty-first century performance art, postmodern novels, the ballet, and *The Lion King* are futile.[3] If we can't enjoy the experience ourselves, it is no wonder that the best we can do is delineate the boundaries of its absence.

It certainly has been popular to argue against universal human experience. New Historicism, among other critical approaches, thinks of human experience as fundamentally and inextricably embedded in particular cultural circumstances, and there are certainly very good reasons, as postcolonial theory has insisted, to resist tendencies to conflate disparate experiences, since such conflations often empty the histories of particular peoples of the meaning they uniquely derive from their experience. Even so, cognitive theory of the recent couple of decades employs compelling neurological evidence to argue that some human experience derives fundamentally from the ways in which human bodies interact with their physical environments. Given essential similarities between human bodies and between the physical environments available in the world, and given the limits on the range of ways in which human bodies can interact with those environments, the notion that we can recognize some experience and some meaning across cultures and historical periods is not absurd. While acknowledging the significant influence of unique cultures on the development and appreciation of art, renowned neuroscientist V.S. Ramachandran argues that "10 percent" of art and art appreciation comes from "artistic universals" (Ramachandran 2004: 41).[4] Those universal elements that account for the infinitely unique and yet commonly understood phenomena of art derive from, according to philosopher Mark Johnson, a common human "grounding of metaphors in bodily experience" (Johnson 2007: 259). Implicit in this approach to artistic phenomena is the possibility that *rasa* may not refer to an obscure relic, but may yet be a useful, an *understandable*, term that can lend clarity to our most profound and perplexing aesthetic experiences. The interest of cognitive theory in human consciousness and in the way that consciousness accesses and invests meaning in the experience of the body in which it is embedded may help us move beyond the *via negativa* of *rasa*, to a better understanding of what it *is*. The articulation of *rasa* in the terms of cognitive theory will be a broad discussion. My focus here will be on what contemporary cognitive theory might tell us about the Natyasastra's paradoxical assertion that whatever *rasa* may be, it operates apart from any material grounding, is not created, nor is it "had"—not embedded in artistic training or techniques.

Human consciousness is similarly understood more often by what it is not. In *Second Nature*, neuroscientist and Nobel laureate Gerald Edelman insists that human consciousness is not computation, is not logical, is not precise—that "artificial intelligence" such as we know it has nothing whatever to do with the mystery of human consciousness (Edelman 2006: 21). Nor, says Edelman, does consciousness have a clearly identifiable cause. While bioelectric signals across brain neurons accompany consciousness, they do not *cause* consciousness. Instead, "neural action *entails* consciousness" (Edelman 2006: 40). Things we might have supposed are causes of consciousness do make a difference, of course. Edelman has many colleagues who join him in noting that the most important thing to understand about the human brain, at least in the context of coming to understand how and why it does what it does, is that it is embodied and embedded (Edelman 2006: 24). That is, the brain is a physical, organic entity, like a heart or a liver, which operates on physical and organic principles. Secondly, the function of this organic entity is interaction with its environment. The brain *goes*, so to speak, on account of the input it receives about its environment. Motion and space, aromas and breezes and the like, have an effect on the way the brain operates.

However, while these physical stimuli certainly affect the function of the brain, they do not, of themselves, bring about the kind of conscious reflection that uniquely characterizes human sentience. To paraphrase V.S. Ramachandran, if you are not conscious of being conscious, you are not conscious at all. The brains of animals in possession of primary consciousness—dogs, for instance—are similarly affected by motion and space and other physical circumstances in which their brains are also embedded. As Edelman points out, such animals do not, apparently, have a concept of the past or future, nor (what is especially important) do they have a "nameable self" (Edelman 2006: 15). The consciousness of consciousness that a nameable self requires is not a product, simply, of the embedded brain's interaction with its environment, and it eludes attribution to any particular cause, other than the operation of consciousness itself.

Hence, following William James, Edelman characterizes human consciousness not as a thing, but as a process (Edelman 2006: 41). Various regions of the human brain communicate with each other along axons, neural pathways that are opened and reinforced and shifted continually by brain activity, resulting in what Edelman calls "reentry," or a condition in which the brain speaks to itself (Edelman 2006: 37). This process of intra-brain dialogue gives rise to consciousness, itself a process, which, in highly developed, human brains consists not only of "awareness" (primary consciousness), but "consciousness of consciousness" (Edelman 2006: 40). Edelman's understanding of consciousness at this level merits quoting at some length:

Conscious states are unitary but change serially over time. They have wide-ranging contents and access. Their range is modulated by attention and, although in large measure they show intentionality—they are about objects or events—they do not exhaust the domains to which they refer. Above all, they entail subjective feelings or qualia. My thesis is that the evolution of a reentrant thalamocortical system capable of giving rise to the dynamic core allowed the integration of vastly increased complexes of sensorimotor inputs.... In brief, conscious states reflect the integration of neural states in the core [Edelman 2006: 39–40].

A conscious state is, here, conceived as a unitary condition, sharing a relationship with physical circumstances, but neither encapsulated in nor arising from those physical circumstances; rather, a conscious state accompanies the brain's own perception of condition, so that consciousness can be understood as a process in which the brain communicates within and between its own components, especially to account not only for environmental effects on the brain, but to account, reflectively, for the condition, or state, of the brain (and, by extension, the human) itself.

Whatever the cause may be, then, the important function of consciousness is organizational, and the brain has developed a number of competencies to facilitate this function, perhaps the most important of which is subjectivity. The brain searches out regularities and cohesion so as to provide itself (its self) with an ordered context in which it can distinguish itself and its state from everything else. For Edelman and others, consciousness is a process through which the brain keeps track of itself by ascribing attributes to the stuff of existence so as to appraise in dialogue with itself its interaction with that stuff. However, since the brain is not a computer and the world does not offer it distinctly binary input, the order that ensues relies on a variety of subjective—reflective—elements, which revolve in the brain in the form of assessments. Just how blue is the sky? How cool is the breeze? *Qualia*, the term that cognitive science employs here, refers to the subjective qualities of things and events and conditions the brain encounters—ascriptions to the things we encounter that are integral to the brain's responsibility not only to sense other things, but to sense its self and its condition amid the wash of stimuli it encounters.[5] In its understanding of what constitutes consciousness, second generation cognitive theory emphasizes the role of qualia, which provide the feedback that is essential to intra-brain dialogue. Ramachandran characterizes qualia as "metarepresentations" of the significance of particular sensory stimuli, and regards them as indispensable elements of the evolution of conscious selfhood (Ramachandran 2004: 103).[6] Consciousness seems to arise in the individual only in its ongoing, reflexive assessment of qualia. You not only sense the sunlight into which you step on a bright, Memorial Day weekend, your brain

measures the value of the sunlight within the context of its experience of sunlight and reports back to itself on the especial quality of *this* sunlight, all other things being equal.

Of course, all things are never equal: the brain has to account to itself for that, too. Consider Ramachandran's description of what the brain does when it encounters something as straightforward as an apple:

> If I see an apple, it is the activity in the temporal lobes that allows me to apprehend all its implications almost simultaneously. Recognition of it as a fruit of a certain type occurs in IT (inferotemporal cortex), the amygdala gauges its significance for my well-being, and Wernicke's and other areas alert me to all the subtle nuances of meaning that the mental image including the word apple evokes; I can eat the apple, I can smell it, I can bake it in a pie, remove its pith, plant its seeds, use it to "keep the doctor away," tempt Eve, and on and on [Ramachandran 2004: 101].

In spite of the great potential for confusion as to what this object is and what it may mean, an apple is most often simply an apple—straightforward, after all. In fact, the subjective nature of qualia helps the brain to stitch the apple together in a unified, not-confusing, whole.

As the philosopher John Dewey brilliantly articulated a century ago, we don't encounter apples or sunlight, *per se*, isolated from the rest of existence. Dewey employed the term "situation" to denote how our experience is not fragmented into bits of qualia here and there to which we give fleeting attention as best we can. Rather, the complexity "is held together in spite of its internal complexity by the fact that it is dominated and characterized throughout by a single quality" (Johnson 2007: 72). We move from scene to scene, each of which is remarkably unified, in spite of how nearly infinite and impossibly contradictory are each scene's constituent qualia. The brain's reflective capacity interacts with qualia to forge this impossible unity by addressing the relative significance of individual qualia to its self, the process of which not only contributes to the hierarchy of relative valuing the brain gives to various qualia, but to the construction of a unified self to which one aspect of an apple will matter more than another. The very reflective nature of consciousness lends unity to our selves and to our circumstances. Consciousness and the self arise together, neither producing the other, but each dependent on the concomitant operation of the other.

We can speak similarly of *rasa*. It is, in cognitive terms, a "state of consciousness"—a process that organizes stuff and contributes to selfhood. Neither an objective quality of a particular dramatic artwork nor purely a subjective feeling experienced by an audience, *rasa* is a commensurate operation that distinguishes and relates the artwork and the audience, and through which the audience comes to know its self. Quoting Abhinavagupta, Deutsch calls

rasa "the process of perception itself" (Deutsch 1981: 215).[7] As consciousness, generally, arises in conjunction with the operation of perceiving the world, so *rasa*, specifically, arises not as the perception and appreciation of a dramatic performance, *per se*, but as a state that is commensurate with the operation of perceiving the dramatic performance.

In his discourse on *rasa*, the author of the Natyasastra emphasizes the role of *bhava*. In the way that consciousness accompanies qualia as they attract the attention of the brain, so, too, *rasa* accompanies the disclosure of *bhavas* to an individual. Theorists often use English terms such as *feeling* and *taste* as translations for *rasa*, but *bhava* is a closer approximation for these English words. *Bhava* is sensation itself. The physical sensation of flavor is *bhava*. The physical experience that we call *feeling*, the physical experience associated with *emotion*, is *bhava*. Mark Johnson is not the only one to point out that *feeling* and *emotion* are not the same thing (Johnson 2007: 59). The author of the Natyasastra, also, understood as much. In fact, as indicated above, in its propensity to discriminate and categorize, the Natyasastra identifies an array of *bhavas*, including *sthayibhavas*, *anubhavas*, *vibhavas*, *vyabhicharibhavas*, and others. These subsets are all distinct, and all play different roles in the development of *rasa*, but a labored explication of each is unnecessary here. It ought to be enough, here, to say that the various *bhavas* are those experiences identified with physical experience—pain, pleasure, taste, emotion, feeling, and so forth. This list will also include some concepts we can regard as abstract, rather than physical, such as *fear* and *sorrow*. When the Natyasastra identifies these concepts with *bhavas* (as it does in 6: 17), it has the physical feeling that characterizes these concepts in mind.[8] Because the Natyasastra uses a metaphorical analogy that likens *rasa* to the effect of the "savoring" of the *bhavas* in the way that a person can savor spicy food (6: 31–33), some modern commentators have mistakenly identified *rasa* with the physical mechanism of tasting and enjoying food.[9] But the classical *rasa* theory seems to reserve its various classes of *bhava* to account for the experience our bodies have, including the subjective interpretation of that experience. "Oh, I've just smelled some kind of charring pork product" is a *vibhava*—the encounter with a physical source of experience. The subsequent "and it smells delightful (and makes my mouth water)" is not *rasa*, but a *sthayibhava*—the subjective appreciation I have of the physical experience of the smell. In a theatrical context, which, as Gerow points out, is the Natyasastra's concern as opposed to "art" in general (Gerow 1981: 228), *vibhava* denotes the actors—how they look and sound, and what they do—and *sthayibhava* indicates the audience's sympathetic, emotional experience of the performance, as Gerow points out. The audience moves, says the Natyasastra, from *vibhava* to *sthayibhava* via a discrete process in which there are many stages (and many other *bhavas*). Which is to suggest

that the Natyasastra's *bhava*s correspond roughly with what the second-generation cognitive scientists are calling *qualia. Bhava*s denote what the embedded brain can encounter and the direct and subjective attention the brain gives to those encounters.

Just as qualia and their subjectivity entail consciousness as an organizing principle that both foments and depends on the discrete, "nameable" self of the individual who experiences them, so the *bhava*s entail *rasa* as that process by which the self becomes aware of itself. *Rasa*, writes Gerow, is "a principle of organization ... an emotional consciousness, wherein all the disparate elements of the play—language, gesture, scenery—have a place and are understood not to be disparate" (Gerow 1981: 230). *Rasa* organizes and unifies what are otherwise distinct stimuli, without obligatory relationships to each other, and this process of organization entails an individual's sense of self as a distinct entity with the capacity for unified experience. Abhinava, consequently, concludes that the various *bhava*s on which the *rasa* phenomenon depends is the self itself (Gerow 1994: 188).

No wonder that the Natyasastra lays great emphasis on the role of the audience member, who should be *sumanas*, well disposed, or, perhaps, of a like mind with the production, and also *budha*, knowledgeable or conscious.[10] Nothing really exists in the production. For the tradition of the Natyasastra, the actors, the costumes, the lighting, even the language and the philosophy, in a play are all transitory stuff that finds its existence only in the organizational process of the audience's apprehension.[11] Since the audience member's very self is the site of *rasa*, in spite of the various gustatory analogies used to describe it, *rasa* cannot be mixed by performers and handed to an audience as on a platter. Performers might "mix" and "serve" *bhava*'s of various sorts, but *rasa* emerges only in the audience—in what Masson and Patwardhan characterize as the audience's "personal involvement"—in its conscious apprehension and appreciation of the *bhava*s (Masson and Patwardhan 1970: 25). Hence, the audience must "bring a highly developed understanding, sensitivity, and life history to bear on the work" (Deutsch 1981: 216). The audience member must be very actively involved in the theatre-going activity, herself engaged in the measuring and mixing of light and shadow, feeling and emotion, language and thought, since this is the reflexive assessment of qualia as encountered in the performance. Just as Ramachandran's encounter with the apple has increasing potential in concert with the scope of what he brings to the encounter, so the audience member's capacity to experience *rasa* increases in a relation proportional with what is already embedded in the neural pathways she brings to the theatre. Not that this measuring and mixing necessarily occurs at a conscious level. As Abhinavagupta asserts, you cannot tell someone to create *rasa*, or even to experience it (Masson and Patwardhan 1970: 32). As consciousness

and the character of conscious experience that comes with it, *rasa* depends on degenerate neural pathways that form and operate as a consequence of a particular audience member's life experience, but that respond to new experiences in creative, astonishing, and unpredictable ways.

Describing *rasa* as a conscious state arising alongside an audience member's experience and reflexive assessment of stuff does not necessarily characterize *rasa* as essentially subjective. At least, a description of *rasa* as a state of consciousness will fail unless it somehow accounts for the Natyasastra's insistence on the impersonality and universality of *rasa*. Partly because the Natyasastra refuses to locate *rasa* in the material stuff of art, and refuses to identify it with emotion and feeling, it has to think of *rasa* as immaterial and impersonal (and, hence, universal). If a play and any *rasa* experience that accompanies it are to have any substantive meaning, the Natyasastra suggests, they must involve some kind of experience that transcends the subjectivity implicit in material reality.

In classical theory, what we sometimes call aesthetic distance is essential, as *rasa* involves impersonal or "universal" experience, even while being expressly individual and personal (Deutsch 1981: 216). The audience member who aspires to *rasa* does not identify with characters and situations, and, hence, does not have a sympathetic emotional experience, and is not engrossed or "caught up" in the play. Rather, the very real *rasa* experience that so attracted the religious thinkers like Abhinavagupta falls on the audience member who apprehends the immaterial and the material content of the play as not real—as a play—and, consequently, as merely a model of something much more real than the content of the performance *can* be. We do not fall in love with Sita, says Abhinavagupta (Masson and Patwardhan 1981: 23). Or, to put it in a Western context, no matter how "caught up" in the play we may be, and no matter how much of Romeo's feeling we think we feel, we do not fall in love with Juliet. Actually, if we experience "love" at all, it is a love that is not embedded in Romeo's fictional character nor in Juliet, the fictional character, as an object, but exists apart from them both, apart from material grounding altogether, as a universal—or, at least, impersonal—phenomenon, which the relationship between Romeo and Juliet merely models.

To the extent that brain science insists on the individual brain's isolation, perhaps there is no way to reconcile theory of consciousness with the universal quality of *rasa*. However, Ramachandran's description of the brain as a model-maker may be the necessary link. Ramachandran relies on the very biologically-based understanding of the specialized neurons, the "mirror neurons," in the brain that help us to understand and relate to other people. These neurons assist us in constructing reliable predictions of what other people might do, based on what we observe, and, in the nearly infinite complex of pathways in

the brain, the result of this simple modeling of others results in imaginative assessments.

> Our brains are essentially model-making machines. We need to construct useful, virtual reality simulations of the world that we can act on. Within the simulation, we need also to construct models of other people's minds because we primates are intensely social creatures. (This is called "a theory of other minds.") We need to do this so that we can predict their behavior.... Furthermore, for this simulation to be complete it needs to contain not only models of other people's minds but also a model of itself, of its own stable attributes, its personality traits and the limits of its abilities.... The two [models] may have co-evolved and enriched each other enormously, culminating in the reflective self-awareness that characterizes *Homo sapiens* [Ramachandran 2004: 105–6].

In this view, an individual's subjectivity includes mechanisms especially evolved to facilitate vicarious experience. But as the brain cannot *actually* experience another brain's experience, vicariously, these mechanisms integrate with the brain's self-assessment, its self, to produce imaginative possible experiences— even probable experiences—of the experiences of the individuals around us. The brain does, perhaps, abstract and universalize the experience of others in very subjective ways (which is to say, in ways that creatively emerge from its own experience). We do not fall in love with Juliet (or Sita), and we do not fall in love with the actresses (or actors) playing these roles, either.[12] But we might experience *sringara rasa*—love that our brains abstract from a particular dramatic situation so as to provide us both with a sympathetic, vicarious experience of Romeo's or Ram's love and also with the "love experience" itself as an object for explicit contemplation, for "tasting."

Gerald Edelman's description, then, of "conscious states" as, primarily, the reflection on subjective feelings and the experience of qualia, suggests that *rasa* in the Natyasastra is such a conscious state (Edelman 2006: 86). Edelman's expanded description of what constitutes a "conscious state" seems equally descriptive of the kind of phenomenon the Natyasastra tries to articulate with different language:

> Conscious states themselves appear to have many of the characteristics of irreversible, contingent, and fleeting events. They are unitary but change serially in short intervals of time. They have wide-ranging contents and access to stores of memory and knowledge. They are modulated by attention. Above all, they reflect subjective feelings and the experience of qualia [Edelman 2006: 86].

Rasa, similarly, comes and goes, fleetingly.[13] *Rasa* acts as a unifying process, not only synthesizing the various elements of a dramatic production, but unifying the self of the spectator, as well. Memory and knowledge, the content

of an individual's neural network, provide the material grounding of *rasa*.[14] *Rasa* accompanies an audience member's particular (and cultivated) attention to a work of dramatic art. Certainly, *rasa* indicates a subjective condition concomitant with the experience of qualia.

For Eliot Deutsch, *rasa* as an aesthetic theory avoids the traps of Formalism, in which the audience need only open itself to receive what the art offers, and of Sentimentalism, in which the audience's own response is all-important, by emphasizing the interaction of an art-object's qualities and an audience's methods of perceiving them, in "a process wherein the artwork *controls* rather than causes the response of the experiencer, and wherein the experiencer must also bring a highly developed understanding, sensitivity, and life history to bear on the work."[15] Thinking of aesthetic experience as the interaction of art-object and individual in this way dispenses with a concern for the discrete effects that depend on causes, and, instead, examines the ongoing encounter itself.

It is not an insignificant point that my experience of the Madison, Wisconsin, bratfest tells you more about me than it does about the bratfest. The transcendent "Ahhh" moment in the culmination of my experience on Memorial Day weekend is not a *product* either of charred pork, or of sunshine, or of gentle breezes and pop music. Certainly my experience has a relationship with all these things, but they do not cooperate to *cause* my experience. The unity with which all these bratfest elements fall on my consciousness does not pre-exist my experience of it, since the sunshine and the springtime and the gentle breeze know nothing of each other. My unified experience of the bratfest tells you something of the way in which I organize my disparate experiences so as to imbue them with a coordinated meaning. Understanding this, the Natyasastra insists on the role of aesthetic distance in the *rasa* phenomenon, a distance, which Abhinavagupta extrapolates in order to characterize *rasa* as, essentially, the experience of the Self. In the classical conception, *rasa* is a mode of reflection, so that the theatrical event is but a catalyst for a state of self-awareness. *Rasa*, like consciousness, is not *caused* by encounters with the world, but is commensurate with them.

NOTES

1. Traditionally attributed to Bharata, the Natyaśâstra may be the product of several authors.
2. A tenth-century thinker, Abhinavagupta wrote treatises in the areas of philosophy, religion, and aesthetics. His commentary on the Natyasastra is considered definitive.
3. Gerow asserts, "The Indian notion of *rasa* ought also to be discussed in its context, in terms of the kind of literature it was intended to explicate, rather than, let us say, exclusively in terms of the psychological reality it evinces.... It emerged first as a principle of criticism in debates about the nature and function of drama as a discrete genre. It was not at first propounded as a universal principle" (Gerow 1981: 226, 228).

4. In an early version of Chapter Four of this book, Ramachandran explicitly cites *rasa* as an example of an artistic universal. See V.S. Ramachandran, 2002.

5. The brain often reads back the "sense" of these ascriptions metaphorically, as George Lakoff and Mark Johnson have demonstrated. See, particularly, Lakoff and Johnson, 1980.

6. V.S. Ramachandran, 2004, 103.

7. Abhinavagupta's phrase in the *Dhvanyalokalocana*, as noted by Deutsch, is *pratîyamâna eva hi rasah*. The participle *pratîyamâna* might also be translated as "knowing," so as to render the translation "*rasa* is (the process of) *knowing*." This understanding of Abhinavagupta's verse seems to be behind Edwin Gerow's declaration, "The *rasa* is a form of knowing" (Gerow 1981: 238).

8. Indeed, the Natyasastra includes some things on its list of *bhâvas* that seem rather not like feelings or emotions, including sleep and death, which it identifies as *vyabhicaribhâvas*. Kathleen Marie Higgins contends that such things as sleep and death are on the *bhâvas* list because they may "occur as side effects or consequences of an emotional state." However, I would suggest that the Natyasastra speaks of sleep and death, etc., as *bhâvas* because we distinctly experience them as physical conditions. See Kathleen Marie Higgins, 2007, 46.

9. The American professor Richard Schechner mistakenly understands *rasa* as a physical sensation equivalent to the eating and digesting of food, and coopts the term to name a battery of physical training exercises. See Schechner 2001, 27–50. The British scholar John Russell Brown equates *rasa* with the *humours*, the body fluids supposed in Elizabethan England to produce emotions and dispositions—not "tasting," as such, but confused with physical process, nonetheless. See Brown 2005, 3–12.

10. Natyasastra 6: 31–33 describes the qualities that spectators ought to possess. Masson and Patwardhan translate both *sumanas* and *budha* as "sensitive" (Masson and Patwardhan 1970: 46).

11. Gerow's assessment of Abhinava's position on this issue is that "the play is in an important sense a fiction whereas its effect is real," to the philosophical end that "*rasa* is more real than the play" (Gerow 1981: 236, 238).

12. Yes, people have been known to fall in love with actors and actresses. However, the audience member who falls in love with an actress playing Juliet does not fall in love with the actress as Romeo. The essential point here is that we *never* experience *Romeo's* love, only our experience of Romeo's love.

13. Abhinavagupta insists that it "does not persist for any length of time" beyond the moment of aesthetic appreciation itself (Masson and Patwardhan 1970: 27).

14. A much more elaborate analysis of the role of memory, or *smarana* in Sanskrit, might be possible here, referencing the essays in Barbara Stoler Miller, 1984.

15. Deutsch 1981, 216.

BIBLIOGRAPHY

Brown, John Russell. 2005. "Shakespeare, the Nasyashastra, and Discovering *Rasa* for Performance." *New Theatre Quarterly* 21.1: 3–12.

Deutsch, Eliot. 1981. "Reflections on Some Aspects of the Theory of *Rasa*." In *Sanskrit Drama in Performance*, Rachel Van M. Baumer and James R. Brandon, eds., 214–225. Honolulu: University of Hawaii Press.

Edelman, Gerald M. 2006. *Second Nature: Brain Science and Human Knowledge*. New Haven: Yale University Press.

Gerow, Edwin. 1981. "*Rasa* as a Category of Literary Criticism: What Are the Limits of its Application?" In *Sanskrit Drama in Performance*, Rachel Van M. Baumer and James R. Brandon, eds., 226–257. Honolulu: University of Hawaii Press.

_____. 1994. "Abhinavagupta's Aesthetics as a Speculative Paradigm." *Journal of the American Oriental Society* 114.2: 186–208.

Higgins, Kathleen Marie. 2007. "An Alchemy of Emotion: *Rasa* and Aesthetic Breakthroughs." *Journal of Aesthetics and Art Criticism* 65.1: 43–54.

Johnson, Mark. 2007. *The Meaning of the Body: Aesthetics of Human Understanding*. Chicago: University of Chicago Press.

Lakoff, George, and Mark Johnson. 1980. *Metaphors We Live.* Chicago: University of Chicago Press.

Masson, J.L., and M.V. Patwardhan. 1970. *Aesthetic Rapture: The Rasâdhyâya of the Nâtyasâstra,* Vol. I. Poona: Deccan College.

Miller, Barbara Stoler. 1984. *Theatre of Memory.* Columbia: Columbia University Press.

Ramachandran, V.S. 2002. "The Neurological Basis of Artistic Universals." *Interdisciplines,* 2 December. http://www.interdisciplines.org/artcog/papers/a (accessed 17 August 2009).

_____. 2004. *A Brief Tour of Human Consciousness: From Impostor Poodles to Purple Numbers.* New York: Pi Press.

Schechner, Richard. 2001. "Rasaesthetics." *TDR* 45.3: 27–50.

Thampi, G.B. Mohan. 1965. "Rasa' as Aesthetic Experience." *The Journal of Aesthetics and Art Criticism* 24.1: 46.

Rasaesthetics: The Enteric Nervous System in Performance

Richard Schechner

Where in the body is theatricality located? What is its place? Traditionally in Western theatre, the eyes and to some degree the ears, are the loci of theatricality. By etymology and by practice a theatre is a "place of/for seeing." Seeing requires distance; engenders focus or differentiation; encourages analysis or breaking apart into logical strings; privileges meaning, theme, narration. Modern science depends on instruments of observation, of occularity: telescopes and microscopes. Theories derived from observations made by means of ocular instruments define the time- space continuum. From super-galactic strings on the one hand to molecular and sub-atomic infinitesimitude on the other we "know" the universe by "seeing" it. Know = see; speed = space; distance = time; story = diachronicity.

But in other cultural traditions there are other locations for theatricality. One of these, the mouth, or better said, the snout-to-belly-to-bowel, is the topic of this essay. The mouth-to-belly-to-bowel is the "where" of taste, digestion, and excretion. The performance of the mouth-to-belly-to bowel is an ongoing interlinked muscular, cellular, and neurological processes of testing-tasting, separating nourishment from waste, distributing nourishment throughout the body, and eliminating waste. The snout-to-belly-to-bowel is the where of mixing, intimacy, sharing of bodily substances, mixing the inside and the outside, emotional experiences, and gut feelings. A good meal with good company is a pleasure; so is foreplay and lovemaking; so is a good shit.

The *Poetics* and the Natyasastra

Aristotle's *Poetics* and Bharata-muni's Natyasastra, a Sanskrit manual of performance and performance theory, occupy parallel positions in European and Indian performance theory (and by extension, throughout the many areas and cultures where European derived or Indian derived performing arts are practiced). Both ancient texts continue to be actively interpreted and debated, theoretically and in practice. Both are at or near the "origins" of their respective performance traditions, both have evoked "after texts" or "counter texts" aimed at enhancing, revising, or refuting their basic principals.

But similar as are in some ways, the two texts differ profoundly. Aristotle was an historical figure (384–322 BCE), the author of many key philosophical texts affecting, even determining, Western thought in various fields as far-ranging as the physical sciences, politics, social thought, aesthetics, and theology. The Macedonian-Greek philosopher's writings have been actively debated for nearly two and a half millennia. He specialized in dividing knowledge into knowable portions; he formulated the syllogism. Bharata-muni is a mythic-historical figure, the name of the author or compiler of a very detailed compendium concerning the religious-mythic origins and practices of *natya,* a Sanskrit word not easily translatable, but reducible to dance-theatre-music. The precise date of the NS remains in question—scholars have placed it anywhere from the 6th century BCE to the 2nd century CE. Exactly how much of the NS was the work of one person and how much the lore of many will probably never be known. Bharata-muni, whoever he was, if he was at all, wrote only the NS.

Furthermore, the NS is a "sastra," a sacred text, authorized by the gods, full of narration, myth, and detailed instructions for performers. The *Poetics* is secular, focused on the structure of drama, and dependent on the logical thinking that its author helped invent. The *Poetics* is so laconic, running in English translation about 30 pages, that some believe it to be lecture notes compiled by Aristotle's students after his death rather than the philosopher's own finished work. The NS takes the form of an extended disquisition (345 pages in the Rangacharya translation) by Bharata in answer to sages who approach him asking explain natya. Bharata begins with the story of how natya came about, what its proper subjects are, and for whom it was made.[1] Then he goes on to detail everything from theatre architecture to how to perform the various emotions to the structure of dramas, and more.

Some centuries after it was completed, the NS was "lost"—fragmented, submerged, misplaced, and unread. The NS comes to modern Indians not directly and not as a single text. The NS comes down in performance practice and as a series of interpretations. The most important interpreter is the 10th

century Kashmiri Saivite, Abhinavagupta. Through Abhinavagupta scholars discern earlier interpretations such as Bhatta Lollata, Srisankuka, Bhatta Nayaka, and Bhatta Tauta. As for the NS "itself," according to Kapila Vatsyayan, "not many texts have been systematically collated and edited and published. Hundreds [...] lie as manuscripts in public or private collections, in India and abroad, and an equal or larger number are in fragments" (1996: 115).

But this fragmentation ought not to be read as "neglect." The NS tradition is active, oral, and corporeal. It is present in performers, their teachers, and their performances. We must distinguish the absence of the NS as a text (a book brought to light in modern times mostly by Western orientalists[2]) from its presence in actual performances where it has been absorbed into, and forms the core of, a multiplicity of genres such as kathak, kathakali, odissi, and bharatanatyam which, taken together, comprising Indian classic theatre-dance. Thus the NS is much more powerful as an embodied set of ideas and practices than as a written text. Unlike the *Poetics,* the NS is more danced than read.

Thus the NS and the *Poetics* are different in style, intent, and historical circumstance. The *Poetics,* written nearly a century after Greek tragedy's heyday, constitutes only a small portion of Aristotle's enormous output. The *Poetics* lacks descriptions of actual performances; it is mostly about drama, not theatre, focusing on one play, *Oedipus,* which Aristotle offers as a model for the right way to write plays. Framed as "rational" and "historical," the *Poetics* is not regarded as sacred, although it has been, and remains, remarkably influential. On the other hand, the NS is a hybrid of myth and down-to-earth performance knowledge, far-ranging and detailed. Its author and protagonist, the semi-divine Bharata-muni, is almost certainly a pseudonym for a collective oral tradition.

But the greatest difference between the *Poetics* and the NS is that the Indian book deals in detail with performance: emotional expression as conveyed by specific gestures and movements, role and character types, theatre architecture, music. The NS considers drama (Chapters 20–21), but that analysis is not the core of the sastra. Many Indian artists subscribe to the ideal of a theatre that integrates drama, dance, and music. Traditional genres accomplish this integration in ways that do not privilege plot (as Aristotle advised) over dance, gesture, and music. And then there is *rasa.*

Rasa, First Take

Of rasa, the NS says:

There is no natya without rasa. Rasa is the cumulative result of *vibhava* [stimulus], *anubhava* [involuntary reaction], and *vyabhicari bhava* [voluntary reac-

tion.] For example, just as when various condiments and sauces and herbs and other materials are mixed, a taste is experienced, or when the mixing of materials like molasses with other materials produces six kinds of taste, so also along with the different bhavas [emotions] the sthayi bhava becomes a rasa.

But what is this thing called rasa? Here is the reply. Because it is enjoyably tasted, it is called rasa. How does the enjoyment come? Persons who eat prepared food mixed with different condiments and sauces, if they are sensitive, enjoy the different tastes and then feel pleasure; likewise, sensitive spectators, after enjoying the various emotions expressed by the actors through words, gestures, and feelings feel pleasure. This feeling by the spectators is here explained as the rasas of natya [Bharata-muni 1996: 54–55].

There is a lot going on here, and I do not intend at this time to go into a detailed explication of rasa theory. I want here to outline an overall theory of flavor as it pertains to performance, what I call "rasaesthetics."

Rasa is flavor, taste, the sensation one gets when food is perceived, brought within reach, touched, taken into the mouth, chewed, mixed, savored, and swallowed. The eyes and ears perceive the food on its way—the presentation of the dishes, the sizzling. At the same time, or very shortly after, the nose gets involved. The mouth waters in anticipation. Smell and taste dissolve into each other. The hands convey the food to the mouth—either directly as in the traditional Indian way of eating with the fingers or somewhat indirectly by means of utensils (a late-comer everywhere). The whole snout is engaged. In the snout all the senses are well-represented. The lower part of the face contains the mouth, in the center is the nose, above are the eyes. The ears are side-center, but focused forward.

Rasa also means "juice," the stuff that conveys the flavor, the medium of tasting. The juices of eating originate both in the food and from the body. Saliva not only moistens food, it distributes flavors. Rasa is sensuous, proximate, experiential. Rasa is aromatic. Rasa fills space, joining the outside to the inside. Food is actively taken into the body, becomes part of the body, works from the inside. What was outside is transformed into what is inside. An aesthetic founded on rasa is fundamentally different than one founded on the "theatron," the rationally ordered, analytically distanced panoptic.

Etymologies and Distanced Knowing

Before more on rasaesthetics, something on Western notions of theatre. The word "theatre" is cognate with "theorem," "theory," "theorist," and such—from the Greek *theatron*, itself from *thea*, "a sight," and from *theasthai*, "to view," related to *thauma*, "a thing compelling the gaze, a wonder, and *theorein*, "to look at" (Partridge 1966: 710). Theorein is related to *theorema*, "spectacle"

and/or "speculation" (Shipley 1984: 69). These words are thought to be related to the Indo-European root *dheu* or *dhau,* "to look at" (Partridge 1966: 710). The Indo-European root of "Thespis"—the legendary founder of Greek theatre—is *seku,* a "remark" or "saying," but with the implication of a divine vision; and from seku derive such English words as "see," "sight," and "say" (Shipley 1984: 353). Greek theatre, then, and all European-types of theatre derived from it, are places of/for seeing and saying. What marks this kind of theatre (and after it, film, TV, and possibly the Internet) is its specularity, its strategies of "gazing."

These etymologies reveal the tight bond linking Greek theatre, European epistemology, and seeing. This binding of "knowing" to "seeing" is the root metaphor/master narrative of Western thought. If the humans in Plato's cave were ignorant, it was because all they saw of "truth" were shadows cast on the wall. True reality was so much brighter even than the sun that no human viewer could look at it directly. What Plato said could be known through dialectics, scientists since the Renaissance have tried to do by devising finer and finer instruments of observation. A single net holds Plato's allegory, Galileo's observations, the Hubble Space Telescope, electron microscopes, and the super-colliding super-conductor particle accelerator.

Where does seeing take place? Only at a distance from what is being seen. There is both a logical and a practical difference necessary keeping what is observed separate from the observing instrument (and/or observer). "Objectivity" is understandable as the desire to keep things at enough distance from the eyes for whatever it is to "take shape" perceptually: to see things "in perspective," to "focus on" them. The "indeterminacy principle" linking the instrument of observation to what is observed does not dissolve the distance between observer-observed so much as assert that what is observed is indissolubly linked to the means of observing. What "moves" the particle is the light that is needed to observe it.

At a more everyday level, as an object is brought close to the face, one loses focus and finally the object blurs, loses its visual shape. And, of course, one mustn't put things into one's eyes. Poking out the eyes is a terrible thing both legendarily (Jocasta, Oedipus, Gloucester, et al.) and actually. But a child learns early to see something, focus on it, reach for it, grasp it, and bring it to the mouth. The mouth replaces the eyes as the end-point of exploring the "outer" world and relating it to the "inner" world. The "transitional object" (see Winnicott 1971) is how the infant first experiences the sameness-difference between the world outside herself and the world inside herself: from the nipple-breast, to the fingers, to the grasped-tasted-chewed whatever, to the security blanket, to the favorite object. Even before birth, as in-utero photographs show, the pre-born suck their fingers and toes. Can we doubt

that the pre-born enjoy this activity? Nor is the mouth a singular conduit connected solely to the brain (as the eye is via the optic nerve). The mouth opens to the nasal cavity and the whole digestive system; the mouth—including lips and tongue—intimately engages the senses of touch, taste, and smell. The ocular system is extraordinarily focused, while the snout system is wide open, combining rather than separating. I shall return to this very simple, but decisive difference between the eyes and the mouth later. For now, let me finish this outline of the consequences of an aesthetics based on seeing.

 The Greek theatre that Aristotle based his theories on was fundamentally a seeing place. Architecturally, as is evident from what is left of the Theatre of Dionysus on the hillside of the Akropolis, the almost wholly intact theatre at Epidaurus, and from other sites and restorations, the Greek theatre was immense. Most scholars place the number in the audience at the ancient festivals at between 14,000 and 17,000. And although Aristotle favored the drama over the theatre, the actual experience of being in a classical Greek theatre strongly includes the spectacle—dancing, songs, and reciting. The Greek theatre was also, and perhaps mostly, a focus of competition. The Athenians were an intensely competitive people. The *agon* was for them the motor, source, and energy of creation, a model of becoming.[3] Whatever Aristotle may have wanted, the living heart of Greek tragedy was not plot as such, but a particular kind of story-telling, the agon. To sort winners from losers, the judges (and those judging the judges, the spectators) had to see clearly and base their opinions on "objectivity." Of course, there may have been all kinds of politicking and pressures. Maybe even bribes and cheating. But, as in today's spectator sports (with or without instant replays), clarity in presentation and reception was absolutely essential. The goal of the shows was to determine winners and losers—both in the dramas and in the competitions among actors and poets.

Rasic Performance Is Different

 Rasic performance has as its goal not separating winners from losers, but extending pleasure—as in an endless banquet or an always deferred "almost" sexual orgasm. Its accomplishes this in a way comparable to cooking: the combination/transformation of distinct elements into a something offering new and/or intense and/or favorite flavors or tastes. Rasic performance values immediacy over distance, savoring over judgment. It's paradigmatic activity is a sharing between performers and partakers (a more accurate term than "audiences" or "spectators," words that privilege ear or eye). The rasic performance event is more a banquet than a day in court. The NS puts it this way:

> Those who are connoisseurs of tastes enjoy the taste of food prepared from (or containing) different stuff; likewise, intelligent, healthy persons enjoy various *sthayi bhavas* related to the acting of emotions [Bharata-muni, 1996: 55].

The Sanskrit word translated as "connoisseur" is *bhakta,* which can also mean a person ecstatically devoted to a god, particularly Krishna who is celebrated by means of singing, dancing, and feasting. The sthayi bhavas are the "permanent" or "abiding" or indwelling emotions that are accessed and evoked by good acting, called *abhinaya.* Rasa is experiencing the sthayi bhavas. To put it another way, the sweetness "in" a ripe plum is its sthayi bhava, the experience of "tasting the sweet" is rasa. The means of getting the taste across—the preparing it, the presentation of it—is abhinaya. Every emotion is a sthayi bhava. Acting is the art of presenting the sthayi bhavas so that *both* the performer and the partaker can "taste" the emotion, the rasa.

In Chapters 6 and 7, the NS gives the eight rasas and their corresponding sthayi bhavas:

Rasa	*Sthayi-Bhava*	*English*
Sringara	Rati	Desire, Love
Hasya	Hasa	Humor, Laughter
Karuna	Soka	Pity, Grief
Raudra	Krodha	Anger
Vira	Utsaha	Energy, Vigor
Bhayanaka	Bhaya	Fear, Shame
Bibhatsa	Jugupsra	Disgust
Adbhuta	Vismaya	Surprise, Wonder

Abhinavagupta added a ninth rasa, *shanta,* "bliss." From Abhinavagupta's time onward, many Indians speak of the "nine rasas." But shanta does not correspond to any particular sthayi bhava. Rather, like white light, shanta is the perfect balance/mix of them all; or shanta may be regarded as the transcendent rasa which, when accomplished, absorbs and eliminates all the others. A perfect performance, should one occur, would not transmit or express shanta (as it could transmit or express any of the other rasas), but allow shanta to be experienced simultaneously and absolutely by performers and partakers.

It is not my aim in this essay to investigate the many connections between the sthayi bhavas and the rasas. It is enough to note that "emotions" in the Indian aesthetic performance system, far from being personal—based on individual experience, or locked up and only accessible by means of an "emotional memory" exercise or a "private moment" (Stanislavsky and his disciples)—are to some degree objective, residing in the public or social sphere.

In the rasic system, there are "artistically performed emotions" which comprise a distinct kind of behavior (different, perhaps, for each performance genre). These performed emotions are separate from the "feelings"—the inte-

rior, subjective experience of any given performer during a particular performance. There is no necessary and ineluctable chain linking these "performed emotions" with the "emotions of everyday life." In the rasic system, the emotions *in the arts, not in ordinary life* are knowable, manageable, and transmittable in roughly the same way that the flavors and presentation of a meal are manageable by following recipes and the conventions of presenting the meal.

When I spoke to kathakali actors, for example, some told me they felt the emotions they performed, others did not feel the emotions. Diderot's question, "Do actors feel the emotions they communicate?" can be deferred. Some of the great Indian performers I have interviewed say they feel the emotions they play, some do not. From this, I conclude that feeling the emotions is not necessary though it is not a bad thing either. Whether it happens or not to any particular performer does not necessarily make the performance better or worse. What is relevant, is making certain that each "partaker" receives the emotions; and that these emotions are specific and controlled. The emotions, the sthayi bhava, are objective, the feelings (what an individual performer or partaker experiences) are subjective. What is shared are the rasas of a single or combination of emotions. In order for rasas to be shared, performers must enact the abhinaya of a particular emotion or concatenation of emotions according to the traditions of a specific genre of performance. The feelings aroused may be personal, intimate, and indescribable; but the emotions enacted are consciously constructed and objectively managed.

According to Stanislavsky-based Euro-American acting, one does not "play an emotion." One plays the "given circumstances," the "objectives," the "through line of action," the "magic if." If this is done right, "real" feelings will be experienced and "natural" emotions will be displayed. But according to my interpretation of the NS rasic system, one can work *directly* on the emotions, mixing them according to "recipes" known to the great acting *gurus* (which means, simply, "teachers")—or even by devising new recipes. From a Stanislavskian vantage, such direct work on the emotions will result in false or mechanical acting. But anyone who has seen performers thoroughly trained in the NS rasic system knows these performers are every bit as effective as performers trained in the Stanislavsky system. Later in this essay, I will describe the "Rasabox Exercise," which I have devised along with several of my East Coast Artists colleagues to train Western-oriented actors in a version of the rasic system.

If performing rasically is to offer emotions to partakers in the same way that a chef offers a meal to diners, then the effectiveness of the performance depends very much on an active response from the partakers. The NS is very emphatic in insisting that natya appeal to people of all stations in life, affecting different people differently.[4] The more knowledgeable the partakers, the better

the experience. To respond to the fullest, partakers need to be connoisseurs of whatever performance genre they are taking in—as wine tasters need to know vintages, bottling procedures, and ways of sampling in order to fully appreciate a wine. There is a sliding scale of how much one needs to know. In the rasic system, each person enjoys according to her abilities; the higher the level of knowledge, the greater the enjoyment (or disappointment, if the performance is not up to standards). Japanese noh actors study the audience immediately before entering the stage and then adjust their performances to the particular partakers on hand. All performers know this. The best performers save their best performances for the most discerning partakers and those who know the most expect the best. In India, at least, the active response of the partakers is expected. At dance or music concerts people quietly beat out the "tal" or rhythm, sing under their breath, and sometimes move their hands in harmony with the *mudras* or hand-gesture system. At the Ramlila of Ramnagar, many persons carry texts of Tulsidas' *Ramcaritmanas,* following along, even singing, as the Ramayanis chant. The same is true of sports or pop music connoisseurs. The "home team advantage" is a direct measurement of how the active participation of the crowd can impact the level of performance.

Oral Pleasures, Rasically

Fundamentally, the attainment of pleasure and satisfaction in a rasic performance is oral—through the mouth, by combining various flavors and tastes; and the satisfaction is visceral, in the belly. How can this be since the Indian theatre, like the Western theatre, is presented visually and sonically? First, the Indian theatre is not based on the agon, on determining winners and losers, either within the dramas (where often, everyone wins) or in terms of competition among dramatists and actors. There were no judges formally ensconced on front marble benches as in the Theatre of Dionysus. Thus there was no attempt to quantify the performing experience, to bring it under the theatron's aegis of visuality. Second, many performances were part of the feasts of the rich or royal, at weddings or other happy celebrations. Religion itself had a feasting quality interweaving performing, worshipping, and eating. The separation of work from play and the sacred from the profane was more a Western than Indian phenomenon. Third, there was no anti-theatrical prejudice or any Puritanism in India (until Islam and then the English arrived). Far from it, the arts infused with intense sexual pleasure were often part of the religious experience.

India today is less open to the rasic mix of art, sensuousity, and feasting than before the advent the Mughals and the British. But imagining perform-

ances from the period of Sanskrit drama (4th–11th centuries CE) as indicated by sculptings and paintings at such sites as Khajuraho, the shore temple of Mamallapuram, or the "theatre caves" of Ajanta can get us closer to the kind of experience I am talking about.

> The Ajanta style approaches as near as it is likely for an artist to get to a felicitous rendering of tactile sensations normally experienced subconsciously. These are felt rather than seen when the eye is subordinate to a total receptivity of all the senses. [...] The seated queen with the floating hand is drawn so that we obtain information, which cannot be had by looking at her from a single, fixed viewpoint. [...] the logic of this style demands that movements and gestures can only be described in terms of the area or space in which they occur; we cannot identify a figure except by comparing its position with others around it. [...] It could be said that the Ajanta artist is concerned with the order of sensuousness, as distinct from the order of reason [Lannoy 1971: 48–49].

Richard Lannoy argues that the Sanskrit drama—some form of which is described and theorized in the NS—like the Ajanta paintings.

> The structure and ornamentation of the caves were deliberately designed to induce total participation during ritual circumambulation. The acoustics of one Ajanta *vihara,* or assembly hall (Cave VI), are such that any sound long continues to echo round the walls. This whole structure seems to have been tuned like a drum [43].

This tuning was not fortuitous. The Ajanta caves are human-made, excavated and carved out of solid rock. Lannoy continues:

> In both cases [the caves, the theatre] total participation of the viewer was ensured by a skillful combination of sensory experience. The "wrap-around" effect [of] the caves was conveyed on the stage by adapting the technically brilliant virtuosity of Vedic incantation and phonetic science to the needs of the world's most richly textured style of poetic drama [1971: 54].

What the NS supplies are the concrete details of that style which at its core is not literary but theatrical, not plot dominated or driven. Indian classical theatre and dance does not emphasize clear beginnings, middles, and ends but favors an a more "open narration," a menu of many delectables—offshoots, sidetracks, pleasurable digressions—not all of which can be savored at a sitting. Performances often were staged in phases, over periods of days or weeks. The performances were part of multi-faceted celebrations that also featured feasting and audience participation integral to the whole performance complex. Some of this can still be seen in such popular religious festive forms as Ramlila, Raslila, and bhajan-singing/dancing with their circumambulations, hymn-singing, trance dancing, food-sharing, and wrap-around or environmental theatre staging.

It's not all one way or the other. There is a lot of movement—actual and conceptual—from one kind of action to another. There are phases of the performance where partakers stand back and watch or listen and other phases where they participate. This blending of theatre, dance, music, eating, and religious devotion is to many participants a full and satisfyingly pleasurable experience that cannot be reduced to any single category religious, aesthetic, personal, or gustatory. This kind of an event yields experiences that dissolve differences, if only for a little while. This kind of experience is hard to measure from the inside or observe from the outside. It is this experience of an "all-is-inside" theatricality that most sharply distinguishes rasaesthetics from orthodox Western aesthetics derived from the Greek theatre and its reinterpretations in the Renaissance and variations in the drama-based proscenium or frontal-stage work of today. Rasaesthetics is experienced "in the gut," a formulation I need now to say more about.

The Enteric Nervous System

Take a step into neurobiology. According to recent studies, there is a brain in the belly, literally. The basic research in this area has been conducted by Michael D. Gershon (see his *The Second Brain*, 1998) whose work was summarized by in the *New York Times* by Sandra Blakeslee:

> The gut's brain, known as the enteric nervous system [ENS], is located in sheaths of tissue lining the esophagus, stomach, small intestine, and colon. Considered a single entity, it is a network of neurons, neurotransmitters, and proteins that zap messages between neurons, support cells like those found in the brain proper and a complex circuitry that enables it to act independently, learn, remember, and, as the saying goes, produce gut feelings [1996: C1].

The ENS derives from the "neural crest," a bunch of related cells that forms in mammals and birds early in embryo genesis. "One section turns into the central nervous system. Another piece migrates to become the enteric nervous system. Only later are the two nervous systems connected via a cable called the vagus nerve" (Blakeslee 1996: C3). According to Gershon:

> The ENS resembles the brain and differs both physiologically and structurally from any other region of the PNS [peripheral nervous system][5] [...B]oth the avian and mammalian bowel are colonized by émigrés from the sacral as well as the vigil level of the neural crest. [...] The PNS contains more neurons than the spinal cord and, in contrast to other regions of the PNS, the ENS is capable of mediating reflex activity in the absence of central neural input. In fact, most of the neurons of the ENS are not directly innervated by a preganglionic input from the brain or spinal cord. The functional independence of the ENS is mirrored in its chemistry and structure [Gershon 1993: 199].

Until relatively recently, people thought that the gut's muscles and sensory nerves were wired directly to the brain and that the brain controlled the gut through two pathways that increased or decreased rates of activity [...]. The gut was simply a tube with simple reflexes. Trouble is, no one bothered to count the nerve fibers in the gut. When they did [...], they were surprised to find that the gut contains 100 million neurons—more than the spinal cord has. Yet the vagus nerve only sends a couple of thousand nerve fibers to the gut [Blakeslee 1993: C3].

What this means is that the gut—esophagus, stomach, intestines, and bowels—has its own nervous system. This system does not replace or pre-empt the brain. Rather it operates alongside the brain, or—evolutionarily speaking—before "before" or "underneath" the brain. Again, Gershon:

The enteric nervous system is [...] a remnant of our evolutionary past that has been retained. [It] has been present in each of our predecessors through the millions of years of evolutionary history that separate us from the first animal with a backbone. [...T]he enteric nervous system is a vibrant, modern data-processing center that enables us to accomplish some very important and unpleasant tasks with no mental effort. When the gut rises to the level of conscious perception, in the form of, for example, heartburn, cramps, diarrhea, or constipation, no one is enthused. Few things are more distressing than an inefficient gut with feelings [Gershon 1999: xiv].

But what about emotional feelings? In December 2000, I emailed Gershon about "rasaesthetics" and the ENS. He replied:

Thank you for your letter. You touch a bit of raw nerve. You are certainly correct in that we in the West who consider ourselves "hard" scientists have not taken Eastern thought very seriously. The problem with a great deal of Eastern thought is that it is not based on documentable observation. You cannot quantify ideas about strong feelings or deep power. We therefore, either ignore Eastern ideas about the navel, or take them as metaphors, which are not very different from our own metaphors about "gut feelings." On the other hand, I have recently become aware of quantifiable research that establishes, without question, that vagus nerve stimulation can be used to treat epilepsy and depression. Vagus nerve stimulation also improves learning and memory. Vagus nerve stimulation is something physicians do and is not natural, but 90 percent of the vagus carries ascending information from the gut to the brain. It is thus possible that vagus nerve stimulation mimics natural stimulation of the vagus nerve by the "second brain." This relationship is particularly important in relation to the human condition of autism. Autism affects the gut as well as the brain. It is thus conceivable that autism could be the result in whole or in part of a disturbed communication between the two brains.

In short, I now take the possibility that the gut affects emotions very seriously. This seems much more likely to me now than it did when I wrote my book. A dialogue between us might be of mutual interest.

The dialogue has not yet progressed beyond the email quoted, but it is destined.

Let us suppose, in light of ENS research, that when someone says "I have a gut feeling" she actually is experiencing a feeling, a neural response, but not one that is head-brain centered. Let us suppose that her feeling is located in, or emanating form, the "second brain," the brain in the belly. When expressed, this feeling is an emotion. Can such feelings be trained? That is, what are the systems converting "gut feelings" into expressible emotions? Gershon is interested primarily in the therapeutic value of vagus nerve stimulation, of causing or evoking feelings in autistics who suffer from lack of affect or lack of range of affect. I am investigating various other kinds of ENS training suitable for "normal" or "artistic" uses.

The presence and location of the ENS confirms a basic principal of Asian medicine, meditation, and martial arts: that the region in the gut between the navel and the pubic bone is the center/source of readiness, balance, and reception, the place where action and meditation originate and are centered. A related place is the base of the spine, the resting spot of "kundalini," an energy system that can be aroused and transmitted up the spinal column. Gaining an awareness of and control over the gut and lower spine is crucial to anyone learning various Asian performances, martial arts, or meditations.

Phillip Zarrilli has for many years researched both in a scholarly and in a practical way the relationship between what in the Keralan martial art *kalarippayattu* is called the *nabhi mula* (root of the navel) and performance art training, psychophysical centering, and ayurvedic medicine. According to Zarrilli:

> When impulses originate from the *nabhi mula* [... they] are "grounded," "centered," "integrated," "filled out," "dynamic." The *nabhi mula* of kalarippayattu is identical to the *svadhisthanam* of classical yoga. Its location is two finger widths above the anus and two finger widths below the root of the navel. It is at the this center that both breath and impetus for movement into and out of forms originate [Zarrilli 1990: 136].

Zarrilli emphasizes that the nabhi mula is important "psychophysically," as the source of feeling-and-movement, a kind of "gripping" (*piduttam*) or firmness of body, spirit, and feelings that effects the whole human being. The Chinese notion of *ch'i* and the Japanese "activating force" *ki* are closely related to the nabhi mula and the sense of piduttam. In noh theatre, the *tanden,* located "in the belly two inches below the navel" (Nearman 1982: 346) is the energy center. The point is that this "center" is a radiating spot.

> The actor is engaged in his total being in a psychophysical process where his internal energy, aroused in his vital center below the navel, then directed into and through the embodied forms of external gesture (body and voice) is of course fundamentally the same [in noh] as the interior process of the kathakali actor. This despite the fact that the exterior manifestation of the interior process is different [Zarrilli 1990: 143].

I could cite many more examples. But it all comes down to what Zarrilli so nicely summarizes:

> In all such precise psychophysical moments, the "character" is being created—not in the personality of the actor but as an embodied and projected/energized/living form between actor and audience. These Asian forms assume no "suspension of disbelief," rather the actor and spectator co-create the figure embodied in the actor as "other." The "power of presence" manifest in this stage other, while embodied in this particular actor in this particular moment, is not limited to that ego. That dynamic figure exists between audience and actor, transcending both, pointing beyond itself [1990: 144].

The rasic system of response does not preclude the eye and ear during actual performance, but during training especially, it works *directly and strongly* on the ENS which, under different names, has been very important and well-theorized in various Asian systems of performance, medicine, and the martial arts—all of which are tightly related in Asian cultures. Thus, when I say the rasic aesthetic experience is fundamentally different than the eye dominant system prevalent in the West, I am not talking metaphorically.

The "Rasabox" Exercise

But if not metaphorically, how? Let me answer that first in terms of training, then in terms of public performances. Over the past five years I and several of my colleagues at East Coast Artists,[6] especially Michele Minnick and Paula Murray Cole, have been developing the rasabox exercise. This exercise is an application of some of the ideas in this essay.[7] It is based on the assumption that emotions are socially constructed while feelings are individually experienced.

The rasabox exercise takes many hours to complete; in fact it is open-ended. It can't be done in one session. It continues from one day to the next. The exercise proceeds as an orderly progression of steps:

1. Draw or tape a grid of nine rectangular boxes out on the floor. All rectangles are the same; and each ought to be about 6' × 3' (see figure).
2. Very roughly "define" each rasa. For example, "raudra" means anger, rage, roaring; "bibhatsa" means disgust, spitting up/out, vomiting.
3. In variously colored chalk, inside each rectangle write the name of one rasa. Which rasa goes where is determined by chance. The names are written in Roman alphabetized Sanskrit. The center or 9th box is left empty or clear.
4. Participants draw and/or write the rasas. That is, each person interprets the Sanskrit word, associates feelings and ideas to it. Emphasize

RAUDRA	BIBHASTA	BHAYANAKA
KARUNA	SANTA (Empty)	SRINGARA
HASYA	VIRA	ADBHUTA

The rasabox grid with one rasa within each box (figure by Richard Schechner).

that these "definitions" and associations are not for all time, but just "for now." Emphasize also that drawings, abstract configurations, or words can be used. In moving form one box to another, people must either "walk the line" at the edge of the boxes or step outside the rasabox area entirely and walk around to the new box. There is no order of progression from box to box. A person may return to a box as often as she likes. Be careful not to overwrite someone else's contribution. Take as much time as necessary until everyone has drawn their fill. When a person is finished, they step to the outside of the rasabox area. This phase of the exercise is over when everyone is outside the rasabox area. Sometimes this takes several hours.

5. When everyone is standing at the edge of the rasabox area, time is allowed for people to "take in" what has been drawn/written. Participants walk around the edge of the rasaboxes. They read to themselves and out loud what is written. They describe what is drawn. But they can't ask questions; nor can anything be explained.

6. Pause. Silence.

7. Someone enters a box. The person takes/makes a pose of that rasa: for example, the pose of sringara or karuna or whatever. The person can

do as few as a single rasa or as many as all eight named rasas. (Remember the ninth or center box is "clear.") A person can move from box to box either along the edge or on the lines—in which case the movement is "neutral." But if a person steps into a box, he must take/make a rasic pose. This phase continues until everyone has had at least one chance to enter and pose within the rasaboxes.

8. Same as 7, but now the pose is supplemented by a sound.

In steps 7 and 8, there is no "thinking." Just take/make a pose and/or a sound. Whatever is "there" in association to the rasa. Move rather quickly from one rasabox to the next. Don't worry how "pretty," "true," or "original" the pose/sound is. Just do it. But once one is outside the boxes, reflect on how you composed your rasa and what it felt like to be in a composed rasa. In other words, begin the exploration of the distinction between feelings (experience) and emotion (public expression of feelings). Don't worry which came first. It is a chicken-and-egg question with no correct answer.

In fact, the first poses/sounds often have the quality of social clichés—of the "already known" that fit the rasas as casually understood. Big laughs for hasya, clenched fists for raudra, weeping for karuna, and so on. The distance between stereotype and archetype is not great. Sooner or later, the social stereotype/archetype will be augmented by gestures and sounds that are more intimate, personal, quirky, unexpected. Practice leads one towards these. The road from outer to inner = the road from inner to outer.

9. Move more rapidly from one box to the next. Quick changes, no time for thinking it out in advance.

Here we are beginning to grapple with Antonin Artaud's call for actors who are "athletes of the emotions." Actual athletic competitions come to mind. A basketball player sits on the sideline, quiet, a towel draped over his shoulder. But when called on to enter the game, he explodes with energy, performs at a high level of skill, and is entirely focused on his task. A whistle blows, and the athlete relaxes. The time out is over, he jumps back into the game. One of the goals of the rasabox exercise is to prepare actors to move with the same mastery from one emotion to another, in a random or almost random sequence, with no preparation between emotional displays, and with full commitment to each emotion. What happens at the feelings level is left indeterminate—as with the performers in India: some doers of the rasabox exercise will "feel" it, others will not. See the sidebars for what Paula Murray Cole and Michele Minnick write concerning their experiences with the rasabox exercise.

10. Two persons enter, each one in their own box. At first, they simply make the rasas without paying attention to each other. But then they begin to "dialogue" with the rasas—and shift rapidly from one box to another. So, sringara confronts vira and then vira moves to adbhuta;

after a moment sringara rushes along the line to bibhatsa and adbhuta jumps to bhayanaka.

At step 10, many new combinations appear. People begin to find things that are far from the social clichés. Those on the outside are often amused, sometimes frightened, or moved. "Something" is happening, though it can't be reduced to words. A few people are hesitant about going into the boxes at all. The exercise is both expressive and a scalpel that cuts very deeply into people. Paradoxically, in performing different emotional masks, the participants discover aspects of their being that had remained hidden—sometimes even from themselves.

11. Texts are brought in from outside—that is monologues from known plays or stuff written just for the exercise. Scenes from dramas enacted by two or even three people. The text remains fixed, but the rasas shift—with no preplanning. So, for example, Romeo is all sringara but Juliet is karuna; then suddenly Juliet springs to bibhatsa and Romeo to adbhuta. And so on—the possible combinations are nearly endless. Occasionally, Romeo and Juliet are in the same box.

At this stage, actors test out the many different possibilities of any given text. Or rather, the texts are revealed as not being fundamental, but permeable, open, wildly interpretable.

12. Scenes are enacted with one underlying rasa on top of which are bits played in different rasas.

Here one begins to see how a whole production could be mapped as a progression of rasas. The progression could be scored or improvised each performance.

There are even more possibilities. The rasabox exercise is designed to be unfinishable. It is not intended to be a "true example" of a NS-based performance. Indeed, what comes from the rasabox exercise is not at all like what one sees at any traditional Indian performance. The exercise actually points to the creative possibilities suggested by the underlying theory of the NS. It "comes from" rather than "is an example of" that theory.

The Empty Box

What about the empty box at the center? What happens there? In the exercise, a person can enter that box—the *shanta* space—only when the person is "clear." What that means ... is not for the one directing the exercise to say. Each person will have her own criteria for total, whole clarity. In the years that I've directed the rasabox exercise, "shanta" has been occupied very rarely, one or two times. There can be no challenge to such a position. So what if it is "not

really so" that the person is "clear?" How can another person tell? And maybe it is so, maybe the participant has surpassed all *samsara,* all the clutter of feelings, the confusion of mixed emotions, the noise of change. I will not judge no.

Rasaesthetics in Performance

Now let me turn from training to performance. Indian theatre, dance, and music are not banquets. In odissi, bharatanatyam, kathakali, kathak, and so on performers dance, gesture, impersonate, and sometimes speak and sing. Occasionally, there is burning incense thickening the air with odor. But for the most part, the data of the performance is transmitted from performer to partaker in the same way as in the West (and elsewhere), through the eyes and ears. How is this rasic?

Watching traditional Indian genres, one sees the performer looking at her own hands as they form different *hastas* or *mudras*—precise gestures with very specific meanings. This self-regarding is not narcissism in the Western sense. Abhinaya literally means to lead the performance to the spectators— and the first spectator is the performer herself. If the self-who-is-observing is moved by the self-who-is-performing the performance will be a success. This splitting is not exactly a Brechtian *verfremdungseffkt,* but neither is it altogether different. Brecht wanted to open a space between performer and performance in order to insert a social commentary. The rasic performer opens a liminal space to allow further play—improvisation, variation, and self-enjoyment.

The performer becomes a partaker herself. When she is moved by her own performance, she is affected not as the character, but as a partaker. Like the other partakers, she can appreciate the dramatic situation, the crisis, the feelings of the character she is performing. She will both express the emotions of that character and be moved to her own feelings about those emotions. Where does she experience these feelings? In the ENS, in the gut—inside the body that is dancing, that is hearing music, that is enacting a dramatic situation. The other partakers—the audience—is doubly affected: by the performance and by the performer's reaction to her own performance. An empathetic feedback takes place. The experience can be remarkable.

In orthodox Western theatre, the spectators respond sympathetically to the "as if" of characters living out a narrative. In rasic theatre, the partakers empathize with the experience of the performers playing. This empathy with the performer rather than on the plot is what permits Indian theatre to "wander," to explore detours and hidden pathways, unexpected turns in the performance. Here rasa and *raga* are analogous. The partakers' interest is not tied to the story, but to the enacting of the story; the partakers do not want to "see

what happens next" but to "experience how the performer performs whatever is happening." There is no narrational imperative insisting on development, climax, recognition, and resolution. Instead, as in kundalini sexual meditation, there is as much deferral as one can bear, a delicious delay of resolution.

I am here expounding a theory of reception—even to the extent that the performer's self-regarding is a reception of her own performance. This needs further elaboration. One treatise on abhinaya instructs the dancer to sing with her throat, express the meaning of that song with her hand gestures, show how she feels with her eyes, and keep time with her feet. And every performer knows the traditional adage, where the hands go, the eyes follow; where the eyes go, the mind follows; where the mind goes, the emotions follow, and when the emotions are expressed, there will be rasa. Such a logically linked performance of emotions points to the "self." Not the self as personal ego, but the *atman* or profound absolute self, the Self that is identical to the universal absolute, the *Brahman.*

Eating in a traditional manner in India means conveying the food directly to the mouth with the right hand. There is no intermediary instrument such as fork or spoon. Sometimes a flat bread is used to mop or hold the food; sometimes rice is used to sop up a curry. But in all cases, the food on the index and third finger is swept into the mouth by an inward motion of the thumb. Along with the food, the eater tastes his own fingers. The performer regarding her mudras is engaging in a kind of "theatre feeding." As with self-feeding, the emotions of a performance are first conveyed to the performer and the partakers by means of the hands.

Orthodox Western performing arts remain invested in keeping performers separated from receivers. Stages are elevated; curtains mark a boundary; spectators are fixed in their seats. Mainstream artists, scholars, and critics do not look on synchronicity and synaesthesia with favor. Eating, digestion, and excretion are not thought of as proper sites of aesthetic pleasure. These sites—aside from rock concerts, raves, and sports matches—are more in the domain of performance art. In early performance art there were Carolee Schneemann, Allan Kaprow, Linda Montano, Chris Burden, Stellarc, and others. Later came Mike Kelley, Paul McCarthy, Karen Finley, Annie Sprinkle, Ron Athey, Franko B. all of whom insisted on making "the body" explicit. Their work began to elide differences between the interior and the exterior; to emphasize permeability and porosity; to explore the sexual, the diseased, the excretory, the wet, and the smelly. Performances used blood, semen, spit, shit, urine—as well as food, paint, plastics, and other stuff drawn from the "literal" rather than the "make believe." This work is not very Asian on the surface, but at an underlying theoretical level, it is extremely rasic.

These kinds of performances need to be studied in terms of rasaesthetics.

That means paying attention to the increasing appetite for arts that engage visceral arousal and experience; performances that insist on sharing experiences with partakers and participants; works that try to evoke both terror and celebration. Such performances are often very personal even as they are no longer private.

What I'm asking for goes beyond performance art. Rasaesthetics opens questions regarding how the whole sensorium is, or can be, used in making performances. Smell, taste, and touch are demanding their place at the table.[8] Thus I am making a much larger claim—and sending out a more general invitation. I am inviting an investigation into theatricality as orality, digestion, and excretion rather than, or in addition to, theatricality as something only or mostly for the eyes and ears. I am saying that performance practice has already moved strongly into this place and now is the time for theory to follow.

This essay first appeared in *The Drama Review* 45. 3: 27–50.

NOTES

1. At the very start of the text, Bharata claims for the NS the status of a veda—the most sacred of ancient Indian texts—is not all that unusual. Such claims to being the "fifth veda" were used to validate and strengthen a text. Tradition finally of course assigned the rank of "sastra" to the NS, a position well down the hierarchical ladder of sacred writings. As for the framing origin myth itself told in Chapter 1, the story of Brahma's composition of the "fifth veda," its transmission to Bharata and his sons, and their performance of the "first natya" on the occasion of the Mahendra's flag festival (the victory celebration of Indra's triumph over *asuras* and *danavas* [demons]—much can be made of it. The demons are enraged by the performance of their defeat, they rush the stage and magically freeze "the speeches, movements, and even the memory of the performers." Indra intervenes, thrashes the demons with a flag-pole which is then installed as a protective totem. Brahma instructs the gods' architect Visvakarman to construct an impregnable theatre, well-guarded by the most powerful gods. This having been done, the gods say it is better to negotiate with the demons than to forcibly exclude them. Brahma agrees, approaches the demons, and inquires why they want to destroy *natya*. They reply, "You are as much the creator of us as of the gods" so why are we omitted from *natya*? "If that is all there is to it," Brahma says, "then there is no reason for you to feel angry or aggrieved. I have created the *Natyaveda* to show good and bad actions and feelings of both gods and yourselves. It is the representation of the entire three worlds and not only of the gods or of yourselves." Thus *natya* is of divine origin, all-encompassing, and consisting of actions both good and bad. For an extended and highly sophisticated interpretation of the NS framing myth, see Byrski 1974.

2. According to Kapila Vatsyayan (1996: 32–36) and Adya Rangacharya, whose recent English translation of the NS is the most readable, in 1865 the American Fitz Edward Hall unearthed and published several chapters. In 1874, the German Wilhelm Heymann (or Haymann as Vatsyayan spells it) wrote an influential essay that stimulated further translations of several chapters by the French scholar, Paul Reynaud (or Regnaud as Vatsyayan spells it). But it was only in 1926 that the Baroda critical edition was commenced. The whole text—in Sanskrit—was not in print until 1954. "In spite of all these results, the final text is contradictory, repetitive and incongruent; there are lacunae too, but, what is worse, there are words and passages that are almost impossible to understand. [...] It is not only modern scholars who suffer this inability to understand; even almost a thousand years ago [...] Abhinavagupta [...] displayed this tendency" (1996:xviii). Vatsyayan (180ff) provides a "Database of the Natyasastra" locating and listing all 112 known extant texts

and fragments. All the texts are Sanskrit but transcribed in a variety of scripts: Newari, Devanagari, Grantha, Telugu, Malayalam, Tamil, Kanarese. Thus we know that from an early time the NS was widely distributed across the subcontinent.

3. "In Presocratic thought the prerational notion of agon is used to describe the natural world as a ceaseless play of forces or Becoming" (Spariosu 1989: 13).

4. According to the first chapter of the NS Brahma created the *natyaveda* "to show good and bad actions and feelings of both gods and yourselves [humans]. It is the representation of the entire three worlds [divine, human, demonic] and not only of the gods or of yourselves. Now dharma [correct living], now artha [warring], now kama [loving], humor or fights, greed or killing. Natya teaches the right way to those who go against dharma, erotic enjoyment to those who seek pleasure, restraint to those who are unruly, moderation to those who are self-disciplined, courage to cowards, energy to the brave, knowledge to the uneducated, wisdom to the learned, enjoyment to the rich, solace to those in grief, money to business-people, a calm mind to the disturbed. Natya is the representation of the ways of the worlds using various emotions and diverse circumstances. It gives you peace, entertainment, and happiness, as well as beneficial advice based on the actions of high, low, and middle people" (NS, 1: 106ff, English adapted from Ghosh and Rangacharya translations).

5. The peripheral nervous system (PNS) consists of the many nerve cells throughout the body connected to the brain via the spinal cord. The PNS receives sensory input which is then transmitted to the brain where it is "interpreted" as various kinds of touch, heat-cold, pain, tickling, etc. Signals are sent are sent back from the brain resulting in bodily movements and so on. The ENS is part of the PNS, but both structurally and operationally very different than the rest of the PNS. The ENS, for the most part, operates independently of the brain though it is connected to the brain via the vagus nerve.

6. East Coast Artists is a company I formed in New York in the early 1990s. Productions I've directed with ECA are *Faust/gastronome* (1992), *Three Sisters* (1997), and *Hamlet* (1999). The rasabox exercise was developed both during ECA rehearsal workshops and at workshops I ran at NYU in the 1990s. In the late 90s, I worked very closely with Michele Minnick and Paula Murray Cole in relation to rasaboxes. Minnick and Cole have led several rasabox workshops in New York and elsewhere. The exercise is dynamic. It continues to change.

7. The exercise is not based on the theory, exactly; nor does the theory result from the exercise, exactly. Rather, there is a convergence and an interplay between what I am thinking and what I am doing. This interplay is open—that is why both the exercise and the theory are "in development" and not "finished."

8. The work of Constance Classen and David Howes and the group of scholars associated with them is well worth noting. They are developing an anthropology and an aesthetics of the senses. See *The Variety of Sensory Experience* (1991) edited by Howes and Classen's *The Color of Angels* (1998). In April 2000, Classen, Howes, Jim Drobnick, and Jennifer Fisher convened "Uncommon Senses: An International Conference On the Senses in Art and Culture" at Concordia University in Montreal with 180 presenters.

BIBLIOGRAPHY

Bharata-muni. 1996. *The Natyasastra*. Adya Rangacharya, tr. and ed. New Delhi: Munshiram Manoharlal.

Blakeslee, Sandra. 1996. "Complex and Hidden Brain in the Gut Makes Cramps, Butterflies, and Valium." *The New York Times*, 23 January: C1–3.

Byrski, Christopher. 1973. *Concept of Ancient Indian Theatre*. New Delhi: Munshiram Manoharlal.

Classen, Constance. 1998. *The Color of Angels*. London: Routledge.

Geertz, Clifford. 1973. *The Interpretation of Cultures*. New York: Basic Books.

Gershon, Michael D. 1999. *The Second Brain*. New York: Harper Perennial.

Gershon, Michael D., Alcmene Chalazonitis, and Taube P. Rothman. 1993. "The Neural Crest to Bowel: Development of the Enteric Nervous System." *Journal of Neurobiology* 24. 2: 199–214.

Howes, David, ed. 1991. *The Varieties of Sensory Experience.* Toronto: University of Toronto Press.

Lannoy, Richard. 1971. *The Speaking Tree.* London: Oxford University Press.

Partridge, Eric. 1966. *Origins: A Short Etymological Dictionary of Modern English.* London: Routledge and Kagen Paul.

Sargeant, Winthrop, tr. and ed. 1984. *The Bhagavad Gita.* Albany: State University of New York Press.

Schechner, Richard. 1997. "Believed-in Theatre." *Performance Research* 2. 2: 76–91.

Schneider, Rebecca. 1997. *The Explicit Body in Performance.* London: Routledge.

Shipley, Joseph T. 1984. *Origins of English Words: A Discursive Dictionary of Indo-European Roots.* Baltimore: Johns Hopkins University Press.

Vatsyayan, Kapila. 1996. *Bharata: The Natyasastra.* New Delhi: Sahitya Akademi.

Zarrilli, Phillip. 1990. "What Does It Mean to 'Become the Character': Power, Presence, and Transcendence in Asian In-Body Disciplines of Practice." In *By Means of Performance,* Richard Schechner and Willa Appel, eds., 131–48. Cambridge: Cambridge University Press.

Synesthetics[1]: Rasa as Metaphors in Performance

Sreenath Nair

It is the east, and Juliet is the sun.—Shakespeare, *Romeo and Juliet*

Synesthetics is a theory explaining the neural mechanism of aesthetic experience. It explains a set of neurobiological principles forming the very nature of human perception and its multiple modes of emotional experiences relating to external stimuli that evoke a specific functional reaction. Perception and its subsequent psychophysical reactions are neural functions of sensory phenomena caused by genetically mediated persistent neural connections causing cross wiring between brain maps (Ramachandran, Hubbard and Butcher 2004; Hubbard and Ramachandran 2003). Aesthetic and emotional responses to sensory inputs depend on hyperconnectivity between the cortices and the limbic system, *fusiform gyrus* and *angular gyrus*, respectively (Ramachandran, Hubbard and Butcher 2004). The hyperconnectivity between these brain regions involves the neural mechanism of metaphor, the same principle that explains synesthetia and artistic creativity. It is also consistent with data suggesting that the right hemisphere of the brain, which processes spatial and nonlinguistic aspects of language, is more involved in the neural mechanism of metaphor than the left (Anaki, Faust and Kravetz 1998; Brownell et al., 1990). For instance, according to V.S. Ramachandran, when we read Shakespeare's "It is the east, and Juliet is the sun," our brains instantly understand the meaning without taking the metaphor literally and therefore thinking that Juliet is a glowing ball of fire (Ramachandran, Hubbard and Butcher 2004). This metaphoric structuring of thoughts and emotions is a creative expression reinforced by the neural mechanism (Johnson 1987: 13). Based on these

results, my intention in this essay is to demonstrate a range of possibilities explaining the biological bases of aesthetic experience in performance practice consisting of mimetic expressions, perception, and meaning, which is a discourse that has long been dominated by phenomenological theories of perception.

Several attempts have been made by critics in anthropology, theatre, and performance studies (States 1985, 1992; Stoller 1997; Connerton 1989; Garner 1994; Strathern 1996; Bochner and Ellis 2002; McConachie and Hart 2006) to express their growing concerns about and theoretical resistance to phenomenology's inability to conceptualize and theorize the lived experience of the body and its multiple perceptual activities that are involved in a performance situation. Until Merleau-Ponty and Foucault, phenomenology was only concerned with subjectivity and meaning in terms of how the world is being experienced or perceived by the self. In phenomenology, the world is only a signifier structured around the self, and it only exists within the self's reflection of the world. Merleau-Ponty has radically shifted these concerns onto the physical body of the human "perceiver" while "returning the body to the field of subjectivity" (Garner 1994: 27), putting a profound emphasis on the body in the discourse of the self. The body interacts with the world "outside" and the formation of individual "subjectivity" is deeply rooted in this perceptual interaction of the human organism. For Foucault, phenomenology encloses the physicality of the world, and there is a lack of logic connecting the signification that meaning never coincides with an event (Murray 1997: 223). Foucault insists upon the body as a discursive site for the formation of self through its interactions with the power structures of institutions. In recent methodologies, the body has received significant attention as a bearer of social, political, and cultural meanings (Connerton 1989: 104).

Bourdieu's theories on practice (*habitus*) are constituted in "practice" and are oriented towards principles of practical functions of the body in social situations that, in turn, influence the perception and appreciation of all subsequent experiences (1990: 52). Bourdieu's *habitus* is a product of history, and produces individual and collective practices in accordance with the schemes generated by history (1990: 54). Recent ethnographic studies in anthropology insist upon embodied practices and sensuous descriptions of the body, which are central to the metaphoric organization of experience in many societies, arguing that cultural memories are embodied (Stoller 1997: xvi). In fact, these approaches to the body, subjectivity, and the signification process in general, raise questions about the methodological authority of textualizing the world and emphasizing linguistics and semiotics. Everything material, including the body, has been reduced to linguistics and semiotics, and this linguistic reductionism in theatre criticism seems to be a distortion of the fundamental nature

of theatre and performance, which is rooted in the physical and sensual aspects of the body (Fortier 1997: 3–4). A performance combines everything that is material—stage space, lighting, props, costumes, and, most importantly, the bodies. No matter whether it is intelligible, aesthetic, or sensuous, whatever we experience as the outcome of a performance has a strong material base. Nonetheless, aesthetic experience involves a great deal of imagination and perception that transforms the material world of performance into a fictive world of experience (Iser 1993; Fischer-Lichte 2008).

Rasa and Perception

The aesthetic theory of *rasa* elucidates the structural components and functional mechanism of a transformational experience in theatre, emphasizing the role of the body and imagination in aesthetic discourse. The aesthetic theory of rasa is particularly important in this debate, mainly because the principles of the Natyasastra are firmly based on the biological foundation of the body and its functional reactions of perception and imagination. The rasa theory combines mimetic blending (*samyoga*), perception (*vibhava*), creativity (*anubhava*), and imagination (*vyabhichari bhavas)* in the mimetic process (*nishpatti*) of the rasa experience. Rasa is aesthetic experience embodied, and its structural elements and functional principles seem close to the neural origins of emotion and perception (Ramachandran and Hirstein 1999). Similarly, recent studies in neuroscience offer empirically tested insights that are directly relevant to many of the concerns of theatre and performance studies, including performativity, audience reception, meaning making, identity formation, the construction of culture, and the process of historical change (McConachie and Hart 2006: x). As a result of what we have learned about the brain, we know that creativity and imagination are neural mechanisms affecting the mimetic representations in a performance. In short, the physical world of a performance is an aesthetically rearranged cultural schema of mimetic patterns; and what is aesthetically pleasing in a performance has a strong biological base. Synesthetics, in this way, is an attempt to scientifically explain the neural foundation for aesthetic experience, comparing the principles of neural mechanism with the performance principles found in the Natyasastra, mainly in rasa. In another way, stylized and nonillusionary performance principles outlined in the Natyasastra are strictly based on universal empirical principles of human anatomy and facial prototypes of emotions (rasa) that "can powerfully activate the same neural mechanisms that would be activated by the [real] objects" (Ramachandran and Hirstein 1999: 17). Based on this evidence, I argue that the Natyasastra model of acting and actor training can activate the limbic sys-

tem powerfully, using imagination as a mode of communication. This interface between rasa theory and neuroscience, in a wider context, may also provide useful connections for understanding the contemporary relevance of the principles of emotion and perception outlined in the Natyasastra.

Hyperconnectivity and Emotions

Performance is a multisensory mimetic event that induces strong and direct emotions in its spectators. Unlike in reading, mimetic expressions are perceived visually and phonically by the audience. Seeing and reading are two very different cognitive processes, and perception in a performance situation cannot be considered as a linguistic activity involving reading (Mancing in McConachie and Hart 2006: 189–191). According to Allan Paivio, the basic difference between visual and linguistic knowledge is that visual representations are analogue, iconic, continuous, and have referentially isomorphic properties. On the contrary, linguistic representations are nonanalogue, noniconic, digital (noncontinuous), and referentially arbitrary and propositional (1986: 16). Perceptual knowledge is a primary cognitive mode that evokes functional reactions in the body. Mimetic and kinetic elements being the primary modes of communication, performance evokes direct and strong emotional responses in the spectators, which underpin specific neural and biological connectivity. Visual information that is recognized by the cortex of the temporal lobe ordinarily gets relayed to the limbic system (Amaral et al., 1992; Le Doux 1992) and evaluates the significance of the perceived objects, developing an "emotional salience map" of objects and events in the world. As soon as an emotionally significant or salient object is identified, for instance predator, prey, or mate, a message will be relayed to the hypothalamic nuclei to prepare the body for the subsequent physical actions related to the object, such as fighting, fleeing, or mating (Ramachandran, Hubbard and Butcher 2004). Neural signals released from the limbic structures do travel down the autonomic nervous system (ANS) to decrease gastric motility and increase heart rate and sweating (Lang, Tuovinen and Valleala 1964; Mangina and Beurezeron-Mangina 1996). This limbic activation of autonomic arousal simultaneously supplies emotional arousal. It is also observed that neutral objects such as a table or a chair do not seem to cause arousal or change in the limbic structures (Ramachandran, Hubbard and Butcher 2004). This evidence clearly suggests that the mimetic and kinetic patterns of the body presented in a performance will activate and reinforce the limbic system through neural signals generated by emotionally significant and salient objects and motions. In fact, the aesthetic and emotional responses to sensory inputs depend on hyperconnectivity between the sensory

cortices and the limbic system (878). In current research on neural mechanism, this cross-activation between different brain regions is the primary source of artistic creativity. Performance is a metaphoric restructuring of "real" events and situations in life, and this very "re-structuring" of the objects and bodies in the real world is the aesthetic process based on our perception of emotionally salient mimetic and kinetic objects and patterns, both of which are stimulated by cross-activation of neurons.

Rasa and the Essence of Art

There is no literal translation of the word *rasa*. The definition that is closest to its meaning is that it is the *very essence of* something. According to Bharata, the mythical author of the Natyasastra, rasa is the very essence of the aesthetic experience of plays, performance, and other artistic means of communication such as music and poetry (NS 6: 32–33). In the "Origin of Theatre," the first chapter of the Natyasastra, Bharata, while explaining the Vedic origin of the art of theatre, also explains the origin of rasa, which is that it is derived from the *Adharva Veda,* one of the four Vedas dealing with occultism. In Sanskrit, this term is used for juice, milk, water, essence, and a tasty liquid. Once again, Bharata offers a clear definition of the term as the combination of determinants (*vibhava*), consequences (*anubhava*), and transitory mental states (*vyabhichari bhava*) (NS 6: 31). The entire discussion in the Natyasastra, in thirty-six extensive chapters, is an elaboration of this statement, and it explains various textual, physical, and psychological elements that create rasa. The primary element is determinants, which are the pure force of external stimuli that create rasa: they are the basis of emotional and aesthetic responses. They are potentially emotive, causing the rasa experience. These *vibhavas* are of two kinds: the objective world, including persons in which all emotional experiences are based (*alambana*) and specific environmental factors that stimulate emotions (*uddipana*). Characters are the repository of latent emotional tendencies (*bhava*), and the mimetic interactions (*anubhava*) of a character, with other dramatic personae and situations, create a series of transitory physical and mental states in a performance. The rasa experience is the essence of these vivid and complex dramatic events in a performance perceived and experienced by the audience (NS 6: 41). The second element in Bharata's definition of rasa is consequences, which are the elements of verbal and physical reactions of the characters involved in a dramatic situation (NS 7: 4–5). Transitory mental states, which are the third component of rasa, are the varying emotional responses accompanying physical re-actions in a performance (NS 7: 12): sadness underpinning happiness and vice versa, for instance. In fact, rasa is about

the awakening of latent emotional tendencies and transiting them onto a mimetic level of perceptible sensations through the means of acting (*abhinaya*) predominantly based on the body.

Rasa is about a theory of mimetic communication through which a core emotion (*bhava*) is rediscovered through a series of perceptible sensory moments in a performance; the felt essence of this emotional evocation is rasa. The erotic rasa as the essence of the emotion love, for instance, is realized through a series of physical and mental properties presented in a performance. The physical presence of the lovers is the stimulus of the rasa. The surroundings or conditions in which the meeting takes place function as the external stimuli, evoking physical responses identical to the feeling that brings the lovers together. According to the Natyasastra, a lonely place, fragrances, music, and cool and pleasant weather are some of the environmental stimuli for erotic rasa. In addition, the physical responses of the lovers, such as glancing, speaking softly, and unintentional touches arouse interest in and enthusiasm for pursuing their feelings further. Based on who the lovers are, where they come from, and what brings them together at this particular moment, the couple experiences a series of transitory mental states that keep the basic feeling growing. As we can clearly see, each person in this example is discovering what is happening with herself or himself and also what the other person might be experiencing at the same time. The erotic rasa as the essence of this situation of love is inherent within the characters as an emotional instinct, but a realization of it can only be achieved by using performance as a medium (Tripathi 1991: 15).

In a similar fashion, a performance unfolds as a multilayered, mimetic event which acts as the external sensory stimulus for the spectators to evoke their own latent emotional instincts, because the imagination is what connects the spectator and performance, and "nothing in the real world happens or is affected" in a performance (Masson and Patwardhan 1970: 24). Abhinavagupta, the tenth-century commentator on the Natyasastra, distinguishes between conceiving an emotion and actually having one. In the theatre we are often removed from "real" emotions, and only experience induced feelings *about* expressed emotions perceived in a performance (Masson and Patwardhan 1970: 35). Abhinavagupa builds up a series of arguments to establish the notion of the "illusory drive" of the spectators, arguing that the audience's experience of rasa is a perceptual experience of "sympathetic responsiveness" while knowing that the perception is unreal (Masson and Patwardhan 1970: 18, 36). The fundamental concept of Abhinavagupta's aesthetic philosophy is based on the notion that the perceptual experience is illusory (*maya*), and therefore it is a metaphoric or symbolic understanding of the "real world." Taking an example from Abhinavagupta, a house on fire in a performance is

only a metaphor of a house on fire, and therefore rasa is experiencing the essence of a "real" event but not actually experiencing the "real" event. Relating the illusory aspect of rasa to dreaming, Abhinavagupta further argues that the objects that appear in a performance are symbolic and metaphorically arranged because those objects do not conform to the conventional standards of reality in the "real" sense of the world (Pandey 2006: 340). Many of Abhinavagupta's discussions on rasa correspond interestingly to recent scientific studies on neural mechanism. To conclude, rasa is the very perceptual essence of aesthetic experience metaphorically mediated through cross-activation (in neural terms) or the *combination* (in the Natyasastra's terms) of sensory objects and mimetic movements. Rasa stands for a metaphoric perception of the world.

Rasa and the Peak-Shift Effect[2]

What does it mean when we say that rasa captures the very essence of something in order to evoke a direct emotional response to the audience, how does rasa do this in terms of communication, and what is its methodology? In acting, rasa is conveyed through different facial features. Erotic is a pattern of facial features that is different from anger. Erotic discriminates between certain features from anger, and in each facial pattern we see a degree of amplification or an exaggeration of specific facial muscular patterns evoking a direct emotional response. Erotic amplifies its difference from Anger. These amplifications of facial features activate the same neural mechanisms that would be activated by actual objects. Physiologist Zeki (1998) has noted that "the ability of the artist to abstract the 'essential features' of an image and discard redundant information is essentially identical to what the visual areas [of the brain] themselves have evolved to do" (Ramachandran and Hirstein 1999: 17).[3] The same neural principle is applicable to rasa acting, and according to Ramachandran there may be neurons in the brain that represent a sensuous response to amplified forms or patterns, producing a correspondingly high limbic activation (18). Highly stylized anatomical poses and postures in dance or other performances stimulate neural mechanisms in the brain through amplification of essential characteristics of emotions. The acting of erotic rasa, in this sense, is amplifying the facial features that, in turn, create the very essence of "amorousness." There are brain regions for remembering the body representations known as *posture space* and face perception known as *ventral stream*. In addition, a memory mapping system exists in the "dorsal" stream of visual processing, which connects with the perceiver's own body representations while perceiving the facial patterns and the bodily postures of the other person. The activities of all these regions are connected to the limbic

systems in the event of perception, and as a result one can recognize an attack posture or a body position, which indicates bodily responses and subsequent emotions (19).

The brain has other specialized visual modalities and functional specializations such as color, depth, and motion in relation to visual aesthetics. The visual brain is characterized by a set of "parallel processing" that are perceptual systems and a temporal hierarchy in visual perception (Zeki 1998). When area V4, the color center, is damaged, the consequence is an inability to see the world in color; and when area V5, the motion center, is damaged, the consequence is an inability to see the objects when they are in motion, but other attributes of the visual sense function normally in both cases (Zeki 1980). One of the specializations of the human visual brain is visual motion, and this specialization is centered on the V5 area in which all cells are selectively responsive to motion. Moreover, a great majority of cells are also selective in terms of the direction of motion, corresponding vigorously when the stimulus moves in one direction (Zeki 1980; Zeki and Lamb 1994; Livingston and Hubel 1987; Allman and Kaas 1971; Van Essen and Maunsell 1980). On the basis of this evidence, one can clearly argue that performing arts generate limbic activation through physical movements, which are perfect stimuli for the V5 brain region. The brain cells in the V5 region are indifferent, and do not respond to the color or form of the stimulus due to their selective motion response. This means that unlike painting, which activates "color space" or "posture space," performance generates emotions through movements and explores the peak-shift effect: regardless of generic forms, the extended body movements in classical western ballet, the stylized and rhythmic movements in Indian classical dance, or the amplified facial movements in rasa acting, and all physical movements operate in "motion space." Once the perceptual focus is centered on movements, other attributes of visual perception, such as color or forms, become insignificant due to the limbic activation of V5 in the brain region.

Movement is the functional modality of rasa-based acting that simultaneously generates visual aesthetics through limbic activation of the V5 area of the brain. In the Natyasastra, each rasa characterized by specific movements of six muscular regions in the face such as eyes, eyebrows, nose, lips, cheeks, and chin (NS 8: 11). In addition, there are thirteen different clusters of head movements and there are clear directions indicating the application of each cluster into a variety of emotional situations. Erotic rasa, for instance, is illustrated as quick movements of the eyebrows, fully opened eyelids, and glancing to one side to look at the person or object of love (NS 8: 39). Anger is portrayed as protruding eyeballs, arched eyebrows, lifted cheeks, and shrinking lower eyelids (NS 8: 44). Although these seem to be pictorial in description, all of

these movement patterns are meticulously activated constantly during the performance. Each cluster of these exaggerated movements, through the peak-shift effect, will create amplified facial patterns of emotions that function as a "releasing stimulus" or a "trigger feature" in the neural mechanism of visual perception.[4] Rasa is not a representational act of creating resemblance. It does not create the imitation of a real object in the world. Rather, it creates mimetic metaphors by using the body as a medium of communication to induce the very essence of emotional experience.

The peak-shift effect is particularly important for the rasa style of acting and is also relevant to the core of the performance discourse proposed by the Natyasastra. According to Bharata, the art of theatre is the art of acting, and the rasa experience is the finest form of experience that the body can create. The Natyasastra has not given as much emphasis to scenographic elements as it has given to kinetic and mimetic properties of the body such as rhythm, movements, bodily postures, and other movement functions of the body. In *Kutiyattam*,[5] the Sanskrit theatre of Kerala, a bare stage is chosen for the performance and then the actors, using their bodies as the only means of communication, will create all the visual imagery, from mountain to forest, rivers, animals, and insects. Hand gestures (*mudra*), eyes, feet and the body will be engaged in the performance in kinetic mode. The play unfolds between the actor and the audience through a powerful imaginary interaction without many extra illusory accessories such as lighting and scenography. Rasa in performance does not work strictly in terms of signs, but rather it is the "representation of movements ... capable of affecting the minds" (Deluze 2001: 8). Each rasa is formed through a cluster of facial and body movements, and the perception of rasa is direct and un-representationally mediated through a powerful "transfer of forces from body to body" (Artaud 1989: 93). In the process of perception of the complex postures or actions, the audience may initially be required to re-enact or rehearse the action before it is identified (Ramachandran and Hirstein 1999: 21). Also, there are cells in the frontal lobes that are thought to be involved in the production of complex movements but which also fire up when the animal perceives the same movements performed by the experimenter (di Pellegrino et al., 1992). On the basis of these findings, together with the peak-shift effect, it is clear that the rasa acting and the performance style proposed by the Natyasastra may powerfully activate these cells in the frontal lobes. It is also clear that in the Natyasastra model the actor–audience dynamic is powerfully manipulated through a peak-shift effect in which amplifications of movements and imagination play important roles in the rasa experience.

Extracting Correlations: Perception and Limbic Reinforcement in *Kutiyattam*

To discover and delineate objects in the visual field is one of the main functions of "early vision" (Marr 1981; Ramachandran 1990; Pinker 1998; Shepard 1981). To do this, the visual areas rely on extracting correlations (Ramachandran and Hirstein 1999). The very process of discovering correlations and of "binding" correlated features to create unitary objects or events must be reinforcing for the organism in order to provide an incentive for discovering such correlations (Ramachandran and Blakeslee 1998). The audience in a *Kutiyattam* performance follows the same neural pattern of perception-discovering correlations and "binding" correlated features to create unitary objects and events in order to relish the rasa experience. The performance structure and acting style of *Kutiyattam* particularly reinforce this limbic activation to a greater extent due to immense deployment of imagination at every moment of its performance and perception. The imagination draws ideas and emotions into concrete forms. Imagination is the foundation for a performance that brings neural function, cultural construction, memory, feeling, and emotions into concrete physical situations in a performance (Blair in McConachie and Hart 2006: 177), and there are interesting interconnecting patterns between the performance structure of *Kutiyattam* and the neural structure of perception.

The visual field of *Kutiyattam* is a single, enormous cluster of vivid and independent mimetic actions superimposed on one another. Performance devices such as dancing, singing, narrative, and hand gestures (*mudra*) incorporate individual scenes and connect them into a stream of mimetic actions. The dramatic scenes in *Kutiyattam* are presented through a series of stylized rhythmic body movements and hand gestures, and it is this enactment by the actor that creates the visual elements in the performance, including the scenography, the objects, and sometimes even other characters and dramatic events in the play. The performance structure of *Kutiyattam* is complex and aesthetically demanding: the actor, with the power of his imagination, visualizes, fantasizes, and creates scenes or situations, and the experienced spectator follows every movement of the actor's eye, hands, and feet in order to make the rasa experience (Paniker 1996: 8). During each moment in a *Kutiyattam* performance, the audience will be completely engaged with the performance, looking out for what each eye movement and hand gesture means. For the audience, each moment will be the moment of "discovery" and of *extracting correlations* leading to recognition of dramatic objects, situations, and events. A hand gesture, coupled with movements of the eye, show the blooming of a flower and the rising of the sun. The dramatic reality, in this sense, is the perceptual reality

imagined by the audience in a mental space somewhere between the hand gesture and the memory of a "real" flower. In "color space," perceptual grouping is explained as wearing a blue scarf with red flowers if you are wearing a red skirt; the perceptual grouping of the red flowers and your red skirt is aesthetically pleasing (Ramachandran and Hirstein 1999). A similar principle may be applicable in "motion space" for the audience to identify a similar grouping of actions that create a flower or the rising of the Sun. Perceptual grouping of actions and movements is important when one considers the aesthetic enjoyment of a performance due to extracting correlations.

The following example will demonstrate the way in which the neural principles such as "extracting correlations" and "perceptual grouping" work in a performance. The enactment of lifting the Kailash mountain (*Kailasodharanam*) in *Kutiyattam* demonstrates a number of clusters of perceptual grouping of actions leading to the rasa experience. This particular scene in *Kutiyattam* is derived from the second act of the Sanskrit play called *Coronation Play* (*Abhisheka Natakam*), written by Bhasa, the Sanskrit playwright from the second century B.C. No single play will be performed completely in the *Kutiyattam* style, but rather a single act from a play will be performed, and normally the performance of this will last for several days. *Kutiyattam* has a peculiar performance structure and acting style that support this mimetic elaboration based on a relatively small portion of the written play (see Paniker 1996; Madhavan 2010). It will take six days to complete the performance of this particular *Kutiyattam* play, and the scene under discussion, The Lifting of the Mountain Kailash, appears during the second day of the performance. The scene will be enacted as follows: the actor, looking at the Kailash mountain, shows, through a variety of eye movements, body positions, other movements, and hand gestures, the height, width, and other spatial dimensions of the mountain, including depicting the caves, rivers, and trees in the forest in the valley of the mountain. Each object will be depicted elaborately by this acting, making sure that the images are conveyed to the audience appropriately. Then the actor will start describing more details of the mountain, demonstrating the animals that are living in the forest. Elephants, lions, peacocks, and many other birds and flies will be enacted in incredible detail. A fight will take place between an elephant and a lion. Once a detailed enactment is over, the actor will look at the mountain once again, showing its enormity by re-enacting its height and width as he did at the beginning of the scene. Now the illusion of the mountain is clearly established. Then, as part of the play, Ravana, the demon king, with all his proud and mighty strength, begins to shake and lift the base of the mountain. Slowly, he lifts the mountain and play with it.

A single actor, without other actors or visual supports, carries out the entire enactment of this scene; using only their body, the actor carefully devel-

ops each image in the visual narrative. Normally, the scene lasts for at least two hours and the actor has enormous freedom to improvise during the performance. The duration of the scene can be shorter or longer depending on the actor's skills. There are multiple layers of mimetic clusters in this scene: (A) the actor establishing the size of the mountain, which is the background cluster; (B) the enactment of animals, birds, and trees; and (C) the enactment of lifting the mountain. A is superimposed on another set of mimetic actions in B that are not directly related to the structural features of the mountain. Nevertheless, these two clusters together form a "single enormous cluster" that is the mighty mountain, Kailash. A is the background cluster in which geometrical features of height and width are put together, whereas in B animate objects such as animals and birds are clustered together to highlight the intensity of the imagined object that is the enormity of the mountain Kailash. Cluster C is another grouping of hand movements coming into the visual field as another layer, amplifying the enormity of the mountain as well as the "valorousness" of its character. The discovery of the mountain is perceptually supported by the constant appearance of linking images that help the audience hold the image of the mountain persistently throughout the performance. Each moment of discovering the mountain creates an "aha" sensation in response to the aesthetically pleasing moments during the performance. A limbic reinforcement is evoked at each and every stage in processing as soon as a partial "consistency" and binding is achieved (Ramachandran and Hirstein 1999). This explains why we say "'aha" when the mountain is seen through different clusters of mimetic actions. Once a particular movement of the actor or a series of hand gestures become perceptually salient as mimetic objects in the performance, they may send a signal to the limbic centers, which in turn suggest that we "hold on" to facilitate further computation. This example suggests that there may be direct links in the brain between the processes that discovers such correlations and the limbic areas that give rise to the pleasurable, "rewarding" sensations associated with "feature binding" (Ramachandran & Hirstein 1999). Through watching a performance of "lifting the mountain Himalaya," you are indirectly tapping into these neural mechanisms.

Recent studies in biological motion research show that the visual system analyses locomotive actions in a rapid manner and that the brain processes clear action representations by categories (Giese and Lappe 2002; Vangeneugden et al., 2009, 2011). Action analysis is more complex than the analysis of static face images due to its spatial and temporal involvement. The perceptual space of the body movements is also correlated with emotion space (Giese, Thornton and Edelman 2008), and the most important perceptual dimension in the emotion space is correlated with kinetic movements of the arms (Pollick et al., 2001). As Ramachandran explains, within the neural mechanism of clus-

tering perceptual actions, there is always a tendency to follow the clue for something potentially "object-like" signal that produces limbic activation and draws your attention to that region (Ramachandran and Hirstein 1999). In *Kutiyattam,* the story of each day's performance will be given to the audience in advance so that they have a hypothetical understanding of the performance that they are going to watch each day. The mountain Kailash is a hypothesis that encourages the audience's "binding" of corresponding actions, which in turn consolidates the final perception of the mountain. The audience feels happy when all the linking images of actions fall into proper places by revealing the hypothesis, the mountain Kailash. What the performer does, in fact, is perceptual problem solving (Gombrich 1973; Arnheim 1956; Penrose 1973), and although aesthetic experience is more than a scientific explanation of neural mechanism, "temporary binding" of perceptual actions send signals to the limbic system to reinforce the binding, which is one source of the aesthetic experience (Ramachandran and Hirstein 1999).

Stylization in Acting: Isolation and Allocation of Attention

Ramachandran noted that isolation of a single visual modality in order to allocate perceptual attention is an important neural principle of aesthetic experience. For instance, an outline drawing or sketch will be more effective as "art" than a full color photograph. Isolating a single area, "form," or "depth" in the case of painting, and the stylized use of the body, including eyes, hand gestures, etc., in the case of classical Indian performance, for instance, allows one to direct attention more effectively to a particular set of visual clues. This, in turn, will allow one to notice the "enhancement" introduced by the artists (ibid. 1999). These enhancements would amplify the limbic activation and reinforcement. In other ways, nonrealistic and stylized artistic representation is more likely to create powerful limbic activation and reinforcement than realistic art. According to Ramachandran, one would expect that the richer the clue available in the object the stronger the recognition signal and associated limbic activation. But "more is less" is the argument in art which is supported by the laboratory evidence of MRI-measured brain activation of the face area, which shows that greater activation is measured for an outline sketch of a face than for a full color photo of a face (ibid. 1999). On the basis of this evidence, one can clearly argue that the rasa acting and various other nonrealistic performance techniques of *Kutiyattam* can create greater limbic activation and reinforcement due to their stylistic emphasis on minimal text and isolation of bodily skills in performance.[6] A *Kutiyattam* performance offers multiple layers of "isolation" of visual modality: 24 hand gestures, 21 eye move-

ments, 48 sequences of movement patterns capable of creating different dramatic situations (*cari*),[7] 21 voice patterns, and so on. Gender identity is created through gaits, and the female motion trajectories are isolated and subtract from the male's in order to amplify the difference. In *Kathakali*,[8] when male actors impersonate female characters, beyond the gender distinctions created by the cosmetics and costumes, it is the motion trajectories that create an aesthetically pleasing experience of "feminineness" in the male body. More astonishingly, in *Kutiyattam,* the actors are trained to show male and female flies only by using eye movements and hand gestures, which is a subtle and delicate application of the isolation principle of motion trajectories to amplify the difference (between a male fly and a female fly).

Contrast Extraction as Transitory Emotions in Reinforcing Rasa

Bharata classifies thirty-three transitory emotions (*vyabhicari bhava*) in the Natyasastra as impermanent and in contrast to eight fundamental rasas (VII: 34). These transitory emotions are physicalized reactions of varying emotional attitudes corresponding to each rasa, and they reinforce the artistic communication in acting. The role of transitory emotions in the aesthetic experience of rasa and the ways in which they reinforce the emotional expressiveness in rasa acting had been and still are topics of great interest and elaborate discussion in Indian aesthetics over the years. Bharata defines transitory emotions in kinetic terms (VII: 34), explaining them as a cluster of contrasting actions, indicative of emotions, selected to reinforce a particular rasa. The transitory emotions for happiness (*harsha*), for instance, according to Bharata, are a pleasing appearance of the face, including bright eyes; sweet words; embracing; tears in the eyes (crying), and shivering (VII: 66). Tears in the eyes and shivering are emotions that contrast with the group of emotions in the earlier list corresponding to happiness. A pleasing appearance of the face, bright eyes, sweet words, and embracing are things that are correspond with the principal emotion of happiness. Bharata, however, uses contrasting emotional expressions, crying and shivering in this example, to reinforce the principal emotion of happiness. Anger in love, as well as sadness in anger, are juxtapositions of emotions that reinforce the expression of the main emotions. Bharata demonstrates his clear understanding of the role of contrasting emotions in aesthetic experience by saying that the rasa experience is brought about by the combination of various contrasting emotions. He further explains this by using the analogy of the sun and stars, saying that it is the sun that brings daylight and the stars to a dark sky: the light comes when the sun rises and

the stars appear when it sets (VII: 34). A contrast, therefore, is essentially part of the unity or cohesion of the rasa experience.

Discarding redundant information and extracting contrasting features are important neural functions and may be intrinsically pleasing to the eyes, reinforcing the aesthetic experience (Ramachandran and Hirstein 1999: 25). Contrast is extracted autonomously by cells in the retina and the visual cortex that respond to it with the allocation of *attention*. Contrast information grabs more attention and is more visually interesting than homogeneous areas or groups of information. There are cells in the different visual areas for color contrast or motion contrast (Allam and Kaas 1971), and it might be coincidental that "what the cells find interesting is also what the organism as a whole finds interesting" (Ramachandran and Hirstein 1999: 25) and experiences as pleasing. Beyond the level of luminance and color, contrast information can also emerge in dimensions. Using Ramachandran's analogy of "jewels and naked skin," a nude wearing baroque gold jewelry is more aesthetically pleasing than a completely nude woman or one wearing both jewelry and clothes (1999: 27). Homogeneity and smoothness of the naked skin contrast sharply with the texture of the jewelry. Contrast, in terms of color or motion, that occurs between dissimilar features that are physically close together can be visually rewarding in terms of the discovery of objects, which is the main goal of vision.[9] Contrast extracting equally identifies recovery of the objects as well as their boundaries. In terms of rasa, the tears in happiness, the anger in love, and the sadness in anger are groupings of opposite emotions, occurring in motion, that are mutually rewarding and reinforce the discovery of the principal emotion. Contrast extraction of rasa through transitory emotions in acting places two opposing emotions into play. Even though they are inconsistent, these opposing emotions complement one another in the process of discovering and intensifying rasa: tears intensify happiness and anger intensifies love in the process of *recovering* a principal emotion. In this way, contrast extraction, through transitory emotions, intensifies limbic activation in the perception of rasa.

Symmetry and Logic of Perception in Rasa

In visual processing, symmetry seems to be extracted very early and this processing also testifies that symmetrical proportions are aesthetically pleasing (Julez 1971). The processing of symmetrical existence between biological objects such as predator and prey or mate is observed as the driving force in biological entities. Between predator and prey or mate, symmetry serves as an early warning system that grabs the attention to facilitate a full recognition of the other (Ramachandran and Hirstein 1999: 27). In this way, symmetry is

observed as one of the primary principles geared towards discovering "interesting" object-like entities in the world.[10] Theories and scientific experiments on visual perception demonstrate the existence of some underlying functional similarities that correspond to the aesthetic principles that are presented in the Natyasastra, especially, in the context of rasa. Bharata establishes a symmetrical relationship between the audience and the actor during the discussion of rasa. In Bharata's aesthetic theory, audience perception is central to the rasa experience as a process between the actor and the audience and to what is to be communicated and what is to be perceived. Rasa is a perceptual experience that is derived by the audience through their engagement with the determinants (*vibhava*), consequences (*anubhava*), and transitory emotions (*vyabhicari*): these elements are objects of perception for the audience through which rasa experience is derived. Here, Bharata places the actor and audience as symmetrical others taking equal parts in the process of the rasa experience. The signals transmitted at one end are fully received at the other end, where the same emotions and thoughts are felt. The audience constitutes a special body of people who are as knowledgeable as the actor is about the performance, who have competitive aesthetic refinement and sensibility, and are prepared for feeling all emotions expressed by the actor (NS 27: 49). Performance is an object of perception, so the audience sees the actor as the symmetrical other in the visual world of performance in order to process the signals needed to "discover" objects and emotions that are appropriate for the rasa experience. The audience–actor relationship is like a chromosome pairing making the physical body of the performance complete, meaningful, and enjoyable. While offering a systematic analysis of the rasa aesthetics, Abhinavagupta (950–960 A.D.) further clarifies the symmetrical entity of the audience/actor by saying that the audience identifies and universalizes the mental and physical schema of the actor during the performance (Vedabandhu 1986: 227). Aesthetic enjoyment (*rasanam*) is a process of discovering and universalizing objects and emotions in the world of performance in order to experience rasa (228). The objects and emotions appearing in performance are impersonal and therefore they are universal and enjoyable: they belong neither to the actor nor to the spectator. Rasa is the "blending (*samyoga*) of different sensory qualia" (Ramachandran and Hubbard 2001: 25), geared by the symmetric others— actor/audience—through their discovery of interesting object-like entities in the perceptual world of performance.

There is a logical progression of perception involved in the process of discovering *rasa*. Each element that combines the rasa experience and in which the rasa experience is based, such as character and dramatic situation (Determinants), characters' emotional responses (Consequences), and their voluntary and involuntary mental states (Transitory emotions) all need to be logically

connected in a proper development of the rasa experience. It is the logical progression of actions that creates the rasa, not the coincidences. In the example of the mountain Kailash in *Kutiyattam,* there is a clear logic in the progression of actions that creates the enormity of the mountain. The height and width of the mountain ranges, the shape and movements of the caves and the rivers, the patterns of trees and the detailed descriptions of various birds and animals are all meticulously and logically enacted to create the illusion of the enormity of the mountain Himalaya. The enactment looks like a rigorous mathematical framework representing the physical and statistical properties of the body and the environment. The example offers a display of logically progressing optical illusions of the body that follow geometrical patterns of lines and curves. Vertical movements of the eyes and face, for instance, create the illusion of height, and horizontal movements create the illusion of width.[11] Evidence based on studies in human perception confirms the fact that very different objects can give rise to similar retinal images and that the same object can give rise to very different retinal images (Geisler and Kersten 2002: 508). A circle and an ellipse, therefore, can produce the same retinal image of a circle slanted in depth, and also the same circle slanted in depth by different amounts can produce many different images (508). In this way, the actor who enacts the Kailash Mountain in *Kutiyattam* uses a range of logically progressing optical illusions of the body to create the rasa experience. From an audience's point of view as the symmetrical other, what interests them is the discovery of the object-like entities within the optical display of enactment and aiming to achieve the same mental image that the actor is holding during the performance. The actor has a complete mental image of the mountain Kailash when the performance begins, but for the audience, following each moment of the enactment and discovering objects like shapes and their material as distributed by the actor is a perceptual process leading to a culmination of the mental image of the mountain Himalaya. There is an "aha" in the audience's response when the mental image of the mountain Himalaya is completed and the rasa is fully discovered. It is evident in this analysis that there are key interlocking systems and underlying principles that are common to rasa as well as to visual perception and neural mechanisms. The human visual system abhors suspicious coincidences (Barlow 1980), and it relies entirely upon the logic of perception.

Conclusion: Rasa as Metaphor

Based on unambiguous evidence derived from brain studies, metaphorically encoding the world is a basic cognitive mechanism (Ramachandran and Hubbard 2001: 31). Objects and concepts are classified and categorized in

visual perception in order to create a single super-ordinary category: repre-
sentation of a chair is linked to an abstract "chairness." The discovery of sim-
ilarities and the linking of dissimilar events in the visual processing lead to
limbic activation, ensuring the process is rewarding (31). These activations
lead to emotions in the amygdala, a part of the limbic system (Hirstein and
Ramachandran 1997), and once the object has been recognized and its emo-
tional significance is gauged by the amygdala, a message is relayed to the auto-
nomic nervous system (ANS) via the hypothalamus so that the subject is
prepare to act—to fight, flee, or mate (Ramachandran & Hubbard 2001: 32).
"A metaphor is a mental tunnel between two concepts or percepts that appear
dissimilar on the surface (Juliet is the sun)" (31) but it enables us to highlight
the crucial aspects that it represents symbolically. Juliet is not the Sun but she
shares radiance and warmth with the sun, a meaning that is suggested in the
metaphor. This suggestive nature of meaning making is the basic cognitive
mechanism encoding the perceptual world. Metaphors structure our under-
standing of the perceptual world and function as a language for our interac-
tions with the world. Rasa is metaphor embodied in the sense that it refers to
neural mechanisms underlying the visual perception and stimuli in perform-
ance practice. Rasa stands for a perceptual discovery of salient emotional evo-
cation in a performance. Rasa is not actual representation of "real" objects and
events and environments, but it is a perceptual process of rediscovering "object-
ness" and "emotioness" through performance. Rasa does not offer "real" emo-
tions of love or sadness, but it offers "loveness" or "sadness," which are physical
metaphors that are suggestive and stylized. Discovery of similarities linking
dissimilar events would lead to limbic activation. It is the basic neural mech-
anism that one taps into, whether with puns, poetry or visual art (31). In this
way, what rasa offers in theatre and performance practice is a rich limbic acti-
vation through shifting the sensory modalities in the perception of objects
and persons in performance. Rasa as a process of embodied practice, as well
as a mode of aesthetic relish, pushes the functional boundaries of the actor's
body, imagination, and creativity, and those of the audience too, and during
the performance this may be likely to activate sensory processors in the brain
and stimulate cross-activation between neurons. The visual, tactile, and kinetic
elements of the Natyasastra-based performance practice seem to provide a
methodology for a comprehensive understanding of emotion and perception
that follows the principles of a neural mechanism of experience.

This essay is a revised version of "Rasa Theory and Neural Mecha-
nism," *New Zealand Online Journal of Interdisciplinary Studies* 1.2
(2012).

NOTES

1. The term synesthetics is derived from a series of neurological studies on Synesthesia presented by V.S. Ramachandran & William Hirstein 1999; V.S. Ramachandran, E.M. Hubbard & P.A. Butcher 2004; V.S. Ramachandran & E.M. Hubbard 2001; and V.S. Ramachandran & E.M. Hubbard 2003. These studies confirm that Synesthetia is a perceptual condition and an involuntary perceptual experience in one sensory modality which is normally associated with another perceptual modality or cognitive processing. A synesthete, for example, may experience a specific color whenever he or she encounters a particular tone (C-sharp may be blue) or may always see any given number as tinged with a certain color (5 may be green and 6 may be red). Synesthesia is explained in these studies as a neural mechanism of perceptual coloring and metaphor making for encoding the world in minimal terms. In this chapter I emphasize "a neurological theory of aesthetic experience" and elaborate the discussion to explore the neural mechanism of the rasa theory of Indian aesthetics.

2. V.S. Ramachandran and his fellow researchers developed a theory on human aesthetic experience mediated by neural mechanism. In order to explain the neural mechanism of rasa aesthetics, in the following sections I refer to the eight laws developed by Ramachandran and his fellow researchers.

3. Peak shift is a neural principle tested among rats, with a result showing that animals respond to exaggerated training stimuli. If a rat is taught to discriminate a square from a rectangle, it will soon learn to respond more frequently to a rectangle even if the object is longer and skinnier. The result implies that what the rat is learning is not a prototype but a rule, i.e., *rectangularity*.

4. Ethologists have long noted that a seagull chick will beg for food by pecking at its mother's beak. Remarkably, it will peck just as vigorously at a disembodied beak with no mother attached to it or even a brown stick with a red dot at the end (the gull's beak has a vivid red spot near the tip). It is the same neural principle of peak shift that works with rasa acting. As Ramachandran noted, what is even more remarkable was Tinbergen's discovery (Tinbergen 1954) that a very long, thin brown stick with three red stripes at the end of it is even more effective in eliciting pecks than the original beak, even though it looks nothing like a beak to a human observer (Ramachandran & Hirstein 1999).

5. *Kutiyattam* is the only existing form of the Sanskrit theatre of India and the oldest existing classical theatre form proclaimed by UNESCO as the intangible heritage of humanity in 2001. The history of the performance dates back to 200 A.D. However, an unbroken history of the performance can be traced back to the tenth century A.D., when it received the royal patronage of King Kulasekhara of Cochin. The temple theatres (*Kuthambalam*) have been constructed for *Kutiyattam* since the fourteenth century A.D. It is the only theatre form that exemplifies the principles of the Natyasastra in practice.

6. *Kutiyattam* uses minimal text; the production scripts (*attaprakaram*) contain detailed descriptions of what the actor has to do during every moment of the performance. One act can be performed for several days, and a few verses can be performed for several hours. Sanskrit plays in general have minimal verbal structure and give more space to enactment and actors' improvisation. Performance becomes a subtextual elaboration rather than representation of mimetic actions. There are several scenes in the *Kutiyattam* repertoire, such as the lifting of the mountain Kailash, the preparation of the war, the flies and the lamp, etc., that can only be completed over several hours and do not use speech.

7. Mani Madhava Chakyar, the legendary actor of *Kutiyattam,* listed forty-eight movement patterns (*Kriyas*) in his book, *Natyakalpadrumam,* which is considered to be the actor's manual (1973: 22–36). In the Natyasastra, Bharata listed thirty-two movement patterns (*Chari*) (XI: 10–46). *Chari* means movements and *Kriya* means actions: both are kinetic properties of the body.

8. *Kathakali* is the dance drama developed in feudal Kerala in the fifteenth century A.D. Owing its performance techniques to the *Kutiyattam* and its aesthetic principles to the Natyasastra, the *Kathakali* flourished as a unique form of the performing arts of Kerala. Unlike in *Kudiyattam,* female actors are not allowed to perform, and therefore male impersonations are common in *Kathakali* and there are well-known female impersonators in the art form.

9. V.S. Ramachandran explains two antithetical principles of vision that are mutually reinforcing and rewarding to the organism: grouping on the basis of similarity and grouping on the basis of

contrast. Grouping can occur between similar features (e.g., color or motion) even if they are far apart in space (the spots on the nose and the tail of a leopard). On the other hand, contrast usually occurs between dissimilar features which are physically close together. Even though the two visual processes seem to be inconsistent, they actually complement one another with the discovery of objects. According to Ramachandran, contrast extraction is concerned with the object's boundaries, where grouping allows recovery of the object's surface. See more details in Ramachandran & Hirstein, "The Science of Art: A Neurological Theory of Aesthetic Experience," *Journal of Consciousness Studies*, 6, No. 6–7, 1999, pp. 15–51.

10. Recent experiments in evolutionary biology suggest that when choosing a mate, animals and humans prefer symmetrical over asymmetrical ones due to reasons relating to fertility. If this is the case in humans, there is an inbuilt aesthetic preference towards symmetry. See more details in Ramachandran & Hirstein, 1999, pp. 15–51.

11. Arya Madhavan offers a detailed study of how eye movements create the rasa experience in *Kutiyattam*. For more details see Madhavan 2012.

BIBLIOGRAPHY

Allman, J.M., and J.H. Kaas. 1971. "Representation of the Visual Field in Striate and Adjoining Cortex of the Owl Monkey." *Brain Research* 35, 89–106.

Amaral, D.G., J.L. Price, A. Pitanen, and S.T. Carmichael. 1992. "Anatomical Organization of the Primate Amygdaloid Complex." In J.P. Aggelton, ed., *The Amygdala: Neurobiological Aspects of Emotion, Memory and Mental Dysfunction*. New York: Wiley.

Anderson, Cameron, D. Keltner, and John P. Oliver. 2003. "Emotional Convergence Between People Over Time." *Journal of Personality and Social Psychology* 84. 5: 1054–1068.

Arnheim, R. 1956. *Art and Visual Perception*. Berkeley: University of California Press.

Artaud, Antonin. 1989. *The Theatre and Its Double*. London: Calder.

Barlow, H.B. 1986. "Why Have Multiple Cortical Areas?" *Vision Research* 26.1: 81–90.

Bochner, Aurther, Tony Adams, and Carolyn Ellis. 2002. *Ethnographically Speaking: Autoethnography, Literature and Aesthetics*. Walnut Creek, CA: Altamira Press.

Bourdieu, Pierre. 1990. *The Logic of Practice*. Cambridge: Polity Press.

Brownell, H.H., T.L. Simpson, A.M. Bihrle, and H.H. Potter, et al. 1990. "Appreciation of Metaphoric Alternative Word Meanings by Left and Right Brain-Damaged Patients." *Neuropsychologia* 28.4: 375–383.

Connerton, Paul. 1989. *How Societies Remember*. Cambridge: Cambridge University Press.

Deleuze, Gilles. 2001. *Difference and Repetition*. London: Continuum.

Di Pellegrino, G., L. Fadiga, L. Fogassi, V. Gallese, and G. Rizzolatti. 1992. "Understanding Motor Events: A Neurophysiological Study." *Experimental Brain Research* 91.1: 176–80.

Faust, M., D. Anaki, and S. Kravetz. 1998. "Cerebral Hemisphere Asymmetries in Processing Lexical Metaphors." *Neuropsychologia* 36(7).1: 691–700.

Fischer-Lichte, Erika. 2008. *The Transformative Power of Performance: Re-Enchanting the World*. New York: Routledge.

Fortier, Mark. 1997. *Theory/Theatre*. London: Routledge.

Garner, S. 1994. *Bodied Spaces: Phenomenology and Performance in Contemporary Drama*. Ithaca: Cornell University Press.

Geisler, W., and D. Kersten. 2002. "Illusion, Perception and Bayes." *Nature Neuroscience* 5.6: 508–510.

Giese, M. A., and M. Lappe. 2002. "Measurement of Generalization Fields for the Recognition of Biological Motion." *Vision Research* 42, 847–1858.

Giese, M. A., and I. Thornton, and S. Edelman. 2008. "Metrics of the Perception of Body Movement." *Journal of Vision* 8(9) 13: 1–18.

Gombrich, E.H. 1973. "Illusion and Art." In *Illusion in Nature and Art*, ed. R.L. Gregory and E.H. Gombrich. New York: Scribner's.

Hirstein, W.S., and V.S. Ramachandran. 1997. "Capgras Syndrome: A Novel Probe for Understanding the Neural Representation of the Identity and Familiarity of Persons." *Proceedings of the Royal Society of London* 264: 437–44.

Hubbard, E.M., and V.S. Ramachandran. 2003. "Refining the Experimental Lever: A Reply to Shannnon and Pribram." *Journal of Consciousness Studies* 9.3: 77–84.

Iser, Wolfgang. 1993. *The Fictive and Imaginary: Charting Literary Anthropology*, Baltimore: Johns Hopkins University Press.

Johnson, Mark. 1987. *The Body in the Mind: The Bodily Basis of Meaning, Imagination and Reason*. Chicago: University of Chicago Press.

Julesz, B. 1971. *Foundations of Cyclopean Perception*. Chicago: University of Chicago Press.

Lang, A.H., T. Touvinen, and P. Valleala. 1964. "Amygdaloid After-Discharge and Galvanic Skin Response." *Electroencephalography and Clinical Neurophysiology* 16: 366–374.

LeDoux, Joseph. 2003. *Synaptic Self: How Our Brains Become Who We Are*. New York: Penguin.

Livingston, M.S., and D.H. Hubel. 1987. "Psychological Evidence for Separate Channels for the Perception of Form, Color, Movement and Depth." *Journal of Neuroscience* 7: 3416–68.

Madhavan, Arya. 2010. *Kudiyattam Theatre and the Actor's Consciousness*. Amsterdam: Rodopi.

_____. 2012. "Eyescape: Aesthetics of Seeing in Kuttiyattam." *Asian Theatre Journal* 2 (Fall).

Mangina, C.A., and J.H. Beurezeron-Mangina. 1996. "Direct Electrical Stimulation of Specific Brain Structures and Bilateral Electrodermal Activity." *International Journal of Psychophysiology* 22: 1–8.

Marr, D. 1981. *Vision*. San Francisco: Freeman and Sons.

Masson, J.L., and M.V. Patwordhan. 1970. *Aesthetic Rapture*, Vol. I & II. Pune, India: Deccan College.

McConachie, B., and Elizabeth Hart. 2006. *Performance and Cognition: Theatre Studies and the Cognitive Turn*. London: Routledge.

Murray, Timothy. 1997. *Mime, Mimesis and Masochism: The Politics of Theatricality in Contemporary French Thought*. Ann Arbor: University of Michigan Press.

Paivio, Allen. 1986. *Mental Representations: A Dual Coding Approach*. New York: Oxford University Press.

Pandey, K.C. 2006. *Abhinavagupta: An Historical and Philosophical Study*. Varanasi, India: Chaukhamba Sanskrit Pustakalaya.

Paniker, Ayyappa. 1996. "Introduction: The Aesthetics of Kutiyattam." *Sangeet Natak Journal* 111–114: 7–11.

Penrose, Roland. 1973. "In Praise of Illusion." In *Illusion in Nature and Art*. R.L. Gregory and E.H. Gombrich, eds. New York: Scribner's.

Pinker, S. 1998. *How the Mind Works*. New York: William Morrow.

Pisharoti, K.P. Narayana. 1987. *Natyasastra of Bharatamuni*, Vol. I & II. Trichur: Kerala Sahitya Akademi.

Pollick, F.E., H. M. Paterson, A. Bruderlin, and A.J. Sanford. 2001. "Perceiving Affect from Arm Movement." *Cognition, 82, B51–B61*.

Ramachandran, V.S. 1990. "Visual Perception in People and Machine." In *AI and the Eye*, A. Blake and T. Troscianko, eds. Chichester: Wiley.

Ramachandran, V.S., and Sandra Blakeslee. 1998. *Phantoms in the Brain*. New York: William Morrow.

Ramachandran, V.S., and William Hirstein. 1999. "The Science of Art: A Neurological Theory of Aesthetic Experience." *Journal of Consciousness Studies* 6.6–7: 15–51.

Ramachandran, V.S., and E.M. Hubbard. 2001. "Synesthesia-A Window Into Perception, Thought and Language." *Journal of Consciousness Studies* 8.12: 3–34.

Ramachandran, V.S., E.M. Hubbard, and P.A. Butcher. 2004. "Synesthesia, Cross-Activation, and the Foundations of Neuroepistemology." In G. Calvert, C. Spence, & B.E. Stein, eds., *The Handbook of Multisensory Processes*. Cambridge: MIT Press, 867–883.

Shepard, R. 1981. *Perceptual Organization*. M. Kubovy and T. Pomerantz, eds. Hillsdale, NJ: Lawrence Erlbaum.

States, B.O. 1985. *Great Reckonings in Little Rooms: On the Phenomenology of Theatre*. Berkeley: University of California Press.

Stoller, Paul. 1997. *Sensuous Scholarship*. Philadelphia: University of Pennsylvania Press.

Strathern, Andrew. 1996. *Body Thoughts*. Ann Arbor: Michigan University Press.

Tripathi, Radha Vallabh. 1991. *Lectures on the Natyasastra*. Pune, India: University of Poona.

Van Essen, D.C., and J.H. Maunsell. 1980. "Two-Dimensional Maps of the Cerebral Cortex." *Journal of Comparative Neurology* 191: 255–81.

Vangeneugden, J., F. Pollick, and R. Vogels. 2009. "Functional Differentiation of Macaque Visual Temporal Cortical Neurons Using a Parametric Action Space." *Cereb Cortex* 19: 593–611.

Vangeneugden, J., et al. 2011. "Distinct Mechanisms for Coding of Visual Actions in Macaque Temporal Cortex." *The Journal of Neuroscience* 31(2): 385–401.

Vedabendhu. 1986. *The Rasa Theory of Abhinavagupta*. Trivandrum: Kerala Language Institute.

Zeki, S. 1980. "The Representation of Colours in the Cerebral Cortex." *Nature* 284: 412–18.

_____. 1998. "Art and the Brain." *Proceedings of the American Academy of Arts and Science* 127(2): 71–104. Reprinted in *Journal of Consciousness Studies* 6(6–7): 76–96.

Zeki, S., and M. Lamb. 1994. "The Neurology of Kinetic Art." *Brain* 117: 607–636.

Rasa Is/As/And Emotional Contagion

Erin B. Mee

Rasa can be understood as a particular kind of emotional contagion that occurs between performer and spectator during performance in which the spectator "catches" and experiences the emotion being portrayed by the performer. How, though, does this process work? Specifically, how does it work in the brain, where the process occurs? Although there have been many studies of rasa, none have been done from the perspective of neuroscience, nor have any taken into account the ways in which recent neuroscientific discoveries about the recognition, processing, and experience of emotion can help us understand more about rasa. Here I use recent discoveries in affective neuroscience to shed light on the neural mechanisms of rasa. I chart action observation and affective processing as modes of perception leading to empathic engagement which in turn leads to emotional contagion; explore rasa as a form of emotional contagion; and review recent experiments in neuroscience to show how, when, and where different rasas and bhavas take place in the brain.[1]

Rasa: A Quick Overview

According to the Natyasastra, the Sanskrit treatise on aesthetics attributed to Bharata, "there is no *natya* [drama] without *rasa*" (Rangacharya 1996: 54). The goal of Sanskrit performance is to create rasa, which has been variously translated as juice, flavor, extract and essence. In the context of performance theory, it is the "aesthetic [emotional] flavor or sentiment" tasted in and through performance. Bharata tells us that when foods and spices are mixed

together in different ways they create different tastes; similarly, the mixing of different basic emotions arising from different situations, when expressed through the performer, gives rise to an emotional experience or "taste" in the spectator, which is rasa (Ibid.: 55).

Technically, rasa has been theorized as "the cumulative result of '*vibhava*' [a stimulus], '*anubhava*' [an involuntary reaction to the stimulus], and '*vyabhicari bhava*' [a voluntary reaction to the stimulus]" (Ibid.: 55). Rasa occurs when the *bhavas* (emotions portrayed by the performer, or emotional stimulus from the performer-character) combine with *sthayi bhavas* (basic or inner emotions in the spectator). Performance scholar Richard Schechner describes it this way:

> The sthayi bhavas are the "permanent" or "abiding" or indwelling emotions that are accessed and evoked by good acting, called *abhinaya*. Rasa is experiencing the sthayi bhavas. To put it another way, the sweetness "in" a ripe plum is its sthayi bhava, the experience of "tasting the sweet" is rasa. The means of getting the taste across—preparing it, presenting it—is abhinaya [2001: 31].

D. Appukuttan Nair, founder of Margi, a school that teaches *kathakali* (a genre of classical dance-drama in Kerala, South India) and *kutiyattam* (a particular way of performing Sanskrit drama from the same region), offers an analogy for rasa in the context of kathakali:

> The essence of the emotions is extracted by the actor from the text; the extracted essence is converted by him with the help of his imaginative insight. The essence thus converted and made enjoyable is then presented to the *sahrdayan,* the connoisseur, who experiences the essence in its new flavour. The process is similar to that of the bee sucking the nectar which is the essence of the flower, converting it within its body to something more relishable and sweet, and finally giving it away in the form of honey [1993: 150].

Rasa is, as the aesthetic theorist Abhinavagupta (CE 950–1025) put it, "the *process* of perception" (qtd. Deutsch 1981: 215, emphasis mine). He refers to it as "the act of relishing" (Deshpande 1989: 85). Or, as J.A. Honeywell puts it, "the existence of rasa and the experience of rasa are identical" (qtd. Deutsch 1981: 215). While Bharata spoke of rasa as something that could be experienced by anyone, later commentators on the Natyasastra, including Abhinavagupta, stressed the importance of audience preparation and expertise in order to experience rasa. Bharata conceives of rasa as something taken in and ingested; Abhinavagupta sees rasa as a participatory act requiring preparation; Schechner theorizes rasa as a latent emotion in the spectator brought to the surface and experienced through good acting; while Nair theorizes rasa as a gift from performer to spectator of the emotional essence of the text. In spite of their different ways of thinking about rasa, all of them agree that rasa is an action and a process in which the performer evokes an emotional response in the spectator.

I would like to propose a new way of thinking about rasa: based on recent neuroscientific discoveries, I would like to explore rasa as a process of emotional contagion that occurs at the neural level through the joint embodiment of action and emotion via spectatorship. Emotional contagion refers to the tendency to "pick up" the emotions of another person and to "converge emotionally" (Hatfield et al., 1994: 5 and 2011: 19). Emotional contagion consists of three stages: recognition of an emotion through mimicry, joint embodiment of the emotion, which leads to empathy (Batson 2011),[2] and finally contagion. "People tend a) to automatically mimic the facial expressions, vocal expressions, and instrumental behaviors of those around them, and thereby b) to feel a pale reflection of others' emotions as a consequence of such feedback. The result is that people tend c) to catch one another's emotions" (Hatfield et al., 2011: 26). The process of rasa, then, is one in which the spectator observes and recognizes an emotion, which leads to the spectator herself "experiencing" that emotion at the neural level, which leads the spectator to experience that emotion either consciously or unconsciously, which leads to the spectator converging emotionally with the performer in a shared embodiment of that emotion.

Observing Action Is a Form of Executing That Action

The mimicry Hatfield refers to is motor mimicry, but spectators "mimic" or "mirror" each other at the neural level as well. Experiments involving observation of dance demonstrate that the spectator is actively engaged by/in performance at the neural level. In one experiment ballet dancers, capoeira performers, and non-dancers observed ballet dancers and capoeira performers. Researchers found that observation of action stimulated, to some degree, "the network of motor areas involved in [the] preparation and execution of action" in the observer, meaning that the motor areas of the brain are not only activated by performing actions, but by observing the actions of others, and that action observation involves "covert motor activity" (Calvo-Merino et al., 2005: 1248). Another study demonstrated that the observation and execution of actions share both motor and somatosensory voxels (a unit of brain measurement equivalent to a million or so brain cells with the number of neurons varying widely by brain region) (see Gazzola and Keysers 2008). This "suggest[s] that the human brain understands actions by motor simulation" (Calvo-Merino et al., 2005: 1243), which means that all spectators (of all kinds of performance) are more than active decoders and interpreters of events on stage; they are, at the neural level, participants: doing along with the performers as a way of understanding what the performers are doing.[3] Action observation does not evoke a latent understanding of movement in the spectator; on the contrary, in order

to understand the movement being observed, the spectator "mirrors" the action at the neural level: observation is a form of execution. Action observation stimulates motor areas of the brain in every observer, which supports Bharata's notion that spectators need no training to experience rasa. However, researchers found that ballet dancers responded more to ballet and less to capoeira, capoeira performers responded more to capoeira and less to ballet, and non-dancers responded least of all, proving that the level of expertise in the spectator affects the neural responses to action observation. This supports Abhinavagupta's assertion that the more experienced theatergoer—one with more imagination, discipline, and/or training—is more likely to experience rasa (see Deshpande 1989: 87–90). Either way, this experiment proves that observation is a form of jointly performed action at the neural level.[4] Performing an action evokes an analogous neural response in the spectator.

Shared Affective Information

The same is true of affective information: observing expressions of others' disgust activates the same parts of the brain as feeling disgust oneself (Wicker et al., 2003: 655).[5] Participants in a study inhaled scents producing a strong feeling of disgust; the same participants also viewed video clips of other people displaying the facial expression of disgust. In both cases, the anterior insula,[6] and to some extent the anterior cingulate cortex (ACC), were activated. Thus, "observing someone else's facial expression of disgust automatically retrieves a neural representation of disgust" (Wicker et al., 2003: 660), and "seeing someone else's facial emotional expressions triggers the neural activity typical of our own experience of the same emotion" (661). There is an "automatic sharing, by the observer, of the displayed emotion" (660). When kutiyattam and kathakali performers express disgust they flare their nostrils, turn down the outer corners of their lips, frown, close their eyes halfway, and look down; the shoulders shrink the chest inward, the performer leans back and away from the disgusting idea or thing, and the hands are held up as if pushing the offending idea or thing away. Observing this portrayal of disgust (if it is done well) triggers a neural representation of the same emotion in the spectator. This explains how rasa works at the neural level—and shows us that *bhibatsa*, the rasa that translates into English as "disgust," activates the anterior insula and the anterior cingulate cortex.

Embodied emotion is, in certain cases, a prerequisite for understanding: experiments exploring responses to disgust (above) and pain (below) suggest "that observational learning is supported by a reenactment of the emotional experience of the [...] observer" (Niedenthal 2007: 1004).

People automatically and nonconsciously mimic the behaviors and manner-
isms of their interactions partners, such as face-rubbing, touching one's hair,
footshaking, and playing with a pen. In addition, laughter, yawning, mood,
and various speech variables are known to be automatically imitated [...]. The
reason we mimic automatically is that the perception of a certain behavior
automatically activates our own motor representation of that action [Van
Baren et al., 2011: 32].

In other words, we recognize someone else's emotional state by consciously or
unconsciously simulating the expression of that emotion in ourselves, which
in turn triggers the experience of that emotion.

The greater the tendency to imitate, the greater a person's empathic ability
(Chartrand and Bargh 1999); conversely, the inability to imitate hampers the
ability to empathize (Dapretto et al., 2006). Women who receive Botox injec-
tions to remove frown lines in the forehead feel happier because they cannot
frown as easily: in other words, the inability to make the facial expression of
an emotion inhibits the occurrence of that emotion. However, they are also
less able to understand someone else's expression of anger or unhappiness
because they cannot mimic the other person's facial expression accurately (see
Chartrand and Neal forthcoming, and Davis et al., 2010). Thus, emotional
contagion—or rasa—depends, to some extent, on our ability to mimic one
another, and thus to empathize—whether consciously or unconsciously. It is
worth noting that spectator responses may not always duplicate performer
emotions: for example, a portrayal of sadness may evoke pity in the observer—
but in order to feel pity the spectator has to jointly embody and recognize the
sadness that then moves them to pity.

In fact, we need to embody emotions to make certain kinds of intellectual
connections. A study of subjects who had to relate nouns to emotions (i.e., "slug"
to "disgust" or "baby" to "joy") exhibited the facial expression of the emotion
just before they made their decision. This demonstrates that "in making their
judgments, individuals embodied the relevant, discrete emotion as indicated by
their facial expressions [...] They appeared to make their judgments on the
basis of the embodiment of the referent" (Niedenthal 2007: 1004), implying
that they needed to embody the emotion in order to complete the task.

Furthermore, the embodiment of emotion affects the way information
is acquired and processed: a smiling person will laugh at a joke faster than a
frowning person; subjects pushing a lever away from them will respond more
quickly to negative emotion than subjects pulling a lever toward them; subjects
who slouch respond more negatively to news of having succeeded in an
achievement test than subjects who sit up straight; and couples who imitate
each other's facial expressions and postures are more likely to have a successful
marriage (see Niedenthal 2007).

We do not have to consciously recognize an emotion in another or in ourselves to be affected by it: in one experiment, subjects rated the humor of a cartoon while holding a pen in their mouth that prevented them from using the muscles involved in smiling, or while holding a pen in their mouth that encouraged them to use the muscles involved in smiling. Subjects who engaged their "smiling muscles" found the cartoons funnier than those who were prevented from using their "smiling muscles." Whether subjects found the cartoons funny or not depended solely on which facial muscles were engaged: "recognizing the emotional meaning of the facial response was not a necessary precondition for the effect. Rather, it seems that the interplay between an emotional stimulus and an innate motor program [...] like the smile is the determinant of the emotional experience" (Strack and Martin 1988: 776). As in the Botox experiment, engaging or being prevented from engaging a particular set of *muscles* rather than *emotions* facilitates or inhibits laughter.

Emotion, then, is physical: it can arise from the physiological embodiment of an emotional expression or pose. This knowledge, while confirmed by the neuroscientific experiments cited above, has been embodied in kutiyattam and kathakali training for centuries. Performers of a number of genres of classical dance and dance-drama including kathakali and kutiyattam, often use the phrase "Where the hand, there the eye; where the eye, there the mind; where the mind, there the heart; where the heart, there the rasa." This phrase describes the way emotion is generated in the performer and spectator—which is reflected in the training. Novices at the Kerala Kalamandalam (one of the premiere institutions for kutiyttam and kathakali training) practice eye, eyebrow, cheek, and lip exercises in the pre-dawn hours; leg exercises, jumps and steps in the early morning; and hand gestures in the afternoon. These separate physical elements are combined later in training. Although kathakali performers will tell you that a performance doesn't mean anything unless the performer "feels" the emotion of the situation they are portraying, emotion is the last element to emerge in training, and it follows physical mastery of the body. Students are not trained to summon up emotion on demand, but to master the physical and vocal expressions of the body; the theory embodied in this kind of training is that the outer expression of an emotion evokes emotion in the performer (and subsequently the spectator) not the other way around (for a longer discussion of this phenomenon see Mee 2008: 114–123). For this reason the master kutiyattam performer Mani Madhava Chakyar was able to separate the various components of acting: facial expression, gesture, and vocal delivery, perfecting each before combining them in such a way that they simultaneously evoked an emotional response in himself and in the spectator (see Panikkar 1993). However, if executed well, the performer does not have to feel the emotion in order to evoke an emotional response from the specta-

tor—any more than a glass has to become the wine in order to deliver a taste to the drinker (for more on this see Mee 2008).

Psychologist William James (1842–1910) famously wrote that we do not run from a bear because we fear it; rather, we see a bear and run, causing the emotion of fear to arise: the way we perceive our adrenaline levels, heart rate, and other physiological responses to a situation is the emotion. What James asserted, kutiyattam and kathakali training embodies, and recent experiments prove: when one executes a gesture mindfully, the execution of that gesture, and the full embodiment of it, will evoke a corresponding emotion in the performer and subsequently in the spectator. Students of rasaboxes (exercises created by Richard Schechner to evoke emotion in both performer and spectator through technical means) can attest to the fact that emotion is almost always evoked through this process. In one rasaboxes exercise, the actor takes a pose indicative or emblematic of a particular bhava (such as disgust); she works on that pose until it is as expressive as it can be. Then she adds breath to the pose. Most actors—regardless of their level of training or expertise—begin to experience the emotion they are portraying at this point. Then actors layer in sound, text, and movement, and begin to interact with one another. Rasaboxes embodies the notion that emotion can be evoked in the performer through the embodiment of its physical characteristics, and trains the performer to do just that.

There is a corresponding process in the spectator: seeing the emotional expression of disgust activates the neural representation of that emotion; seeing the gesture that accompanies an expression of disgust activates the neural representation of that gesture; conscious and unconscious mimicry of gestures and facial expressions create an empathic engagement with the performer, which in turn paves the way for that which is being performed to be experienced by the spectator, and causes the spectator to converge emotionally with the performer. In other words, rasa is evoked through a process of active and embodied observation of both action and emotion, neural representation, and mimicry, which are the components of action and emotion understanding, leading to an empathic engagement, and further to emotional contagion.

However, emotional recognition, mimicry, and contagion are modulated by the situation. As we would expect, experiments involving pain show shared brain areas for both experienced and witnessed pain: "both feeling a moderately painful pinprick stimulus to the fingertips and witnessing another person's hand undergo similar stimulation are associated with common activity in a pain-related area in the right dorsal anterior cingulate cortex (ACC)" (Morrison et al., 2004: 270). Another study comparing the responses of people experiencing a painful stimulus and reacting to a signal indicating that a loved one—present in the room—was experiencing pain, showed that in both

instances the bilateral anterior insula, the rostral anterior cingulate cortex (ACC), the brainstem, and the cerebellum were all activated. However, other areas in the brain (the posterior insula/secondary somatosensory cortex, the sensorimotor cortex, and the caudal ACC) were only activated by experienced pain, suggesting that "the neural substrate for empathic experience does not involve the entire 'pain matrix'" (Singer et al., 2004: 1157). Only "a part of the pain network associated with its affective qualities but not its sensory qualities, mediates empathy" (Ibid.: 1157). With regard to pain, the magnitude of the response "is modulated by the intensity of the displayed emotion, the appraisal of the situation, characteristics of the suffering person such as perceived fairness, and features of the empathizer such as gender or previous experience with pain-inflicting situations" (see Hein et al., 2008: 153). In other words, the magnitude of a spectator's response is determined by their understanding of the situation (including their awareness that they are seeing a performance). Abhinavagupta understood that the "magnitude" of the spectator's response (to use the terminology from the neuroscientific study) is tied to their understanding of the situation on stage, and believed their understanding and appreciation would increase with study. Abhinavagupta argued that spectators must have: (1) an "inborn taste for literature"; (2) the "capacity to identify himself with the situation [on stage] at [an] imaginative level" which "presupposes the study of drama and poetry and occasional visit to theatre"; (3) "the capacity to visualize the situation and form an aesthetic image"; (4) the "capacity to identify with the focus of the situation"; and (5) "the contemplative habit" (Deshpande 1989: 89–90). The spectator's ability to experience rasa is automatic in that it is something that always occurs at the neurological level; but according to both Singer et al., and Abhinavagupta, the magnitude and quality of that experience depends upon socialization and cultural training.

Responses to affective information are and can be trained/learned. Although most scholars believe that neural responses to affective information are not culture-specific, a 2008 study found that the amygdala responds more to facial expressions of fear when these are expressed by people belonging to the subject's own community (Chiao et al., 2008). We know that culture shapes how and when particular facial emotions are expressed (see Elfenbein and Ambady 2002) as well as the appropriateness of expressing certain emotions at certain times (see Ekman, Sorenson, and Friesen 1969). But people infer nationality from facial expressions of emotion (e.g., Japanese–American vs. Japanese). People are better at inferring nationality from expressions of emotion than from neutral expressions, which suggests that "subtle, but significant, cultural variation in the way that fear is expressed in the face can serve as [a] cue to cultural group membership" (Chiao et al., 2008: 2167 citing study by March, Elfenbein and Ambady 2003). This information, when combined with

the fact that "children do not display as robust an amygdala response to fear relative to neutral faces as adults" (see Thomas et al., 1999), which suggests a developmental change in the kinds of information the amygdala detects and responds to (see Chiao et al., 2008: 2172), leads scientists to conclude that "greater experience with and exposure to a particular set of facial expressions of fear (e.g., Japanese or Caucasian) may sensitize the amygdala to optimally respond to facial configurations of fear specific to one's own cultural group by adulthood (Marsh et al., 2003; Skuse et al., 2003)" (Chaiao et al., 2008: 2172). These neuroscientists have shown us that "cultural group membership of both the expresser and the perceiver of the fear signal modulates the magnitude of the response" (Chiao et al., 2008: 2171). In other words, responses to affective information are acquired. Once again, this supports Abhinavagupta's notion and the Calvo-Merino et al., experiment that a trained spectator—one who has seen many productions and/or received training in the particular genre they are observing—will respond more fully to a performance.

Although kutiyattam performers strive to evoke a dominant rasa in the spectator for each play, not all spectators have the same response to the same performance. These different responses are most often created by what spectators bring to performance (i.e., their own experiences and preoccupations), but some of the differences may be neurological: men and women may use different parts of the brain to identify and process emotions. A study of happy and sad faces revealed that "male and female subjects used a rather different set of neural correlates when processing faces showing either happy or sad expressions."[7] (Lee et al., 2002: 13). The authors of this study note that their findings provide preliminary support for the notion that gender plays a role in perception, and that the same stimulus may activate different brain regions in the two genders.

Although rasa is more likely to occur when attention is consciously being paid to a consciously performed set of actions, the part of the brain that processes emotions (the amygdala) responds to affective information even when facial expressions are not noticed consciously, when they are noticed briefly, or when the brain is simultaneously processing other information (see Pessoa et al., 2005). Interestingly, however, while the amygdala always plays a large role in processing affective information[8] and is therefore the most important area of the brain as far as rasa is concerned, some emotions activate the amygdala more than others: the ventral amygdala responds much more to fear than to anger or to a neutral facial expression (Whalen et al., 2001). In fact, disgust, fear, and anger have been easier to study in the brain because, it is thought, they signal threat to the observer, are thus of evolutionary significance, and are therefore easier to observe on an fMRI scan (functional magnetic resonance imaging), which is the tool used in most of the brain studies cited here.[9]

Of course recognizing emotions—which is a prerequisite for empathic engagement and emotional contagion, or rasa—is more complicated than the articles I have cited thus far would lead us to believe. The unconscious recognition of emotion may involve a different neural pathway than the conscious recognition of emotion, although some neuroscientists propose that emotional processing might involve simultaneous activation of both pathways in order to speed the process along (see LeDoux 1996). Happy faces, when presented to subjects below the threshold of conscious attention, elicited response in the anterior cingulate gyrus and amygdala (where conscious awareness of happy faces is also processed), while sad faces presented to subjects below the threshold of conscious attention elicited limited activation in the left anterior cingulate gyrus, where conscious recognition of the same emotion occurs (Killgore et al., 2004: 1). As noted above, rasa assumes conscious attention to a consciously delivered performance, but this does not preclude either the unconscious portrayal of unplanned gesture and emotion, or the unconscious perception of emotion, both of which modify the rasic experience.

Finally, recognition of emotion may not be as simple as a one-to-one correlation between specific brain regions; it may well rely on networks that spread throughout various regions of the brain. As of a 2008 paper published in *Neuroimage,* there were over 200 neuroimaging studies of emotion, most of which were designed to induce a particular emotion corresponding to an English word such as "anger," "fear," "disgust," or "happiness," and locate the area of the brain that was activated by/during the affective state (Kober et al., 2008: 2). However, "meta-analyses have not yet yielded strong evidence that human-defined categories of emotion can be consistently discovered from neuroimaging studies" (Kober et al., 2008: 2) meaning that the brain may not deal with emotion in its entirety in a region-specific manner. Kober et al., analyzed data from 164 studies to identify what they call "functional groups" active during what we call "anger" or "perceiving anger" (2008: 3). This approach, they posited,

> may allow us to explore alternative ways of classifying emotions and eventually even develop a new typology, one based on the relative involvement of various psychological regulation, another to action generation and inhibition, a third to meaning analysis (and consequently retrieval and processing of memories appropriate for the context), a fourth to perceptual processing relevant to the emotion eliciting situation, and so on. In such a typology, the category now called 'fear' may be decomposed into distinctly different scientifically meaningful categories [Kober et al., 2008: 3].

Kober et al., did find functional groups, and concluded that

> emotions such as anger, sadness, and fear, and even broad categories such as positive and negative affect, are likely to be generated via the interplay of more

basic processes in perceptual, attentional, and mnemonic systems that are not unique to emotion. Whether there are gross brain regions unique to affective states requires further testing ... [2008: 25].

Kober et al., acknowledge the correspondence between seeing and experiencing while hypothesizing that more brain areas may be involved than are currently known.

Neural Mechanisms of Rasa: The Mirror Neuron Network

The link between seeing and experiencing—the idea that one triggers the other—is currently attributed to the "mirror neuron network." In 1996 Vittorio Gallese, Giacomo Rizzolatti, and others found that neurons in the ventral premotor area F5 of the macaque monkey responded both when the monkey executed a particular movement (such as reaching for a peanut) and when the monkey observed an experimenter performing the same movement.[10] These neurons came to be called "mirror neurons" because the neurons in the observing monkey appeared to mirror the same neurons active in the person executing the action. Their findings were quickly applied to humans, and hundreds of experiments involving fMRI scans have been used to try to determine whether mirror neurons exist in the human brain. A debate about the existence of mirror neurons—and their function if they exist—has been raging for the last twenty years (see Dinstein et al., "A Mirror Up to Nature," Lingnau et al., 2009, Dinstein 2008, and Hickok and Hauser 2010). Nonetheless, the most recent experiments, as outlined in the "Mirror Neuron Forum," a discussion between Vittorio Gallese, Marco Iacoboni, Gregory Hickok, Morton Ann Gernsbacher, and Cecelia Heyes (2011) do indeed suggest the existence of mirror neurons in humans, and propose a complex role for them—not only as decoders of observed action, but of aural information as well.[11] Christian Keysers and Valeria Gazzola (2010) report the existence of mirror neurons in the human brain[12] (2010: 353) based on the work of neurosurgeons Itzhak Fried and Mukamel, who found, while trying to help patients with severe epilepsy, eleven neurons in humans that discharge during both the execution and observation of frowning, smiling, and certain finger and hand movements (Mukamel et al., 2010).[13] Keysers and Gazzola explain their finding by referring back to "Hebbian learning," in which "neurons that fire together wire together": eventually neurons that are involved in both watching and doing become part of the same neural network because they fire together.[14] In other words, they argue that it would be hard for humans *not* to have mirror neurons given the way the brain creates networks.

If this is the case, then why do we not literally feel what the observed person

feels when we see, for example, someone else's arm being touched? How do we distinguish between self and other? Neuroscientist V.S. Ramachandran explains that touch and pain receptors in the skin send messages to the brain saying we are not being touched, allowing the brain to empathize while maintaining a distinction between self and other (Ramachandran TED Talk 2009). Keysers and Gazzola propose the existence of "anti-mirror neurons," or neurons that inhibit mimicry, which are neurons that "increased their firing rate when the patient was executing a particular action, but decreased their firing rate below baseline when the patient observed someone else perform this action" (354). This, they suggest, is how we refrain from mimicking everything we see, and how we are able to differentiate between our own actions and those of another.

The significance of the current studies is that they demonstrate the "goals" of the mirror neuron system. In a review article, Ocampo and Kritikos (2011) note that in one experiment (Rizzolatti et al., 1988) "some grasping neurons activated with the monkey flexed its fingers to grasp an object but not when the same flexion was made to push it away. Thus, our own actions are controlled by neurons that activate specifically to simple goals rather than kinematic parameters" (261).[15] This means that mirror neurons "understand" *intention* rather than just movement,[16] which leads Ocampo and Kritikos to the most useful conclusion with regard to performance: because our own actions are organized in terms of complex motor outcomes rather than simple physical properties, we can form interpretations of other's behaviors *without the need to resort to mentalizing processes*" (261, emphasis mine).[17]

The value of mirror neuron theory for performance and rasa is that it is a theory of embodied understanding; it demonstrates how we understand others directly motor neuron to motor neuron, auditory neuron to auditory neuron, or affective state to affective state, rather than resorting to or engaging in another type of brain activity. In other words, we do not need to mentalize to interpret and understand what other people are feeling. Rasa, then, is a direct mode of embodied understanding, through a process of joint experience of the stimulus via the mirror neuron network.

Emotional Contagion, or Rasa

Mirror neurons are the mechanism the brain uses to understand the actions and emotions of another. As shown earlier, neural mirroring and both conscious and unconscious physical mimicry lead to the recognition and joint embodiment of emotion, to an empathic understanding of another, and then to emotional contagion. People who spend time in each other's company tend to converge emotionally.

Emotional convergence has been referred to as 'the chameleon effect" (Chartrand and Bargh 1999: 893). The authors who coined the term "chameleon effect" note the existence of an *unconscious* perception-action link. Groups led by an emotionally expressive person converged emotionally, and converged around the emotion most strongly expressed by the "leader" of the group, leading researchers to conclude that "people are attracted to emotionally expressive others" (Barsade 2002: 670), which is one way to describe a spectator's relationship to a performer. Interestingly, positive emotional contagion led to increased cooperation among group members, and increased job performance. Other studies show that people "converge" over time: couples in long-term relationships develop emotional similarities, a process that has also been shown to happen with same-sex roommates and dating couples—in fact, the more the couple converged emotionally, the more stable the relationship became (Anderson et al., 2003: 1054). This emotional convergence is thought to be a result of emotional contagion: in other words the continual sharing of emotions can develop into habits of emotional expression (1066). Mood contagion occurs not only through facial and action observation, but through the voice: when subjects were asked to report on their mood after listening to a speech that was read with either a "happy" or "sad" voice, they reported moods corresponding to the affective information conveyed in the tone of the reading. Researchers noted that "an emotional experience induced a concurrent mood state in the listeners" even when "participants apparently did not know the correct source of their affective response" (Newmann and Strack 2000: 211 and 221) and even when the voice was disembodied—when there was no visual input. Thus we change (chameleon-like) to suit our environment and those around us. Anderson et al., note that emotions appear to be socially derived patterns of behavior as opposed to "private, personal, and covert" experience. Thus the spectator is not only converging emotionally with the performer, but with other spectators in the room. In other words, spectators are also groups that converge emotionally. Thus there are multiple feedback loops between seeing, feeling, and doing (a) within the performer; (b) between performer and performer; (c) between performer and spectator; and (d) and between spectator and spectator. These feedback loops all participate in the creation of a rasic experience for the individual spectator.

Emotional contagion and convergence are another way of describing the process of rasa and how it occurs in the spectator. Emotional contagion involves the recognition of emotion through neural mirroring and conscious and unconscious physical mimicry, which leads to an empathic engagement and finally to emotional contagion. The neuroscientific experiments I have summarized here are useful in explaining exactly how rasa works in the brain. However, it is fascinating to see the ways in which these experiments

support a notion of emotional contagion—*rasa*—that predates them by centuries.

<h1 style="text-align:center">NOTES</h1>

1. I would like to thank Zoran Josipovic for allowing me to audit his courses on cognitive neuroscience and affective neuroscience at NYU, and for commenting on an earlier draft of this essay. All mistakes, as they say, are mine. I would also like to thank Sreenath Nair for his invaluable comments on an earlier draft.

2. C. Daniel Batson distinguishes between eight different uses of the term:
Knowing another person's internal state, including his or her thoughts and feelings [also known as cognitive empathy or empathic accuracy ...] adopting the posture or matching the neural responses of an observed other [which involves finding out how someone else feels through motor mimicry or matching someone's neural state ...] coming to feel as another person feels [via emotion matching or emotional contagion ...] intuiting or projecting oneself into another's situation [or imagining oneself in another's situation, sometimes referred to as "aesthetic empathy" ...] imagining how another is thinking and feeling [based on what they say or the behavior they exhibit ...] imagining how one would think and feel in the other's place [...] feeling distress at witnessing another person's suffering [... and] feeling for another person who is suffering [which has often been conflated with sympathy or compassion] [Batson 2011: 4–8].
Empathy is not itself an emotion, but as Bruce McConachie notes in *Engaging Audiences,* "it readily leads viewers to emotional engagements" with the material, with the performers, and with other spectators (65). Empathy then, leads to, and is a prerequisite for, emotional contagion or rasa.

3. It is important to note that the activation is stronger in someone with prior experience of the actions they are watching (ballet dancers watching other ballet dancers, pianists watching other pianists, etc.).

4. See also B. Calvo-Merino, J. Grezes, D.E. Glaser, R.E. Passingham, and P. Haggard, 2006; B. Calvo-Merino, C. Jola, D.E. Glaser, and P. Haggard, 2008; E.S. Cross, A.F. Hamilton, and S.T. Grafton, 2006. And for a recent review of this literature, see Calvo-Merino and Haggard, 2011.

5. Antonio Damasio distinguishes between feelings and emotions: "Emotions are basically biological responses, while feelings are conscious mental formulations of the former. Both emotions and feelings are connected to the struggle for homeostasis, in that their first function is to help us detect threats or benefits and thereby negotiate our environments effectively" (Damasio 2003: 53).

6. "A number of investigations show that, among other structures, the insula and the amygdala are activated when subjects are exposed to disgusting odors or tastes" (Royet et al., 2003; Small et al., 2003; Zald and Pardo, 2000; Zald et al., 1998a). Independently, a number of functional imaging studies (Phillips et al., 1997, 1998; Sprengelmeyer et al., 1998; Schienle et al., 2002) and electrophysiological investigations (Krolak-Salmon et al., 2003) have suggested that the insula is activated during the observation of disgusted facial ex-pressions. The aim of the present study will be to directly determine whether the same locations in the insula are activated during the experience of disgust and the ob-servation of the facial expression of disgust in others" (Wicker et al., 2003). This is the question that led to the study I summarize here.

7. "This was more noticeable when they were processing faces portraying sad emotions than happy emotions" (Lee et al., 2002: 13).

8. "Facial expressions of fear and anger [...] result in significant increases in amygdala activity" (Williams et al., 2004: 2898)

9. fMRI stands for functional magnetic resonance imaging, which measures brain activity via changes in blood oxygen levels in the brain: neural activity is measured by the degree of cerebral blood flow and energy demand. "It is currently believed that when a cognitive task is performed, the area of neural activation becomes more perfused as a result of an increased need for oxygen. This, in turn, increases oxyhemoglobin concentration in the local tissue while the deoxyhemoglobin (hemoglobin without any bound oxygen) found in red blood cells decreases. Deoxy and oxyhemoglobin have different magnetic properties. Deoxyhemoglobin is paramagnetic and introduces an inhomogeneity in the local magnetic field of the hydrogen atoms and reduces the MR signal

(MR signal comes from water molecules, hydrogen atoms in the water molecule to be precise). Oxyhemoglobin, on the other hand, is diamagnetic and has little effect. So a decrease in deoxyhemoglobin (i.e., an increase in oxyhemoglobin) would result in an increase in the received signal" (Ozdemir 2012).

10. Similar movement-selective mirror neurons were discovered in the inferior parietal lobule of the macaque monkey.

11. Mirror neurons have also been found to respond to aural stimuli: neurons in the F5 area fired "both when the monkey performed an object-directed action and when it heard corresponding action-related sounds (Kohler et al., 2002). These so-called 'audiovisual mirror neurons' responded when the monkey actively performed and observed actions such as breaking a peanut or ripping paper. Interestingly, they also fired upon hearing the corresponding sound that these actions produced" (262). This proves that mirror neurons function independently of action observation.

12. They also found mirror neurons "in more brain regions than previously suspected" (2010: 353).

13. Keysers and Gazzola note that "mirror neurons are a minority of neurons" but that they "exist in many brain regions" (2010: 353).

14. "After repeatedly performing and perceiving ourselves perform the action, Hebbian learning would make many neurons, not only in the vPM [...] and IPL [inferior parietal lobe], but also in the SMA [supplementary motor area] and medial temporal lobe, have the property of being excitable both when we perform the action and when we see or hear someone else perform a similar action. The only prerequisite for such learning would be for a neuron to have connections with both sensory and motor systems—a frequent property in a brain that has evolved to connect perception and action" (Keysers and Gazzola 2010: 354).

15. In another experiment (Bonini et al., 2010) "neurons with mirror properties were equally responsive to the end-goal of the motor act (i.e., eat/place), irrespective of the type of grasp used to achieve it" (261).

16. Then again, Ocampo and Kritikos note:
One thing is to understand automatically the motor intention of an observed agent when performing an unambiguous action, another is to require the observer to interpret an ambiguous or implausible action. While in the first case the mirror neuron circuit is necessary and sufficient (e.g., Iacoboni et al., 2005), in the second, the mirror circuit is still active but further areas come into play (see, for instance, Brass et al., 2007). This is to say, the two cortical circuits are not necessarily in alternative (265).
They go on to point out that "the motor outcome of another individual's behavior is crucial to the planning of our own responses" (265), that most of the actions we perform are goal-driven, and that "it is therefore not surprising that motor maps are stored in parallel with their corresponding action goals such that a seamless flow between intention and action can be achieved" (265).

17. We also use mirror neurons to predict another's action, and to perceive "an intention to move" (Ocampo and Kritikos 263). Thus "the mirror neuron system is involved in processing complex goal-directed actions, with a specific role in decoding intentions" (264). Furthermore, "in the absence of a direct kinematic copy of an observed action, the mirror system is able to represent actions on the basis of their motor outcomes alone" (Ocampo and Kritikos 264), suggesting that mirror neurons "do indeed differentiate between actions at a conceptual, rather than a purely motor, level" (264) and are thus involved in understanding action intention.

BIBLIOGRAPHY

Anderson, Cameron, D. Keltner, and John P. Oliver. 2003. "Emotional Convergence Between People Over Time." *Journal of Personality and Social Psychology* 84.5: 1054–1068.

Barsade, Sigal. 2002. "The Ripple Effect: Emotional Contagion and Its Influence on Group Behavior." *Administrative Science Quarterly* 47.4: 644–675.

Batson, C. Daniel. 2009. "These Things Called Empathy: Eight Related but Distinct Phenomena." In *The Social Neuroscience of Empathy,* Jean Dacety and William Ickes, eds., 3–16. Cambridge: MIT Press.

Calvo-Merino, B., D.E. Glaser, J. Grezes, R.E. Passingham, and P. Haggard. 2005. "Action Observation and Acquired Motor Skills: An fMRI Study with Expert Dancers." *Cerebral Cortex* 15.8: 1243–1249.

Calvo-Merino, B., J. Grezes, D.E. Glaser, R.E. Passingham, and P. Haggard. 2006. "Seeing or Doing? Influence of Visual and Motor Familiarity in Action Observation." *Current Biology* 16: 1905–1910.

Calvo-Merino, B., and P. Haggard. 2011. *Art and the Senses*. Oxford: Oxford University Press.

Calvo-Merino, B., C. Jola, D.E. Glaser, and P. Haggard. 2008. "Towards a Sensorimotor Aesthetics of Performing Art." *Consciousness and Cognition* 17: 911–922.

Chartrand, T.L., and J.A. Bargh. 1999. "The Chameleon Effect: The Perception-Behavior Link and Social Interaction." *Journal of Personality and Social Psychology* 76: 893–910.

Chartrand, Tanya, and David Neal. 2011. "Embodied Emotion Perception: Amplifying and Dampening Facial Feedback Modulates Emotion Perception Accuracy." In press: *Social Psychological and Personality Science*.

Chiao, J.Y., T. Iidaka, H. Gordon, J. Nogawa, M. Bar, E. Aminoff, N. Sadato, and N. Ambady. 2008. "Cultural Specificity in Amygdala Response to Fear Faces." *Journal of Cognitive Neuroscience* 20.12: 2167–2174.

Cross, E.S., A.F. Hamilton, and S.T. Grafton. "Building a Motor Simulation de Novo: Observation of Dance by Dancers." 2006. *Neuroimage* 31(3): 1257–67.

Dapreto, M., M. Davies, J. Pfeifer, A. Scott, M. Sigman, S. Bookheimer, and M. Iacoboni. 2006. "Understanding Emotions in Others: Mirror Neuron Dysfunction in Children with Autism Spectrum Disorder." *Nature Neuroscience* 6: 28–30.

Davis, Joshua Ian, Ann Senghas, Frederic Brandt, and Kevin Ochsner. 2010. "The Effect of BOTOX Injections on Emotional Experience." *Emotion* June 10 (3): 433–440.

Decety, J., and T. Chaminade. 2005. "The Neurophysiology of Imitation and Intersubjectivity." In *Perspectives on Imitation: From Neuroscience to Social Science, Vol. I. Mechanisms of Imitation and Imitation in Animals*, S. Hurley and N. Chater, eds., 119–140. Cambridge: MIT Press.

Decety, J. and P.L. Jackson. 2004. "The Functional Architecture of Human Empathy." *Behavioral and Cognitive Neuroscience Reviews* 3: 71–100.

Decety, Jean, and William Ickes, eds. 2011. *The Social Neuroscience of Empathy*. Cambridge: MIT Press.

Deshpande, G.T. 1989. *Abhinavagupta*. Delhi: The Sahitya Akademi.

Deutch, Elliott. 1981. "Reflections on Some Aspects of the Theory of Rasa." In *Sanskrit Drama in Performance*, Rachel Van M Baumer and James R Brandon, eds., 214–225. Honolulu: University of Hawaii Press.

Dinstein, I., U. Hasson, N. Rubin, and D.J. Heeger. 2007. "Brain Areas Selective for Both Observed and Executed Movements." *Journal of Neurophysiology* 98: 1415–1427.

Dinstein, Ilan. 2008. "Human Cortex: Reflections of Mirror Neurons." *Current Biology* 18.20: 956–959.

Dinstein, Ilan, B. Thomas, and D. Heeger. 2008. "A Mirror Up to Nature." *Current Biology* 18, 1: 13–18.

Ekman P., E.R. Sorenson, and W.V. Friesen. 1969. "Pan-Cultural Elements in Facial Displays of Emotion." *Science* 164: 86–88.

Elfenbein, H.A., and N. Ambady. 2002. "Is There an In-Group Advantage in Emotional Recognition?" *Psychological Bulletin* 128: 243–249.

Fauconnier, Gilles, and Mark Turner. 2002. *The Way We Think: Conceptual Blending and the Mind's Hidden Complexities*. New York: Basic Books.

Gallese, V., M.A. Gernsbacher, C. Hayes, G. Hickok, and M. Iacoboni. 2011. "Mirror Neuron Forum," *Perspectives on Psychological Science* 6, 4: 369–407.

Gallese, Vittorio. 2001. "The 'Shared Manifold' Hypothesis: From Mirror Neurons to Empathy." *Journal of Consciousness Studies* 8.5–7: 33–50.

Gazzola V., and C. Keysers. 2008. "The Observation and Execution of Actions Share Motor

and Somatosensory Voxels in All Tested Subjects: Single-Subject Analyses of Unsmoothed fMRI Data." *Cerebral Cortex* 19 (November): 1239–1255.

Hasson U., O. Landesman, B. Knappmeyer, I. Vallines, N. Rubin, D. Heeger. 2008. "Neurocinematics: The Neuroscience of Film." *Projections* 2.1: 1–26.

Hatfield, E., J.T. Cacioppo, and R.L. Rapson. 1994. *Emotional Contagion.* Cambridge: Cambridge University Press.

Hatfield, Elaine, R.L. Rapson, and Yen-Chi Le. 2011. "Emotional Contagion and Empathy." *The Social Neuroscience of Empathy.* Cambridge: MIT Press.

Hein G., T. Singer. 2008. "I Feel How You Feel But Not Always: The Empathic Brain and Its Modulation." *Current Opinion in Neurobiology* 18.2: 153–158.

Iacoboni, M., R.P. Woods, M. Brass, H. Bekkering, J.C. Mazziotta, G. Rizzolatti. 1999. "Cortical Mechanisms of Human Imitation." *Science* 286: 2526–2528.

Iacoboni, M. 2005. "Understanding Others: Imitation, Language, and Empathy." In *Perspectives on Imitation: From Neuroscience to Social Science, Vol. I. Mechanisms of Imitation and Imitation in Animals,* S. Hurley and N. Chater, eds., 77–99. Cambridge: MIT Press.

Keysers, Christian and Valeria Gazzola. 2010. "Social Neuroscience: Mirror Neurons Recorded in Humans." *Current Biology* 20.8: 353–354.

Killgore W.D.S., and D.A. Yurgelun-Todd. 2004. "Activation of the Amygdala and Anterior Cingulate During Nonconscious Processing of Sad Versus Happy Faces." *Neuroimage* 21.4: 1215–1223.

Lakin J., and T.L. Chartrand. 2003. "Increasing Nonconscious Mimicry to Achieve Rapport." *Psychological Science* 27: 145–162.

Lakin J.L., V. Jefferis, C.M. Cheng, and T.L. Chartrand. 2003. "The Chameleon Effect as Social Glue: Evidence for the Evolutionary Significance of Nonconscious Mimicry." *Journal of Nonverbal Behavior* 27: 145–157.

LeDoux, Joseph. 1996. *The Emotional Brain: The Mysterious Underpinnings of Emotional Life.* New York: Simon & Schuster.

Lee, T.M., H.L. Liu, R. Hoosain, W.T. Liao, C.T. Wu, K.S. Yuen, C.C. Chan, P.T. Fox, and J.H. Gao. 2002. "Gender Differences in Neural Correlates of Recognition of Happy and Sad Faces in Humans Assessed by Functional Magnetic Resonance Imaging." *Neuroscience Letters* 333.1: 13–16.

Lingnau, Angellka, Benno Geslerich, and Alfonso Caramazza. 2009. "Assymetric fMRI Adaptation Reveals No Evidence for Mirror Neurons in Humans." *PNAS* 106.24: 9925–9930.

Marsh A.A., H.A. Elfenbein, and N. Ambady. 2003. "Nonverbal 'Accents': Cultural Differences in Facial Expression of Emotion." *Psychological Science* 14: 373–376.

Maurer R., and J. Tindall. 1983. "Effect of Postural Congruence on Client's Perception of Counselor Empathy." *Journal of Counseling Psychology* 30: 158–163.

McConachie, Bruce. 2008. *Engaging Audiences: A Cognitive Approach to Spectating in the Theatre.* New York: Palgrave Macmillan.

McConachie, Bruce, and F. Elizabeth Hart, eds. 2006. *Performance and Cognition: Theatre Studies and the Cognitive Turn.* London: Routledge.

Mee, Erin. 2008. *Theatre of Roots: Redirecting the Modern Indian Theatre.* Calcutta: Seagull Books.

Morrison I., D. Lloyd, G. di Pellegrino, N. Roberts. 2004. "Vicarious Responses to Pain in Anterior Cingulate Cortex: Is Empathy a Multisensory Issue?" *Cognitive Affective, and Behavioral Neuroscience* 4.2: 270–278.

Mukamel, Roy, Arne D. Ekstrom, Jonas Kaplan, Marco Iacoboni, and Itzhak Fried. 2010. "Single-Neuron Responses in Humans During Execution and Observation of Actions." *Current Biology* 20, 750–756.

Nair, D., K. Appukuttan, and Paniker Ayyappa, eds. 2010. *Kathakali: The Art of the Non-Worldly.* Mumbai: Marg.

Neumann, Roland, and Strack Fritz. 2000. "'Mood Contagion': The Automatic Transfer of Mood Between Persons." *Journal of Personality and Social Psychology* 79.2: 211–223.

Niedenthal P.M., L.W. Barsalou, F. Ric, and S. Krauth-Gruber. 2005. "Embodiment in the Acquisition and Use of Emotion Knowledge." In *Emotion and Consciousness*, Lisa Feldman Barrett, Paula M. Niedenthal, and Piotr Winkielman, eds., 21–50. New York: Guilford Press.

Niedenthal, Paula. 2007. "Embodying Emotion." *Science* 316: 1002–1005.

Ozdemir, Mahir. 2012. "Controversial Science of Brain Imaging." Guest Blog, Scientific American Blog Network, 5 July (accessed 10 July 2012).

Palmer, Stephen. 1999. *Vision Science*. Cambridge: MIT Press.

Panikkar, Kavalam Narayana. 1993. *Mani Madhava Chakyar: The Master at Work*. Documentary film directed by Kavalam Narayana Panikkar. In Malayalam and Sanskrit with English subtitles.

Pessoa L., S. Japee, and L. Ungerleider. 2005. "Visual Awareness and the Detection of Fearful Faces." *Emotion* 5.2: 243–247.

Preston S., and F. de Waal. 2002. "Empathy: Its Ultimate and Proximate Bases." *Behavioral and Brain Sciences* 25: 1–72.

Ramachandran, V. S. 2009. "The Neurons That Shaped Civilization." TED Talk (posted 2010). Accessed 22 June 2012.

Rangacharya, Adya. 1996. *The Natyasastra*. Delhi: Munshiram Manorharlal Publishers Pvt. Ltd.

Rizzolati G., L. Fogassi, and V. Gallese. 2001. "Neurophysiological Mechanisms Underlying Action Understanding and Imitation." *Nature Reviews Neuroscience* 2: 661–670.

Schechner, Richard. 2001. "Rasaesthetics." *TDR* 45: 27–50.

Singer T., B. Seymour, J. O'Doherty, H. Kaube, R.J. Dolan, and C.D. Frith. 2004. "Empathy for Pain Involves the Affective but not Sensory Components of Pain." *Science* 303,5661: 1157–1162.

Skuse D., J. Morris, K. Lawrence. 2003. "The Amygdala and Development of the Social Brain." *Annals of the New York Academy of Sciences* 1008: 91–101.

Sommerville J.A., and J. Decety. 2006. "Weaving the Fabric of Social Interaction: Articulating Developmental Psychology and Cognitive Neuroscience in the Domain of Motor Cognition." *Psychonomic Bulletin and Review* 13.2: 179–200.

Strack, Fritz, and Leonard L. Martin. 1988. "Inhibiting and Facilitating Conditions of the Human Smile: An Unobtrusive Test of the Facial Feedback System." *Journal of Personality and Social Psychology* 54.5: 768–777.

Thomas K.M., W.C. Drevets, P.J. Whalen, C.H. Eccard, R.E. Dahl, N.D. Ryan. 1999. "Amygdala Response to Facial Expression in Children and Adults." *Biological Psychiatry* 49: 309–316.

Van Baaren R.B., J. Decety, A. Dijksterhuis, A. van der Leij, and M.L. van Leeuwen. 2011. "Being Imitated: Consequences of Nonconsciously Showing Empathy." In *The Social Neuroscience of Empathy*, Jean Dacety and William Ickes, eds., 31–42. Cambridge: MIT Press.

Van Baaren, R.B., T.G. Horgan, T.L. Chartrand, and M. Djikmans. 2004. "The Forest, the Trees and the Chameleon: Context-Dependency and Mimicry." *Journal of Personality and Social Psychology* 86: 453–459.

Van Baaren, R.B., W.W. Maddux, T.L. Chartrand, C. de Bouter, and A. van Knippenberg. 2003. "It Takes Two to Mimic: Behavioral Consequences of Self-Construals." *Journal of Personality and Social Psychology* 84: 1093–1102.

Whalen, P., L. Sin, S. McInerney, and H. Fischer. 2001. "A Functional MRI Study of Human Amygdala Responses to Facial Expression of Fear Versus Anger." *Emotion* March 1(1): 70–83.

Wicker, Bruno, Christian Keysers, Jane Plailly, Jean-Pierre Royet, Vittorio Gallese, and Giacomo Rizzolatti. 2003. "Both of Us Disgusted In *My* Insula: The Common Neural Basis of Seeing and Feeling Disgust." *Neuron* 40: 655–664.

Williams, M., A. Morris, F. McGlone, D. Abbott, and J. Mattingley. 2004. "Amygdala Responses to Fearful and Happy Facial Expressions Under Conditions of Binocular Suppression." *The Journal of Neuroscience* 24.1: 2898–2904.

The Aesthetics of *Kutiyattam*

K. Ayyappa Paniker

Kutiyattam is often defined as the traditional presentation of classical Sanskrit drama on the Kerala stage. It is also frequently described as the only surviving form of the Sanskrit theatre tradition in the whole of India. Sometimes it is also claimed that it is the most authentic and pristine form of ancient Indian theatre. These statements are perhaps not wholly incorrect: but they tell us either too much or too little about *Kutiyattam*. They are at best partial definitions and imperfect evaluations. They do give us some ideas about *Kutiyattam,* especially what it appears to be on the surface. But they do not tell us what is distinctive and unique about this theatre. They try to give us the impression that *Kutiyattam* has existed for a thousand years or more in the same form in which we find it today. If "traditional" "Sanskrit" and "Kerala" are the operative terms, the first should refer to its long history, the second to the language used, and the third to the locale of the performance. One has to go beyond these parameters to get a more precise knowledge of this theatre style and its tradition.

The Malayalam word *Kutiyattam* may be taken literally to mean ensemble acting. *Kuti* means "together" and *attam* refers to acting or dancing: rhythmic and stylized movement. But this literal meaning also does not go very far. It gives us very little information about the complexity and sophistication of this performing art. That it uses scenes and situations from Sanskrit plays is true. Often it confines its attention to single acts or scenes—not to a whole play. And even a single act may take as many as 20 or 30 or 40 nights. Many scenes are presented as solo performances, without many actors appearing on the stage together, but with the same actor impersonating several characters without change of costume or makeup. So if someone takes *Kutiyattam* to mean *Kutiyattam,* that is elaborate acting or extended performance, there is

some justification for it. Actors are free to go beyond the verbal text of the play as written by the playwright and bring in related episodes from other texts. When the characters recite verses, whatever be their source, they do so in a very specialized and stylized manner. The movements of the body and the gestures of the hands are highly codified. *Netrabhinaya* or the movements of the eyes and eyebrows as well as facial expressions are endowed with a lot of significance. Make-up and costume as well as stage decor are conditioned by rigid specifications. There are ritualistic enactments, which may not have any obvious or intimate connection with the text, of the play concerned. Excessive stylization may at times obscure the connection between the actor's gestures and speeches on the one hand and the body movement and vocal utterances in real life on the other. Realism on the surface is thus kept to the minimum. The emphasis is thus shifted to imagined reality. And all the stage conventions are aimed at projecting this imagined reality. In other words, stylized acting (*natyadharmi*) is allowed to subsume, though not to displace, realistic acting (*lokadharmi*). In the use of language too, except in the case of the Jester (*Vidushaka*) who uses mostly Malayalam, the verbal acting (*vachika*) is subordinated to physical (*angika*) and emotional (*sattvika*) acting. Malayalam prose is, profusely, employed by the Jester (*Vidushaka*). Female characters use language of ancient nature known as *Prakrit* as given in the original text. The relationship between master and servant, king and courtier, senior and junior, husband and wife, is indicated by a predetermined code of postures and stances, gestures and vocal formulaic expressions. Every movement of every limb, every gesture, and every utterance is controlled by the rhythm of the percussion instruments, especially the percussion instrument called *mizhavu*. The entire choreography is closely linked to the beats of the drum. When a character has to speak or recite any verse, he has to show a special gesture with his right hand to stop the drumming, and that too to the accompaniment of the drumbeats. It is well within the very tight set of these checks and controls that the *Kutiyattam* actor has to appear to move with ease and freedom. The natural flow of rhythmic movement seems to hide from our view the strict discipline and rigor the actor has undergone to achieve this creative freedom. The synchronization of the actor's movements and the sound of the drums is of infinite importance. The actors take freedom here to combine the rhythm and movements by the gift of disciplined training. Any impression of staccato movement or jerkiness or failure to keep the rhythm (*tala*) will destroy the felicity and will not be forgiven by the *sahridaya* or connoisseur. The beauty of the stylized movements of the body in consonance with the rhythm of the drum—beats arises from the precision in expression of the dramatic role.

The Theme of the Imagination

From the point of view of what the performance communicates, *Kutiyattam* may be thought of as the theatre of imagined reality. What the imagination of the actor bodies forth is what the spectator has to look for. It is not just the translation of the meaning of individual words or sentences through gestures. The entire body of the actor and his costumes (*aharya*) are involved in this process aesthetic communication. The actor, with the active support of the drummer, has to rouse the imagination of the spectator so that the latter can catch up with the flights of imagination of the former while presenting detail after detail of a specific passage. When in the play *Anguliyankam*[1] Hanuman, the Monkey King, presents the different situations of the Epic *Ramayana* through elaborate physical acting (*angika abhinaya*), the spectator is spellbound, and automatically extends his full co-operation to the creative imagination of the actor. This is not achieved solely through the correspondence between what the actor shows and what exists in the world outside as already known to the spectator: the actor by the power of his imagination visualizes, fantasizes, creates scenes or situations, and the experienced spectator follows every movement of the actor's eyes, hands, feet, even costume, in order to make that aesthetic experience his own. The theatrical experience here is not a 'reality' that exists outside the performance, but it is an experience created jointly by the actor and the spectator during the performance. The greater the skills of a gifted actor, the greater the pleasure of the spectator. The "togetherness" implied by the word *Kutiyattam* seems to extend from the actors to the audience through a shared imagination.

Text Versus Performance

Kutiyattam seems to prefer a minimal text to one that contains detailed descriptions of what the actor has to do every moment of the play. It makes its own *attaprakaram* or performance text for each unit of the play text. The playwright who specifies in advance what the character has to do before or during or after a piece of dialogue or monologue is not the ideal playwright for the *Kutiyattam* theatre. Hence Bhasa (5 BC), the legendary Sanskrit playwright, with his under-worded laconic text or minimal verbal structure in his plays is preferred to Kalidasa (370–450 AD), the most celebrated playwright in Sanskrit literature, who seldom forgets to tell the reader/spectator what each character at any given moment is thinking or doing. Bhasa leaves textual gaps in his plays for the actors to improvise and recreate the performance. This may be because Kalidasa is taken primarily as a poet and his text as more nar-

rative than dramatic. Working with a minimal text the *Kutiyattam* player can find occasions to add his own imaginative elaborations. This is probably the reason for Bhasa's popularity on the *Kutiyattam* stage. The attempt to present imagined reality in the performance taxes and teases the imagination of the actor as well as the person who prepares the performance text (*attaprakaram*). Ideally, in theatre, there is no text exists without a performance: in fact, it is the performance environment that determines the nature of the text. In *Kutiyattam*, it seems, the performance itself is the 'real' text due to the actor's sub-textual elaboration. An over—written or verbose text is often a hindrance to performance. The physical elaboration is the actor's contribution to the *Kutiyattam* performance. It is achieved in a number or ways: one of them is the narration of the events starting at some point in the past and leading up to a particular point in time. Another device is the narration in reverse: from the present moment back to some point of time in the past. A third is the narration entirely through gesticulation without the actor or actress speaking. A fourth means of elaboration is the explication or illustration by narrating an implied story within a story. The purpose of all these techniques of sub-textual elaboration is to dramatize an interesting event or anecdote which may be interesting in itself, although it may not be an integral part of the main plot. In fact, *Kutiyattam* is seldom concerned with the mere telling of a particular story from beginning to end, so as to entertain the audience with the whole play at one sitting. It delights in delaying, deferring the end. Invented episodes are dwelt upon by the jester, (*Vidushaka*), for instance, like an inveterate story-teller, using all his inventive skill to bring in stories from outside the puranic context of the play, which he is supposed to be presenting. The author of *Natankusa* (15 AD),[2] a critical commentary on *Kutiyattam* performance, denies the aesthetic validity to all these types of performative elaboration, which are of the very essence of *Kutiyattam*. Just as the *Kutiyattam* spectator accepts the convention that Ravana or Hanuan or Jimutavahana has to move in a stylized way, recite his speech in a stylized rendering pattern using musical notes (*raga* or *swaras*) assigned to it, wear a costume that is most unrealistic, and has to keep to the rhythm (*tala*) of the drumbeats, he also accepts the technique of elaboration and derives pleasure from it. The minimal text is thus made maximal: the actor collaborates with the playwright, the playwright with the drummer and the costume-designer, in producing the performance text. When the actor pretends to look at the sea, which he imagines to be in front of him, the spectator should concede the experience of the pretense, instead of saying there is no sea on the stage. The actor's role implies four types of *abhinaya* (acting), a term more potent than acting: costumes (*aharya*), words (*vacika*), the actor's body (*angika*) and emotions (*sattvika*). The text of a play supplies only the material for words (*vacika*), which is only one-fourth of a perform-

ance; three—fourths of it is constitute by the contribution of the performer. *Kutiyattam* is the actor's theatre per excellence.

Actor Versus Character

One of the most distinctive features of *Kutiyattam* is the provision for multiple impersonation on the part of the actor without changing the make-up and costume. The role-transformation or *pakarnnattam* makes a distinction between actor and character. The actor is a vehicle or a medium; he is never totally identified with any one role or single character. When the actor in the role of Ravana enacts the separation of Parvati from Shiva (*Parvativiraham*), he narrates the whole episode in great detail by changing his roles from Ravana to Shiva and Parvati alternately. The skill of the actor is to be judged by his ability to achieve this complex process of transformation. The lack of total identification between character and actor makes this possible. Hanuman, that is, the actor in the make-up of Hanuman, in the play *Anguliyankam* (The Play of Rings), assumes many fast—changing roles without changing the costume. The experienced spectator sees beyond the make-up and costume and sees the projected character, be it Rama or Sita or Lakshmana. The assumption here seems to be that he is a superior actor who can project the character of Sita by means of his gestures and facial expression but without changing the make-up. What we have on the stage is not Hanuman, but the actor with the make-up and costume of Hanuman. Sita's grief when conveyed by Hanuman assuming her role has a peculiar appeal. This is the ultimate in artistic impersonation. It is the concept of stylized acting (*natyadharmi*) that makes one character transforms into another character. In *Kutiyattam, natyadharmi* has precedence over *lokadharmi,* the realistic mode of acting, although both are employed.

Kutiyattam and *Kathakali*

Both *Kutiyattam* and *Kathakali* are stage performances of puranic episodes and both are typical of Kerala. Yet there is a lot of basic differences between the two. Some similarities may be found in the stories, in the characters, in some of the costumes perhaps: but they are only superficial. *Kutiyattam* is essentially dramatic theatre (*natya*), while *kathakali* comes under dance-drama (*nrtya*), *Kutiyattam* used stylized movements, while *Kathakali* uses dance. *Kathakali* is based on *attakatha,* a poetic narrative specifically written for *Kathakali* performance, while *Kutiyattam* uses a dramatic text. The *Kathakali* actor does not speak or recite his dialogue; musicians standing

behind render it on his behalf. The musical notes and scales (*swaras* or *ragas*) employed in both performances are different; the percussion instruments are different, and their style of playing is also very different. *Kutiyattam* is more ritual—bound; more elaborate; perhaps even more stylized; and based on plays in Sanskrit. *Kathakali* uses a libretto in Malayalam, the language of Kerala; is more folk-oriented; commands a wider audience; and perhaps has a larger repertory. *Kutiyattam* is much older and more exclusive and more intimate. Both employ stylized (*natyadharmi*) and realistic (*lokadharmi*) acting styles; the hand gestures (*mudras*), postures and body movements are considerably different; both require years of training, and have developed their own aesthetics and ways of appreciation.

The Critical Tradition

Kutiyattam has had its detractors. Some have suggested changes with full knowledge of its tradition and technique. But even people who have probably never seen it have gone on record as suggesting reform. Few of them remember that it has had a long and rich tradition and that what has sustained this highly sophisticated performing art is its very sophistication. The detractors are eager to destroy that foundation itself. There is a reference to something often identified as *Kutiyattam* in Ilango's poem *Chilappatikaram*.[3] But it is believed that *Kutiyattam* came to have its fully-developed form at the time of Kulasekhara, the author of two Sanskrit plays, *Subhadradhananjaya* (The wedding of Arjuna and Subhadra) and *Tapatisamvarana* (Tapati and Samvarana) in 11 Century AD. *Dhananjayadhvani* (Commentaries on Dhananjaya) and *Samvaranadhvani* (Commentaries on Samvarana) are believed to be commentaries on the performances of these two plays. Although the history of its evolution is still a matter of dispute, *Kutiyattam* grew into a full-fledged theatre art in Kerala. *Natankusa* is perhaps the most sustained critique of *Kutiyattam*. It criticizes to many of the conventions of *Kutiyattam* performance. The author suggests a reform and his proposals for reform go counter to the directions given in all the written performance texts (*Kramadeepikas* and *attaprakarams*) of the *Kutiyattam* repertory. In the past, *Kutiyattam* had been a temple art; in recent times, it has come out of the temple premises. Formerly it was the exclusive preserve of two small castes, the *Chakyars*[4] and the *Nambiars*.[5] But now there are a few from other castes also performing in Kutiyattam. As time passes, further changes may occur; but it is difficult to forecast what they are likely to be.

Conclusion

When the performance texts (*kramadeepikas* and *attaprakarams*) were first prepared, those who were responsible for them did visualize an art form extremely serious in its purpose and procedure and capable of providing aesthetic enjoyment of a rare kind. Merely declaiming the verbal text of the play from the stage by actors in various roles was not their chief aim. What might have been a flourishing concern in the early days—the numerous legends about the great actors of the past are an indication of the high regard in which the art of *Kutiyattam* was held—appear to have suffered a decline. Are we now witnessing rejuvenation of this art form? Will the various governmental and voluntary agencies be able to support and sustain this traditional art in this age of other forms of mass entertainment? To answer that question is beyond the scope of this brief introduction. Perhaps the article that follows might provide the inspiration for concerned people to devise ways and means of preserving this unique art form, which can provide us exquisite moments of aesthetic pleasure.

NOTES

1. It is the sixth Act of the Sanskrit play *Ascharyachoodamani* (Wondrous Crest Jewell) written by Sakthibhadra believed to be written in 8 AD. It is the most performed *Kutiyattam* plays depicting the story of Rama and Sita, the principle characters in the Epic Ramayana.

2. *Natankusha* (c.15 AD) is a text of theatre criticism of *Kutiyattam*. The author is believed to be a Brahmin scholar belonging to the renowned Payyur family in North Kerala. His criticism is directed against some of the stage practices followed by the Cakyars in presenting *Kutiyattam*.

3. *Chilappatikaram* (200 BC–200 AD) is one of the five Great Epics of Tamil literature composed by the King Ilango Adikal who was born in the Chera dynasty and ruled what is now known as Kerala. The poetic rendition illustrates in details, the arts and culture of the land of the time and there are references to *Kutiyattam* performance in the Epic. Historians of *Kutiyattam* consider the Epic with great historical importance to locate the origins of the art form.

4. A *Chakyar* is a male member of the *Kutiyattam* actor family in Kerala. *Chakyar* is the actor and each family has distinctive training methods and performance repertory. There are 18 *Chakyar* families in Kerala.

5. A *Nambiyar* is the male member of the *Kutiyattam* musician family in Kerala. *Nambiyar* plays *mizhavu*, the major percussion instrument in the *Kutiyattam* performance. His duties traditionally include helping with back stage and on stage preparations for the performance.

BIBLIOGRAPHY

Jones, Clifford. 1984. *The Wondrous Crest-Jewel in Performance*. Delhi: Oxford University Press.

Sowle, Steven John. 1982. *The Traditions, Training and Performance of Kutiyattam: Sanskrit Drama in South India*. Ph.D. Dissertation, University of California, Berkeley.

Unni, N.P., and Bruce Sullivan. 1995. *The Sun King's Daughter and King Samvarana: Tapati-Savaranam and the Kutiyattam Drama Tradition* (*Text with Vivarana Commentary*). Delhi: Nag Publishers.

Actor's Imagination:
Kutiyattam and the Natyasastra

Arya Madhavan

My five-year-old daughter Pia plays "school" nearly every evening. She enjoys being Mrs. Yeates, her teacher. She sits on a chair, as Mrs. Yeates does, puts questions to the "children," pretends to listen to their answers by creating pauses, and even imitates her teacher's accent and other vocal characteristics. She may also decide to sit on the floor briefly, pretending to be another child, if answering Mrs. Yeates's questions as that child is crucial to the logical and convincing enactment of the piece. Like Pia, as children we have all played and enacted similar episodes in our life, alone or with other children, easily employing our imaginative capacities. Yet, as adults, we find it incredibly difficult to be as imaginative as we were as children. Why? What changes in us when we grow older? Is it the rational thought pattern that hampers our capacity to be imaginative? If so, is imagination totally irrational and illogical? Pia's actions, however, are totally logical in nature, aren't they? She even intonates Mrs. Yeates and imitates several of her actions. Yet she is thoroughly imaginative when playing school. There is very clear logical progression in her actions. So is imagination logical and rational or not? Given these questions, this essay focuses on exploring the approach to the actor's imagination from the perspective of *kutiyattam*[1] and the training that facilitates such treatment of the actor's imagination in the context of the Natyasastra.

Imagination and the Natyasastra

The Natyasastra's approach to bodily engagement in theatre is highly complex and intrinsically multilayered: therefore, isolating any individual com-

ponents that contribute to the development of the actor's imaginative qualities becomes highly problematic. In contrast, we can list several individual techniques intended to develop the actor's imagination that are taught to actors and theatre students across the world. Natyasastra is a colossal treatise on the theatre, which discusses theatre practice in thirty-six long chapters. However, to my surprise, I cannot find a single line in it that directly addresses the actor's imagination. The initial reference we get from Bharata about the actor training is in chapter thirty-five, where he discusses the necessary qualities of an actor. According to him, "an actor should be handsome, having plenty of experience in watching theatrical performances, possessing sharp memory, be knowledgeable in his art and an expert in acting" (NS 35: 61). Imagination, however, is not a point of explicit discussion in the Natyasastra. Yet the vigorous practice of any of the Indian theatre or dance forms makes an actor highly imaginative. Why is that so? How do various performances from India help to develop an actor's imagination? What is the connection between the actor's bodily practice and imagination? I think that a careful consideration of the Natyasastra's approach to acting will provide the answer to this dilemma.

The Natyasastra method of acting is highly physical. The body is the primary medium through which the drama is carried forward. The entire physical regime of the Natyasastra is carried out through sixty-four hand gestures, one hundred eight dance postures, thirteen head movements, nine eye movements, seven eyebrow movements, six cheek movements, six lip movements, and so on: the list is exhaustive. Each of these kinetic elements of the body relates to one of the eight basic emotions (*rasa*[2]) which give rise to feelings that can be described as "erotic," "melancholic," "heroic," "marvelous," "fearful," "mockery," "odious" and "furious" because it is the physical actions that lead to the experience of rasa. Erotic feeling, for instance, is enacted with specific movements of the eyes, eyebrows, and lips. Each rasa, according to Bharata, generates a corresponding bodily reaction. He discusses detailed functions and a range of possible actions for various body parts, including but not limited to the eyelids, the eyebrows, or the lips. These actions are then related to one or more rasa. Such detailed analysis of the actor's physical response to rasa provides us with a comprehensive set of physical actions employable in invoking a corresponding mood within a performance situation. In this manner, instead of discussing the imagination as such, Bharata discusses the physical properties and mode of actions that induce an actor's imagination. When the dramatic action is embodied to such an extent, imagination is an organic by-product. The Natyasastra, in this way, does not speak much about the poetics of drama, but it gives importance to the detailed elaboration of the practice, which informs the theory. Otherwise, Bharata would have dedicated the entire Natyasastra to a discussion of the aesthetics of *rasa* theory and not to theatre practice.

Imagination in Practice

Kutiyattam is in many ways an actor's theatre. The *kutiyattam* actors never perform the play, but rather they write their own performance text and directions based on the play they choose to perform by expanding upon the suggestions within the text. They enact such expanded suggestions through bodily actions. Drama, in this sense, is highly embodied and corporeal. Moreover, all the physical exercises, which actors perform at the beginning of their training prepare them to endure the challenges of representing imagination through bodily means. It is not unusual, however, for the complete staging of a play to take up to forty-one nights, or even more. As noted by Ayyappa Paniker, "it delights in delaying, deferring the end.... The minimal text is thus made maximal" (1995: Introduction). At each individual moment of enactment, the actor extends and elaborates the performance by means of improvising and using their imaginative capacities. In this way, performance is rewritten by the actor imaginatively through elaborating the subtext of the play while remaining connected to the main body of the text. Needless to say that the *kutiyattam* approach to drama exerts serious demands upon the actor's physical and imaginative capabilities. So how do actors develop such imaginative skills? More importantly, what device helps them to embody their mental images? The answer to this lies in *pakarnnattam,* the "multiple, transformational acting." Actors are taught the systematic method of imagination in a very organized manner by means of this acting device. I shall explain *pakarnnattam* in some detail below.

Genealogy of the Term

Pakarnnattam literally means the play of multiple transformations. It is the fundamental dramatic device employed in *kutiyattam* as well as *nangyar-kuthu*.[3] *Nangyar-kuthu* is a forty-one-night-long, female solo-performance form, which is an offshoot of *kutiyattam*. The acting conventions and stage conventions structured for both these forms are identical. So how does dramatic elaboration take place in *pakarnnattam*? An actor who is in the role of a king or a messenger transforms changes himself into the role of another character, be it a woman or a boy, a demon, or even a tree, without changing their costume or applying different cosmetics. Here, the actor's body is a theatrical instrument that creates and re-creates images, other characters (bodies), and a series of dramatic events. The actor, during the course of rendering lines from the play, takes pauses in between the lines and embarks on elaborating the unelaborated suggestions within the play. A particular dramatic situation

in the text is extended to two hours or more, and one act of a play is stretched to a performance lasting several days. This means that the *kutiyattam* performance is an extended suggestiveness (*dhvani*) of the text. In other words, it is an act of replacing the language with the body through interpreting and elaborating the subtext.

I shall explain *pakarnnattam* by taking a specific example from the Sanskrit play *The Wedding of Arjuna and Subhadra* (Subhadra Dhananjayam). The first act of this play contains a detailed description of the hermitage. The playwright describes this hermitage as a place where opposite forces in nature coexist—flies that fall into the fire come back to life and fly out and the elephant calf and the lion coexist, and so on. The actor utters the lines from the play containing the above dramatic images—the interaction between the lion and the elephant or the flies falling into the fire—and then elaborates upon them. He embodies the gestures of the elephant calf, lion, and other animals that are referred to in the text, employing facial emotions, eye movements, *mudra,* and physical movements. The character that sees the hermitage becomes the "seen"—the elephant and the lion in this particular instance. The actions are quite detailed and meticulous. The actor then enacts the flies falling into the fire in a very unique way that requires commendable mastery over his

Arya Madhavan performing *Nangyar-kuthu,* a scene from the play *The Salvation of Poothana* (photograph by Devika Wasson, 2010).

eye movements. Fire is shown using hand gestures and the eyes, followed by showing the movement of the flies. The eyes are moved in a figure of eight very quickly several times, which is then followed by the vertical movement of the eyes, denoting the falling. The actor looks at the fire in a desperate way, indicating that the flies are dead, but is amazed on their rising from the fire and flying back out of it alive. The enactment of such dramatic images could take up to an hour and a half. The very same line, which the actor uttered at the beginning of the enactment of these images is repeated at the end of it in order to reestablish the connection back to the play. Any *pakarnnattam,* in this sense, is a performance that takes place in between the repeated rendering of a single dialogue. It is an act of elaborated inbetweenness.

Pakarnnattam and the Natyasastra

Where does the root of *pakarnnattam* lay? K.G. Poulose, a critic of *kutiyattam,* argues that *pakarnnattam* is against the rules of Natyasastra and that *pakarnnattam* is the result of the influence exerted by dance on drama (2001: 49). Furthermore, Poulose asserts that *kutiyattam* also draws heavily upon various folk forms from Kerala such as *theyyam* and *mudiyettu* with respect to *pakarnnattam* (2001: 126). In effect, Poulose is categorically dismissing any remnants of *pakarnnattam* in the Sanskrit theatre tradition and plants its roots safely back in the local folk traditions of Kerala. Although *pakarnnattam* draws heavily upon the local performance traditions, Poulose's view on the disavowal of Natyasastra with regard to *pakarnnattam* seems to be highly unsubstantiated. So what is Natyasastra's take on *pakarnnattam?* An extensive investigation into finding the roots of *pakarnnattam* is beyond the remit of this essay. However, it is significant to enquire whether we can completely rule out any traces of *pakarnnattam* from the Sanskrit theatre tradition. A rereading of some of the sections of Natyasastra might throw some light on this issue.

Evidence for the existence of *pakarnnattam* vividly presents itself in Bharata's discussion of the ten dramatic forms. Bharata suggests ten independent dramatic forms: *natakam, prakaranam, samavakaram, eahamrugam, dimam, vyayogam, ankam, prahasanam, bhanam,* and *veethi.* Each of these dramatic forms is characterized by its own unique features, either relating to the story line or to the number of acts, the nature of the characters, or the number of actors, and so on. *Natakam,* for instance, is a dramatic form characterized by the presence of a brave hero of royal stature, happy and sad events (in their lives), various emotions and rasa, several acts, and heavenly beings (NS 20: 8–10). *Natakam,* however, is a term generically used to suggest drama.

Out of the ten dramatic forms cited above, *bhanam* is a one-act play performed by a single actor. Bharata says that "*bhanam* is a dramatic form which includes enactment of one's own experiences, descriptions of others [experiences] as well as encompassing a range of topics of interest. Here, a single actor must enact the roles of other characters" (NS 20: 95–98). In Sanskrit, a solo performance is called *ekaharyam—ekah* meaning single and *aharya* meaning costume and cosmetics; therefore, it is a performance of a single actor in the same costume and with the same cosmetics throughout. This is a very strong indication of *pakarnnattam* in Natyasastra because *pakarnnattam,* like *bhanam,* is performed without any change of costume or cosmetics. Interestingly, there is no suggestion regarding the gender of the *bhanam* actor, and therefore I argue that this can be performed by both male and female actors. So I am not sure why *pakarnnattam* is considered as "against the rules of Natyasastra" since there are apparent indications within the text itself for the existence of *pakarnnattam.*

Veethi, which is another dramatic form found in Natyasastra, can also be a solo performance (as well as a performance with two actors). This is a highly complex dramatic form, performing one-act plays that are rich in characterization and the use of rasa (NS 20: 99). So what we have are two significant dramatic forms, *bhanam* and *veethi,* which are solo performances. However, it is significant to note whether there are any suggestions for *pakarnnattam* being interspersed with *natakam*: evidence for this could indicate an earlier prototype of the *kutiyattam* model of dramatic structure within Natyasastra. Interestingly, Bharata discusses the existence of a solo performance strand called *lasyam,* which is interspersed with *natakam.* He maintains that *lasyam* emerged from *veethi* and that it is a solo performance like *bhanam* that suggests the characteristics of a one-act play performed by a single actor within the dramatic structure of *natakam.* Moreover, Bharata discusses *lasyam* after completing a detailed discussion of the ten dramatic forms. Nevertheless, it is unclear why *lasyam,* although not listed among the ten, is discussed extensively in this chapter. The reason could be that *lasyam* only occupies a semi-independent status as a dramatic form because it is part of a *natakam,* occupying the status of both *veethi* and *bhanam.* So it is imperative to incorporate a discussion on *lasyam* without listing it as an independent dramatic form. Therefore, one can easily see the dramatic structure of *natakam* as generic drama with intermittent interludes of solo performances. A striking parallel to a dramatic structure such as this can be easily found in *kutiyattam* in that it is a theatrical form consisting of actions involving several characters as well as *pakarnnattam.*

Unlike *bhanam* and *veethi,* Bharata's description of *lasyam* envelops vivid gender references regarding the actor. Bharata defines *lasyam* as "playing." "[I]t

is 'playing' dependent on the mutual mental states (affection) of a man and a woman ... like *bhanam,* a single actor must perform this and the meaning has to be suggestive" (NS 31: 274). Therefore, *lasyam* looks like a theatrical device in which a single character suggests a covert meaning that is distinct from its peripheral suggestions. Clear indications can be found suggesting that it is actually a woman who performs *lasyam.* Bharata mentions ten dramatic devises[4] specific to *lasyam,* which all suggest that the actor has to be a woman, owing to the explicit references to dressing, use of language,[5] and mental states that are usually assigned to female characters. Moreover, Bharata makes explicit references to cross-gender performances of actresses (NS 20: 120 and 122) in the fourth and sixth segments. The fourth segment, called *pushpagandika,* is the enacted cross-dressing of a female character as a man speaking Sanskrit. The sixth segment is the actress's enactment of a Sanskrit-speaking, proud man (*purushabhavadhyam*—pride of a man). All these invariably point to *lasyam* being a semi-independent, female solo performance form found as part of *natakam.* In effect, what Bharata suggests here is the incorporation of a female solo performance segment within the course of a dramatic production. He also provides a highly descriptive account of the music and rhythm appropriate to the ten segments of *lasyam* later on in the text.

The question now is what example will probably provide a suitable link to the dramatic praxis discussed so far. I think that the answer to this question can be found in *nangyar-kuthu.* The theatrical formulation of *nangyar-kuthu* (of Krishna stories) reiterates the functional possibilities of interspersing a female mono-act within a generic dramatic structure. *Nangyar-kuthu* performance emerges and reintegrates itself into the second act of the play, *The Wedding of Arjuna and Subhadra.* Once the tangent is drawn, *nangyar-kuthu* maintains an independent status throughout its performance, and at the end of its performance it reverts to the point from where it started by uttering the connecting line that links back to the main play. Therefore, I argue that *lasyam* is a prototype of *nangyar-kuthu.*

Bharata talks about cross-gender performances in chapter thirty-five of Natyasastra, providing a further lead to the discussion of solo performance in Natyasastra. He talks about three varied natures for dramatic acting: (a) natural (*anurupa prakruthi*), which is when women act as women and men act as men; (b) unnatural (*virupa prakruthi*), which is when a boy act as an old man and vice versa; and, finally, (c) mimetic (*rupanusarini*), which is when a man act as a woman. Bharata adds that a female actor is free to dress and act as a man. These are further strong evidence for *pakarnnattam* in Natyasastra.

So what is the difference between the Natyasastra and the *kutiyattam* models of *pakarnnattam?* As far as Bharata is concerned, the actor is someone who performs according to the advice given by the Guru. Although an actor

has to be a trained performer characterized with a mixture of numerous performance qualities, she is not expected to exert independence outside the textual remits. There is no room for an actor's manual in Natyasastra. On the other hand, the competence of a *kutiyattam* performer is measured by her capability in interpreting the text through the bodily apparatus. Replacing the text with the enactment of its suggestion is absent in Natyasastra. *Pakarnnattam* in *kutiyattam* could also be interpreted as the natural evolution of the solo-performance models found in Natyasastra, which are shaped through decades of practical experiments and addition of further ingenious devices. Moreover, it is such evolutionary transformations in aesthetics and praxis that define the character of any performance genre.

So far, I have explained the relationship between *pakarnnattam* and the actor's imagination. But the question now is what technique trains the actor to be imaginative to such an extent? A *kutiyattam* student is taught *cari,* the set of kinetic images describing various actions, sceneries, or persons. The actors intersperse such *caris* with the dramatic moments within the text so that they can present an aesthetically meaningful piece. A *cari,* therefore, integrates *pakarnnattam* into its performance structure. For example, in the *cari,* "dressing a woman" (*koppaniyikkal*), the actor describes the intimate details of how a maid dresses the heroine. So if the actor is enacting a piece that involves dreaming about the physical beauty of the heroine, "dressing a woman" invariably fits the bill. She intermittently transforms herself into a maid and a heroine. There could be more than a single maid and perhaps also a messenger who carries a note (of love) from her lover. The possibilities are manifold, depending upon the capabilities of the actor. Significantly for the actor, she becomes initiated into the habit of observing the minute details of things/events, which she might then be able to use in his/her acting. *Cari,* therefore, is a highly significant tool that is used to train the actor's imagination.

Cari: The Kinetic

Cari, also referred to as *attam* or *kriya,* is a series of movement patterns taught to a student during the early stages of their student life. In fact, there is no overarching term to denote these elaborate physical acting sequences in *kutiyattam,* but some are termed as *attam,* some as *cari,* and some even as *varnana* or "detailed descriptives." I use *chaari* as an overarching term to denote these acting sequences. In Sanskrit, *chara* means "moving" and *cari* means "that which moves" or "denoting movement." So *cari,* in terms of *kutiyattam,* is the description of an object, person or scenery or a dramatic situation, which is

expressed through bodily movements. There are several *caris,* such as the "preparation for a war" (*yuddha cari*) for example. This is a series of movements suggesting a warrior's preparation for a war, but not the actions of war. Both male and female actors are taught *cari* during their actor training. In *cari,* for the first time, the actor learns to bring together all the various corporeal skills that she acquired during the rigorous training, such as the expressive eyes and face, hand gestures, and other physical movements. *Cari* is essentially a solo performance, a mono-act of the actor. The actor uses her body to create and re-create a continuum of bodily images, emotions, and characters, both human and animal, during the enactment of a *cari.* If she is enacting how a few children play with a ball (*panthattam*), she employs *pakarnnattam* and plays the part of all the children, their conversations, and their actions entirely with his physical movements, incorporating hand gestures, eye movements, and facial expressions. What Pia does every day while she plays "school" is *pakarnnattam.* The actor training prepares an actor to accomplish this highly complex series of transformations (without any change in costume) with commendable ease.

Kutiyattam and Stanislavski: A Brief Comparison

Stanislavski's *Given Circumstances* offers an interesting lens through which to comprehend the nature and function of *cari* in *kutiyattam.* According to Stanislavski, "we need a continuous line of Given Circumstances through which the scene can proceed, and secondly ... we need an unbroken series of inner images linked to these Given Circumstances. Put briefly we need an unbroken line not of plain, simple Given circumstances but ones that we have coloured in full" (2008: 74). *Cari,* in other words, is the physicalized representation of such an "unbroken series of inner images." Here, Stanislavski envisages *Given Circumstances* as the background information that helps an actor to understand the mental situation and the physical circumstances of the character that she is portraying. But what does Stanislavski mean by saying that they need to be those, which "we have coloured in full?" Yes, the progression of the events in our "mind's eye" is logical and realistic, yet such mental images are further enriched by the actor's imagination and intuitive process. Stanislavski also provides an exercise for the creation of such an "unbroken line of mental images" as given below:

> "Let us use our imagination to make a film," Tortsov proposed.
> "About what?" the students asked.
> "... I propose that you live the life of a tree with deep roots in the earth."
> "Fine! I am a tree, an oak a hundred years old," Pasha decided....

"... say to yourself, ... this is me, but if I were an oak, if around me and within me the circumstances were such and such, what would I do?" said Tortsov ...

"Yes, but," said Pasha thoughtfully, "how can I be active in a state of inaction, standing motionless on the spot?"

"... But there are other actions apart from this. To stimulate them you first need to decide where you are? In a forest? In the middle of a field, on a mountain peak? Choose the place you find the most exciting."

Pasha thought he was an oak growing in a mountain clearing, somewhere in the Alps...

"Now tell me, what do you see close by?"

"I see my own dense crown of foliage which is making a great deal of noise because my branches are swaying.... In my branches I can see birds' nests of some kind ... there is nothing good about it. Life with these birds is difficult. They make noise with their wings, sharpen their beaks on my trunk and sometimes squabble and fight...." [2008: 77].

The above process that the student undergoes when she imagines herself being an oak tree is highly interesting. The gradual development of his imagination from the initial ignorance of the need for and the process of creating mental images to the development of a fully comprehensive "unbroken line of images" is strikingly apparent from the rather long quote above. *Cari* is very similar to this. Let us take the example of the "description of a tree" (*vriksha varnana*) in *kutiyattam*. "Description of a tree" is part of the "description of a garden" (*udyana varnana*), and the latter is an acting sequence which lasts for as long as an hour and a half. The "description of a garden" involves the enactment of various objects in the garden such as the trees, small hills, streams, the birds and the animals, small huts made of leaves and creepers, or any other things imagined and devised by the actor. Among these, the "description of a tree" is a very long and physically strenuous acting sequence.

Once the nature, size, and location of the garden are established, the actor then moves on to take a close look at the garden itself. She identifies a huge tree in a corner. She then enacts the breadth of the trunk with widely open arms stretched out to either side of it in an attempt to measure it. The trunk of the tree is so broad that her arms do not meet when she attempts to hug it. Then she establishes the height of the tree by looking to the top, and once again she is unable to see up to the top-most bit of the very tall tree. These two initial "measures" firmly determine the nature of the tree, which is old, and massive. Interestingly though, the actor does not specify which tree she is referring to, whether it is an oak or teak or some other tree. Both the actor and the audience are free to imagine their own trees in their own ways. The actor's physical gestures are only suggestive of *a* tree and not *the* tree. In *kutiyattam,* the action takes place by establishing the mutual freedom between

the actor and the audience; the audience follows the "rough sketch" drawn by the actor, which is painted on by each and every member of the audience (and the actor of course because she also sees his own tree) according to their own imaginative capacities.

Once the size of the tree is sketched by the actor, she then describes several long, winding branches of the tree (the mental image that I developed and maintained when I learned and performed this was that of the branches which are competing between themselves and stretching out to get the sunlight), the leaves of these branches, fruit and flowers, bees swarming over to suck the nectar from the flowers, and birds flying towards the tree to eat the fruit, and so on. When I enacted this a long time ago, I also imagined a pair of love-struck cuckoo birds who sat on one of the branches, and one of them picking the fruit with its beak and feeding it into the other's beak. The sketch of a tree is now complete. During the training period, the actors are also instructed to enact the dance of a peacock, the bees sucking nectar from the flowers, and a stream, which is flowing to the garden. The "description of a garden" is, therefore, the permutation of a range of descriptions of events and/or objects that are present in the garden itself.

The *Given Circumstances,* according to Stanislavski, "create a corresponding mood inside, which then acts upon your mind and evokes matching experiences" (2008: 74). So these images only inform the creation and the development of a corresponding mood for a character within the actor. Only the actor sees her mental images that caused the generation of any particular emotion within her. As far as *kutiyattam* is concerned, the audience know precisely what images invoked the corresponding emotions within the actor. If the actor is expressing sexual love through her body and face, the audience knows why she is sexually charged. Earlier, she would have described the physical features and the exquisite beauty of the woman that she has come across in great detail (*cari,* known as "the hair to the toe," or *kesadipadam*) and she would also have given emphasis to the enactment of the lips, breasts, and hips of the woman that she described. The audience, along with the actor, also appreciates the "mood" of the character and generates matching experiences within them. The Stanislavskian system is very close to the *kutiyattam* method of training the actor's imagination. The difference, really, lies in the histrionics. It is the logical strip of images that triggers imagination in both Stanislavskian and *kutiyattam* actors.

So, how does *kutiyattam* train the actor's imagination? The actor's physical apparatus is primarily trained so that his flexibility and physical stamina are cultivated and fostered. This includes training that relates to the eyes and face, gestures, posture, and movement. Then *cari* is taught, where the actor learns to incorporate all the various aspects noted above. What *cari* does is to

train the actor to meticulously dissect an action or an object or the scenery into smaller subsections, then carefully analyze and describe each individual subsection and "paint" the picture of a whole slowly and diligently. Therefore, when describing the eyes of a heroine (which is only a subsection of the "hair to the toe"), the actor only sees the eyes and nothing else. The action is unhurried and the aim is to picture the beauty of the eyes. There is almost no need to mention that such acting also demands immense concentration from the actors. This justifies the intense physical exercises and long hours and years of training. A painful body cannot concentrate well during a performance. Similarly, continuous physical actions involved in the *cari* of "describing the mountain" can cause an actor to be very tired. I have myself experienced shaking and aching legs during one of my early performances due to the vigorous action involved in that performance piece. So the actor has to be primarily comfortable in her action. The physical training in *kutiyattam* therefore prepares the actor to physicalize the mental images with commendable ease. It also helps her to maintain concentration during the performance. If Stanislavskian actors create *scores of actions,* the *kutiyattam* actors go one step further. They perform *scores of actions.* Actors read the play, identify the potential gaps within the play, fill the gaps with their imagination, and only perform these repainted or refilled gaps. The text provides a context for the actor in which to display her skills in imagination and interpretation, as well as her capability to translate them into physical actions. The eyes, the face, and *cari* help her in further nourishing the creative abilities. The unity between the creative abilities of the playwright, the director, and the actor rests safely within the *kutiyattam* performer. It is the actor's theatre and it is entirely dependent on her "active imagination."

Conclusion: Transformation, Intuition, and Logic

Kutiyattam is also a bundle of paradoxes. While the imagination is completely logical in nature, the action can be intuitive during a performance. There are instances when the actors freely improvise during the performance, and this does not surprise the fellow actors or the percussionists. Moreover, the outcome of the rigid and strict actor training is expected to be the production of a spontaneous and creative actor who is highly imaginative, but still maintains the meticulous detail of the performance structure. How do we understand such a paradox? First of all, we have the paradox between logic and intuition, and secondly we have the paradox between the rigid structure and spontaneity. At what point are they transposed? In my experience, this happens during the transformation in a performance, that is, the transforma-

tion from the actor to the corridor between actor and the character, and the transformation of the bodily behavior from the daily to the extra-daily.

The body is a transformational tool during the performance. Various geometrical and kinetic movements of the eyes, hands, and the rest of the limbs create a fictional space. When the actor technically moves her eyes from left to right, what the audience see is a riverbank or a village square or the scared face of a character. When the actor lowers his lips and curls up her eyebrows, the audience experience sadness. When the kinetic, physical movements take place in a performance, the audience willingly perceives an animal or an emotion or certain actions of a character, experiencing aesthetic pleasure or rasa; or the audience will only see the horizontal pattern of the eyes and not a riverbank or a fearful face. Bodily techniques transform into a performative experience through an imaginary journey that is shared between the actor and the audience. The audience experience rasa in this journey, which is temporal in nature and engages mental and physical properties. Rasa, therefore, mediates the actor's actions and their experiential outcome. The empirical reality and the existence of a body with organs (the actor's body) are completely displaced in such transformation. The actor embodies fiction in all senses, which only exists within the imaginary domain of the audience. The performance and its subsequent experience only exist within the imagination of the actor as well as that of the audience.

There is something that is very interesting in Natyasastra, which signifies Bharata's view on the actor's imagination. He mentions that "when the actor acts with appropriate make up and a well trained physical apparatus, the actor becomes like a king and the king, like an actor…. King has his natural kingliness and the actor has his enacted kingliness. But the actor's kingliness is more effective because it is copied and reproduced (NS 35: 52–53). Although the imagination is not discussed explicitly in Natyasastra, snippets such as this justify the links between physicality, embodiment, and the imagination. While the defining line in the actor-character transformation is set down strongly by Bharata (the actor doesn't become the king, but only like the king), the quote above also illustrates the demands upon the actor's imagination during performance that are required to create convincing characterization. *Kutiyattam* training aims to achieve the levels of imagination as envisaged by Natyasastra. The *kutiyattam* actor training has such an impact upon the actor that imagination becomes the second nature of the actor. We see a series of imagined bodies emerging from and submerging within the actor during a *kutiyattam* performance.

NOTES

1. *Kutiyattam* is the oldest existing form of Sanskrit theatre from India, with a continuous performance history of at least 2000 years. The earliest references to the existence of this theatre form

can be found from the Tamil epic, *Chilappathikaram,* which dates from about AD 100. A thorough modification of the performance is believed to have taken place in the late 10th century AD. In this sense, it is, arguably, older than Noh. Unesco listed *kutiyattam* as the "oral and intangible heritage of humanity" in 2001. This dramatic form uses Sanskrit plays for its performance and the communication is mainly nonverbal. Although Sanskrit verses and text are used by the actors, the meaning of the text is conveyed through hand gestures, facial and ocular expressions, and physical movements. The *kutiyattam* actor training is long and arduous and the actors are initiated at a very young age.

2. Natyasastra believes that the aim of any drama is to produce *rasa. Rasa,* literally translated as the essence, is achieved through the combination of determinants, consequences, and transitory emotions.

3. The emergence of this performance is traced back to the 10th century AD, and various historical records suggest the continuous existence of this form since then, till today (see Poulose 2001, Moser in eds. Bruckner, Bruin and Moser 2011 and Daugherty in eds. Bruckner, Bruin and Moser 2011). Until recently, *nangyar-kuthu* only presented Krishna's stories (Srikrishna Charitam), which are thought to have been written by a 10th century king of Kerala called Kulasekhara Varman. He inserted a female mono-act segment into the second act of a Sanskrit play he wrote, called *The Wedding of Arjuna and Subhadra* (Subhadra Dhananjayam). *Nangyar-kuthu* starts from a monologue of the maidservant to princess Subhadra, the sister of the God Krishna, called Kalpalathika, whom Subhadra sends to go in search of her blouse, given her by Krishna, which she lost while being kidnapped by a demon. During her journey, Kalpalathika recollects the stories of Krishna, and this becomes the starting point of her long dramatic monologue describing the birth and life of Krishna. Interestingly, the very first line of this long monologue, "I am being ordered by my mistress, Subhadra," is a line from Act II of the play mentioned above. The same line is repeated at the end of the monologue as a means of connecting it back to the play. *Nangyar-kuthu* is a performance that takes place in between the repeated rendering of a single dialogue.

4. Bharata mentions dramatic devices (*angam*) relating to two of the dramatic forms that are discussed in Chapter 20. These are verbal, acting or textual devises employed in the staging of a play. For example, one of the devises (of *lasyam*) is a female actress enacting a male character, whereas another devise (of *veethi*) is to play with the words in the shape of question and answers. Dramatic devises are prescribed only for *veethi* and *lasyam* and both are solo performance forms.

5. Natyasastra suggests that the Sanskrit language is to be used by upper-class male characters and occasionally by queens and prostitutes (owing to their need to interact with upper-class men): women, children, cruel characters, drunkards and people of a lower class in general have to use an unrefined layman's language called *prakrit.*

BIBLIOGRAPHY

Carnicke, Sharon Marie. 2000. "Stanislavsky's System: Pathways for the Actor." In *Twentieth Century Actor Training,* Alison Hodge, ed., 11–36. London: Routledge.

Chakyar, Mani Madhava. 1973. *Natyakalpadrumam.* Cheruturuthi: Kerala Kalamandalam.

Daugherty, Diane. 2011. "Subhadra Redux: Reinstating Female *Kutiyattam.*" In *Between Fame and Shame. Performing Women—Women Performers in India,* Heidrun Brückner, Hanne de Bruin, and Heike Moser, eds., 153–167. Wiesbaden: Harrassowitz.

Moser, Heike. 2011. "How Kutiyattam Became *Kuti-Attam:* The Changing Role of Women in the *Kutiyattam* Tradition of Kerala." In *Between Fame and Shame. Performing Women— Women Performers in India,* Heidrun Brückner, Hanne de Bruin, and Heike Moser, eds., 169–188. Wiesbaden: Harrassowitz.

Paniker, Ayyappa. 1995. "Introduction." In *Sangeet Natak,* 7–11.

Pisharodi, K.P. Narayana, ed. and trans. 1984. *Bharatamuniyude Natyasastram.* Trissur: Kerala Sahitya Academy.

Stanislavski, Konstantin. 2008. *An Actor's Work: A Student Diary.* Jean Benedetti, trans. London: Routledge.

Zarrilli, Phillip. 2009. *Psychophysical Acting: An Intercultural Approach after Stanislavski.* Oxford: Routledge.

The Religious Background of the Natyasastra Tradition

Natalia Lidova

As has long been noticed, the tradition of describing the Ancient Indian theatre took an abrupt start with a treatise that comprises all the basic themes pertaining equally to the theoretical appraisal and practical production of the drama. That is the Natyasastra—a grandiose, encyclopaedic compendium,[1] which has no equals among the analogous ancient and mediaeval works in terms of the scope of information and thematic diversity.[2]

The first scholars of the Natyasastra regarded it as a specialized manual for drama performers or producers.[3] They thought that only such of its chapters were noteworthy as those concerning the typology of genres, describing dramatis personae, and the theory of *rasa*. This treatment of the Natyasastra had its objective reasons—particularly the extremely unreliable dating of the treatise. It was a priori regarded as fairly recent,[4] so it was not merely unjustified but even impossible to peruse it for testimony to the genesis and early development of the theatre. Thus, a majority of hypothesis concerning the origin of the Ancient Indian theatre arose without consideration for the material contained in the Natyasastra.

One of the first hypotheses was advanced in 1869 by prominent Indologist Friedrich Max Müller on the grounds of his analysis of *Rigveda*. The unconventional form of its hymnic dialogues, which presupposed two or more performers, allowed him to believe that they could be acted out by several priests during solemn Vedic worship. Max Müller even tried to reconstruct a particular ritual, in which one of the best-known dialogues of the first mandala of *Rigveda* (I.165) might have been used. The researcher supposed that the dialogue was performed during sacrifice in honor of the *Maruts* by two

parties, one playing Indra and the other the *Maruts* and their followers (172–173). His hypothesis on the so-called Vedic mystery play set the bearings of European studies of the origin of the Ancient Indian drama for a fairly long time.

Silven Lévi, the foremost French Indologist, supported Max Müller's assumption in the 1890s. He was the author of one of the first generalizing studies of the Ancient Indian theatre, which also did not use the material of the Natyasastra. According to Lévi, not only the dialogue hymns but also other Vedic texts indicated that sacral dramatic performances existed even at the time of the *Rigveda*. He assumed that they were acted by priests imitating celestial events and playing gods and god-like wise men.

A number of other scholars developed the concept of the Vedic mystery play later on. Genetic links of the drama with the dialogues in *Rigveda* appeared obvious, so they concentrated on the origin of hymns themselves, which were interpreted now as random parts of Vedic mystery plays, widespread in the ancient Indo-European past,[5] now as remnants of archaic epic compositions, of which only verse parts survived.[6]

Arthur Berriedale Keith was the first to collect and analyze all basic hypotheses on the link between the drama and the *Rigveda* dialogues in a fundamental monograph. He was also the first to level well-grounded criticism on these hypotheses. As he saw it, the sheer presence of stagy elements in the Vedic tradition could not be regarded as doubtless testimony to the existence of full-fledged drama. He advanced an absolutely true idea that the ritual develops into artistic drama only when the spectacle is a value in itself and actors are playing for the enjoyment of it, however small it might be, if not for money. As Keith rightly pointed out, no Vedic texts mention the stage profession even in passing. In particular, actors are not mentioned in a long list of contemporaneous trades and professions in *Yajurveda* (Ch. XXX.6). More than that, the term *nata,* the Sanskrit word for an actor, never occurs in Vedic literature (17–18).

Proceeding from his data in the aggregate, Keith concluded that it was possible to assume that the drama originated in the Vedic era only insofar as all parts of the future whole—music, singing, dancing, and prose recitals during rituals—existed even at that time. However, as he observes, "unless the hymns of the *Rigveda* present us with real drama, which is most implausible, we have not the slightest evidence that the essential synthesis of elements and development of plot, which constitute a true drama, were made in the Vedic age" (26–27).

Keith's conclusions determined the evolution of ideas on the genesis of the Ancient Indian theatre. First, it was no longer believed to have emerged in such hoary past as the archaic Ancient Indian age. Second, traces of its gen-

esis were no longer sought in the dialogue hymns of *Rigveda:* as Keith convincingly demonstrated, they did not contain whatever undoubted proof of the existence of the drama.[7]

As he disproved the hypothesis of the Vedic mystery play, Keith was one of the most consistent champions of the hypothesis of the "verbal" origin of the theatre. Of all hypotheses advanced by the time he wrote his book, he fully supported and developed only the assumptions of the theatre's link with epic recitations. He did not think the classic drama would have ever emerged if not for them. He wrote: "There is every reason to believe that it was through the use of epic recitations that the latent possibilities of drama were evoked, and literary form created"(27).[8]

This hypothesis of the origin of the Ancient Indian theatre had numerous followers. Heinrich Lüders was the first to advance it during a discussion on *Patanjali*'s rule (*Die Śaubhanikas; Philologica* 428). Hermann Oldenberg supported it (*Die Literatur; Zur Geschichte*), and Sten Konow developed on it in detail in his "Das indische Drama," published in 1920 (40–42).[9] Moris Winternitz wrote about rhapsodic recitations of epics (*History* 180–181).[10] Later on, R.V. Jagirdar (36),[11] Paul Thieme (*Das indische* 26–51), Hartmut-Ortwin Feistel (*Das Vorspiel* 33) and others raised the issue of epic influence on the emergent drama. Beside general arguments, the proponents of this hypothesis pointed at the drama-like structure of Ancient Indian epics and the stylistic dependence of the Sanskrit drama on epic legends, much to the detriment of the dramatic form.[12]

We can say that the hypothesis on the link between the Ancient Indian epics and the drama remains one of the most influential, if not universally accepted, to this day. At any rate, it is hard to find a scholar who would offhandedly reject it. It is quite a different matter that even among its most consistent champions, none insist that epic recitals were the only source of the early theatrical forms and the much later Sanskrit literary drama. They all recognize the simultaneous presence of a pantomime plastic basis whose role was not inferior to that of the epics in the emergence of the theatre. Despite shared theoretical position, scholars strongly differ in the definition of the scenic quality that stood at the cradle of the drama hand-in-hand with the epic. Some trace it to the shadow theatre while others to dancing[13] and the pantomime.

Heinrich Lüders was the first to assume the connection between the emergent drama and the shadow theatre (*Die Śaubhanikas; Philologica*). He regarded the latter as a vehicle of the epic tradition because the *Śaubhanikas* not merely recited and acted out epics but also described the content of shadow pictures presented simultaneously. Though no explicit evidence to the existence of the shadow theatre in India at the early time have come down to us—which fact Keith later emphasized (34–36, 53–54),[14] Lüders' assumption

found the support of many eminent Indologists, Sten Konow and Paul Thieme among them.[15] Though both recognized the importance of the verbal component for the emergence of the drama, they saw its principal source not in it but in pantomimes that preceded the literary drama. Konow (*Das indische* 40–42) was among the first to suggest that the origins of the drama should be tracked back not only to the shadow theatre[16] but also to dancing and the mime.[17] Thieme turned to this hypothesis several decades later, developed it and gave it a more profound substantiation (*Das indische* 26–51). Apart from the shadow theatre, he saw the sources of the drama in the ritual musical and dancing pantomime on epic and mythological themes, on the one hand, and in the folk pantomime without musical accompaniment, on the other hand, the latter basing on comic and erotic themes taken from everyday life. He traced to these two the basic types of scenic action characteristic of the classic literary theatre tradition—the *nataka,* which he defined as Tanzdarstellung (36) with relevant imagery (*natayati*), to the sacral musical pantomime with dancing, and the *prakarana,* whose action he proposed to define as *rupayati,* folk pantomime on everyday themes (29–38). To these two, Thieme added the shadow theatre (through which, as he saw it, the influence of the epic tradition was channelled). With this he, in fact, united all actively debated hypotheses on the origin of the Ancient Indian theatre. Thieme's concept was unique in this respect: it not merely recognized and equalized the movement and the word as the pillars of the drama but also reconciled with each other the two basic concepts of the origin of the theatre—the secular and the religious.

In this, we cannot but note that a majority of Indologists who connected the genesis of the theatre with the verbal element were the most consistent adherents of the religious source of the drama, while those who insisted on the priority of scenic movement most often favoured the hypothesis of its secular source. Though the stances of many scholars were somewhat ambiguous,[18] it is evident nevertheless that an overwhelming majority of the academic community thought that the drama was born in the folk not priestly *milieu,*[19] and movement held priority to the word. Apart from Hillebrandt, Konow and Thieme, the latter included Horsch, Feistel (*Das Vorspiel* 33) and many other scholars, while the religious source of the drama had only one consistent adherent, Keith. Decades later, Franciscus Bernardus Jacobus Kuiper joined him in connection with the origin of the *Vidushaka,* the jester, and the Vedic tradition of verbal duels.

That was the first hypothesis on the origin of the theatre to draw on the material of the Natyasastra extensively and consistently. Kuiper was attracted by Vedic reminiscences in Chapter I. As he saw it, they provided an opportunity for an exhaustive proof of the Vedic source of the drama. The scholar

interpreted the testimony of the Natyasastra that the first drama was staged at the festival in honor of *Indra*'s victory and re-enacted the rout of the *Daityas* by the gods as indication of a stage version of one of the variants of the principal Vedic myth.[20] Though his conclusion was made largely by analogy proceeding from the part played by *Indra* in Chapter I of the Natyasastra, it became the cornerstone of Kuiper's hypothetic substantiation of the Vedic roots of the entire Ancient Indian theatre.

In Kuiper's opinion, the purely Vedic context of the *Indra* festival, and information in the treatise that the first presentation of a *natya*, the performance, was connected with that festival leaving no doubt of the genetic link between the drama and Vedic culture.[21] He connected the *natya* performed at the festival with the same. As Kuiper saw it: "the authors of the oldest handbook on Indian dramaturgy considered the drama as having originally been a ritual re-enactment of creation, considering of an imitation of Indra's victory over the Asuras" (*Varuna* 142). This and other circumstances make "it possible for modern research to reconstruct the religious background against which the older parts of the Natyasastra were written" (*Varuna* 142).

Kuiper thoroughly studied the chapters of the Natyasastra pertaining to rituals, focusing on the rite preceding the drama—the *purvaranga*. He aimed to demonstrate that it was not so much a prologue to the drama, as previously considered, as a specific ritual act performing before every play. In Kuiper's opinion, the drama and the ritual preceding it had essential religious functions, which he reconstructed proceeding from his previous cosmogonic concept of the Vedic religion. According to Kuiper, not only the drama but also the *purvaranga* were connected with the ritual set of New Year's competitions that provided safe passage from one cosmic cycle to another. He saw their main difference from each other in the following: the theatre re-enacted *Indra*'s heroic deed in fighting the *Asuras* while the ritual repeated it symbolically to reach its climax the instant *Indra*'s divine banner was erected. The *natya* was at its source a scenic impersonation of the Vedic cosmogonic myth while the relevant ritual was an equivalent of the Vedic *yajna* sacrifice.[22]

Kuiper's concept was fairly widespread. Meticulous studies of the Natyasastra, characteristic of the Dutch school of Indology, and an intricate and well-substantiated system of proofs appeared to leave no doubt of the Vedic origin and specific roots of the Sanskrit drama. Really, if the content of the Natyasastra were exhausted by Vedic reminiscences pointed by the scholar, the problem of the origin of the Sanskrit drama could be regarded as settled once and for all after Kuiper's fundamental work.

However, academic objectivity makes us doubt that Kuiper's conclusions are final—mainly because the Natyasastra contains many phenomena inexplicable in the context of the Vedic tradition. No Vedic analogies, direct or

oblique, can be offered to them. We mean here not so much details and particulars as things of principled importance, including the pivotal question of the origin of scenic rituals.

Indicatively, while pointing at a particular Vedic myth as the source of the early drama, Kuiper at the same time did not intend to track down a particular Vedic ritual that could, even if hypothetically, lie at the basis of the Natyasastra rites. That would be understandable and justified if we had no information about the Vedic ritualism. However, the many extant ritual monuments from the Vedic era give us a fairly extensive and, to all appearances, sufficiently correct idea of the Vedic ritual system. We might even postulate that, at its inception, the Ancient Indian drama was not connected with any of the numerous Vedic rites we know from description in the ritual texts, and took shape independently in the atmosphere of the Vedic cult, as scholars say. However, if the Natyasastra preserves not only ritual elements but also rituals characterized in detail, it would be natural to assume that even with their indirect connection with the *yajna* cult, they should retain at least the generic names of Vedic rituals. However, this is not so, according to the testimony of the Natyasastra. The Natyasastra rites are never referred to as *yajna* but are termed *puja*.

We come across testimony that none other than *puja* was connected with the birth of the drama and the emergence of the theatrical tradition in the myth of Chapter I of the Natyasastra, in which *Brahma,* the god of creating, orders to the other gods: "Perform sacrifice the due way in the house of *natya:* with offerings and sacrificial libations. The offering should be accompanied by mantras and medicinal herbs, by prayer, food and drink. Then will you all be worthy of a happy *puja* as you come to the world of mortals. Without performing the *puja,* you should not equip the stage and produce the spectacle. He who makes a stage and a performance without a *puja,* his knowledge will be barren and he will have a bad rebirth, for this *puja* for the gods of the stage is similar to *yajna.* The performer or wealthy patron who does not perform a *puja* or does not make others celebrate it will be reborn a nonentity, while he who makes the *puja* according to the rules will acquire auspicious wealth and reach the celestial world."[23]

This testimony of the Natyasastra is of extreme importance, first, because *yajna* and *puja* are compared here as two different rites and, second, because of these two, *puja* not *yajna* is recognized as the principal rite connected with the performance of the drama.

The name of the ritual in itself could hardly be regarded as an argument against the Vedic origin of the *natya* if the words *yajna* and *puja* were synonyms used similarly in the Vedic cult context. However, as Ancient Indian sources testify, these words are not synonymic at all. More than that, the Vedic tradi-

tion merely did not apply the term *puja* to its religious practice but did not know any rituals of that name.

In other words, this type of adoration was perfectly irrelevant to the Vedic-Brahmanic ritual system. Consequently, despite the desire to fix religious practice, which was so typical of Vedic culture, *puja* is not described in any ritual texts of the Vedic era, which means that this type of adoration was entirely alien to the Vedic-Brahmanic ritualism. More than that, the root *puj*-extremely rarely occurs in the Vedic texts—in one *Rigvedic* hymn (VIII.17.12),[24] twice in the *Satapatha-brahmana*[25] and, several times, in the much later Vedic texts, in particular, in the *Asvalayana-*[26] and the *Saikhyayana-*[27]*grhyasutras.*

Descriptions of *puja* appear in texts from quite a different time—medieval ritual texts whose types and names vary from one particular Hindu confession to another. The most generalized cover term for this class of texts, the *Agama,* reflects a terminological delineation offered by the tradition itself, with whatever that pertained to the Vedic-Brahmanic religion in its orthodox variety known as the *Nigama,* while the ritualistic system which emerged on the basis of *puja* was termed the *Agama* (Gonda, *Medieval* 5).

However approximate the dating of *Agamic* texts may be, the oldest of these had not emerged before the 5th–6th century CE (Brooks 29–34). These texts have recorded already rather an advanced stage of development of the *puja* cult, the first mentions of which concern a much earlier epoch—the middle of the first millennium BCE.[28] Thus, in the Natyasastra, a treatise forming throughout centuries and existing as a canonical text as early as the 1st–2nd century CE, was preserved one of the first-ever detailed description of *puja*.

In other words, *yajna* and *puja* were topical in different periods of its evolution and are known to have been mutually counterposed in the Indian tradition. *Yajna* held pride of place as a solemn rite in the Vedic time, while *puja* became widespread in the post–Vedic era to become the central ritual of Hinduism. Some scholars emphasized the similarities between the two, some others brought out the differences (Charpentier 276–297; Bailey 1–12; Thieme, *Indische Wörter* 105–137; Radhakrishnan 225–228; Stietencron 126–138; Östör; Einoo 73–87). Irrespective of this, all proceeded from comparison between the outward aspects of the ritual practice, with extremely vague results. More than that, there was a sophisticated religious system behind each of these two rituals, with a multitude of rites, some of them much differing between themselves. It was impossible to compare all rites without exception, while a selective comparison was not representative enough.

A comparison of rituals appears to be destined for success only if it proceeds from a specific methodological approach that allows us to compare not the outward aspects of rites but ritual principles underlying them. Here, our task is reduced to the identification of what I may conventionally term the

"ritual archetype" at the basis of *yajna* and *puja*. As I see it, the most salient features of a ritual archetype are determined by three principal aspects, which can be put into the form of three queries. "Where?" pertains to the arrangement of the ritual space; "How?" to the type of the offering; and "What for?" describes the ritual goals of the worship.

The full-length comparison already presented by me on other occasions (*The Changes* 205–231) demonstrated that the ritualism of *yajna* and *puja* never coincided in any of the basic aspects of religious practice which determined: (1) the type of the arrangement of the ritual space, (2) the way of bringing the offering, and (3) ritual goals of the adoration. As I see it, this gives us sufficient ground to assume that *yajna* and *puja* ascended to different ritual archetypes, with different sacrificial structures and symbolisms (*The Changes* 205–231).

However widespread *puja* might be, with its importance for the three post–Vedic religions—Hinduism, Jainism and Buddhism, surprisingly few academic studies are dedicated to it. Apart from above mentioned publications, I can name only Gudrun Bühnemann's monograph *Pūjā. A Study in Smārta Ritual*, which appeared more than 20 years ago.

Among the earliest textual sources, describing *puja* in detail, Bühnemann reckons appendices (*parisistas*) to *Grhyasutras*. As the pioneering text she considers the important ancillary text to the *Baudhayana-grhyasatra*, which, according to her, "shows Hindu ritual at an early stage" (32). This text particularly deals with

- the consecration of an idol of *Vishnu,*
- the ritual of the adoration of *Mahapurusha,* a form of *Vishnu,*
- the ceremony of the bathing of *Vishnu,*
- the consecration of an idol of *Rudra-Siva,*
- the adoration of *Mahadeva,* a form of *Rudra-Siva,*
- the ceremony of the bathing of *Rudra,*
- the second consecration of an idol and so on.

We cannot but see that all themes enumerated here are traditional also in the medieval *Agamas,* i.e., they reflect a rather developed not embryonic form of the *puja* cult, quite close to a 16-part *puja,* which formed at a fairly late stage of Hindu culture. It is also confirmed by the fact that gods are worshiped as idols, and that *Vishnu* and *Rudra* occupy the top of the pantheon, while the early *puja* tradition, to all appearances, had *Brahma* for supreme god. This initial stage of the *puja* cult, close to the time of its inception, is in fact reflected in the ritual mythological chapters of the Natyasastra. However important in the Natyasastra pantheon *Vishnu* and *Siva* might appear, *Brahma* is evidently the supreme god. None other than *Brahma* creates the drama and *puja,* orders a templar theatre built, and appoints gods to protect it.

We have only vague information about the transitional time that laid the bridge between the late Vedic and early Hindu cultures, and can be dated by several centuries before and after the conventional borderline of the mid–1st millennium BCE. This information cannot offer any reliable criteria for dating the *parisistas*. However, as every Veda had at least one *parisista*, they can be classified as a separate group of late Vedic works.

The greatest number of *parisistas*, 72, were created in the *Saunaka* school of *Atharvaveda*. However, Bühnemann paid no attention to this *parisistas*, though they may provide one of the earliest detailed descriptions of rituals of the *puja* cult.

In this paper I intend to analyse the *Brahmayaga* ritual, described in a source of the late/post-Vedic period—*Atharvaveda-parisista* XIXb (*Saunaka* school).[29] This *parisista* has never been translated into any European language, and so demands detailed analysis. It is a unique source—on the one hand, it contains one of the earliest extant description of the *puja*-type ritual, while on the other, it offers the closest analogue of the rite of consecrating the new templar theatre, as presented in Chapter III of the Natyasastra. Both rituals were performed to sacralise a newly built ritual pavilion, to which both texts refer as the *mandapa*.

In the *Brahmayaga* ritual *mandapa* was erected in a flat wondrous place, full of brilliance and remote from all danger and from birds of prey. That was where the sacrificial edifice was to rise, decorous with arches and flags, and having several doors (*maōōapaü kārayet tatra yathoktavidhinā guruḥ/patākā-toraōir yuktaü dvāraiś ca api pçthagvidhaiḥ AVPar* XIXb. 1.5).

Construction over, the ritual edifice was consecrated. At first, it was sprinkled with blessed water or, as a variant, *pancagavya*—a mixture of five products received from a cow: milk, curd, purified melted butter, urine and dung. This mixture was considered auspicious and was used for purification (*Manu* XI.166). Once the floor was coated with dung, the *puja* was performed by anointment (*abhyukùya śāntitoyena pañcagavyena vā sakçt/gomayena pralipya ādau pūjayed varōakiḥ pçthak AVPar* XIXb. 2.1).

Another *puja* was performed at night to worship the *mandapa* with flowers and white fruit, with a sacrificial offering to the four cardinal points, as prescribed (*puùpaiś ca vividhaiḥ śubhraiḥ phalaiś ca api arcayed budhaḥ/tato baliü hared rātrau caturdikùu vidhānavit AVPar* XIXb. 2.2). Once the *mandapa* was consecrated, lamps full of oil were brought there, next to make a divine circle of *mandala* in the centre of the *mandapa* (*pradīpān ghçtapūrōāüś ca pradadyād vividhān tathā/tato maōōapamadhye tu vartayed divyamaōōalam AVPar* XIXb. 2.3).

The priest next drew a lotus of great beauty in the centre of *mandala* with white powder, and decorated everything outside the flower with bright

colors (*sitacūrōena tanmadhye likhet padmaü suśobhanam/bahiś ca varōaiḥ śubhrair nānā śobhāü prakalpayet AVPar* XIXb. 2.4). Once he installed *Brahma Paramesvara* in the middle of the lotus, the priest was to start the ritual by worshipping *Brahma* with the words "*brahma jajñānam ...*" ("*Brahman* born ...*" AV* IV.1.1; V.6.1)" (*madhye padmaü tu saüsthāpya brahmāōaü parameśvaram/brahmajajñānasūktena yathoktam upakalpayet AVPar* XIXb. 2.5).

The most solemn part of the ritual started next. The priest made a perfusion of water and other liquids, as prescribed, with the words "These waters" (*AV* III.12.9; IX.3.23), and performed the *puja,* sacrificing to *Brahma* lotuses, sandal, flowers, incense and other offerings (*tathemā āpa ityādyair yathāvad adhivāsayet/rocanācandanādyaiś ca puüpair dhūpaiś ca pūjayet AVPar* XIXb. 3.1). He also sacrificed to *Brahma* garlands of oil lamps, opulent garments, food, white sandal and camphor, or burned incense (*ghçtapradīpamālyaiś ca vastrair bhaküaiś ca śobhanaiḥ/sitacandanakarpūraü dadyād vā api hi guggulam AVPar* XIXb. 3.2).

The solemn sacrifice over, the priest performed the *pradaksina* by walking in a circle round the lotus image on the floor, next to bow to the ground before it to worship the god inside the flower (*pradaküiōaü tataḥ kçtvā namet sarvāïgakair naraḥ AVPar* XIXb. 3.3a). He next left the centre of the ritual space to go over to the south or west part of the *mandapa* for altar worship (*daküiōe paścime vā api bhāge vediḥ praśasyate AVPar* XIXb. 3.3b) and performed a number of other ritual acts to prepare the anointment (*abhisheka*) of the King (*kçtvājyabhāgaparyantaü tataḥ śāntyudakaü punaḥ/brahmajajñānasūktena kuryāc caivātra pūjanam/tathaiva raudramantraiś ca abhiüekāya kalpayet AVPar* XIXb. 3.4).

That ushered in another stage of the ritual as the King entered the sacrificial building. After long preparations and perfusions to *mantra* recital, the priest performed the *homa* in the King's presence to the sounds of the hymn of *Kutsa* (*AV* X.8), invocations of *Agni* and carefully recited mantras of *Ayusa,* collected from the *Kausika-sutra,* and prayers for luck and well-being (*homayet kutsasūktena ucchuümaiś ca yathāvidhi/japen mantrān tathāyuüyān maïgalyāüś cāpi yatnataḥ AVPar* XIXb. 4.1). As he made offerings with *Catana* u *Matrnama* mantras from the *Atharvaveda,* the priest ordered to make the ablution of the King with *pancagavya* and blessed water (*hutvā ca cātanaü tatra mātçnāmagaōena ca/snāpayet pañcagavyena tathā śāntyudakena ca AVPar* XIXb. 4.2). Next, in profound concentration, the priest himself sprinkled the King with fruit juice while the congregation chanted blessings, singers the connoisseurs of Vedas and fair women sang fair songs holding wondrous fans, while others stood holding brightly painted sceptres and mirrors (*phalasnānaü ca kurvīta yukto maïgalavādibhiḥ/bandibhir vedavidbhiś ca strīsaügītair manoramaiḥ // cārucāmarahastābhiś citradaōōaiḥ sadarpaōaiḥ AVPar* XIXb. 4.3–4.4a).

After that, the King performed the *pradaksin* round the *mandala* and knelt to it. He received the desired fruit with the whole congregation who prayed for his weal (*tataḥ pradakṣiōaü kçtvā jānubhyāü dharaōīü gataḥ/aśāsyeùñaphalaü tatra yukto maïgalapāñhakaiḥ AVPar* XIXb. 4.5). The goal of the ritual thus obtained, it was to have a worthy ending. To *turya* sound and verbal blessings, the King beat a drum. The solemn sound was echoed by timpani and shells (*tūryaghoùeōa saüyuktaḥ kçtasvastyayanas tathā/kuryād dundubhinādaü tu śaïkhabheriprapūritam AVPar* XIXb. 5.1). The King was also to take part in the final ceremony of the ritual. He was to let its participants speak up and, when possible, give out food to *Brahmanas* and *Veda* experts on the spot (*kuryād uttaratantraü ca sadasyān vācayet tataḥ/bhojayec chaktitas tatra brāhmaōān vedapāragān AVPar* XIXb. 5.2). The King was also to serve the crippled, helpless, blind, poor, hungry and thirsty by diverse means (*dīnānāthāndhakçpaōān bhakùabhojyair anekadhā/annapānavihīnāüś ca viśeùeōa prapūjayet AVPar* XIXb. 5.3). Once *daksina* was distributed and *yogins* fed, the King ordered not to fell trees and to avoid killing live creatures. He then greeted his master, freed his enemies from prison, and proclaimed peace and safety in the realm (*AVPar* XIXb. 5.5–6). By giving his country safety, the ruler attained longevity in *Brahma- Paramesvara* to enjoy his entire land (*abhayaü sarvato dattvā iüñe ca parameśvare/dīrgham āyur avāpnoti kçtsnāü bhuükte vasuüdharām AVPar* XIXb. 5.7).

As they finish the description of the ritual, the author of *Atharvavedaparisit* XIXb says that the *Brahmayaga* was performed in his time by the priest *Atharvan* in heaven for *Indra* the King of Gods, after which he became the unlimited ruler of the Third Heaven once obtaining protection (*AVPar* XIXb. 5.8–9).

As I already suggested this ritual is the closest analogue of the rite of consecrating the new templar theatre, presented in Chapter III of the Natyasastra. The rituals are extremely close to each other not only symbolically but also structurally. I even observe in the *Brahmayaga* the stages of theatre consecration.

The Natyasastra ritual starts with a ceremony allowing to consecrate the ritual building as a whole. The *Brahmayaga* starts similarly, with acts consecrating the *mandapa,* which had just been built. The same ritual, *puja,* was performed with this goal on both instances to give the earthly structure the status of a sacral building—the temple.

The interiors of both *mandapas* were arranged in conformity with a patterned characteristic of an overwhelming majority of *puja* rituals. It had a precisely emphasised centre, which symbolised the centre of the sacral space, and was oriented on the cardinal and midway points. Serving this purpose in the Natyasastra ritual were four doors that broke the *mandala* circle, opening east,

north, west and south. *Brahmayaga* offerings were also made to the four cardinal points during one of the *puja* rituals. Sometimes the four-cornered *mandala* was depicted with four doors (*caturaśraü caturdvāraü vçttākāram atha api vā AVPar* XIXb. 2.3).

The *Brahmin* performing the *Brahmayaga* made a *mandala* in the *mandapa* centre. Likewise, the *acarya* of the Natyasastra himself drew the *mandala* in the centre of the stage. What the priests did next was also analogous as they opened the solemn ceremony of installing gods. For that, the *acarya* placed "*Brahma* seated in the lotus" in the centre of the *mandala* (*padmopaviünaü brahmāōaü tasya madhye niveśayet* NS 3.23), while the *Ahtarvavedic* priest placed *Brahma Paramesvara* in the centre of the white lotus whose image he had made (*madhye padmaü tu saüsthāpya brahmāōaü parameśvaram AVPar* XIXb.2.5).

The Natyasastra and *Atharvaveda-Parisist* XIXb do not say explicitly whether the priests were performing a symbolic act or really placing material objects in the centre of the sacral space. If the latter assumption is correct, these objects might have been traditional for *puja,* e.g., *kumbha* vessels, or they might be images endowed with the total of particular iconographic characteristics. It is of tremendous importance that none of the texts mentions idols, i.e., they do not suppose the use of anthropomorphous images of gods. In that, the very vagueness of both texts is another proof of doubtless closeness of the rituals I compare—an oblique proof of both fixing approximately the same developmental stage of the *puja* cult.

The installation of the supreme god *Brahma Paramesvara* in the centre of the *mandala* preceded the beginning of the principal part of the ritual. Properly arranged and sanctified by divine presence, the ritual space was ready for *puja,* the culmination of the whole ritual. At this stage, the longest and the most solemn *puja* was performed in both rituals to bring gods not only such traditional offerings as water, flower garlands, oil lamps, ointments and diverse fragrances but also garments and special ritual food. To all appearances, the priests acts were also analogous as they recited mantras while they were arranging those generous offerings close to the place where gods were.

The solemn *puja* over, the priests opened the next stage of the ritual, characteristic of which was not similarity but full identity of their acts. Performed at this stage was the *havir-yajna,* a ritual traditional in Vedic culture. Both texts refer to it with a more special term—*homa*. It demanded burning fire, as all *yajna* rituals. In *Brahmayaga,* fire was lit on a special altar in the west or south part of the ritual pavilion. The Natyasastra ritual did not specify the location of the ritual fire while it explicitly described the *acarya*'s acts. They fully coincided with the acts of the *Atharvavedic Brahmins*—solemn pouring of purified melted butter on the burning fire to *mantra* recitals. Indicatively, *homa* was

used at the start of the royal rite in both rituals. In the Natyasastra ritual of theatre consecration, the King appeared on the stage accompanied by seven girl dancers made up as goddesses. He took part in the ceremony performed for his well-being, with numerous perfusions and recitals of blessing mantras.

Practically the same was taking place in the *Atharvavedic* ritual of *Brahmayaga*. The King was also repeatedly sprinkled and anointed with prayers for his luck and well-being. The King was surrounded by his subjects. Women, who were among them, were holding beautiful fans and singing wondrous canticles. Thus, however concise the description of the royal rite in the Natyasastra and *Atharvaveda-Parisist* XIXb, I cannot rule out that both texts refer to the same rite.

The coincidences between theatre consecration and *Brahmayaga* are too great not to assume not only typological but also direct genetic links. The latter assumption does not appear implausible if we consider that *Atharvaveda-Parisist* XIXb supplements *Atharvaveda-Parisist* XIX, which describes the ritual of the *Indra* festival (Lidova, *Indramahotsava* 85–108; Gonda, *The Indra* 413–29; Sathyanarayana 3–13), while the Natyasastra contains a mythological account of the *Indra* festival at which the world's first drama was performed (NS 1.54–55).

The content of the *Atharvaveda-Parisist* XIX, which precedes *Atharvaveda-Parisist* XIXb, almost literally coincides with the description of the *Indra* festival in another later *Vedic* work by the *Atharvavedins*—*Kausika-sutra* 140.1–22, created earlier than the *Parisiksanas*. Neither the *Kausika-sutra* nor the *Atharvaveda-Parisist* XIX mentions the rite named *Brahmayaga*. This allows the assumption that the rite initially was not part of the *Indra* festival ritual, and was introduced later, when the basic features of the festival had taken final shape and became firmly established (Lidova, *Indramahotsava* 85–108). In that, the introduction of the *Brahmayaga* did not violate the central ritual of the *Indra* festival as the two rites were, in a way, parallel to each other. The traditional *Indra* festival was celebrated outdoors with huge congregations, while a temporary ritual pavilion built in an auspicious place housed the *Brahma* worship attended by the king and his chosen courtiers. The *Brahmayaga* rite imitated the worship once performed in heaven by the celestial priest *Atharvan* for *Indra,* the heavenly patron of the king.

In particular, this explains why *Brahma* and *Indra* were the protagonists of the myth in the opening chapter of the Natyasastra, active in the making of the *natya*. *Indra,* who inspired the creation of the drama, was depicted in the myth in the hypostasis of the royal leader of gods, which the later Vedic *Indra* festival re-created. In that, *Indra* did not compose the *natya* on his own but asked *Brahma* to do so—just as an earthly king would recur to the help of a learned *Brahman* in a similar situation.

To all appearances, the ensuing part of the initial chapter of the Natyasastra also reappraises the ritual reality of the later Vedic *Indra* festival. This part of the myth portrays demons attacking the *natya*. *Indra*, the first to enter battle, uses for weapon the symbol of the festival devoted to him—the *dhvaja-jarjara*. It is, however, *Brahma* who offers a way of total defence as he orders a *mandapa* built, where the drama will be performed hereafter. *Brahma* approves the theatre built by *Visvakarma,* the great architect of heaven, and appoints deities to protect it. He next stands in the centre of the stage. Hence, according to the Natyasastra, comes the tradition of spreading white flowers there (1.94). He also orders to perform the *puja* in the new edifice, during which *Brahma* in the lotus shall be placed in the centre of the stage (3.23). Both these testimonies almost literally follow the indication of the *Atharvaveda-Parisist* XIXb, according to which a white lotus flower was to be portrayed in the centre of the ritual pavilion for *Brahma* worship, as the flower symbolized him.

To all appearances, the first joint performances of the *puja* and the drama were connected with the *Indra* festival. This found reflection in the myth of the opening chapter of the Natyasastra and determined the mutual closeness of the ritual of new theatre consecration and the rite of *Brahmayaga*. If we proceed from the Natyasastra, we can assume that mythological pageants were initially performed only outdoors, where the drama was rather vulnerable, according to the treatise. Later on, when the festival grew to include the worship of *Brahma Paramesvara* alongside *Indra,* the *natya* was probably also performed in the *mandapa,* a ritual pavilion built for the purpose.

As I demonstrated in another work, the myth of the opening chapter of the Natyasastra preserves ample authentic historical testimony giving an idea not only of the origin of the drama but also of the circumstances in which *puja* spread (Lidova, *Drama and Ritual*). The Vedic era really had neither the theatre nor a ritual topical for *Aryan* society and known as *puja.* Both appeared in the transitional period of the middle of the 1st millennium BCE, when the religious bases of ancient *Brahmanism* were revised (the Natyasastra refers to it as a time of crisis). As the result, a part of *Brahmins* adapted a ritual new to *Aryans*—*puja*—and began to use the practice of staging myths (*natya*) for popularising and establishing reformed religion. The same tradition, which we presently know as Hinduism, determined the construction of temples, which were unknown in the Vedic period, and the making of liturgical images of gods, who inherited the attire, makeup and movement of actors enacting divinities. Possibly, ascending to the festival of *Indra* was only the idea of synthesizing the ritual and the entertainment—an idea fruitful enough to be considered the cornerstone of the *puja* tradition, which accounted for the profound theatralisation of post–Vedic culture.

NOTES

1. Written in Sanskrit verse, the treatise comprises about 6,000 *slokas* alongside passages in prose, divided into chapters, whose number varies from 36 to 38. The manuscripts of the Natyasastra date to various eras and differ from each other due to interpolations and errors inevitable in copying. However, they are all considered to based on one and the same manuscript. The manuscripts were described in detail in the prefaces to Natyasastra editions prepared by Joanny Grosset (IX-XXIII) and M. Ramakrishna Kavi (GOS 68, VIII-XXII). There is no critical edition of the treatise. Two editions of the Natyasastra are of primary importance. The Calcutta edition, prepared by Manomohan Ghosh, was used in writing this work (Natyasastra 1967, Natyasastra 1956). The other, comprising Abhinavagupta's commentary, was published in Baroda (Natyasastra 1926 (GOS 36); Natyasastra 1934 (GOS 68); Natyasastra 1954 (GOS 124); Natyasastra 1964 (GOS 145).

2. Compiled throughout centuries, the Natyasastra comprises the apprehension of the most diverse formative stages of the Ancient Indian drama from the early, mysterial to the classic literary. Connected with the latter are chapters dedicated to the analysis of the poetic idiom and the kinds of recitation (Ch. XV-XIX), the structural laws of dramatic composition, the structure and varieties of plots (Ch. XXI), the types of heroes and heroines (Ch. XXV; XXXIV) and the principles of casting (Ch. XXXV). Of a more extensive character, which supposes analyses not only of literary forms but also of their scenic antecedents, are chapters describing the ten types of drama works (Ch. XX), the manner and style of acting (Ch. XXII), and the renowned rasa theory, which characterizes the emotional impact of the drama on the audience (Ch. VI-VII). The treatise analyzes the stage practice in sufficient detail, too. Alongside such special matters as the theatre architecture (Ch. II) and the musical accompaniment on the stage (Ch. XXVIII-XXXIII), it regards a majority of traditional theatre themes connected with the rules of stage equipment and scenery (Ch. XIV; XXIII), the principles of acting and techniques of dramatic identification (Ch. VIII; XXIV), and costumes and makeup (Ch. XXXIII). Special chapters are dedicated to dancing (Ch. IV), mime, gesture and conventionalized stage movement (Ch. IX-XIII). A separate theme is represented by the ritual and mythological chapters, which concern the genesis of the theatre, the consecration of a new theatre building, and a religious rite preceding the performance (Ch. I, III, V, XXXVI). The same theme also comes up in numerous excerpts from legends occurring in many chapters usually to substantiate some aspect of the stage practice.

3. The Natyasastra was discovered in 1865, when American scholar F.E. Hall published several of its chapters using one single manuscript. His attention was attracted by chapters describing the various types of the drama (Ch. XVIII-XX) and classifying parts and dramatis personae (Ch. XXXIV). They were published as supplementation to the *Dasarupa* by *Dhananjaya* (a book on the drama from the 10th century CE). The publisher (Hall) attempted to introduce the text he had found as a sequel of the book. It soon became clear, however, that the treatise was not merely independent but also far older than the *Dasarupa*.

4. The dating of the *Natyasastra* is a separate and extremely sophisticated problem, varying within a limit exceeding a thousand years from the 5th century BCE to the 7th–8th centuries CE. In this, the extreme dates reveal the principled difference between researchers' approaches to the monument: some try to identify its oldest nucleus while others deal with the latest of its formative stages, when the text included all interpolations made throughout centuries. One of the first opinions on this score was published by Paul Regnaud, the foremost French Sanskritologist. Proceeding from his studies of the rhetoric and metrical character of the treatise, he concluded that it appeared no later than the 1st century BCE, though admitting that an earlier version might have been present even in the 4th century BCE (Regnaud 1884 and the Preface to *Bharatiya-natya-sastram*, I, L-LI and *Le metrique*, II). Haraprasad Shastri came out with even an earlier dating somewhat later— he thought the Natyasastra more probably appeared in the 2nd century BCE (351–358). Sten Konow insisted on the 2nd century CE (1920, 2–4; 49). Arthur Berriedale Keith, who proceeded from analyses of Prakrit languages, mentioned in the Natyasastra, thought that it was written between the 2nd and 4th centuries CE (72–75). Sushil Kumar De regarded the 4th–5th centuries CE as the most probable lower time limit, though acknowledging that the treatise could have acquired the form we know as late as by the 8th century, while warning against putting the upper limit too early (29–31). Pandurang Vaman Kane dated the treatise by the 3rd–4th centuries CE (41). Paul Thieme thought that it appeared before the 2nd century CE (35; 52). Hartmut-Ortwin Feistel's stance was

close to his: he supposed that the nucleus of the Natyasastra took shape approximately in the 1st century CE (1969, 136; 138; 1972, 26). Pramod Kale admitted that some parts of the treatise could have been written in the 2nd century CE. However, like Sushil Kumar De, he did not think the final redaction might have appeared before the 8th century CE (9).

5. That was the opinion of Leopold Schröeder (3–13; 35; 68–69) and Johannes Hertel (1904, 59–83, 137–168; 1921, 344, 367).

6. This view was supported by Ernst Windisch (404), Hermann Oldenberg (1883, 54–86; 1885, 52–90) and Richard Pischel. For other adherents of this theory, see Moris Winternitz (1959, 92–93, 1909, 102–137).

7. Later on, when he returned to the consideration of this hypothesis, Paul Thieme pointed at the absence of whatever testimony to the dialogue hymns of *Rigveda* acted out. He also thought they lacked dynamism of the plot, which he considered essential for the initial development of the drama (26–51).

8. Keith also saw a rational kernel in Alfred Hillebrandt's hypothesis, which related the birth of the drama to *somakrayana,* a Vedic ritual that included elements of acting (1891, 69–72; 1914). In this connection, Keith pointed at another Vedic rite, *mahavrata.* Considering that, as any other primitive worship, both rituals contained theatrical elements, Keith primarily pointed at the obscene dialogue between the *brahmacarin* and the courtesan as they were bickering and contesting in ritual blasphemy during the *mahavrata.* Keith thought the dialogue between priests and queens should be regarded in the same context in the rite of *ashvamedha.* Thus, in this case, too, Keith saw the sources of the drama in sacral verbal activities (23–25).

9. Cf. his earlier *Aufsätze.*

10. Cf. his article *Dialog.*

11. His book "Drama in Sanskrit Literature" was published in Bombay in 1947. A second, enlarged and verified edition of the book was published in 1967 under his pen-name Adya Rangacharya.

12. This opinion belonged to Indu Shekhar (140–141).

13. The connection between the drama and dancing was noted even by Horace Hayman Wilson, the first researcher on the Indian theatre, in his two volumes of translations from selected Sanskrit dramas. The book came out in Calcutta in 1826–27, and was republished in London in 1835 (vol. I, XIX).

14. As said above, Keith attached great importance to epic recitations in the appearance of the drama. However, he denied the role of the shadow theatre in that process, and did not see sufficient grounds to assume that it existed at such an early time.

15. The influence of the shadow theatre was also recognized by Hartmut-Ortwin Feistel, 1969, 33.

16. Apart from shadow performances, the sources of the drama were discerned in the puppet theatre, which was another subject of heated academic discussion. For a review of opinions, see Kuiper, 1979, 111, note 9.

17. Alfred Hillebrandt (1914) was the first to advance the hypothesis on the drama originating from the folk ritual pantomime. Sten Konow largely proceeded from his opinion.

18. Heinrich Lüders, Sylvain Lévi, Sten Konow and Polish researcher Andrzej Gawronski recognized the religious antecedents of the theatre alongside secular ones. For a generalization of their opinions, see Kuiper 1979, 117.

19. We should notice rather widespread ideas of the theatre being unable to develop within the narrow limits of religion or in the aesthete atmosphere of the royal court. Allegedly, the theatre needed commoners' hustle-and-bustle and the inexhaustible energy of the crowd. Indicative in this sense is the opinion of Indu Shekhar, who argued that the drama had emerged not in the priestly circles dedicated to Vedic wisdom but among the demos (128).

20. Kuiper regarded the myth of Creation, which he reconstructed, as the principal myth of *Rigveda.* He saw the festival of *Indra*'s banner as an essential proof of its existence. As he assumed, the festival re-created the instant of creation of the Universe when *Indra,* after vanquishing the powers of chaos, set cosmos into order by installing a pillar to divide earth and heaven. For details, see Kuiper 1975, 107–120.

21. Characteristically, we cannot either prove or disprove the Vedic origin of the myth in the first *natya* if we proceed from the Natyasastra. We possess only the most general description of the

performance. As the treatise has it, gods' victory over *Daityas* was its most salient feature. This information can relate either to a particular myth or to the archetypal model of two mutually confronting clans of deities, which lay at the foundation of Vedic and a great number of other epic myths. In other parts, the Natyasastra says with a great degree of certainty that the first drama was titled *Amritamanthana* (No. IV.1–3) and was a scenic version of the well-known epic myth of the churning of the *amrita*.

22. It should be noted that, as he was substantiating the hypothesis on the Vedic origin of the drama, Kuiper did not insist that it took shape in the Vedic era proper. It was proved even in the early 20th century that Vedic monuments did not contain whatever detailed references to the drama, so Kuiper bypasses the theme, explaining it by the insufficiency of our knowledge. He says that: "since only a part of the top of the iceberg of Vedic culture is visible in the priestly literature, there is no reason to expect that here the starting-point for the later evolution of the drama can be found" (1979, 115).

23. *kurudhvam atra vidhivad yajanaü nāñyamaōōape //*
balipradānair homaiś ca mantrauùadhisamanvitaiḥ /
bhojyair bhakùaiś ca pānaiś ca baliḥ samupakalpyatām //
martyalokagatāḥ sarve śubhāü pūjām avāpsyatha /
apūjayitvā raïgaü tu naiva prekùāü pravartayet //
apūjayitvā raïgaü tu yaḥ prekùāü kalpayiùyati /
tasya tan niùphalaü jñānaü tiryagyoniü ca yāsyati //
yajñena saümitaü hy etad raïgadaivatapūjanam /
nartako'rthapatirvāpi yaḥ pūjāü na kariùyati /
na kārayiùyanty anyair vā prāpnoty apacayaü tu saḥ //
yathāvidhi yathādçùùaü yas tu pūjāü kariùyati /
sa lapsyate śubhānarthān svargalokaü ca yāsyati // (NS I.122–127).

24. In the name *Śācipūjana:* "O *Śācigu, Śācipūjana,* this (*soma*) has been squeezed for thee to rejoice" (*śācigo śācipūjanāyaü raōāya te sutaḥ*).

25. *atha laspūjanyā spandyayā prasīvyati* (*ŚB* III.5.3.25; III.6.1.25).

26. *yatra enam pūjayiùyanto bhavanti tatra etām rātrīm vaset* (*ĀśvGS* 3.9/3).

27. *ayāta yāmatām pūjām sāratvam chandasām tathā* (*ŚāiGS* 4.5.15).

28. In Jarl Charpentier's opinion: "The word *puja* stands quite alone within the Sanskrit dictionary; the verbal root *puj-* (*pujayati*) is with every probability secondary in comparison with the noun. Both words are used many times already by *Yaska* and *Pāōini* and consequently belonged to the common dictionary of the *dvijas* in the sixth century BCE" (98).

29. The problem of the date of the *Atharvaveda Parisistas* texts though already discussed still needs further research. According to Modak: "the *Atharvaveda Parisistas* obviously represent a composite text, being a collection of tracts presumably belonging to different chronological periods" (471). He considers that "the date of the compilation of the *Atharvaveda Parisistas* lies somewhere between second century BC ... and fifth century AD," and therefore: "one may not be far from the truth if one assigns the *Atharvaveda Parisistas* to a period somewhere round about the beginning of the Christian era" (473). At the same time Modak assumes that some of the *Atharvaveda Parisistas* could belong to a much earlier period, i.e., 3rd or 4th century BCE (482, note 141). For the dating of the *Atharvaveda Parisistas* texts to the second half of the first millennium CE see Bisschop and Griffiths, *The Pāśupata Observance* 324; *The Practice involving* 1–46.

BIBLIOGRAPHY

Bailey, H.W. 1961. "Cognates of Pūjā." *The Adyar Library Bulletin* XXV, 1–4 : 1–12.

Bisschop, P., and A. Griffiths, 2004. "The Pāśupata Observance (Atharvavedaparisista 40)." *Indo-Iranian Journal* 46: 315–348.

_____. 2007. "The Practice Involving the Ucchuùsmas (Atharvavedaparisiùña 36)." *Studien zur Indologie und Iranistik* 24: 1–46.

Bolling, G.M., and Negelein von Julius. 1909. *The Pariśistas of the Atharvaveda.* Leipzig: Otto Harrassowitz.

Brooks, D.R. 1992. *Auspicious Wisdom: The Texts and Traditions of Śrividya Śākta Tantrism in South India*. Albany: State University of New York Press.

Bühnemann, G. 1988. *Pūjā. A Study in Smārta Ritual*. Wien: Institut für Indologie der Universität Wien.

Byrski, M.C. 1974. *Concept of Ancient Indian Theatre*. New Delhi: Munshiram Manoharlal.

Charpentier, J. 1926. "Über den Begriff und die Etymologie von Pūjā." *Beiträge zur Literaturwissenschaft und Geistesgeschichte Indiens*. Festgabe Hermann Jacobi zum 75. Geburtstag. Ed. by W. Kirfel Bonn: Kommissionsverlag F. Klopp. (Eng. trans.: Charpentier, Jarl. "The Meaning and Etimology of Pūjā." *Indian Antiquary*, Bombay LVI: 93–98, 130–35).

Chemburkar, J. 1976. "Śrirādhikānāmasahasram." *Annals of the Bhandarkar Oriental Research Institute* LVII: 107–16.

Dagens, B. 1984. *Architecture in the Ajitāgama and the Rauravāgama*. New Delhi: Sitaram Bhartia Institute.

Dange, S. 1987. "Some Non-Vedic Rituals in the Vedic Tradition." Proceedings of All-India Oriental Conference, Annals of the Bhandarkar Oriental Research Institute, Poona, 163–68.

De, S.K. 1960. *Studies in the History of Sanskrit Poetics*, vol. 1. Calcutta: Firma K. L. Mukhopadhyay.

Einoo, S. 1996. "The Formation of the Pūjā Ceremony." *Studien zur Indologie und Iranistik* 20: 73–87.

Farquhar, J.N. 1913. *The Crown of Hinduism*. London: Milford.

_____. 1928. "Temple and Image Worship in Hinduism." *Journal of the Royal Asiatic Society*, 15–23.

Feistel, H.O. 1969. *Das Vorspiel auf dem Theater: Ein Beitrag zur Frühgeschichte des klassischen indischen Schauspiels*. Diss., Tübingen.

_____. 1972. "The Pūrvaraṅga and the Chronology of the Pre-Classical Sanskrit Theatre." *Samskrita Ranga Annual* VI, Special Felicitation Volume in Honor of Dr. V. Raghavan: 1–26.

Gawronski, A. 1921. "Notes sur les sources de Quelques drames indiens." *Mémoires de la Commission orientale de l'Academie polonaise des Sciences*.

Ghosh, M. 1930. "Problems of the Nāṭyaśāstra." *Indian Historical Quarterly* VI: 71–7.

_____. 1957. *Contributions to the History of the Hindu Drama: Its Origin, Development and Diffusion*. Calcutta: Firma K.L. Mukhopadhyay.

_____. 1967. *The Natyasastra, Ascribed to Bharata Muni* by M. Ghosh. Vol. I (Chap. I-XXVII). Calcutta.

Gonda, J. 1967. "The Indra Festival According to the Atharvavedins." *Journal* of the *American Oriental Society* 87.4: 413–29.

_____. 1977. *Medieval Religious Literature in Sanskrit*. Wiesbaden: Otto Harassowitz.

Grosset, J. 1898. Bharatiya-nātya-sāstram: traité de Bharata sur le théâtre. Texte Sanskrit. Édition critique, avec une introd., les variantes tirées de quatre manuscrits, une table analytique et des notes. Précédée d'une préface de Paul Regnaud. Tome I. Premiére partie. Annales de l'Université de Lyon, fasc. 40, Paris.

Hall, F. 1865. *The Daśa-rūpa or Hindu Canons of Dramaturgy by Dhanañjaya with the Exposition of Dhanika*, the Avaloka ed. Calcutta: Baptist Mission.

Hertel, J. 1904. "Der Ursprung des indischen Dramas und Epos." *Wiener Zeitschrift für die Kunde des Morgenl* 18.1–2: 59–83, 137–68.

_____. 1909. "Der Suparnādhyāya, ein Vedisches Mysterium." *Wiener Zeitschrift für die Kunde des Morgenl* 23: 273–346.

_____. 1921. *Indische Märchen*. Jena: Eugen Diederichs.

Hillebrandt, A. 1891. *Vedische Mythologie*. Bd. I. Breslau: Wilhelm Koebner.

_____. 1914. *Über die Anfänge des indischen Dramas*. München: J. Roth, Königlich Bayerische Akademie der Wissenschaften.

_____. 1918. "Zur Geschichte des indischen Dramas." *Zeitschrift der Duetschen Morgenlandischen Gesellschaft* 72: 227–32.

Horsch, P. 1966. *Die vedische Gāthā- und Śloka-Literatur.* Bern: Francke Verlag.

Kale, P. 1974. *The Theatrical Universe: A Study of the Nātyaśāstra.* Bombay: Popular Prakashan.

Kane, P.V. 1961. *History of Sanskrit Poetics.* Delhi: Motilal Banarsidass.

Kavi, R.M. 1926. Natyasastra of Bharatamuni with Commentary Abhinavabhārati by Abhinavaguptācārya with a Preface, Appendix and Index, vol. I. Baroda (2d rev. ed., 1956) (GOS 36).

_____. 1934. Natyasastra of Bharatamuni with Commentary Abhinavabhārati by Abhinavaguptācārya with a Preface, Appendix and Index, vol. II. Baroda (GOS 68).

_____. 1954. Natyasastra of Bharatamuni with Commentary Abhinavabhārati by Abhinavaguptācārya with a Preface, Appendix and Index by Manavalli Ramakrishna Kavi, vol. III. Baroda, 1954 (GOS 124).

_____. 1964. Natyasastra of Bharatamuni with Commentary Abhinavabhārati by Abhinavaguptācārya with a Preface, Appendix and Index by Manavalli Ramakrishna Kavi and J.S. Pade, vol. IV. Baroda (GOS 145).

Keith, A.B. 1911. "The Vedic Ākhyāna and the Indian Drama." *Journal of the Royal Asiatic Society* 2: 979–1009.

_____. 1924. *The Sanskrit Drama in Its Origin, Development, Theory and Practice.* London: Oxford University Press.

Konow, S. 1916. "Zur Frühgeschichne des indischen Theater." *Aufsätze zur Kultur- und Sprachgeschichte vornehmlich des Orients.* Ernst Kuhn zum 70.Geburtstage am 7. February 1916 gewidmet von Freunden und Schülern. München, Breslau: Verlag & Marcus: 106–14.

_____. 1920. "Das indische Drama. Berlin und Leipzig: de Gruyter." *Grundriss der indo-arischen Philologie und Altertumskunde* 2, Heft 2 D.

Kuiper, F.B.J. 1975. "The Basic Concept of Vedic Religion." *History of Religions* 15.2 (November): 107–20.

_____ 1975. "The Worship of the Jarjara on the Stage." *Indo-Iranian Journal* 16.4: 241–68.

_____. 1978. "Sthāpaka and Sūtradhara." *Annals of Bhandarkar Oriental Research Institute, Poona, Diamond Jubilee Volume*: 173–85.

_____. 1979. *Varuoa and Vidūùaka: On the Origin of the Sanskrit Drama.* New York: North-Holland.

Lévi, S. 1890. *Le théâtre indien,* Vols. I-II. Paris: Bouillon.

Lidova, N. 1994. *Drama and Ritual of Early Hinduism.* Delhi: Motilal Banarsidass.

_____. 2004. "Indramahotsava in the Late Vedic and Early Epic Traditions." *Journal of the Asiatic Society of Mumbai* 76–78 (2002–2003): 85–108.

_____. 2009. "On the Genesis of the Nātyaśāstra Rituals." Abstracts of the 14th World Sanskrit Conference, Kyoto, Kyoto University: 359–60.

_____. 2010. "The Changes of Indian Ritualism: *Yajña* versus *Pūjā.*" *Archaeology and Text: The Temple in South Asia.* Ed. by Himanshu Prabha Ray. New Delhi: Oxford University Press.

Lüders, H. 1940. *Philologica Indica: Ausgewählte kleine Schriften von Heinrich Lüders. Festgabe zum siebzigsten Geburtstage am 25. Juni 1939 dargebracht von Kollegen, Freunden und Schülern.* Göttingen: Vandenhoek & Ruprecht.

Lüders, H.H. 1911. *Bruchstücke buddhistischer Dramen.* Berlin: Druck und Verlag von Georg Reimer.

_____. 1916. "Die Saubhanikas, ein Beitrag zur Geschichte des indischen Dramas." *Sitzungsberichte der Königlich Preussischen Akademie der Wissenschaften zu Berlin* I: 698–737.

Ludwig, A. 1964."The Ākhyāna Theory Reconsidered." *Journal of the Oriental Institute* 13: 195–207.

Max Müller, F. 1869. *Rig-veda-samhita: The Sacred Hymns of the Brahmans,* vol. I: Hymns to the Maruts or the Storm-Gods. London: Trübner.

Meyer, J. J. 1937. *Trilogie altindischer Mächte und Feste der Vegetation: Ein Beitrag zur vergleichenden Religions- und Kulturgeschichte, Fest- und Volkskunde.* Zürich-Leipzig: Max Niehan.

Modak, B. R. 1993. *The Ancillary Literature of the Atharva-Veda: A Study with Special Reference to the Parisistas.* New Delhi: Rashtriya Veda Vidya Pratishthan.

Oldenberg, H. 1883. "Das altindische âkhyàna, mit besondrer Rücksicht auf das Suparôàkhyàna." *Zeitschrift der Deutschen Morgenländischen Gesellschaft* 37: 54–86.

_____. 1885. "âkhyàna-Hymnen im Rigveda." *Zeitschrift der Deutschen Morgenländischen Gesellschaft* 39: 52–90.

_____. 1903. *Die Literatur des alten Indien.* Stuttgart-Berlin: Cotta.

_____. 1917. *Zur Geschichte der altindischen Prosa. Mit besonderer Berücksichtigung der prosaisch-poetischen Erzählung.* Berlin: Weidmannsche Buchhandlung.

Östör, A. 1982. *Pūjā in Society.* Lucknow: Ethnographic and Folk Culture Society.

Pingree, D. 1981. *Jyotihsāstra. Astral and Mathematical Literature.* Wiesbaden: Otto Harrassowitz.

Pischel, R. 1900. "Die Heimat des Puppenspiels: Rede bei Antritt des Rektorats der königl." Besprechung: Halle.

_____. 1906. "Das altindische Schattenspiel." *Sitzungsberichte der Kgl. Preuss Akademie der wissenschaften* 23: 482–502.

Radhakrishnan, R. 1965–67. "On Pūjā." *Indian Linguistics* 26: 225–28.

Rangacharya, A. 1967. *Drama in Sanskrit Literature.* Bombay: Humanities Press.

Regnaud, P. 1884. *La rhétorique sanskrit exposée dans son développement historique et ses rapports avec la rhétorique classique.* Paris: Leroux.

_____. 1884. "Le métrique de Bharata, texte sanscrit de deux chapitres du Natya-sastra publié pour la première fois et suivi d'une interpretation française." *Annales du Musée Guimet,* Tome II.

Sathyanarayana, R. 1993. "The Banner Festival of Indra." *Sangeet Natak* 110 (October–December): 3–13.

Schröeder, L. 1908. *Mysterium und Mimus im Rigveda.* Leipzig: Haessel (Rpt.: Amsterdam, 1974).

Shastri H.M. 1909. "The Origin of Indian Drama." *Journal and Proceedings of the Asiatic Society of Bengal* V: 351–61.

Shekhar, I. 1960. *Sanskrit Drama: Its Origin and Decline.* Leiden: Brill.

Sinha, K.P. 1991–93. "Vedic Origin of the Tantric Practices." *Annals of the Bhandarkar Oriental Research Institute* LXXII-LXXIII: 195–204.

Stietencron, H.V. 1967. *The Nātyaśāstra, Ascribed to Bharata Muni.* Ed. by M. Ghosh. Vol. I. Calcutta.

_____. 1977. "Orthodox Attitudes Towards Temple Service and Image Worship in Ancient India." *Central Asiatic Journal* XXI: 126–138.

_____. 1993. *Thoughts on Tantra and Vaisnavism.* Calcutta: Punthi Pustak.

Thieme, P. 1939. "Indische Wörter und Sitten." *Zeitschriften der Deutschen Morgenländischen Gesellschaft* 93: 105–37 (trans.: "Pūjā." *The Journal of Oriental Research* XXVII 1957–1958 (1960): 1–16.

_____. 1966. "Das indische Theater." *Fernöstliches Theater.* Stuttgart: Alfred Kroner: 26–51. (2d rev. ed.; *Einführung in das Ostasiatische Theater.* Mit Beiträgen von Erich Horstein mit Beiträgen von Erich Horsten, et al., Herausgegeben von Heinz Kindermann. Wien: Böhlau, 1985).

Visvanatha, K. 1951. *The Sāhityadarpana of Visvanātha. With Exhaustive Notes and the History of Sanskrit poetics by P.V. Kane,* 3d ed. Bombay: Nirnaya Sagar.

Weber, A. 1852. *Akademische Vorlesungen über indische Literaturgeschichte.* Berlin: Dümmler.

Wilson, H.H. 1827. *Select Specimens of the Theatre of the Hindus,* vol. 1. Calcutta: Asiatic Press.

Windisch, E. 1917–1920. *Geschichte der Sanskrit-Philologie und Indischen Altertumskunde,* 2 vols. Strasbourg: Trübner (Rpt.: Berlin: de Gruyter, 1992).

Winternitz, M. 1959. *History of Indian Literature*, vol. I. Calcutta: University of Calcutta.
Yano, M. 2003. "Calendar, Astrology, and Astronomy." *Blackwell Companion to Hinduism*. Ed. Gavin Flood. London: Blackwell, 376–392.
Yano, M., and Miki Maejima. 2009. "The *Nakṣatra* System of the *Atharvaveda-Pariśiṣṭas*." Abstracts of the 14th World Sanskrit Conference, Kyoto; Kyoto University.

Zero Plus One: Beckett and the Natyasastra

Ralph Yarrow

The Natyasastra is full of measurements, classifications and definitions. The measurements are about stage architecture, detailing the dimensions of playhouse, stage space and greenroom. The classifications are of great variety, spanning types of plays, characters, emotions, stage techniques and modalities of performance. Definitions are kinds of procedural mechanics for producing *rasa,* the emotional states, which are present in a theatrical event. This suggests two investigations:

1. What "stage space" is like and how it can best serve an imaginative transaction with an audience.
2. What a performer does and how s/he can best operate imaginative transactions with an audience.

The common question is: what are the ground conditions for the generation, stimulation and reception of imaginative worlds, the creation of signs and meanings, the materialisation of forms and relationships? By implication, these will give rise to the intelligent body of the performer and the active body of the receiver.

Like the Natyasastra, Beckett was actually very precise about measurements and definitions, length of pauses, ways of speaking, pace of walking etc., for his performers. Is this specificity necessary to propel the performer beyond specificity? Does it result in a skill which, like the world of Beckett's work, unremittingly engages with entropy and in so doing shows it to be generative in the most subtle and inventive ways? My answers in "Theatre Degree Zero" led through an investigation of "zeroing," of the moves suggested by Beckett's

words, structures and methods towards a "no-place" somehow before movement and vocalisation. They mostly concerned performers and receivers, in other words the dimensions which relate to point 2 above, so my investigation in this essay[1] will start by picking up from there.

Both Beckett's texts and the Natyasastra are in the business of providing instructions for performance with a specific goal, which is to take performers and receivers to a condition in which they are "experiencing" the initial phases of the trajectory of "making work." The Natyasastra is the more direct version of this, although of course it probably, in practice, represents a writing-down of instructions, which were given verbally—or indeed, more probably, transmitted visually and physically. The teacher performs, the student mimics; or the student performs and his/her limbs are manipulated by the teacher. So the process of learning is embodied to a large degree. Beckett's play texts are studded with directions, most often in the form of indications of when to pause but also as discursive descriptions, for example of the journey Krapp takes to the room "offstage" where he keeps a bottle, or of the movements of putting tapes in and out of a recorder, or as directions to the follow-spot operator in *Play*. These directions translate directly into physical actions, which extend to the business of the rhythm and pace of speech (e.g., in *Not I*) and the placing of actions and effects by non-speaking "characters" (the "knocker" in *Ohio Impromptu,* the silent listener in *Not I*). A great deal of attention is thus accorded to kinds and degrees of physical action.

Basic exercises usually proceed in stages. You find a position (of the feet, the fingers, the eyes); hold it; push it further to test the limits; relax; move on to the next one. It tends to be a staccato process, rather than a completely smooth one. Beckett makes it clearer: as a performer in *Not I* or *Footfalls,* you are in a way learning again how to emit language, how to walk: you practise breathing and moving, you learn what it feels like to do it from the beginning. It is a kind of re-education, this time consciously, into what are often autonomic activities.

The Natyasastra arises in a culture and an era in which thinkers determined that "reality" needed not one but six systems of philosophy to chart it depending on the kind of consciousness, which is operating at the time. They were careful to point out that what you see depends on the quality of your awareness. The compilers of the Natyasastra similarly indicate that rasa operates at different levels or degrees of intensity: at less intense stages you appreciate the precision or elegance of individual moves or expressions (as, from the perspective of Samkhya, you are clear about the distinctions between phenomena); whereas greater intensity permits a kind of multiple seeing, sensing and understanding, a simultaneity of "reading" and registering, of imaginative engagement in the flow of performance and the world it presents (as, from the

perspective of Karma Mimansa or Vedanta, you may be more aware of the relationships and energies between things). So this seems to suggest a framework of many layers and degrees of "truth," in which operation at different levels enables perception of different processes and relationships.

In acting, according to the principles of the Natyasastra, you do things with emphasis on subtle distinctions (glances, *mudras*,[2] vocal tone). You entreat the spectator into these, so that discrimination becomes increasingly subtle. Each distinction shifts the effect slightly. Like semi or quartertones, glissades, intermediate beats. The effects are sensory—visual, aural, almost visceral. You are hearing patterns and variations, not notes, seeing shapes and contours. It is a training in visual and sonic perception. From these degrees of greater subtlety (less overt events) comes a greater sense of the coherence and interrelatedness of the world, which the performance is composing. Attention to precise detail leads into awareness of processes of formation and generation, of the aesthetic in and as production, the world as becoming. The taxonomies and categorisations (nine *Rasas,* dominant and subdominant emotions, *mudras*) all target the precise shifts between shades of expressive gesture and the affects it signals and/or stimulates. They compose a dense continuum, a gradation or scale on which performers can play, as in a *raga*[3] in Indian music.

In Beckett's novel *Molloy,* the second protagonist Moran could watch the "dance" of his bees "for ever." They move in ever-renewed visual and sonic patterns. Watching them enables him to sink into a sense of equivalence with the genesis of form. Moran has been "sent" on a quest to find Molloy, the protagonist (actually the word doesn't quite apply to either of them, they are not very proactive) of the first part—who is also on a quest, to find his mother or the room in which he thinks she may be/may have given birth to him. They are thus both working "backwards," towards what initiated their journey. Neither arrives at a definitive conclusion. Molloy does not find his mother in any physical sense: he ends up crawling round in circles in a ditch; Moran does not find Molloy, though his motion-without-progress comes increasingly to resemble the latter's. In an earlier novel, Beckett's Murphy ends up rocking in a chair (a situation which also characterises the entire action of the short play *Rockaby*); here he claims to be in what he calls a "third zone," between here and there, between one movement and the next, between movement and stasis, between life and death. Often the movement slows down so that attention is increasingly focused on "lessness," on more and more subtle distinctions, until there is no visible or audible event as the object of attention, only the condition of being attentive.

The bees' patterns, like Molloy's and Moran's journeys, are trajectories, which offer potential rather than actual significance or outcomes. They are kinetic inscriptions which have generated much speculation: there is not (I

think) any completely accepted interpretation about what they "mean" to other bees, although it is clear that they signal something, probably a plurality of information depending on a whole range of variables (intensity, pace, dimension, position etc.). In the case of *Molloy,* the bees also die, while Moran is away looking for Molloy. All that is left is a handful of dust, some wings, some wax. Components of motion, home, nourishment. "Such stuff," perhaps, as Prospero puts it, "as dreams are made on" (*The Tempest* Act 4 scene 2).

At the same time, there is an aspect both to Beckett in performance and to the Natyasastra-inspired Indian work which is much less ethereal, much more immediately rooted in the capacities, and indeed, in the case of Beckett, incapacities, of the body as a very physical mechanism. I will consider this subsequently.

Sreenath Nair writes that *mudras* are "kinetic energy," through which "the body remembers." He rightly indicates that they are a good deal more specific and indeed—to some extent—mimetic than what the bees are doing. But he also says: "[m]udra ... is a language without inscription. It is not written anywhere, but rather it is a performative utterance delivered by the dancer's body extended into air, impermanent and leaving no visible traces" (Nair 2012). This might in fact be one description of performance itself. It is a trace in space and time, a sign of becoming and a signal of the genesis of that becoming; it "fade[s] into air, into thin air ..." (*The Tempest*). In Beckett's performance worlds, any specific location, function or designation of "sets" is mooted only to be rapidly retracted or have any sense of specificity removed from it; a heap of sand, an empty road, a bare room, some jars. In *Kutiyattam* and *Kathakali,* the worlds may be more "recognisable" (as mythological terrains—rivers, mountains, forests), but they are in fact even less material. Indian performers "construct" them through gesture and expression; Beckettian performers have to fight against or work with the banality, discomfort, repetitiveness or lack of assistance, which the few objects in their domain afford. Both of these procedures are more interested in locating the "action" as a "set" of impermanent performative utterances. But in both cases this occurs as a result of specific "training," either as a long-term programme as set out in the Natyasastra, or in response to specific instructions in the text (as stage directions) or given by the director (in many cases leading up to first performances, Beckett himself); and this training is focused on minimal but precise movements of hands, face, eyes, musculature, body positions. Concomitantly, the audience's attention is drawn to and held within this relatively small zone of action: what may extend to an imaginative engagement or co-creation starts with a practice of tight focusing. Thus, as I said elsewhere (Yarrow 2001), Beckett's demands require actors (and to the extent just indicated, spectators) to "move into a condition in which the performative flows of energy, attention and intention operate at

the very threshold of action." Indian work, which takes Natyasastra as a basis in some way starts with this degree of precision, and may move "out" into variously configured body-work and kinetic language.

Doing this involves working with the parameters and modes of balance and control of the body as "extra-daily" mechanism, as Eugenio Barba puts it (1991). *Mudra,* says Nair via Heidegger, is "recollection of being" experienced in the body (Nair, 2012). Yes, though this "being" is, in recollection-as-performance, more of a becoming: it is not so much the recollected thing, which is the matter, it is the setting-in-motion of its re-collection and re-enactment. *Mudra* is thus (Nair via Deleuze) a "skeletal apparatus" : a kind of translucent structure, perhaps, the x-ray of form taking shape. Skeletal is however important in another sense: the skeleton is the frame of the body, that which maintains its contours. The Natyasastra is compiled from a very precise understanding[4] of what kinds of movement and what kinds of "hold" or "pause" the body is capable of. It has methodically categorised them according to emotional dynamics, but in practice these have to be delivered by certain kinds of finely controlled expressive gests. Working over long periods with this awareness strengthens and refines those skills in operation. As with the Japanese notation *jo-hya-kyu,*[5] it is possible to distinguish temporal phases or cycles for each gest, by which it is established, held (amplified, explored) and dismantled. Beckett uses light in a somewhat similar way in *Play,* where each head/face/mouth of the three performers (immersed in jars up to their necks) is "caught" successively by a follow-spot as s/he speaks her/his version of their past relationship; in *Footfalls* the placing of each step marks a stage in the "recollection" of the mother/daughter situation; in *Rockaby* the old woman's recollection is rhythmicized by each swing of the chair and the repeated and ambiguous phrase "time she stopped."[6] So the body in space, the head at a particular angle, the vibration of voice, is arrested and framed: only for a moment, but that moment is where action is "made" again, and it is that which is illuminated—in *Play,* literally. *Mudra* thus becomes (Nair/Deleuze again) an "optical-mechanism" which makes visible the body's kinetic capacity.

Actors, asked about their experience of performing Beckett, describe a whole set of "interruptions" to the flow of action, narrative or character, ranging from physical difficulties occasioned by being required to adopt strange positions, through shifts between "I" and "s/he" (causing them to reassess what kind of speech-and-performance-act they are engaged in vis-à-vis the "character" they are playing), to the need to react to "external" control by a prompter figure (Yarrow 2001). Simone Benmussa's comments on working on a play by Cixous echo this in identifying the need to "break up" text and structure; and like Lucky's speech in *Waiting for Godot,* the drive seems to be towards "oppos[ing] the great edifying and reproducing machines that we see all

around us" (Benmussa 1979: 10–11). Pieces like *Rockaby, Not I, Come and Go, Play* and *Footfalls* operate a "stuttering" (Deleuze 1994: 23–29)—a "repeated hiatus of language" (Yarrow 2001)—and of movement—and this "perpetual disequilibrium" (Deleuze op. cit., 24) is reminiscent of Barba's "luxury balance" (1991). Bodies in the Natyasastra-derived work are in this condition all the time, and are always, as it were, in danger of being excessive, engaging in almost impossible "extensions" of gait, amplification, expression: percussion and chanted text often underscore this. They seem constantly to be (over) *demonstrating* the process of signifying—corporeally, gesturally, facially. Beckettian bodies on the other hand (or should that be "foot?") are radically prevented from getting beyond the first move, and are, often physically, *impeded* from getting as far as signifying. "What, us: mean something? That's a good one!" says Clov in *End Game*. But precisely by repeatedly halting just before they start to do so, they renounce joining the motion of the "great edifying machines' and instead continually replay the how and not the what of signifying practice. That is a further kind of luxury expenditure: it doesn't join the cycle of producing and consuming. But what it says is "hang on a moment" (quite literally): "do you know what you are doing?" By hanging on the span of a moment, calling a halt to the "narrative" teleology of words and movements, they engage fully and consciously in just what they are doing and nothing more ("nothing to be done," says Hamm: Beckett's world is often about doing "no-thing," "better"). Things are on the verge of becoming things, but they never quite make it—like Hamm's toy dog, "finished" with one leg missing so, like a kind of composite of several other Beckett characters, it can neither stand nor sit properly (Hamm can't stand, Clov can't sit; Molloy can't walk, and so on; Hamm and Clov, as "hammer and nail," nearly make up something together, but their individual limitations mean that what they do achieve is at best a continuous failure to achieve). No-one really goes anywhere and most of them can't anyway (Winnie up to her neck in sand, *Play* characters in jars, Krapp moving only between one room and the next, Didi and Gogo at the same spot on the same road).

I could, of course, go on. I even find the argument so far relatively plausible. Both sets of practice can be positioned not just as deriving from, but as being techniques for investing over and over in, moments of generation: located via the body's capacity to engage its own kind of memory, to trace again the trajectory of signifying. Both, in the tightness of focus on the expressive details produced by the performers, and in the elimination of distractions (e.g., of set or technical support), seem intent on taking their audience on a similar journey, rather as does Noh, similarly pared down to the minimalism of a bare space, embryonic gestures, movements and sounds and the search for the quintessential moment of *hana,* the sudden recognition of the opening of

the flower. Elsewhere, (Yarrow 2001) I use Molloy's "instructions" to "keep in mind" the impetus to "say" along with the awareness of not knowing what is to be said as a means of identifying an "unlimited but desiring condition," a "beforeness" preceding language and movement.

But yet, hang on (in another sense). Do you really recognise the sometimes violent energy, the pantomimic caricature, the vast mythic grandeur, the thundering percussion, the brilliant costume of Indian forms deriving most closely from the Natyasastra–not to mention the feel of air flowing through the slats in a *Kuttambalam,*[7] or the wind in the trees, or the howling of dogs from the village? And in reducing Beckett to a set of embryonic signs, are we not disregarding the real *hindrances* of bodies, of their relentless entropy? Working with them is one thing; fighting against them, and thereby being made inescapably aware of their limitation, is another. The older I get, the more I realise that I can't get away from my body. In a way, acting is always being reminded of what Bakhtin calls "the body's big toe" (Bataille 1985: 23). You would like to "flow," but most of the time you are "standing water," as Sebastian says in *The Tempest*- somewhere on the way to being not so much a god or a superhero—like a lot of Kathakali characters—as a rather less than halfway-plausible sensory mechanism which tries and fails to embody and communicate some of the streams of the performance-text. Bits keep getting in the way, like Molloy's stiff leg when he (in an ungainly and non–Centaur-like fashion—that is, neither mythologically elegant nor human-in-control-of non-human-environment) rides his bicycle. Gogo's feet hurt, even though there doesn't seem to be anything in his boots. My body is a machine in the ghost, an ambulant turd polluting the ambrosian landscape. So here the body is always proclaiming its own imperfection, interrupting any ideal notion of performance as a sphere of perfect harmony or a harmony of perfect spheres; or advertising its corporeality, its embeddedness in a world of sounds and sensations. It may be possible to read it as a sign of *poesis,* but in operation it is often stridently resistant to any such construction.

Carl Lavery points out that "[t]heatre's capacity to create a semiotic fiction, to put what Ionesco might call "le piéton dans l'air" ("the walker in the air"), is necessarily subject to the forces of gravity. As Nicholas Ridout has shown in *Stage Fright, Animals and Other Theatrical Problems,* no other medium has such a capacity to stumble and totter, and, ultimately, to disenchant: "theatre's failure, when theatre fails, is not anomalous, but somehow, perhaps constitutive" (2006: 5). "Theatre's pre-programmed tendency to fail cannot help but focus attention on the body" (Lavery 2012). This Deleuzian "stuttering" is less elegant than aerial kinetics, and more rooted in the difficult effort to produce. It would be nice to produce effortlessly (I am writing this in India and the current has stopped and started twice in this sentence already).

But if it looks too much that way, like the (supposedly) perfect proportions of western classical art (until someone asked: "perfect from whose perspective?," perhaps), we may lose sight both of the kinetic origination and of the actual bodily expenditure involved. So we need to be made aware of the effortfulness as well as experiencing it as a staccato. Even in Kathakali, this principle holds, though with longer sequential sections than in Beckett: a performance functions as a set of bursts of episodic action/expression rather than a seamless narrative.

Bodies ineluctably work; even autonomically and entropically they go on doing it without our "conscious" involvement. So what they signal, "on their own" (if they could be like bees, for instance), is that they can make little darts towards coherence (Didi and Gogo), recall brief moments of harmony (Krapp's memory of being on the boat, moved gently by the water); but that they always trip "themselves" up, partly because they have imperfectly functioning bodies and partly because they can never just be bodies and something else, which we call "thought," intervenes. So either the "body" or the "mind" intervenes in the flow of action and awareness. You could say that the mind gets in the way of the body or vice-versa. Or from a slightly different angle, what is being staged is the continual struggle, which is acting. Can you do and think at the same time? Maybe, with practice (or actor-training) a kind of awareness goes alongside the doing. Clive Barker, whose book *Theatre Games* signalled a renewed focus on the body in European actor training, calls it "body/think" (1977). Like Csikszentmihalyi's[8] "flow experience" and the sense of ease and detachment sometimes accessed by sports performers, it is a goal of much physical training (1997). Being more of a Beckettian operator, for me the sequence is usually more jerky: I experience; I register/evaluate/categorise that; I react. Stop/go, or as Beckett puts it *"Come and Go."* He also has a fictional work entitled *Comment C'est* (a *double-entendre* signifying both "how it is" and "beginning"), in which rather indistinct and indistinguishable entities (Bim, Bom, Bem) crawl in short bursts through a sea of mud towards tins of tuna fish: a sort of non-lapsarian procrustean landscape of primeval being.

Beckett often replays a Cartesian joke about duality. Entities apparently without bodies (*Play* characters in jars, the Unnameable in a similar state in the novel of that name, Mouth in *Not I* reduced to being a [contested] stream of words) find that when the body has been "left behind," as in certain forms of spiritual practice, it just makes the resistant and incessant presence of "thought" more intrusive: the remainder of the body manifests itself as this kind of electrical and/or linguistic detritus rolling on and on. Bodies without minds and minds without bodies are equally impossible and equally revelatory of that impossibility. There is "no remedy" and "no painkiller" (*End Game* 1956).

There is also "no more nature," according to Clov (*End Game* 1956), which puts a (slightly) different perspective on it. In terms of the environment predicated in the play, Clov refers to the instrumental readings he reports: zero on the hygrometer, the anemometer and the thermometer; in other words there is no perceptible degree of humidity, wind velocity or temperature. We are, you might say, *nulle part,* nowhere. But why?

I) Nature ("instinct," our autonomic nervous system; or the universe) is running down/out.

II) What we used to think was "natural" (self-evident, taken-for-granted, habitual) is now redundant: because we can't do anything "naturally."

III) We think, therefore we perform.
We always observe (spectate) what we do.
We think, therefore we cannot just be.

IV) So performance (an extra-daily, difficult, excessive, luxury-balance mode of activity) actually merely confirms our inevitable condition of unnaturalness, artifice.

V) We are (and are not) "nature." There isn't anywhere else. There is no-one/where-else to pass the buck to. That is how it is. Nature is infected with culture, nature is unnatural. There is no more (unadulterated) nature.

I'm not sure the Natyasastra sets out to say this. Beckett possibly does, or discovers it *en route.* But the mechanics of both, foreground it by the way in which they insist upon full physical and mental reinscription into each act. Starting again in full awareness is the difficult task they impose.

The Natyasastra subscribes to a monist view that mind/body (and perhaps therefore also human/nature) form a continuum, not a dualism. Beckett would agree, if from a less unambiguously positive perspective. The methodology outlined in the Natyasastra implies working on the whole body/mind, indeed on what might be called an ecology of the mind/body in its relationship with the space in which it is functioning and the forms and energies which inhabit it. That space is both the "theatre" building–which as I noted earlier is understood as having a relationship with the air and light which surround it, and whose orientation is carefully designed in accordance with this relationship (extending to an awareness of the kinds of material from which it is constructed)—and the cultural and material world surrounding the theatre. Thus animal and elemental forms and forces are part of that world as they are a part of many of the performances. Performers both engage with this "natural dynamics" and (as kinetic inscriptions) "speak" in human signs. Beckett's plays, on the other hand (foot), imply working with how the body/mind comically mismanages its own dynamics and "stutters" its own absurdity.

But here's another thing. Picking up from what I have mentioned several

times, bodies in performance are trained (and the Natyasastra work and Beckett certainly require training) to be "more" fluid, articulate, efficient than "normal"—they are in extra-daily, even superconductive mode. So: the bodies in a Beckett piece are actually much more "competent" than they appear to be— they are very competently signalling incompetence. The bodies in e.g., Kathakali are, in contrast, *approaching* what they mainly appear to be—in some sense superhuman (gods, heroes, demons). The body in performance is, in neither of these cases, quite what it is in everyday life. But it is articulating the highs and lows of being a body, in other words the full spectrum (if you take the two situations together) of bodyfulness (even if that means bodylessness for Beckett).

As earlier sections show, body can be the site and sign of kinetic and expressive potential (the capacity of symbolic utterance); it can also be the means of (dis)articulating the corporeality of abjection. Oddly enough, abjection isn't all it might seem either. Recognising the limitations of physicality is also, not infrequently, a way of acknowledging the transience of mortality, of the entropy, which affects all Beckett's characters. His contemporary Jean Genet, as Carl Lavery signals, discovered in the presence of a down-and-out sitting opposite him in a railway carriage the sensation that he was not different from this "other." For Genet this produced a kind of liberation from ego, which translated into aesthetic and political activity (Lavery 2010, 71–77). When performing Beckett, the activity is therefore one of embodying both the hiatus and the framing of it, being both part of it and apart from it. Or perhaps, discovering and making available for discovery the possibility that cessation, although inevitable, is neither all there is to it nor without its own generative potential.

So how does this "give rise to the intelligent body of the performer and the active body of the receiver?" In respect of the performer, what it engenders is an intense, sequential, minutely focused and interrupted/repeated awareness of the procedures which produce movement, action and vocalisation/speech, in other words which underlie all forms of significant intervention in the life of thought and matter. This "awareness" continually oscillates between and operates on the borders of "thinking" and "doing." It develops the potential to shift between these modes or perhaps to experience them as (almost) simultaneous. If there were a situation in which thinking could be doing, without intervention, action would "flow." There isn't, quite; just as in visual perception eye movements operate in a series of "fixations." But a familiarity with this mechanism both gets as close as possible to surmounting this and also identifies the function of the minuscule hiatus in the process.

For receivers the goal must also be to give some access to this process. Commentaries on the Natyasastra have discussed its poetics at length, thus

identifying the performative strategies it lays out as integral to the process of making (*poesis*) and to the mechanics of imagination. In a way, this locates it as a kind of Hamlet-machine, in Heiner Müller's sense of the term, a play-structure, which targets certain effects. Beckett's work can be viewed similarly, with the proviso that the trajectory is from greater to smaller. Whereas the Natyasastra starts from the "beginning" and builds up sets and sequences of movement and gest, Beckett starts from the "end" (explicitly of course in *End Game*) and draws the attention to increasingly less overt manifestations; so they move over the same course in different directions. Following this, in either direction is a bodily, as well as a perceptual, activity. It is a kind of five-finger exercise, where "finger" also means any of the five senses and their relation to sense-making. Playing each note along a spectrum of intensity (volume, duration, pitch, texture) may lead to increasing capacity to sense each one in relation with the others, to begin to operate with the whole pattern rather than with the individual components. In order to really learn how to go, learn how to stop. Learn, as Beckett said, "to fail better" (*End Game*).

Both Beckettian text and the Natyasastra are thus engaging radically with the whole range of sensory perception and physicality and the processes of their operation in the creation of shared imaginative constructs. In so doing they serve to foreground the nature of performance as process and to identify at the subtlest levels the stages of its trajectory. They exhibit a highly-tuned awareness of the functioning of the body in relation to its material and spatial environment and an almost "scientific" understanding of its articulations across the range of perceptual and motoric activity.

In pursuit of these goals, neither however appears to follow the model of performance-training current in most establishments at present. It is true that in both cases a base of physical flexibility and control is a *sine qua non,* and this is also on the curriculum of conservatoires and drama schools. But teaching by rote and by mirroring is not found very much outside the Kerala Kalamandalam,[9] and the degree of rigorous, almost sadistic, restriction demanded by Beckett is unusual. Training establishments and directorial practice do use these methods to a limited extent; but in taking them to extremes, the kinds of work I have been discussing are again radical and uncompromising. This confirms their intention to get to what Lady Macbeth calls "the sticking place," to arrive at the "point de départ" which is both end and beginning. First get to zero, then find what lies beyond.

NOTES

1. This is a spin-off of my 2001 essay "Theatre Degree Zero" (*Studies in the Literary Imagination* 34, no. 2 (*Drama and Consciousness*), Fall: 75–92), which considered what kinds of psychophysical conditions might be targeted by Beckett's texts and production instructions for actors and directors.

2. Bodily positions and hand gestures, which compose an expressive language in Indian Dance.

3. Musical composition reflecting particular emotional mood; Indian music is based on nine ragas.

4. (Contemporary practice and performance history suggest that this understanding derives from [Keralan] martial art forms and medical systems.)

5. Jo-ha-kyu: "beginning," "middle" and "end" phases of a movement, e.g., in Noh performance.

6. Curiously "outside time," then; the words function as three drops of sound, increasingly, as they are repeated over and over again, devoid of meaning; they become mere pulses, tactile markers of the ineluctable pace of entropy.

7. *Kuttampalams* are the traditional temple theatres of Kerala in which the *Kutiyattam* plays are performed. The playhouse is the living example of the Natyasastra's legacy on theatre architecture. *Kutiyattam* is the only existing form of presenting Sanskrit plays on which there is an unbroken history of performance in Kerala from 9 century AD.

8. The sense that activity (particularly creative activity or play) is effortless.

9. Kerala Kalamandalam is the University of Traditional Performing Arts in Kerala. The institution has produced generations of traditional performing artists in Kerala. Major directors from western theatre, like Grotowski, Barba, Brook and Schechner have visited the place at some point in their theatre careers.

BIBLIOGRAPHY

Barba, Eugenio. 1995. *The Paper Canoe: A Guide to Theatre Anthropology*. London: Routledge.

Barba, Eugenio, and Nicola Savarese. 1991. *The Secret Art of the Performer: A Dictionary of Theatre Anthropology*. Richard Fowler, trans. London: CPR & Routledge.

Barker, Clive. 1977. *Theatre Games*. London: Methuen.

Bataille, Georges. 1985. "The Big Toe." In *Visions of Excess, Selected Writings 1927–1939*, Allan Stoekel, ed. and trans., 23. Minneapolis: University of Minnesota Press.

Beckett, Samuel. 1954. *Waiting for Godot*. London: Faber.

_____. 1956. *Fin de Partie (End Game)*. London: Faber.

_____. 1964. *Play*. London: Faber.

_____. 1971. *Come and Go*. London: Faber.

_____. 1973. *Not I*. London: Faber.

_____. 1976. *Footfalls*. London: Faber.

_____. 1982. *Ohio Impromptu*. London: Faber.

_____. 1982. *Rockaby*. London: Faber.

_____. 1954. *Molloy*. Paris: Minuit.

_____. 1959. *Murphy*. London: Calder.

_____. 1959. *The Unnameable*. London: Calder.

Benmussa, Simone. 1979. *Benmussa Directs*. London: Calder.

Csikszentmihalyi, Mihaly. 1997. *Finding Flow: The Psychology of Engagement with Everyday Life*. New York: Basic Books.

Deleuze, Gilles. 1994. "He Stuttered." In *Gilles Deleuze and the Theatre of Philosophy*, C.V. Boundas and D. Olkowski, eds., 23–29. London: Routledge.

Lavery, Carl. 2010. *The Politics of Jean Genet's Late Theatre*. Manchester: Manchester University Press.

_____, with Franc Chamberlain and Ralph Yarrow. 2012. "Performing the Oikos: Bodies, Practices, Metabolisms: Steps Towards an Ecology of Performance." *University of Bucharest Review*, Vol. XIV, no 1: *(M)OTHER NATURE? Inscriptions, Locations, Revolutions*, pp. 1-33

Nair, Sreenath. 2012. "Mudra: Choreography in Hands." *Body Space & Technology* 11/02.

Ridout, Nicholas. 2006. *Stage Fright, Animals, and Other Theatrical Problems*. Cambridge: Cambridge University Press.

Shakespeare, William. *The Tempest* (various editions).

Yarrow, Ralph. 2001. "Theatre Degree Zero." *Studies in the Literary Imagination* 34.2 (75–92).

Darshana and *Abhinaya:*
An Alternative to Male Gaze[1]

Uttara Asha Coorlawala

In this study,[2] methods developed within the frames of feminist film theory of deconstructing the gaze are applied to "read" abhinaya[3] (techniques of narrating in Indian classical dance). The study yielded an alternative model to Kaplan's model of the inevitable male gaze and arises from a performance mechanism for generating transcendence. It also shows that de-contextualized readings of dance can yield very different meanings from the readings that consider the religio-aesthetic environment of Indian dance. Euro-American perceptions informed by Freud and Lacan recognize the importance of seeing and its relationship to knowing. So do Yogic (*Samkhya* and *Advaita*) theories of perception that inform the dance theory and practice. Cross-examining inherently different performance methodologies, techniques and forms yield fascinating connections and insights, but it also has limitations. Perspectives cannot be equated. Each view has value-laden socio-cultural orientations, which must be considered.

Looking in Indian Classical Dance

In theories of aesthetics and of perception, looking, (*drishti*) is integrally linked to a notion of identity (*nama-rupa*) and perception.[4] *Nama* refers to naming, an internal mental activity of cognizing and organizing information. *Rupa* (literally form) references the interaction of the senses, and the external object of perception. Thus, what is "seen" is constructed out of the encounter between the seeing subject's internalized worldview and experience, and the physical and essential qualities of what is seen externally?[5]

In dance, mastery of techniques for communicating meaning (*abhinaya*) include the ability to direct the audience's sensibilities towards a particular understanding through the use of eye movements. The eyes are used not just for "looking" at, or responding to another imaginary character. The focused gaze directs attention to an action, a place or a part of the body and so underlines that activity, place or part of the body. Thus they might follow the path of the hand as it inscribes spirals in the air.[6] This guides the observers towards "seeing" what they are supposed to see. Eyes also can indicate temporal spaces as the *Kathak* performer swiftly changes the direction of her head and gaze to "draw" or make visual, the spaces between the sounds of the *tatkar* (rhythmic footwork). Occasionally, the hands will accompany the head and trace the pattern of the rhythms (Vatsyayan 1990; Coorlawala 1994).[7]

The Gaze in Feminist and Film Theory

The concept of the "Gaze" in feminist film theory is based on theories originally postulated by Freud and Lacan. The pleasure of looking according to Freud derives from the sexual drive and voyeurism, a controlling gaze (Freud 1962: 22–23 & 88–96).[8] For Lacan, the gaze is situated somewhere between the eye and what is seen. Seeing involves naming, interpreting, or translating the seen object. However, the seeing subject cannot see his or her self, and by simply existing has entered the scopic field. Each seeing subject in turn is named and informed by how s/he is seen. The gaze thus remains elusive and beyond the control of even the one who is looking (Grosz 1990: 77–79).[9]

In analyzing gender constructs and structures of control within Hollywood filmed narratives, Laura Mulvey arrived at three mechanisms of the voyeuristic and fetishizing gaze. I have deployed these three mechanisms as tools for deconstructing embedded meanings of actions in an alternative culture-specific gaze. I use the word "alternative" with hesitation, but Ann Kaplan's later essay "Is the Gaze Male?" further proposes that the film audience (whether male or female) is always in the dominant or male position and finds no structural option. This filmic structure (where the male gender is the power location rather than a biological inevitability) is reminiscent of the structure of the individual–God or female-male relationships of the Radha-Krishna narratives. Mulvey's first mechanism consists of the gaze of the camera, which frames and edits, or "choreographs," what the audience can see. The second is the gaze of the male characters, who construct meaning within the film.[10] The third specular mechanism in play is gaze of the spectator. Whereas Mulvey is concerned specifically with the voyeuristic and fetishizing gaze of feminist film theory, and Kaplan is unable to arrive at any other model of the gaze, I

propose that "darshan" offers another model. In any filmed sequence of dancing, more than three mechanisms of gaze are actively constructing layers of meaning for the observer to decipher. In the following analysis, I have applied gaze mechanisms that relate most directly to the meaning of Mahapatra's dance as prescribed within its own culture. The dance when performed outside its source culture would then encounter a different gaze than the one being described here.

Gaze Mechanisms in the Filmed Dance

The most obvious mechanism is within the filmed dance performance, where the body and visual focus of the performer constructs or "sees" participating male and female protagonists whether they are imagined or physically present. The performer is following a set of conventions of representation, specific to the codified dance form, Odissi, in this case. Within this filmed performance, the interactions between the movements, the performed narrative and its literary text, the *Geeta Govinda*, are choreographed in accordance with aesthetic proscriptions that frame the dance separating art, literature from "real life." This framing mechanism is taken here to constitute the second mechanism of the gaze. The third mechanism of the gaze is that of the observers. What observers see, is mediated by more than instinctual drives. The reception of performances is mediated by individual and social psychological and religious beliefs, personal histories, aesthetic expectations, and norms of socially acceptable behaviors. All of these mechanisms of conveying meaning within the performance, intermingle, inform and comment on each other so that it is hard to isolate any one mechanism even for the purposes of description.

Kelucharan Mahapatra and the Dance as Filmed

In a film produced by Shankar Jha, titled *Odissi*,[11] Kelucharan Mahāpātra (1924–2002) performs an excerpt from the classic text of Odissi dance the *Geeta Govinda*.[12] This dance sequence is shot on the outer level of the *nata mandappa* (dance hall) of the Sun temple of Konarak at Bhubhaneshwar which is today an archaeological monument, but which in the past is said to have served as a performance platform. If any one person could be said to most popularly represent the Gotipua tradition of Odissi dance, it was Kelucharan Mahapatra, of Raghurajpur, Orissa.[13] At his own request, Mahapatra trained as a "Gotipua" and started his theatrical career at age nine in the Raslila group

of Guru Mohan Sunder Goswami in Cuttack, Orissa. He then went on to perform at the Annapurna B theater, where he was tutored by Guru Pankaj Charan Das. Teaching at the college for Music in Dance in Cuttack, *the Kala Vikas Kendra,* for about fifteen years, he also headed the Odissi dance faculty at the Odissi Research Centre, and here headed the reconstructive project of codifying contemporary Odissi dance. During this time he choreographed several dance-dramas. He is the recipient of India's highest awards to artists such as the Padma Shri, Padma Bhushan, Sangeet Natak Akademi Award. His students include all of India's foremost Odissi dancers.

Kelucharan Mahapatra's entrance in the film consists of *cari*-s or stylized walks as he moves forward into full view of the camera.[14] Initially the camera includes within its frames, the parts of the temple sculptures and terrace around Mahapatra. The commentary informs that he is about to perform an *Ashtapadi* from the *Geeta Govinda,* where Radha invites Krishna to arrange her clothes and ornaments and as He follows her instructions, the two become absorbed in the ecstatic communion of God and devotee. Gradually the frame closes in on the performer's body and then on his upper torso and head. He is dressed in a yellow-orange silk dhoti, with typical silver Odissi dance belt. His chest and arms are bare, except for armlets and neck ornaments. His eyes are lined with kohl and on his earlobes are stud earrings. The soft relaxed contours of his torso are very different from the lean hard muscular look that is current in commercial films and in contemporary dance. There is a distinctly androgynous look to Mahapatra's performance persona. After a protracted entrance, Mahapatra proceeds to elaborate on two stanzas (12 and 17) of the 24th song in the Twelfth part of Jayadeva's *Geeta Govinda* (Stoler Miller 1977: 124–25).[15] The camera alternates between close shots of the performer looking directly through the camera, and more distant shots, which take in his entire figure. As in the solo dance conventions, Mahapatra plays both the roles of Radha and Krishna. First, Krishna is indicated by gestures of playing a flute, and then Radha by gestural descriptions of her full spherical breasts. This Radha adorns herself and presents herself in poses for Krishna to admire.

It is Radha who initiates this dialogue, as she invites Krishna to decorate her nipples with sandalwood. Krishna agrees. He becomes absorbed in the subtle creative decisions that the task presents. He pauses thoughtfully studying the subject, then in a flurry of inspiration applies two dots (*tikka*) very gently, (one for each bosom?) He applies the cooling sandalwood paste all around, and surveys his "art" appreciatively.

With a sidelong and semicircular movement of his eyeballs, Mahapatra signals the lover to be seated by him. Then as Radha he raises his chest and arms up in a proud and contented display and slowly closes his lid as if in ecstasy while the camera of course—closes in on his face. Radha offers her

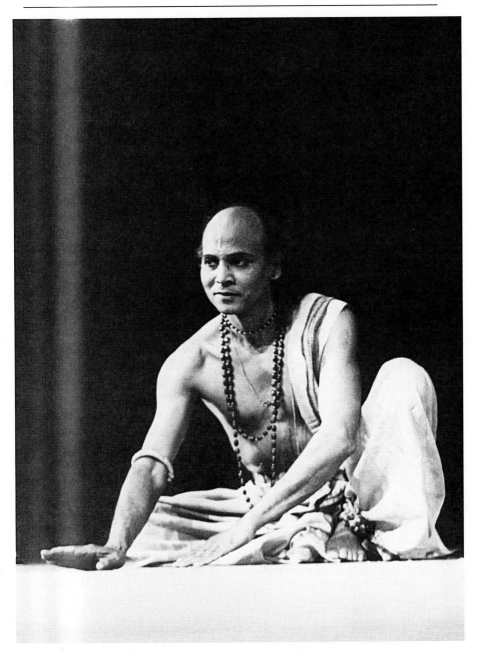

As Krishna Sri Kelucharan Mahapatra grinds sandalwood paste to anoint Radha (photograph by Avinash Pasricha).

own pleasure as a visual delight to her lover, just as a dancer might delight in the sculpted poses that she displays for the audience to admire. In the next line of the same verse, Radha joins the activity of adding to the decorations of her body, watching Krishna as she does so. With this subtle reversal of the gaze, she rises to join her Lover with uncomplicated eagerness and directness. Here Mahapatra's rendering is tremendously moving in its simplicity and lack of coyness or seductive innuendos. Mahapatra rises. The camera cuts away and we see him perform a brief rhythmic dance sequence with spiraling gestures and sculptural postures while the refrain narrates that the Lord's playfulness delights and fills her (Radha's) heart.

The dance skips to verse 17 of the same poem where Radha invites Krishna to "Fix flowers in shining hair loosened in loveplay!" Here Mahapatra shows four or five different versions of how Radha might have reassembled her long hair shining like snakes into different knots at the back of her head and adorned them with flowers. The gestures culminate in sculptural postures that superbly evoke the iconic archetypal quality of the temple carvings on the wall behind the performer. Yet here, the almost excessively luxuriant intimacy of the previous verse has receded to foreground a display of creativity in visualizing the poetry through fanciful poetic conventions for example, the curls framing her face wave like the temple flag on its pinnacle. No longer does the intense focus of artist's eyes reach out to and beyond the camera, rather Mahapatra's focus withdraws to an inward attention to movement, to the hands, the body. The seeing eye, the camera, too, seems to have withdrawn spatially from close ups of the face and hands to take in the full body in relation to the temple sculptures. The metaphoric *shikhara* i.e., Radha's head, is shown juxtaposed against a background of temple *shikara*/pinnacle. Both lovers have dissolved into shadows of their intimate presences as the poetic conventions of the form such as metaphoric snakes and pinnacles—take precedence.

There is a display of iconic hand symbols of aesthetic union, and poses of aesthetic display. Finally, Radha bends forward drawing the *sindoor* of the wife on her head.[16] She rises and modestly draws a veil around herself and walks away. Radha's position in the performed narrative starts as erotic object but gradually we realize that Radha has shifted into the dominant position of seeing-constructing subject. Mahapatra, as he performs Radha, offers visual pleasure to male observers, even as he constructs 'her' as an active subjective participant in the love-game. Mahapatra, as Krishna a *nayaka* or hero figure, offers identification for male observers, while his attentive actions seduces female observers. Intimacy transforms to narrativity as Mahapatra transits from the personalized acting mode to the more impersonal narrator's position. Identification with either of the roles that Mahapatra plays gives way to admiration for the sensitivity of his gender-bending artistry.

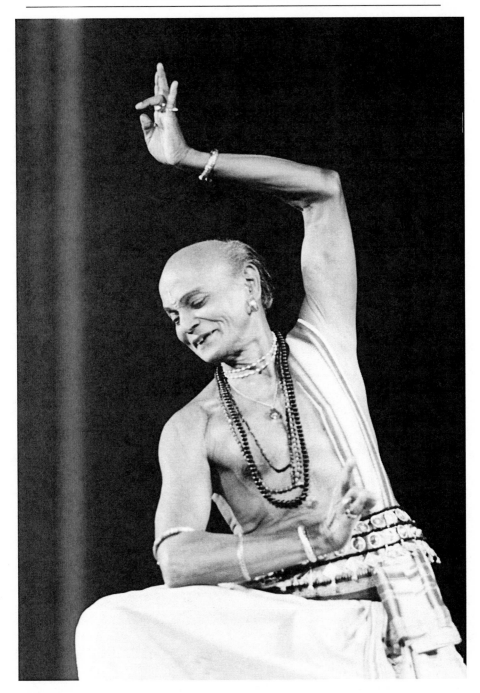

A sculpturesque dance pose (photograph by Avinash Pasricha).

As Radha: "Come, Krishna come like a bee drawn to drink the nectar of the full-blown flower. Come" (photograph by Avinash Pasricha).

The Gazes of the Choreography and the Poem

The gender and person constructions within the abhinaya closely corre-
spond with the gaze mechanisms of the poem. In the poem typically, the first
two lines of each verse are in the first person, and Radha "speaks" here. The
emotional intensity of the game of love in stanza 12 is embodied in the per-
former's enactments of looking, his sensual relaxed torso, curving shaping
movements, chiseled sense of space and close-up camera shots.

The performance of the second part of the dance (stanza 17) foregrounds
the rhetorical conventions of the poetry. An example is the now famous pose
where liquids of lovemaking are compared to *amrit,* the elixir of immortal
bliss so reminding us through exquisite form, of the poem's religious context.
Skeins of hair morph into snakes and curl into temple flags and these images
recur even within this short clip. Camera angles too, echo the rhetorical con-
ventions with the focus closing in on the face for emotional intensity, and
retreating to show the entire body and temple sculptures in the background.
One shot juxtaposes the background temple pinnacles right behind Radha's
head, a metaphorical pinnacle.

In the refrain which follows each verse, the male poet's narrating presence
outside the "story" is acknowledged: "She told the joyful Yadu hero, playing
to delight her heart" (13). This recurring reference to Radha in the third person
is made visual by Mahapatra in the introduction, conclusion and the interludes
between verses where as narrator he signals or sparsely alludes to Radha's allure
and Krishna's magnetism (the irresistible flute) while he dances rhythmic pat-
terns (*nrtta.*). Mahapatra's choreographic realization of the rhetoric conven-
tions and play of meanings of the poetry is not done in a match-for-match
literal way, but rather the oral/aural and visual texts are so enmeshed, that it
is hard to conceive them separately. In the refrains, is Mahapatra "speaking
for" himself or for Jayadeva, the poet? Their perceptions mingle in construct-
ing the entire presentation as invisibly as the camera, which guides viewers to
"see" the director's vision. Perhaps the seamless layering of the poet, choreog-
rapher and camera gazes is not so surprising when one notices in the credits
that the film director has been advised closely throughout the process by none
other than dance and Sanskrit aficionado Sunil Kothari.

Even as Mahapatra's unique choices of imaginative and eloquent gesture
seduce the observer into rapt attention, the observer is reminded that these
are conventional artifices, merely techniques of visual focus. These are iconic
gestures and poses being masterfully manipulated by a real body in real time.
Thus despite the intimacy of the content, and the filmic medium, a critical
aesthetic distance is maintained by the stylization that frames the narrative.
During performances or screen showings, often empathy or projected fantasies

are disrupted by applause, expletive comment etc. There is no attempt to maintain the illusion of a silent invisible fourth wall. So the observer's visual drive for erotic control (that also separates and individualizes) is propelled by the performer's mastery towards the pleasures of abandoning individuality and difference

Another Gaze: Bhakti

Enveloping the frame of the performance is another mechanism that constructs the meaning of this dance. It consists of bhakti, the shared belief system that provides the *raison d'être* for Odissi dance performances and even more specifically is the subject of the *Geeta Govinda*. The *Geeta Govinda* is an ecstatic series of erotic songs addressed to Krishna, and represents the belief of many Vaishnavites in North India and Bengal, that the Divine can be approached through cultivating a direct and intimate relationship with Krishna.[17] In the Bhakti tradition of worship, the Divine Lover is positioned as Male. All His devotees, male and female, actively identify with Radha's constant longing for His presence. This inner attitude of personal devotion is referred to as *madhurya bhava* as described in *the bhakti rasa* theory.[18]

When devotees visit the temple, it is to have darshan (to see the deity, or rather to be in the presence of Divinity). Darshan is a transformative experience where the mind becomes engrossed in an experience of the deity's presence. It is "a subjective experience implying a heightened awareness. For devotees blessed with the faculty of subtle sight the image is a sentient being, but for those with the limited faculty of gross sight it remains a lifeless statue" (Marglin 1990: 234).[19] The inner activity of the devotee, seeking communion, is different from that of voyeurs in the darkened theaters of commercial films. Scopophilic pleasure involves anonymity (Mulvey 1989: 18–26).[20] Invisibility and nonrelationship empowers the voyeur with the capacity to name and thereby manipulate mentally, what is being projected on the screen, while remaining unmarked, unseen. On the other hand, a mutually complicit exchange of subject-object positions is a necessary requisite of darshan. A transformative darshan necessarily involves reciprocal "seeing." The devotee wants to be seen and touched by the Divine Presence. It is only when the devotee is "seen" by the deity/performer, that Divine presence or transformation is experienced. An observer who aligns with the dominating male gaze, which claims possession, and which criticizes and separates, may be entertained, but is unlikely to experience epiphany.

Darshan reflects back the proclivities of the observer. Like a mirror (*darpana*) the performance catalyzes the collective empathizing gaze of the

audience, ritual associations with divinity and the performer's accomplishment into a return gaze, one that touches the heart of the audience (*sahridaya*) as rasa.[21] The performance of a respected master performer whether on television in homes or in a theater in India, invariably demands the mental and emotional participation of its audience and offers an opportunity to participate in an inner ritual, one which rekindles the Presence of Krishna and his *Lila* or divine play.

Tantra: Mechanism for Transcendence— Identification and Shifting Dominant Positions

In the dance, oppositions abound and alternate. As the dance continues, tendencies to identify with a singular position are set up and then interrupted. Suggestive eroticism is the accepted metaphor for spiritual union but desiring a dancer while she was involved in this devotional act, could be tantamount to criminality (Marglin 1990: 234).[22] (The controlling ego drives the desire deeper into the subconscious.) As the viewer's attention becomes engrossed in the sensual aspects of the dance, the mobilized attention is redirected towards abstractions. The same single person performs psychological empowerment (good) and seduction, (bad) religiosity and sensuality, theatrical artifice and human emotions, male and female, dominant and subordinate positions. This constant demand that observers alternate attention between dialectically opposed personal locations fractures the tendency of the observer-participant to focus on or identify with any singular position. Its cumulative effect diffuses both identification and critical distance. Responding, interpreting, and distinguishing the observer is propelled towards a savoring of intimacy. The amazed trans-mental, trans/post-sexual memory that lingers on as an aftertaste is rasa the goal of abhinaya in Odissi.[23]

Mahapatra may not have deliberately set out to juxtapose apparent contradictions in his dancing, yet, the concurrence of juxtaposed opposites is not accidental and particular only to Mahapatra's representation. It is at the core of Tantric practices that are also embedded in the belief-systems that are the very cause and reason for Odissi dance. Dual or split focus is a mechanism that is characteristic of several *dharana*-s or exercises for concentration, in the *Vijnanabhairava*.[24] Many *dharana* involve attempting to attend to two different processes simultaneously so as to almost trick the aspirant into falling into the silent thought-free space between the two moving mental images. Their objective is to situate the mind in a state that is most conducive to meditation and its reward, *ananda* or bliss.

Skill and Local Responses: A Continuum

Live performances of classical Indian devotional dances today fall in various places on a continuum between darshan and entertainment according to how closely the performance fulfills the function of inner darshan or *sattvikta*. The extent to which a concert fulfills this prescribed function depends upon individual performer training and techniques, the circumstances around the development of the form concerned, the structures within the choreography, and the intensity of the audience's alternation between active identification and observation.

Superlative performances such as those of Mahapatra that re-embody traditional aesthetic values and effect an inner transformation of the sympathetic viewer's state are exceptional. In fact, since this film was broadcast, this dance has become obligatory for artists of Odissi and also of other classical forms. With Mahapatra's passing, his construction of this particular role for Radha has become iconic. Yet, young women dancers tend to avert their gaze, to distance their participation from Radha's eager eroticism. In doing so, they retrace the inevitable male patriarchal gaze, re-enact the desire for middleclass respectability, and darshan via the return of the gaze is denied. In this nationally televised film of Kelucharan Mahapatra dancing, his male person, his artistry and the camera gazes work together. The dance gazes back at its audience. Memories linger.

Intercultural Performances

The art in abhinaya is the art of filling in details and shades of characterization, which imbue archetypal images with living multidimensional presence. The archetypal models of role are meant to be rediscovered, or rewritten by each generation. Performances might be richly layered and nuanced, or project flat stereotypical images. In either case (prior to the profusion and far reach of YouTube recordings) in each single night stand in an alien place, the artist was often taken to stand for an entire culture and for all performances of the same or similar genre in his culture. At an ISTA Conference of intercultural performance techniques, Phelan described a specific spectator-performer exchange in within the discourse on feminist theory. For her a Gotipua dancer "Gopal" from a village in Eastern India, stood in for a fetishizing structure of the gaze of an entire group of "Eastern theatrical roles" made possible by the absence of the woman.

Whereas the argument for contextualized readings is strong, to what extent can the audience be educated beyond their customary expectation? The

convention of performing gender, invariably involves the absence of one sex. Its effect could be as disturbing as the audience's expectations to the contrary. It might then be argued that the dance is part of an ancient inviolable tradition, too complex and too culture-specific to be understood. The generosity of those who accept this explanation, returns ownership to the performers. However, it also places such performances beyond the purview of understanding and criticism, and into the realm of the mysterious other. This strategy further ghetto-izes the forms.

Comparably, while feminist readings of Indian dance can be theoretically provocative, decontextualized readings no matter how meticulous impose the value structures of the reader upon the read object (Martin 1987: 32–40).[25]

Conclusion

In Kelucharan Mahapatra's dancing, the complexity of the interaction amid the layers of gazes, results in a more nuanced reading of the performance of gender. His performance involves choreographic mechanisms that fracture the tendency of the observer to identify with a singularly male or female orientation. Mahapatra's superlative embodiment of diverse gendered locations, his use of rasa theory to construct his narrative, and the long revered custom of giving and receiving darshan in India, combine to offer an alternative structural model. This model of the performer-viewer relationship is based on reciprocal recognition, rather than the separation and will to power inherent in construction of the inevitable "male" gaze of European-American performer-audience positions.

Movement analysis and feminist film theory have provided two powerful tools for examining a brief excerpt of a traditional Odissi Gotipua dance. Movement analysis exposed social and aestheticized mechanisms whereby traditional or socially determined representations of gender are perpetuated or are subverted. An analysis of the gaze mechanism in the film of Kelucharan Mahapatra dancing, does confirm some traditional statements about the purpose of the dance but also uncovers the way that choreographic mechanisms in traditional Indian dance fracture the tendency of the observer to identify with a singularly male or female orientation. Again, had the philosophic underpinnings assumed by the use of these tools been overlooked, then a different reading would have resulted, a reading that would have privileged the priorities of the culture that produced the tools. I hope that this exercise deploying many tools, to look at how an other looks at one's self, offers back fresh insights to both sides of the discourse, just as the dynamic interaction between symmetric perspectives of the performer audience exchange offers its mirror, the alternative to the persistence of a single male gaze.

NOTES

1. I am deeply grateful to Peggy Phelan for introducing me to the excitement and insights of Feminist theory, and for challenging me to respond to her article. I am indebted to Cynthia Novak for sharing with me her context-sensitive approach to movement analysis. I want to thank Sunil Kothari for his constant generosity in sharing with me his astonishing knowledge and love of dance and dancers. I thank Swami Muktananda Paramahamsa for demonstrating the meaning of darshan clearly and invariably. Finally there is the generosity of Kelucharan Mahapatra, himself, the performer and teacher who invited me into his world.

2. This was originally written as a chapter of my dissertation at NYU in 1994. A part of that chapter was published under the title "Darshan and Abhinaya: An alternative to the Male Gaze" in *Dance Research Journal* 28.1 (Spring 1996). This version includes an update of the original chapter.

3. The Natyasastra defined *abhinaya* as that which carries the performance towards its fulfillment when the observer is absorbed in the resonances of the narrative and "tastes" its emotions. *Abhinaya* works through prescribed conventions of movement, costume, decor, instrumental or vocal accompaniment and inner attitude Natyasastra *VIII, 6–9*.

4. These terms recur in the *Upanishads,* the *Mimamsa* and other commentaries on them, in Buddhist texts and in present day common knowledge and speech.

5. The encounter differs according to the philosophic perspective. In *Advaita* notions of perception there is mutual interaction between *Pramaat,* the seeing/knowing subject and what is seen, *Prameya,* the object of knowledge. They are even said to be identical. However, in Samkhya, a dualistic theory of existence, the enjoying subject (*bhokta*) and the enjoyed object of attention, (*bhogya*) are always distinct. Consciousness or Purusha and Prakriti, or matter are always distinct. *Purusha* cannot be regarded as the source of inanimate world, because an intelligent principle cannot transform itself into the unintelligent world.

6. For convention of hand-eye co-ordination during nrrta or abstract dances see Nandikesvara's Abhinaya Darpana vs. 36 When narrating the eyes are used in many additional ways to indicate presence of another character, etc etc.
yatho hasta tatho drishtir, yatho drishtirstatho manah,
yatho manah tatho bhāva, yatha bhāva tatha rasah.
variously translated as
Where the hand there the gaze, Where the gaze there the mind,
Where the mind, there bhava, and Where bhava there rasa.

7. Birju Maharaj, now recognized as India's foremost exponent of Kathak dance and repository of the Lucknow lineage, has often reiterated that rhythms are most clearly understood when they are visualized as patterns drawn on paper and that performance should explicate this perception. Such statements are recorded on an audiotape of a press interview in New York, May 28, 1991, and in a videotape of a lecture demonstration at an International Conference on Time and Space in Dance, in New Delhi, December 12, 1990, organized by Dr. Kapila Vatsyayan. See also Coorlawala, 1994, p. 101.

8. Sigmund Freud, 23–33. For Freud's construction of a love-object, see 88–96.

9. See Grosz, 77–79. She cites J. 1977, 182–83. For how a multiplicity of forces interact in the formulation of hegemonies, see Foucault 1990, 75–80.

10. In Mulvey's argument female characters were usually shown on screen as objects of the gaze, fetishized with close up shots emphasizing beauty and being. Men on the other hand were the active movers of the narrative, seen in full body shots in action. After this article was published it is notable how female characters in filmic representations began to transform.

11. Odissi. A Prakash Jha Production featuring Kelucharan Mahāpātra, Guru Mangani Dass, Kokil Prabha and Hari Priya, Guru Pankaj Charan Dass, Guru Debu Prasad Dass, Smt. Sanjukta Panigrahi. Television Broadcast sponsored by Doordarshan and broadcast nationally in the early 1980s.

12. Originating in Orissa in the 13th century, the *Geeta Govinda* has been known to have been historically performed in both Carnatic and North Indian musical styles and all over India in temples including Orissa, Bengal, Manipur, Kerala. Now its songs (Ashtapadi) are almost obligatory in the repertories of dancers of several of the classical forms.

13. Guruji Kelucharan Mahapatra 1924–2002.

14. I find it necessary to distinguish between Mahapatra's body language in this filmed version of the dance and the several consequent re-enactments of this choreography which was performed later by several of his students, themselves accomplished Odissi performers, and each with different inflections of gaze. I distinguish between the conventions of representing the gaze in dance and the gaze as in this particular seminal version.

15. Translations from Sanskrit of the two verses of the twenty fourth song of the Geeta Govinda performed in this excerpt are:

Madhava hero, your hand is cooler than sandalbalm on my breast.
Decorate my breasts with leaf designs of musk;
Paint a leaf design with deer musk, here on Love's ritual vessel!
She told the Joyful Yadu Hero, playing to delight her heart [12th part, verse 12].
Fix flowers in shining hair loosened in love-play, Krishna!
Make a whisk outshining peacock plumage to be the banner of Love.
She told the Joyful Yadu Hero, playing to delight her heart [verse 17].

Barbara Stoler Miller, 124–25.

16. This action of reminding the audience of her married status, is itself subversive. Radha flaunts her willful dalliance outside of marriage, with Krishna.

17. The Gotipua tradition of young male dancers performing outside the temple seems to have been nurtured by the King Prataparudradeva in the 16th century, whose minister Ramananda is said to have founded the performance genre. Ramananda is said to have been was a close follower of Sri Chaitanya and his brand of Vaishnavism and Bhaktism, where devotion is both expressed and practiced performatively. Thence, the idea that young male performers could best express their devotion to the supreme power of Krishna through, becoming "Radha." According to a discussion with dancer scholar Anurima Banerji, she speculated that since the Vaishnavas held restrictions around women performing in public, mahari (the women's tradition of Odissi) public appearances declined at this time, while Gotipuas took their place.

18. In *Bhakti-rasamarta-sindhu* Rupa Gosvami describes bhakti as practice.

19. Bennett 1990, 189–196.

20. Mulvey (18–26) uses the term "scopophilic pleasure" to identify the using of another person as an object of sexual stimulation through sight. See also Grosz 77–79.

21. In fact the fruitlessness of this kind of gazing is even demonstrated in the story of how Krishna dances with his devotee, until she begins to feel that she is his exclusive Beloved. At the instant when the gopi recognizes her seductive prowess, Krishna vanishes.

22. Marglin cites a nineteenth century palm leaf manuscript written by a devadasi. Marglin 1990, 234.

23. Whether there may be some correspondence between this prescribed post-performance phenomenon in Indian aesthetic theory, and the state of pre-verbal completeness referred to as pre–Oedipal by psychoanalytic feminists is another investigation.

24. *Vijanabhairava Tantra* is a key text of Trika school of Kashmir Shaivism and considered as the important source of Shaiva philosophy. The text presents a range of concentration exercises and conducts in-depth debates on non-dualistic principles of Shaivism.

25. Carol Martin refers to a different event at the same conference, and points out that until cross-cultural Feminist analysis takes into account the cultural beliefs of the other it participates in the same imperialist stance as missionaries and sexism (32–40). Issues of cultural hegemony in intercultural performances of theatre is the subject of Rustom Bharucha's book and Coorlawala's report in *Sruti 90*, 34–5.

BIBLIOGRAPHY

Bennett, Peter. 1990. "In Nanda Baba's House. The Devotional Experience in Pushti Marg Temples." In *Divine Passions. The Social Construction of Emotion in India*, ed. Owen Lynch, 189–196. Berkeley: University of California Press.

Bharucha, Rustom. 1990. *Theatre and the World*. New Delhi: Manohar Publications.

Coorlawala, Uttara Asha. 1992. "Issues Relating to the Festival in the U.S." *Sruti 90* (March): 34–5.

_____. 1994. "*Classical and Contemporary Indian Dance: Overview, Criteria and a Choreographic Analysis*" Ph.D. Dissertation, New York University.

_____. 1996. "Darshan and Abhinaya: An Alternative to the Male Gaze." *Dance Research Journal* 28.1, Spring Congress on Research on Dance.

Foucault, Michel. 1990. "The Deployment of Sexuality." *The History of Sexuality, Volume I.* New York: Vintage, 75–80.

Freud, Sigmund. 1962. *Three Essays on the Theory of Sexuality.* Trans. and ed. James Strachey. New York: Basic Books.

Grosz, Elizabeth. 1990. *Jacques Lacan, A Feminist Introduction.* London: Routledge.

Kaplan, E. Ann. 1983. "Is the Gaze Male?" *Women and Film.* New York: Methuen.

Khokar, Mohan. 1976. "Male Dancers." *The Illustrated Weekly of India*, March 7.

Kothari, Sunil. 1990. *Odissi.* Bombay: Marg Publications.

Lacan, Jacques. 1977. *The Four Fundamental Concepts of Psycho-Analysis.* London: Hogarth Press.

Marglin, Stephen. 1990. "Refining the Body." *Divine Passions. The Social Construction of Emotion in India.* Owen M. Lynch, ed., 234. Berkeley: University of California Press.

Martin, Carol. 1987/1988. "Feminist Analysis Across Cultures: Performing Gender in India." *Women & Performance: The Body as Discourse* 6: 32–40.

Mulvey, Laura. 1989. "Visual Pleasure and Narrative Cinema." *Visual and Other Pleasures.* Bloomington: Indiana University Press.

Phelan, Peggy. 1988. "Feminist Theory, Poststructuralism, and Performance." *The Drama Review* 23.1: 107–127.

Roland, Alan. 1989. *In Search of Self in India and Japan. Towards a Cross-Cultural Psychology.* Princeton: Princeton University Press.

Singh, Jaideva. 1981. *Vijnana Bhairava.* New Delhi: Motilal Banarsidass.

Stoler Miller, Barbara. 1977. *Jayadeva's Gita Govinda. Love Song of the Dark Lord.* Bombay: Oxford University Press.

Trimillos, Ricardo D. 1990. "More Than Art: The Politics of Performance in International Cultural Exchange." Proceedings of a Conference of the Dance Critics Association, CSU-LA, 2 Sept.

About the Contributors

M. Krzysztof **Byrski** is the head of the Eurasian Research Centre at Collegium Civitas and professor emeritus and the former director of the Institute of Oriental Studies, University of Warsaw, Poland. He is also an eminent Sanskrit scholar and was appointed the first ambassador of the sovereign Republic of Poland to India in 1993.

Uttara Asha **Coorlawala** teaches dance at Barnard College. She is the co-curator of the Erasing Borders Dance Festival and is the former editor of *CORD Dance Research Journal*. In 2010 she received the Sangeet Natak Puruskar, India's highest honor in the performing arts.

Daniele **Cuneo** is a research associate in the Faculty of Asian and Middle Eastern Studies, University of Cambridge. He studied Sanskrit logic at the University of Vienna. His research areas include classical Indian philosophy, Sanskrit poetry and aesthetics, tantrism, codicology and the ancient Tamil culture.

Vashishtha **Jha** is the former director of the Centre of Advanced Studies in Sanskrit, University of Pune. An eminent scholar of Indian logic and epistemology, he is a visiting professor at Mahathma Gandhi Institute (Mauritius) and has taught at Nagoya University (Japan), Lausanne University (Switzerland) and Humboldt University (Germany).

Natalia **Lidova** is a senior research scholar, Institute of World Literature, Russian Academy of Sciences. She is the author of several books and articles on Sanskrit literature and the Natyasastra including *Drama and Ritual of Early Hinduism* (Motilal Banarsidass, 1994, second edition, 1996).

Arya **Madhavan** is a lecturer at the Lincoln School of Performing Arts, University of Lincoln, United Kingdom. A performer and scholar of the Sanskrit theatre of *Kudiyattam*, she is the author of *Kudiyattam Theatre and the Actor's Consciousness* (Rodopi, 2010).

David **Mason** is an associate professor of theatre at Rhodes College in Memphis, Tennessee. A former Fulbright Fellow in India, he is the author of *Theatre and Religion on Krishna's Stage* (Macmillan, 2009) and has contributed articles on classical Sanskrit aesthetics to *Theatre Research International*, *New Literary History* and the *Journal of Dramatic Theory and Criticism*.

Erin B. **Mee** is an assistant professor and faculty fellow in the Department of English at New York University. She is the author of *Theatre of Roots: Redirecting the Modern Indian Stage* (Seagull, 2009) and she has published in *TDR, Theatre Journal, Performing Arts Journal,* and *Seagull Theatre Quarterly.*

Daniel **Meyer-Dinkgräfe** is a professor of drama at the Lincoln School of Performing Arts, University of Lincoln, United Kingdom. He has numerous publications on theatre and consciousness to his credit, and he is the founding editor of the peer-reviewed web journal *Consciousness, Literature and the Arts* and the book series of the same title with Rodopi.

Sreenath **Nair** is a senior lecturer at the School of Performing Arts, University of Lincoln, United Kingdom. His publications include *Restoration of Breath: Consciousness and Performance* (Rodopi, 2007) and *Manikin Plays* (CSP, 2013). He served as guest editor of *South Asian Film and Media* volumes 4.2 and 5.1 (2013).

K. Ayyappa **Paniker** (1930–2006) was a professor of English and the director of Institute of English at the University of Kerala, India. He was a foremost Indian poet and critic and one of the greatest writers in the Malayalam language. He won the highest literary awards in India, the Padmasree and the Saraswathi Samman in 2004 and 2006, respectively.

Richard **Schechner** is a professor of performance studies at New York University. He is the author of *Performance Studies: An Introduction* (Routledge, 2002); *Performance Theory* (Routledge, 1998), and *Between Theater and Anthropology* (University of Pennsylvania Press, 1985). He is also the editor of *TDR,* founder of the Performance Group and East Coast Artists, and the director of many theatrical works.

Kapila **Vatsyayan** is the founder and director of the Indira Gandhi National Center for the Arts and a member of the executive board of UNESCO. An eminent Indian scholar, he is the author of numerous books including *The Squares and Circles of Indian Arts* (Abinhav, 1997), *Bharata: The Nātyaśāstra* (Sahitya Akademi, 1996), and *Some Aspects of the Cultural Policies in India* (Unesco, 1972).

Ralph **Yarrow** is an emeritus professor in drama and comparative literature, University of East Anglia, United Kingdom. His publications include *Sacred Theatre* (Intellect, 2007), *Indian Theatre: Theatre of Origin, Theatre of Freedom* (Curzon, 2000), *Consciousness, Literature and Theatre: Theory and Beyond* (Macmillan, 1997), and *Improvisation in Drama* (Palgrave Macmillan, 1990 and 2007).

Index